Zoltan Szabo
ARTIST AT WORK

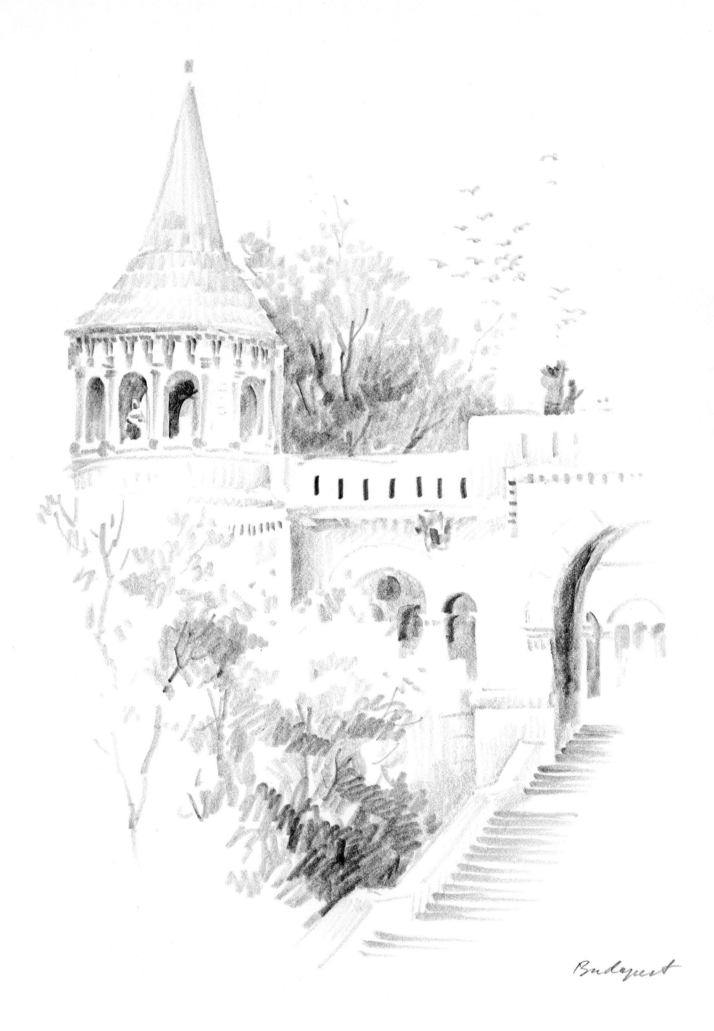

Budapest

Zoltan Szabo
ARTIST AT WORK

BY ZOLTAN SZABO

WATSON-GUPTILL PUBLICATIONS/NEW YORK
PITMAN PUBLISHING/LONDON
GENERAL PUBLISHING CO. LTD/DON MILLS, ONTARIO

Editor's Note: The pencil and watercolor sketches in the interview section are reproduced from pages in the author's numerous sketchbooks. Paintings in the demonstration and one-man show sections are on half sheets (15 x 22 inches/38 x 56 cm) of 300-lb cold-pressed Arches watercolor paper.

First published 1979 by Watson-Guptill Publications,
a division of Billboard Publications, Inc.,
1515 Broadway, New York, N.Y. 10036

Library of Congress Cataloging in Publication Data
Szabo, Zoltan, 1928–
 Zoltan Szabo, artist at work.
 Includes index.
 1. Szabo, Zoltan, 1928– 2. Water-colorists—
Canada—Interviews. 3. Water-color painting—Technique.
4. Landscape in art. I. Title.
ND1843.S97A4 1979 759.11 79-16097
ISBN 0-8230-5977-4

Published simultaneously in Great Britain by Pitman Publishing Ltd.,
39 Parker Street, London WC2B 5PB
ISBN 0-273-01446-3

Published simultaneously in Canada by General Publishing Co. Ltd.,
30 Lesmill Road, Don Mills, Ontario, Canada M3B 2T6
ISBN 0-7736-0077-9

Manufactured in Japan

First Printing, 1979

DEDICATION

Our philosophy of life and the way we apply it represents human values that our fellow men and women judge us by. Like many of you, I am constantly in the process of developing a personal philosophy that will let me dream, grow, and aim for faraway stars. Those shiny little flickering lights may seem unreachable at first, but they have an obliging tendency to keep glistening invitingly until at last I can believe that I actually may touch them.

In my lifelong evolutionary trip, my paintings, the products of my creative growth, represent a series of stages along the way. This book contains a collection of them for you to look at and enjoy. I hope to communicate to you through their visual qualities the emotional experiences that I felt while I painted them. I also hope that they reflect my love of God's nature through the enchanting beauty of transparent watercolor.

As a spiritual bouquet, I offer them to all of you, but especially to the one dearest to me, my little wife Linda. Her constant encouragement, patience, and inspiring, unselfish companionship really made the birth of this book possible. To her, as your representative, I lovingly dedicate this book. I am sure that by sharing it with all of you, it will become a more precious gift than if I had given it to her alone.

ACKNOWLEDGMENT

I wish to express my gratitude to those fellow painters who honored me by inviting me to conduct watercolor seminars for them. As some of the following paintings may remind them, my growth as an artist has been enhanced by these wonderful experiences.

Also, my most sincere thanks to Don Holden, Editorial Consultant; Marsha Melnick, Editorial Director; Bonnie Silverstein, my little editor; and Bob Fillie, graphic designer of this book. Their truly professional attitude, as well as that of Hector Campbell, who was involved with the production, made this, my new dream come true. Most of all, I thank the great Critic above who allowed me to have the opportunity and good health to complete the job.

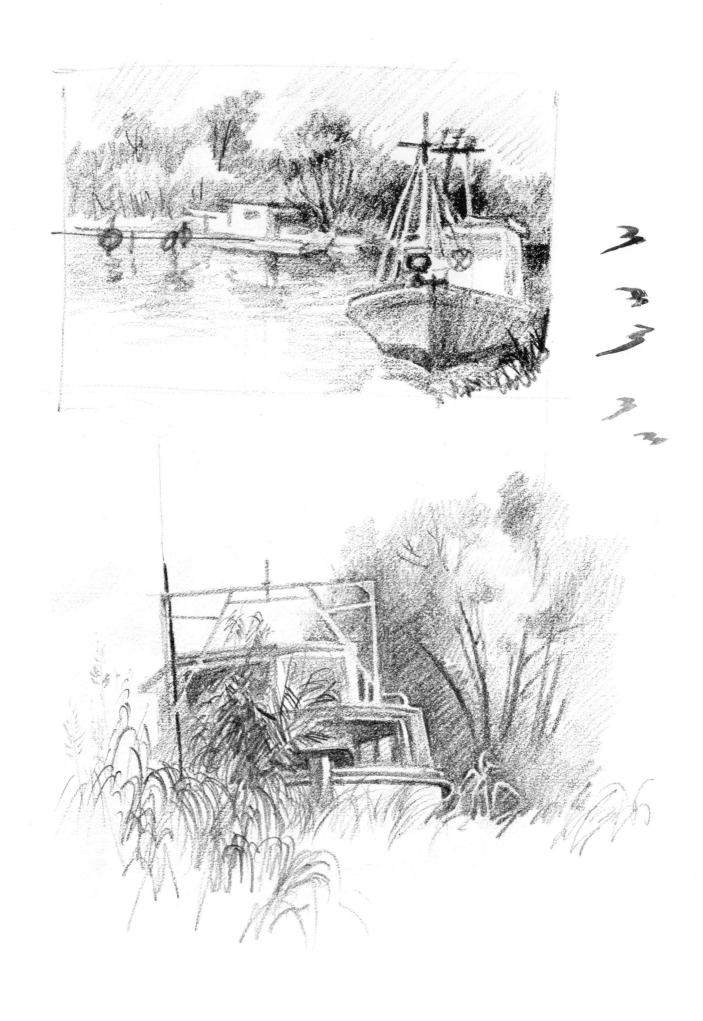

Contents

An Interview with the Artist

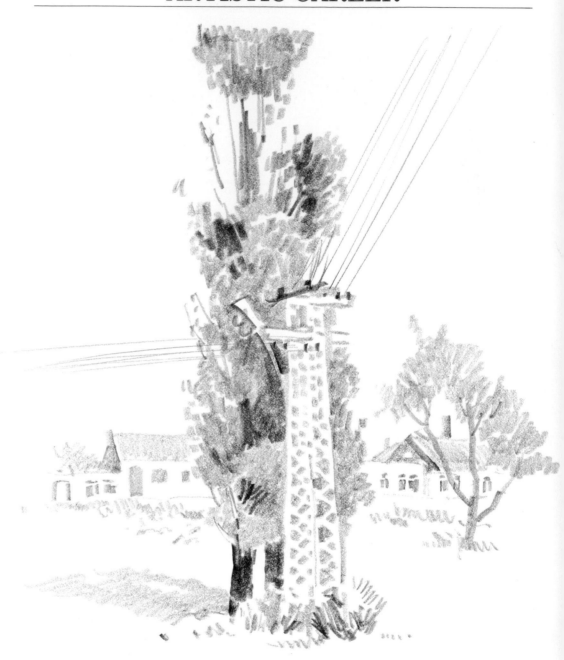

When did you first know you wanted to be an artist?

I always dreamed of it. Apparently my mother couldn't keep me on the potty "long enough" unless she supplied me with plenty of paper and colored pencils. When the war tore up my homeland, Hungary, my teenage years were interrupted, but my interest in art wasn't disturbed at all. I used to drool over some of the lovely war illustrations in magazines. I really can't remember most of the subjects, but I can still clearly recall the style of many artists of the forties, surprisingly from both sides of the war. I guess this was the time when I realized that I had my own ideas and felt like communicating them "skillfully." I grew more and more determined to gain this skill and be an artist, and made the final plunge in my late teens.

Where did you get your artistic training?

I loved drawing and enjoyed working with paint all my life. In high school, art was compulsory and taken very seriously. I had an enjoyable start during

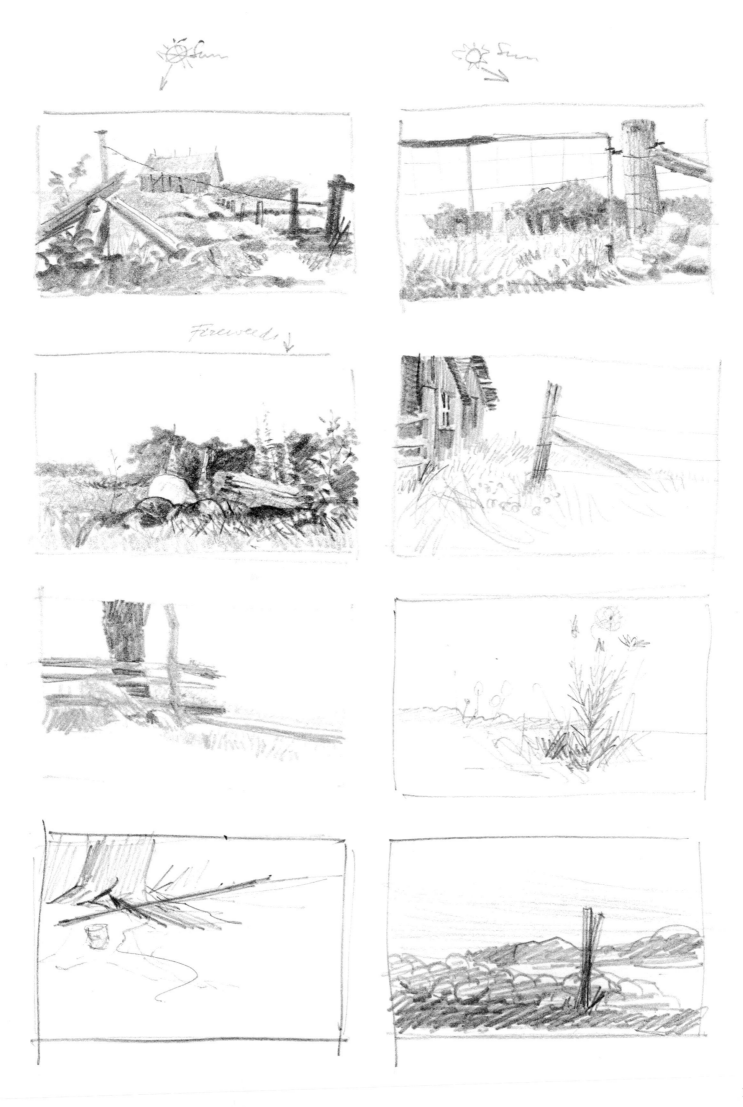

these years. The program was designed to teach technical control of the hand; otherwise, craftsmanship was the goal. After high school and the Second World War, I decided to be an artist. I was eighteen. After just one year in the Academy of Industrial Art in Hungary, I had to leave my country to find a better future in America. Canada gave me a home and a wonderful future. I lived there for twenty-nine years, and developed my skill and philosophy as a watercolor artist there—I was a commercial artist as well as a painter for fifteen years. This way I had the financial security to raise my children, as well as a chance to train myself on the job, so to speak. I painted in my free time as often as I could.

Who did you study with and what kind of training did you have?

I can't drop big names. Two of my high school teachers, humble but very devoted artists, taught me many of the basics. In art school I was surrounded with great teachers who continued to refine my technical disciplines. In Canada I worked with good artists. One I'm especially grateful to is Sid Dyke of Vancouver, who encouraged me a great deal to paint with watercolor. He's an excellent, inventive painter and a sincere friend. His early influence is the most outstanding in my mind. I also read Eliot O'Hara, Ted Kautzky, and Rex Brandt books with great thirst, and I took the Famous Artists' course, but essentially, I taught myself by working all the time and trying to learn from my mistakes. I feel that when you create, you have to be and are alone even when dozens of people are watching you. We can be our own best teachers if we're willing to think while we work.

Did you study all media or did you concentrate only on watercolor?

In high school we were allowed only to draw and later to use watercolor. In art school, I used all major media. In my early career in Canada, I painted with both oil and waterbased media, but most often with transparent watercolor. Somehow my personality was always most compatible with watercolor. The challenge of this untameable medium squeezed out my love of all others, except for pencil drawing.

When you first came to Canada, did you work as an artist right away?

I had a real break. Two weeks after my arrival in Canada I got a job in the art department of a small printing house, even before I could speak English. This is where Sid Dyke was my art director. I also lived and worked in a nearby farm for the first year to fulfill my farm contract with the Canadian government for bringing me to the promised land.

What made you decide to devote yourself to painting?

During my years of gradual growth as an artist, my need to express my ideas became more and more apparent. When the public started to buy my work, I realized that I was communicating with them successfully. Besides a good income, my commercial art offered many frustrations beyond my control. I decided that if I ever reached the point where my painting income (earned with left-over energy after a full day's work) matched my commercial income, I'd quit the commercial job. I thought that this ambitious condition was not likely to happen, but it did. You'd have to know the dynamic support of the people of Toronto to understand how this occurred. At that point I did what I'd promised myself; I started to paint in watercolor full time.

Once you made that decision, what did you do to get started?

I worked like hell. I reached for any opportunity that offered itself: outdoor shows, gallery exposure, solo shows, and group shows. I also taught art in winter programs and in seminars locally as well as in nearby cities. But the greatest boost came when I got a chance to publish my first book, *Landscape Painting in Watercolor,* by the best art publishing house in the United States, Watson-Guptill Publications. Thanks to its Editorial Director, Don Holden, who gave me a chance to introduce myself to all of North America, my career shot up and has been on the rise ever since. Finally, the years of self-training, learning from here, there, and everywhere, bore an unexpected harvest. I developed some techniques that were unique, even though I was not aware of them until the response from the readers of my book pointed them out. Since then I have been just trying to grow a little every time I paint.

How did you begin to build your reputation?

Exposure is a personal thing. By selling the best paintings that I could produce, my name was spread by their new owners. It was a slow, but sure, process. All my best opportunities resulted from these unexpected contacts. Suddenly it was happening all around me. Some of these original customers became dear friends and collectors of my and others' work. Three friends went as far as contracting all my work for two years during the most critical time of my development. They managed to acquire some of my major works along with lesser ones, but it was the best I could do at the time. The galleries followed, but they were of only secondary importance.

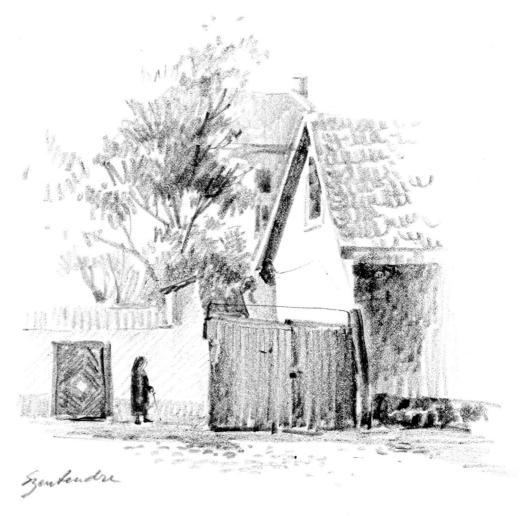

Did you combine painting with teaching right from the start?

Teaching came after a lot of painting, after an awful lot of it. I had to have something worth teaching first. I painted for about fifteen years before I thought of teaching. A few beginner artists who liked my painting asked me if I would teach them. I tried it and liked it. Evening classes followed, and I became more and more comfortable with people. I enjoyed watching others learn and grow. In the meantime, I reinforced my own theories by testing them with others. When I moved to Sault Ste. Marie, Sault College invited me to join their faculty. I did, and spent five wonderfully happy years there as a teacher, with an impressive productivity in my resident artist's studio. In other words, I got a lot of breaks and I tried to make the best of them, for me as well as for those who offered them.

Why do you like to teach? Does it help you in your own work?

Teaching complements my work. I've spent the last three years traveling and teaching one workshop after another. This involved doing demonstrations practically every day. I'm exposed to some excellent artists and I make sure that my work shows them my honest best without holding back. At the same time, I carefully think out my approach. Each time I try to offer something new. If I get a new idea, I can hardly wait for the next class to show it to my new friends so that they can try it out too. Teaching makes me more inven-

tive and exposes me to new ideas and new environments. It's tiring, but it's also very exciting and rewarding. People, particularly watercolorists, are wonderful.

How do you teach?

I both lecture and demonstrate. First I describe my ideas on a chosen subject. I generalize a little, but try to close in on a lot of specifics. Then I follow this with an appropriate demonstration. I try to explain very carefully not only what I'm doing as I paint, but *why* I'm doing it. When my demonstration is completed, I sum up the result. Then it's the participants' turn. They paint a related subject for a few hours. I help those who need it, but try not to encourage them to paint as I do. I respect their individuality and try to help them develop technically so that they'll be better equipped to express that individuality. I never try to tell another artist what to do on his or her work. This must be the individual's decision. I'm there to tell only how it may be done. I show what I can't tell. A picture is worth

What do you teach beginners, intermediates, and advanced watercolorists?

Well, it's in the books—my books! For the beginner, I teach basic technique with a strong emphasis on values and just a few colors. The palette in *Landscape Painting in Watercolor,* which is for the beginner and early intermediate painter, contains grays to avoid the confusion of mixing complementary colors, yet still guarantees a good control of values. For the intermediate painter, I get into composition a little—I use the word "shapes" constantly—and discuss color qualities more (see *Zoltan Szabo Paints Landscapes: Advanced Techniques in Watercolor).* We also polish up technique. Finally, in teaching advanced painters, I reach for the unusual in technique. Here individuality is a must! The idea I try to put across is for them to try my way and decide if they like it. Some of my techniques are new to advanced students, and if they can use them, they can adapt them to their own style. In my advanced workshops we exchange ideas, spell out philosophies, and paint, paint, paint. . . !

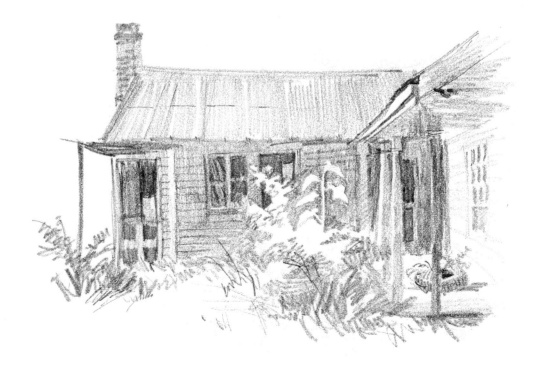

STUDIO MATERIALS AND EQUIPMENT

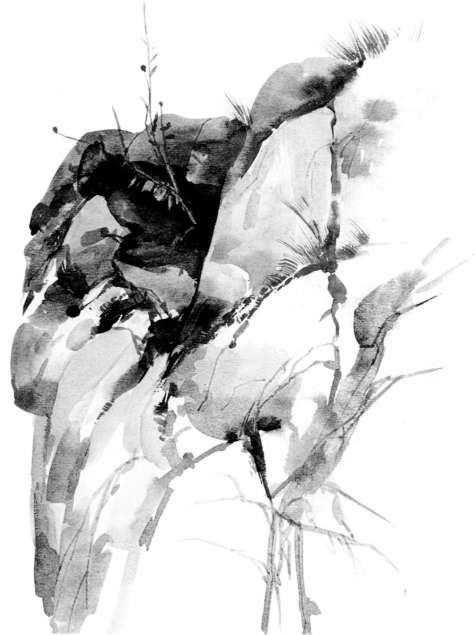

What does your studio look like?

I have two studios, one in my home and a big one under the sky. My home studio has a large drawing board to paint on and a stool. I also have a taboret (high cabinet) to hold my palette, colors, and brushes—in one word, my tools. I have a sink with hot and cold water, and lots of surfaces for spreading things around; storage space for paper and mats; a large guillotine for cutting paper; and storage for frames and finished work. I have a bench with a small press for my "aquagraph" prints, described in *Creative Watercolor Techniques*. There's also a cozy little corner where I'm surrounded with books, my slide collection, projectors, a low soft chair and table, and a good hi-fi and tape. This is my thinking corner, and I love to think and work with quiet, light classical music. I also have a model stand for figure studies with electrical outlets all around it for spotlights, and a private corner for the model to change in. There's also a secretarial desk, chair, and file, and, finally, a washroom with a shower. What I don't have is a telephone, mail chute, television, or other distracting elements.

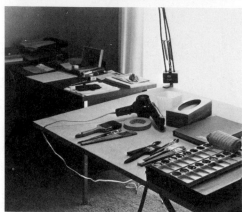

In terms of lighting, I like the place to swim in light while I work. There's lots of indirect light coming in through high windows from different angles, with north light over my drawing board. I also have white floodlights all over on strips, plus four bars of cooler daylight fluorescent bulbs. But there's no substitute for daylight. However, I try to match the color of my artificial lights to be just a little warmer than cool daylight. I like lots of light in my painting area, but just a spot or two in my thinking corner.

What watercolor brushes do you use? What do you use each one for?

I have two sets of brushes: those that I use to paint with and those that I use to brush on clean water only. My painting brushes are a 2-inch (5-cm) soft oxhair flat brush for large washes and a 1-inch (2.5-cm) pure sable flat brush for well-controlled washes or glazes. I have two nos. 6 and 8 sable brushes, with points for details. My rigger (a long-haired, slim, sable brush) is for thin, long, calligraphic brushstrokes. I have a 1-inch (2.5-cm) and a ¾-inch (2-cm) hog bristle brush for painting rich colors and firm shapes on wet paper and also to brush dark colors with in order to lift out color (recovered luminosity). I have a palette knife with a round flexible tip and a firm part at the heel to texture the paint by lifting off excess color or to apply firm branches, twigs, or weeds.

On the clean water side (my left), I have a big 4-inch (10-cm) flat bristle brush for wetting the paper. I also have 1½, ¾, ⅜, and ⅛-inch (4, 2, 1 and 0.3-cm) bristle brushes for applying clear water, for losing edges, and for wetting and lifting out dark colors. These brushes are cleaned with tissue each time they touch color on the painting to prevent even the slightest pollution of the clean water supply. The water in the dish on my left must stay clear enough that I could drink from it even after the painting is finished. (Incidentally, I often do drink it outdoors.)

What are your favorite watercolor papers?

I prefer 300-pound cold-pressed (medium rough) Arches paper. It's a pure rag paper with a consistent quality. The surface is just the right texture for me. It has a hard finish and it can withstand a lot of lifting with a brush or knife. I also like its warm white hue. The paper is available in 140- or 90-pound weights as well, but I like the heavier 300-pound because it holds the moisture longer than the thin ones and it doesn't buckle as much.

Even though I prefer cold-pressed paper, I occasionally use a rough or a smooth, hot-pressed paper. I choose the rough paper when I intend to paint with a coarse drybrush technique. On the other hand, on hot-pressed paper, which is extremely smooth, granulating colors (like raw sienna and cerulean blue) separate beautifully into exciting patterns. Also, a flat wash is textured more on hot-pressed paper than on a rougher surface, so when I want this effect, I use hot-pressed paper. Drybrush is almost impossible to do on it, though, and if it does happen, it's so gentle that it's hardly noticeable. Hot-pressed paper is extremely good for detailed work and calligraphic touches. But it's easy to slip into tightness on it; consequently, I watch the progress of my work so I don't get carried away.

What's your working surface?

In my studio I use a large drawing board; outside, I use an easel of my own design (see page 22). Both in the studio and outdoors, I mount my dry paper

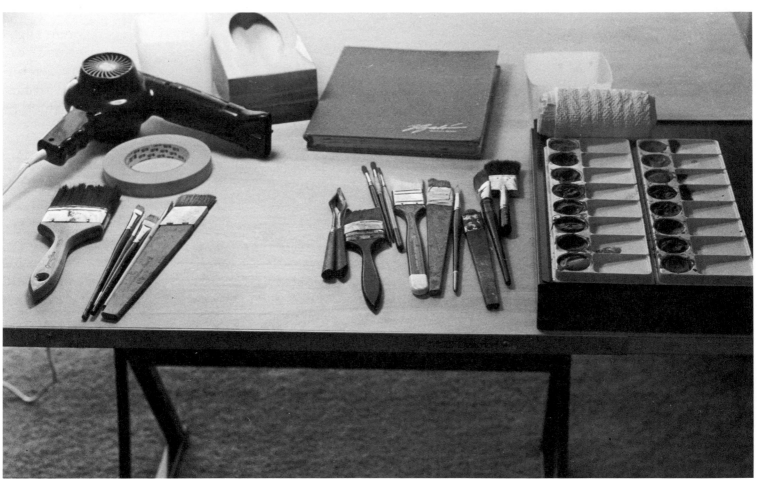

onto a piece of Masonite with masking tape. By mounting it, I can tilt the paper with the support board any time I want, without having to tilt the work surface. Also, the Masonite is firm and forces the dry-mounted paper to flatten out after the washes I paint on it dry.

What other tools do you paint with?

I wrote a whole book on all the tools I use; it's all spelled out in *Creative Watercolor Techniques.* Some of my special favorites are as follows: My flexible palette knives are great little tools for branches, weeds, and any linear strokes that occur in nature. I use their edges or tips for applying color. I use the heavier, widest part (heel) to texture surfaces by squeezing excess color off in the desired area, and then by pressing hard, I prevent the remaining wet paint from re-entering the squeeze-dried light shape. They're great friends of mine, and I use them all the time. I use salt for texturing ice, snowflakes, and such. I use wax (a resistant) or liquid latex for masking. A sponge is used to texture the mottled effect on rocks, moss, and so forth. I use these only occasionally, and if the subject calls for it, I'll use anything, even a razor blade. However, I never let any tool become a crutch.

How do you arrange your materials and tools on your working surface?

My paper is in front of me, about 36 inches (91 cm) from the ground, a comfortable height for me when I stand. I'm right-handed, so my painting brushes as well as my wet paper pad, my palette, and the mixing water are on my right. On my left, *very handy,* is my box of paper tissues, my clear water brushes, and another dish of clear water.

19

Do you use anything to speed the drying process?

On location I often have the sun or the heater in my car, if I'm close enough to it. In my studio, I use the heat from a strong light bulb or a heavy-duty hair dryer. I'm cautious in using the light bulb because if the paper gets close enough, the bulb can scorch it.

What is your color palette?

My palette is divided into two halves: essential colors and luxury colors, all Winsor & Newton artist-quality pigments. I can't be without my essential colors, but if I had to, I can mix those on the luxury side. However, since it's the quality of the paint that counts, particularly in the case of those on the luxury side, I prefer to use the tubed color instead of mixing a comparable hue.

My essential colors are:	My luxury colors are:
New Gamboge	Aureolin Yellow
Raw Sienna	Cadmium Orange
Burnt Sienna	Cadmium Red Medium
Brown Madder (Alizarin)	Alizarin Crimson
Sepia	Cobalt Blue
Antwerp Blue	Sap Green
Manganese Blue	Winsor Blue
French Ultramarine Blue	Cerulean Blue

My palette has gone through a lot of changes and grown with me until I arrived at this one. It's a practical combination of colors for my way of work. I know their nature well and never change their location on my palette. (I devoted an entire chapter, including a color chart, to them in *Zoltan Szabo Paints Landscapes.*) All these colors are transparent when well diluted with water, though some may be opaque when applied thickly. When I glaze color over dry washes, I use my most transparent ones. If I intend to lift out darker hues from a wash, I make sure that a staining color dominates the mixture so its hue remains after the other colors are lifted. For example, when I'm painting a shallow creek bed and anticipate lifting out the ripples in the water above, I paint the bottom of the creek with a mixture of burnt sienna and sap green, which together makes a lovely dark green color. When the wash is dry, I can rewet it and lift out the darker brownish color and leave the green (which represents the foliage reflected in the water), because sap green is a staining color, while burnt sienna is not.

I also use other colors in special ways. I use separating or granulating colors such as raw sienna, manganese blue or cerulean blue for dotted textures such as sand or sparkling snow in the shadow. Whenever I expect to lift off a color, I try to include manganese blue in the mixture. It can be wet-lifted out completely, even after it's dry, and it makes other colors come off more easily too when it's mixed with them. When I use the more opaque colors—such as cerulean blue, sepia, and the two cadmiums—I use restraint and dilute them well.

Do you have any preferred colors or color schemes?

All the colors on my palette are friends. However, raw sienna, Antwerp blue, burnt sienna, brown madder, and French ultramarine blue are the colors I use the most—so I guess they're my favorites. I like to mix brown madder

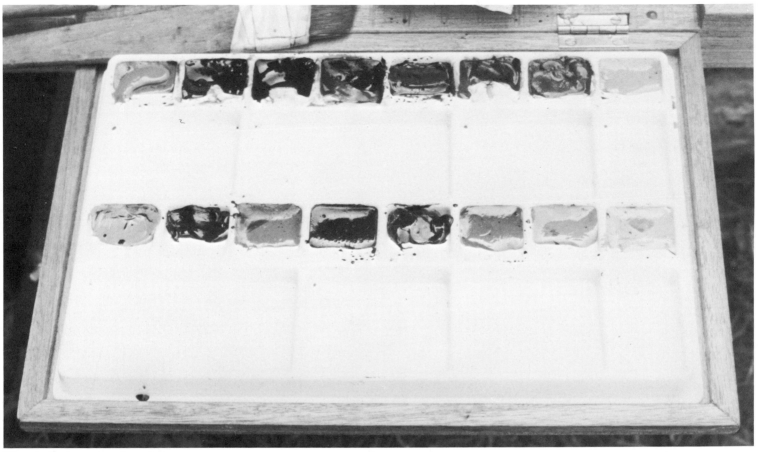

The new Szabo watercolor palette.

with Antwerp blue or French ultramarine blue with burnt sienna for grays. Both combinations can easily lean towards cool or warm temperature, depending upon which pigment dominates. I also enjoy the staining effects of sap green when it's recovered from a mixture with other darker colors. I use only a few colors for each painting; seldom more than six. I pick a mini-palette for each painting before I start by first analyzing the idea and then choosing the colors that will give me the most versatile result. Once selected, I never deviate from these colors while I paint. This way my color unity is assured.

Do you mix your colors on the palette or on the paper?

I start the mixing on my palette and get an idea of the color by glancing at my brush, but complete the final mix on the paper because the reflective strength of the palette differs from the final illuminating whiteness of the paper. I work out and finalize my colors on the paper where I can see *exactly* what they look like. The palette is always the same, but papers vary from brand to brand and even from batch to batch. It doesn't do me any good to be able to mix a color that looks good on the palette and, for example, on Arches cold-pressed paper, if I happen to be painting on Fabriano. I have to see and judge the color on the paper I'm actually painting on.

What kind of watercolor palette do you use?

I use the original Szabo watercolor palette, that's my own design. It has sixteen wells into which I squeeze my colors. Next to the wells are various sized slanted square mixing spots. I like these *slanted* squares because I often paint with my palette knife, and it's easier to dip my knife into pooling liquid paint than into color on a flat surface.

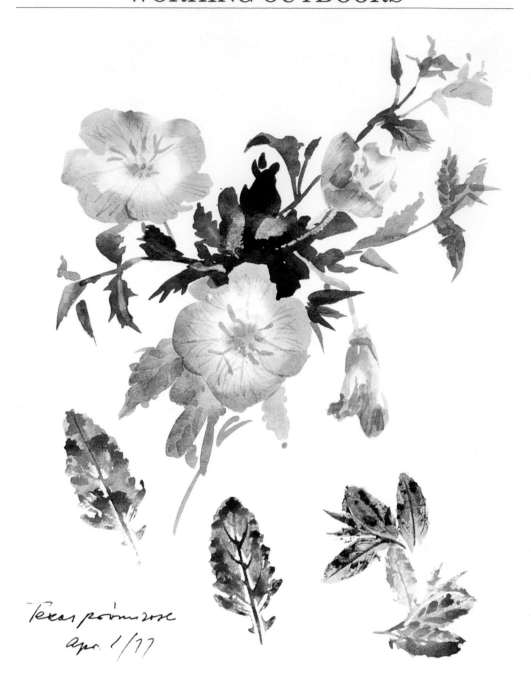

Texas primrose
apr 1/77

What equipment do you take when you paint outdoors?

When painting outdoors, I use an easel of my own design, the Szabo easel, which is sold commercially together with the Szabo watercolor palette (which fits it exactly). (Artists can now purchase my easel and palette from SZ Enterprises, P.O. Box 736, Saulte Ste. Marie, Michigan 49783.)

Other than the easel, I use the same equipment indoors and out. I pack everything in the easel except a big plastic jug of water and a box of paper tissues. It has two drawers to hold my palette, brushes, and other tools. Inside I have several sheets of paper and my sketchbook. When I paint, I like a flat surface most of the time (though the top of the easel can be tilted). I pull out both side drawers halfway. On my right, the drawer has a hinged flap that folds out to hold my palette and a damp paper pad. I have a place for my brushes, plastic "mixing water" container, and wet paper pad in the exposed part of the same drawer. In the half-opened left-hand drawer, I keep a box of

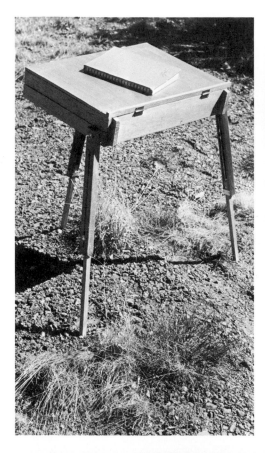

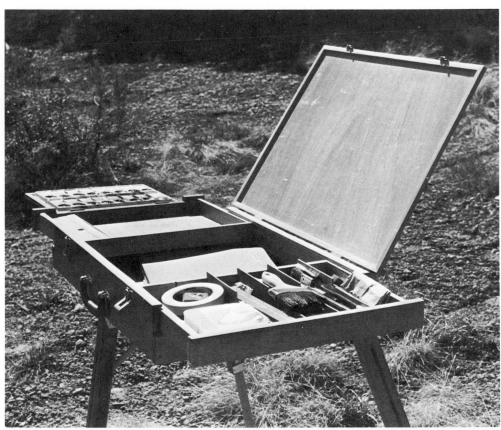

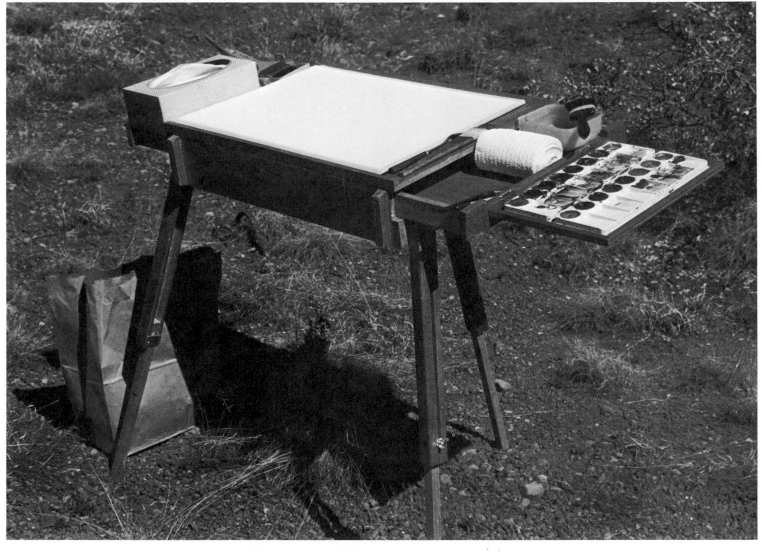

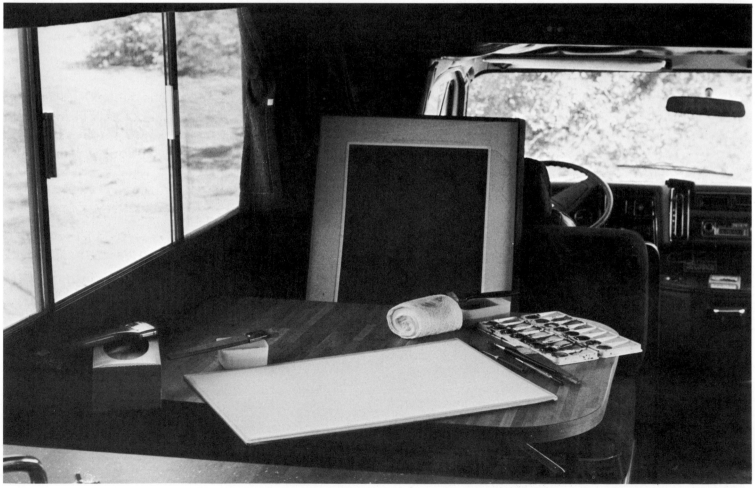

paper tissues, a set of brushes used only with clean water, and another plastic container with clean water only.

My easel is not only practical to use, but it sets up anywhere in little time. By adjusting any or all three legs, I can have a level surface, even on slanting or rough ground. (I use my translucent water container as a level to make sure the surface of my easel is flat.)

How do you carry all your materials and equipment?

My easel can be mounted on a backpack frame, but I usually drive to location and walk from the car holding my easel by the handle. I carry my easel in one hand and a plastic bag with my water jug, and tissue box in the other. The bag also serves as a waste container to throw my discarded tissues in. I despise people who throw paper and Polaroid clutter all over the place. It's not only ugly, but animals eat it and it kills them. To prevent my bag from blowing away while I paint, I put a small rock in the bottom.

Do you stand or sit when you paint outdoors?

I always stand. I feel that the natural bobbing motion of my body prevents me from getting too close to my work surface for too long. If I feel tired, I sit anywhere, but while I work, I prefer standing. Naturally I sit if I paint in the car, but if I'm painting in my motor home, I work standing in there as well.

How do you keep from freezing in really cold weather?

I dress warmly, but I'm fortunate to have really good circulation, and I can stand a lot of cold. I can do my drawings or graphite washes without gloves, but I can't stop the water from freezing on the paper. This means that I don't paint with watercolor if the temperature is below 28° F (–2° C). I also make sure that my feet are warm, so I wear felt-lined boots.

How does painting outdoors affect your work?

The fresh air and experiencing the real thing loosens me up. I really enjoy on-location painting, and somehow it shows in my paintings. The freedom of nature demands fresh techniques. If I do lots of painting from nature, my studio work also gets fresher. I couldn't be happy painting indoors all the time.

Is there any difference between your studio and outdoor paintings?

I hope not, since I do both all the time, and I only paint subjects that I've experienced outdoors. In my studio, I dream and ad lib a lot. My studio paintings have a little more of me in them, but they're the fruits of one or several earlier outdoor experiences. Inside, where conditions are ideal, I have time to play and plan more carefully. I suppose at first glance these larger paintings appear more polished because I painted them in comfort indoors without the pressure of time. My studio work is also more daring, and I design more around an idea. Very often these ideas are invented, so their creative value is possibly greater. However, I leave that judgment to my viewers, who are similarly divided. Spontaneity versus polish—which is more important? I try to balance these qualities, but one wins over the other a little each time.

On the other hand, my outdoor paintings are bolder, freer and more spontaneous, and are done faster. They certainly are bolder, because I have to

bright NG + BS, maple

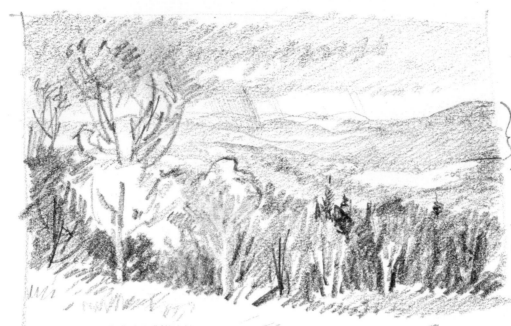

} blue

← sun patch

} edge of forest
NG + BM + BS + AB

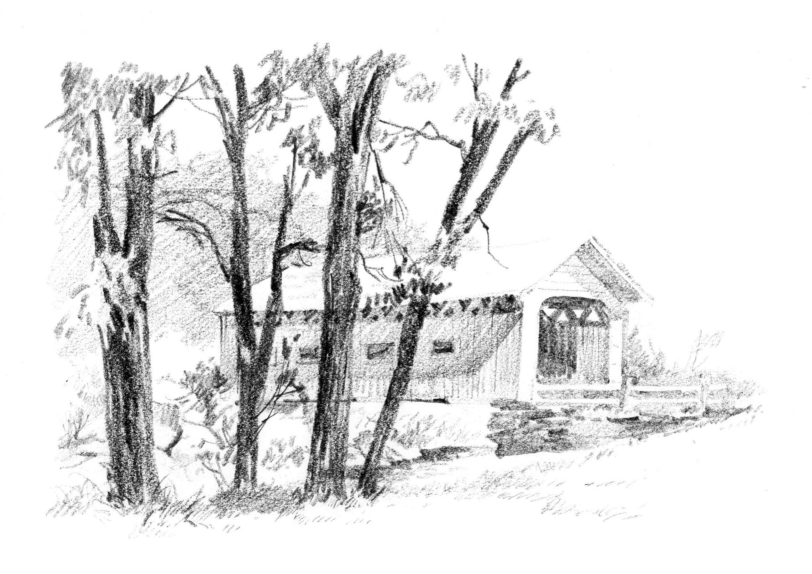

paint quickly before the light, weather, or other conditions change the mood of the landscape. The psychological effect of the light and sounds of nature become part of my work. When water, clouds, or weeds move, I try to imply movement. Movement can't be painted, but it's possible to suggest it better from the real scene than from a sketch or photograph, where the movement had to be stopped.

Do you work on a different scale outdoors than you do indoors?

My favorite painting scale outdoors or in, is a half sheet (15 x 22 inches—38 x 67 cm). I used to do a lot of quarter-sheet paintings outside because they're fast and I was able to bring home more ideas. But now I use a 12 x 16-inch (31 x 41 cm) cold-pressed watercolor block for this purpose. Arches makes blocks in 90-pound or 140-pound weight. I prefer the latter because it's a little heavier. I also occasionally use Fabriano 100% rag paper in blocks. In my studio I enjoy using a full sheet (22 x 30 inches—56 x 76 cm) or double-elephant size (26 x 40 inches—66 x 102 cm). I can really get my teeth into the thing and show off watercolor in all its exciting majesty.

How do you cope with the changing light outdoors?

Speed is one answer. I paint fast enough to keep ahead of the change. If there's strong sunlight, which means sharp cast shadows, I make a mark on the edge of my board (outside the painting area) to locate the sun. If the light moves too much, I just paint the shadows opposite to my light source, the sun. Another foolproof method of painting the more complicated shadow shapes is to take a black and white Polaroid shot when the shadows are in the most desirable position, and follow the photograph for the shadow design and use nature for the details.

Do you prefer any special kinds of lighting effects?

No. I like sunshine, because the shadows are interesting design elements. Lifted-out shadows in particular are fun to do. Overcast lighting is even and allows good mood and texture studies. Mist, fog, snow, and rain are ideal conditions for wet-in-wet blending. So, I like any light, and light is part of the subject I pick; usually a very important part of it.

Do you prefer to work at any particular time of day?

On a sunny day I prefer morning or late afternoon because the shadows are more interesting then. This is particularly true with more panoramic subjects, where longer distances are involved. On the other hand, I can paint live stills (to be discussed next) before, during and shortly after noon, because their charm doesn't need the help of a lot of shadows. On an overcast day, the time of day doesn't matter, because the light source is the whole sky. The light doesn't change rapidly, and the shadows show subtle variations in value, so I can do modeling within them instead of just painting them as a single-value shape, as I would cast shadow on a sunny day.

SUBJECT MATTER

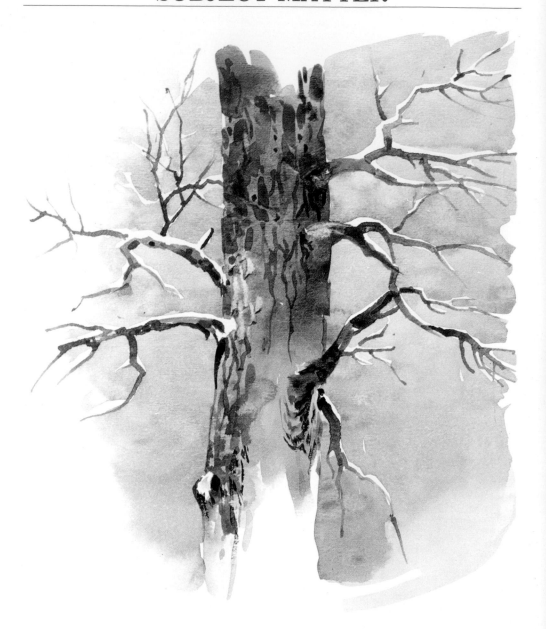

What subjects do you like to paint most?

I don't know what my favorite subjects are, but I know I look for mood. The feeling, the emotional quality, is important. To paint a tree is no longer a challenge. But to paint a *protective* tree, a *happy* tree, a *powerful* tree or a *weak* one is what I'm after. The more unusual things are, the better I like them. If I can't find mood, I use any subject and invent the mood I think it could and should have. The only real favorite of mine is not a subject, but a season: winter. Snow is white; so is paper. Watercolor has the main ingredients given before I start painting. Shapes are clearly evident and the modeling is subtle and challenging. I really love painting snow, but in general I just love to paint landscape, particularly *live stills*.

You talk about live stills. What are they?

Live still is a little word I cooked up to differentiate it from *still life*. Live stills are probably my favorite subjects. They can be anything as long as they are viewed close up: a clump of grass, little wild flowers, a cluster of

leaves, a castaway basket, anything of this nature. Live stills, however, are not tampered with; they are as I find them. A still life is set up by the artist, and the light is controlled too. But a live still is naturally lit and is undisturbed as a unit. Live stills are anywhere and everywhere. Usually I find them right at my feet, if I just bother to look down at them. Panoramic beauty is for everyone to see, but live stills are nature's hidden gifts, only for those who care to look for them and are willing to get down to earth once in a while.

Are there any subjects that you really dislike painting?

No. I've never seen anything that ugly that I couldn't paint it with enthusiasm. I don't enjoy painting the same way as everybody else. I interpret nature my way, but I can't find satisfaction painting another duck painting when there are so many artists doing them. Many of them are great. I like animals in their environment once in a while, and I like to paint people, but somehow I don't mix them together, though I've done it and I am sure that I will again. It's just that I'm awed by nature too much. When I paint people, my mind is on the figures; when I paint the landscape, I think of the land. That's something like the way it works with me.

How do you go about finding subjects to paint outdoors?

I go hunting with my brush. I don't look for specific things. I start out with an open mind, usually by driving along the road. When I see an area that responds to my mood with its mood, I stop, set up my easel, and begin. Sometimes I don't even get out of my car—for instance, in the winter—but just pull off the road and paint from my seat. I may just use my sketchbook, or do a painting, or just shoot the scene with my camera. It all depends on the circumstances. The ideal is to set up my easel on location and paint the real thing while the birds are entertaining me or the churning waters supply additional sounds. On-location painting is an absolute must for me.

Does it take long to find a subject?

There's no simple answer to this; each situation is different. Time spent has nothing to do with aesthetic values, so I'm not aware of how long I spend looking for things. If I'm anxious to paint, I stop sooner, but often I just go out to enjoy nature, and when I find "the mood," it excites me and I start painting. I very seldom go home from a painting drive without a sketch or two. Nature is simply too full of beautiful things. I'm a painter, and a painter must learn to see and not drive or walk by things like other people, whose mind is on something else. I try to see everything.

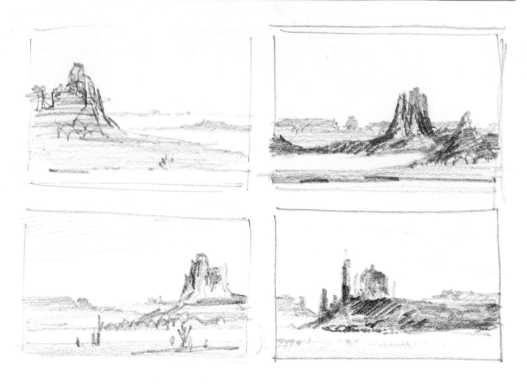

How do you arrive at a satisfactory composition?

This is like asking, "how do you go to heaven?" It's hard to say exactly what I do. I go after *balance,* using good taste and careful judgement. Composition is impossible to pigeonhole. However, some basic systems are available, for example, relating the movement in a painting to some of the letters of the alphabet, such as C, O, S, X, and L; avoiding the geometric center and the four corners; trying not to point objects or lines at the edges of the painting or to other strong shapes; avoid equal measurements, and so forth. All these basics have been organized by countless artists and rules set up; yet, here and there we find creative minds with a pioneer spirit breaking these rules one by one very successfully. Nevertheless, all artists, however daring they may be, go after *balance* in their painting in their own personal way. Composition is as personal as love. It has to feel just right.

Do you paint nature as you see it or make changes?

Composition means balance. Nature is always well balanced in the whole, but it's too big to paint. The little square-ish detail that I want to paint is never the way I want it. Again, I keep the mood, but rearrange the details to emphasize what I consider important, and play down or leave out the trivia. I like to pick a strong center of interest and subordinate everything else to complement it. I feel that composition is a personal thing, and I like my composition to be the way I decide, not the way it really is. I use the elements I find, but rearrange them into a new, more personalized balance.

How do you decide what to leave in, add, move around, or take out in order to make a successful composition?

The demand of the unit dictates it. I like to paint my center of interest as a conductor would lead an orchestra. He is the most important member, and he calls the shots. All other elements have to be in their right places and play

in harmony whenever he decides that they should. I decide how many complementary elements I need in my composition and base their location on my own judgement. The ability to make the right decision is what the game of painting is all about, and it takes a lifelong effort to improve it, even though I know full well that I, like everyone else, will never achieve perfection.

Do you prefer any particular kind of composition?

I was about to say "no," but I think I do have slight preferences—a very high or very low horizon are two of them. This way perspective can really create the illusion of depth. I also like negative and positive shapes to balance and relate pleasantly. I avoid placing major shapes or edges at the corners and the center of a painting. I also try not to just touch a shape in one plane with another shape in a different plane. And I try not to compose a shape resembling a slingshot, bull's-eye, teeter-totter, brasier, or any other mechanical-looking shape.

Do you ever use a viewfinder or other device in composing a subject?

No. I occasionally use my thumbs and index fingers to enclose a square piece of nature, but I can do it just as well mentally. Viewfinders and similar aids are a great help in the beginning. So is a reducing glass, to hold over the sketch while comparing it with nature. But these aids just become superfluous clutter in your gear as you become more experienced.

Do you have a philosophy on composition?

Yes, I plan my compositions according to a four-point system: shapes, value, color, and textures. This is a psychological order, not a time sequence. Good shape relationship is a must. Without balance of shapes, value, color, and texture are useless. Value is the tool to create the illusion of three dimensions on a two-dimensional painting surface. Color gives life to the things I paint, and with atmospheric color control (also known as *aerial perspective*) helps give the feeling of depth. Texture gives the final definition to the shapes. It describes their material surface and nature and offers variety and visual excitement. While I paint, I keep these four points in their order of importance in mind. This discipline is a good safeguard against confused paintings that would fall apart.

How do you use shapes, values, colors, and textures in composing?

The human mind can't grasp everything in a painting at a glance. Our eyes aren't capable of reporting visual images fast enough to the brain; they have to roam from the surface of one area to another in a visual travel pattern called the *path of vision*. In a well-composed painting, the path of vision is predetermined by the artist.

The ideal path of vision works like a corkscrew, moving in a circular motion toward infinity. It touches all four sides of the paper, while bypassing the four corners. My first compositional task is to determine the starting point for this visual trip.

In arranging a composition, I keep certain points in mind. For one thing, our impulsive attention is first directed to any isolated bright color or to a spot with strong contrast. If both conditions exist, the attraction is even stronger. Now, if these conditions are present in several locations in equal

strength or importance, our eyes will select the lowest one on the page first. When the composition consists of patternlike, equally important, and equally well-distributed elements, our vision will tend to enter the painting at the bottom center. Our natural tendencies will also make us look to the right first because we read from left to right, and this habit influences our tendencies. But our eyes can be directed in the above manners only if all other conditions are equal.

Can you describe the role shapes play in composition?

Of the four points I keep in mind when composing a painting—shapes, value, color, and texture—shapes play the number-one role. Repetition of shapes sets up a pattern or rhythm in a composition. But when I repeat them, I try to avoid a stiff, mechanical rhythm. Instead, I try to paint them like a melodic rhythm that complements the entire unit. I explain it to my students like this: When a child is fooling around on a piano, he may strike the same key a hundred times, over and over again, driving everybody else up the everloving wall. This is a monotonous rhythm. On the other hand, a concert pianist can also hit the same key a hundred times in playing a concerto, but the sound blends into the music and creates an exciting rhythm. We don't notice its independent existence, but just enjoy the melody as a *whole*.

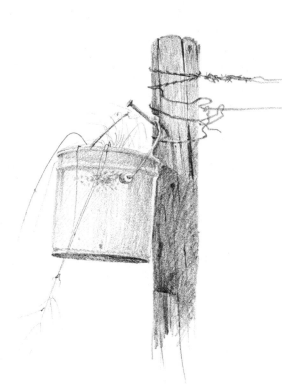

Choosing the shape of my paper, the painting surface (rectangular, square, horizontal or vertical) is the first decision I make concerning the painting to follow. This shape, called the *support shape* because it supports all the details of a particular painting, is flat and two-dimensional. So, because I work within a two-dimensional shape that must appear to have three-dimensional depth, I must think about it in three-dimensional terms, and use every trick I know to give a convincing illusion of depth.

How do you create depth in a painting?

This is where perspective comes in. Perspective is one of my friendly helpers because it allows the shapes within the painting to appear to be located in a space that has depth. Leonardo da Vinci was the first to define the law of perspective. He stated that distant objects appear paler, bluer, and less detailed than closer ones. Da Vinci was talking about color perspective or atmospheric perspective in this particular instance. But there is also linear perspective, which refers to drawing lines or shapes so that they appear to recede or advance. Like color or atmospheric perspective, linear perspective is also governed by a series of laws.

One basic law of linear perspective is that the closer the object is to the viewer, the larger it appears, and vice versa. (One of the typical errors children or primitive artists make is in instinctively placing distant elements above closer ones, instead of making them smaller.) Objects must relate to each other in scale; then must be in relative proportion to each other. For example, a man can't be bigger than the horse he's riding, and a tree can't be larger than the mountain on which it stands. But slight distortions, if they're carefully thought out, can add a creative touch and draw attention to an important detail that might have gone unnoticed if painted in the correct scale.

Do you have any special methods for recording perspective?

Just experience. I understand the laws of perspective, but when I paint, I just judge perspective by eye, and I can get close enough to correct perspective to be convincing. I keep the two vanishing points in mind while I con-

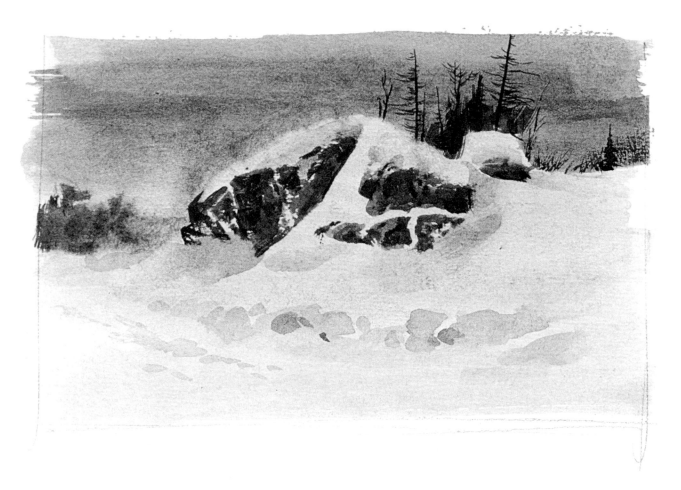

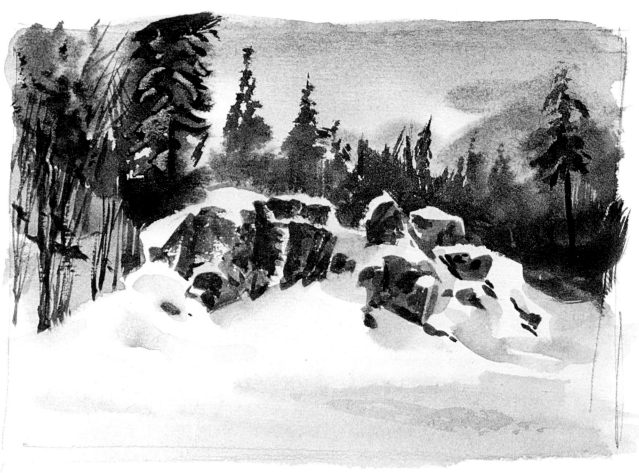

struct my painting, and above all, I try to keep my drawing consistent.

Color (aerial) perspective is as important as linear perspective. Atmospheric colors indicate atmosphere, and this means distance. Color perspective and linear perspective are two of the tools I use to show depth.

As I said earlier, the white paper is flat and two-dimensional. If you stare at it for a while, though, and your mind wants to see it as a three-dimensional plane, it will begin to look more and more like one. For example, if you draw a line across a paper from one side to the other and concentrate on it for a while, it will appear to be no longer a line but an edge where two planes meet. At first, the planes will look flat, but as you continue to stare at their junction, the line between them will seem to advance or recede and the connecting planes will feel like they're at different tilts or angles.

Changes in perspective are also created by overlapping shapes or planes. When one plane overlaps another, it appears to be in front of the other. In addition, if these overlapping planes are transparent, this may indicate movement, possibly in different directions.

Planes can also attract or repel one another. Two flat rectangular shapes, placed beside each other, don't have movement; they're neutral and feel agreeable. But if you taper them slightly in each other's direction, you'll begin to feel a tension between them. If they're strongly tapered toward each other, they'll appear to support or balance one another, but if they taper away from each other in different directions, an active imbalance, like a tug of war, occurs. You don't know which direction to look. On the other hand, if they're both tilted in the same direction, the movement will be so strong that they'll appear to be slipping out of the painting.

The placement of planes also affects the feeling of movement in a painting. Narrow planes placed close together vertically seem to resist each other, but if you turn these same planes to a horizontal position, the effect will be more calming.

Thus the interaction of planes creates excitement, prevents monotony, and allows the viewer to reach every area and detail in a composition with ease. In other words, it sets up a path of vision and creates a feeling of three dimensions. And I never allow representational details to distract from this planar interaction. I think of planes as simple shapes that just happen to have details or texture for decoration; for example, a mountain slope is a shape that only incidentally contains rocks and trees.

You have discussed the effect of line and shape on perspective. Does value and color also affect the psychological movement of planes?

Yes. When planes have different values, their relative lightness or darkness describes their distance from one another and their location in space. Dark tones generally make a plane appear to advance, while light ones make it seem to recede. However, this effect can be reversed if the planes are overlapping.

Color temperature also has an effect on the movement of planes. If you paint two connecting planes (or shapes) with graded washes, light and cool at the outer edges, and warm and dark in the center, the corners of the shapes will appear to recede. But if you reverse the colors, placing the darks on the outside, the corners will appear to advance. If you paint these two shapes with flat washes of strongly contrasting or complementary colors, the intensity will force the corners to jump back and forth with disturbing tension. I therefore carefully avoid juxtaposing these colors in compositions of a

quiet nature, but take full advantage of this effect when doing vigorously active paintings.

Our eyes also travel more easily from object to object when they're equal in shape, value, and color. This psychological trip continues not only up and down and sideways but into the distance, over established planes, and even over what appears to be level ground. It's that corkscrew action I referred to earlier: our eyes tend to skip the corners and travel in a circular pattern unless the corner (or corners) contains a distraction strong enough to interrupt this movement. For example, a strong straight line across the painting, such as the horizon, acts as an obstacle to a comfortable path of vision. Such a line or edge must be broken up by blocks of strongly crossing lines and shapes in order to keep our eye moving into or around the painting. But you can't plan the entire path of vision completely in advance. It has to grow with the composition, as the painting progresses.

Are there any general points to keep in mind when planning a path of vision?

Yes. Some lines, shapes, or edges have a natural directional power of command. For example, wedge shapes point like arrows. Curves, straight lines, and repeating shapes also direct our eye. If our attention lingers too long in any one spot, it means that too many directional pointers are aiming there. On the other hand, if our eyes wander out of the composition on one side, two or more of these directional signals are probably pointing that way.

The presence of people in a painting also effects our path of vision. For one thing, people attract attention. Also, our eyes will tend to follow the general direction or specific focus of a person's gaze, skipping other points of interest in between.

In short, the key to good composition is balance. An object with a strong visual attraction will disturb a painting's harmony unless it's countered by a complementing element or elements. The juxtaposition of many well-balanced objects induces an exciting play of tension into a painting, but bad balance creates tension in the viewer, who may walk away not really knowing why. He'll only know that he didn't like the work!

Getting back to your four-point system of composition, you mentioned that, after shapes, values are most important. Why?

Values are important in establishing the location of planes and the space between them. The local color of anything will change when it's far away because of the influence of the atmosphere, which acts like a filter. Parts of a composition in bright light will have a lighter value than those elements that are in shade. The contrast between them, either subtle or strong, gives a painting the feeling of depth. I structure my paintings on three basic values: light, medium, and dark. The in-between shades relate strongly to one of these three. My foreground, middleground, and background have to belong to one value each. I pay extra attention to the value strength of my center of interest plus the complementary values directly next to it. Other than that, I concentrate on the value of the larger shapes, which identify the bulk of each plane.

Do you paint values in any special sequence?

The safe, conventional order is to work from light to dark. Although I use this system sometimes, particularly if I work wet-in-wet, when I have a pow-

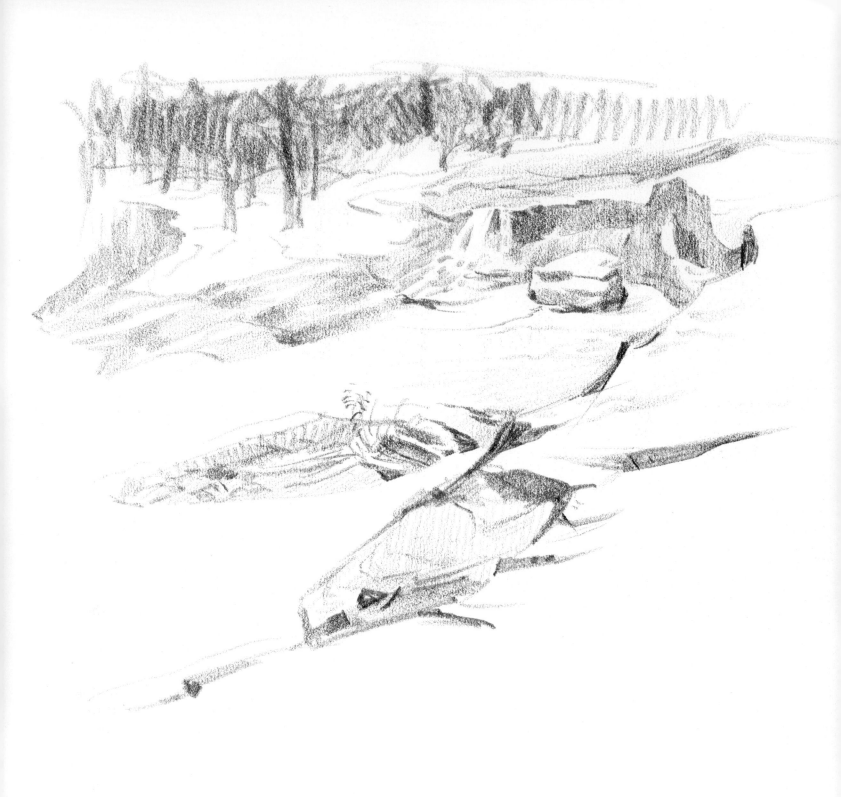

erful center of interest in mind, I prefer to start with this. I establish my most important element visually and relate the shapes and values of the other elements to it in order to enhance this focal point. I sometimes also start with the medium values and their basic shapes. By painting them first, I automatically paint around the light shapes, where the paper will stay white. Then all I have to add to this is the darks and some details, and my painting usually feels three dimensional. However, I generally don't have a set rule to do anything. Each painting is a new choice of approach.

You also talk about the importance of color in composition. Do you preplan color schemes in your head?

Very much so. I not only preplan them, but I select a palette of five or six colors maximum for each painting. These colors hold within them all the potential combinations necessary for that particular idea. I know my colors well and I can clearly visualize their individual and combined possibilities so, as I go ahead with my painting, I very seldom add to these colors. I have my mind so well tuned to this selection that I'm hardly aware of the existence of the rest of my palette.

Do you try to establish a color balance in your painting?

Yes. In fact, the preselected limited palette and the discipline of sticking with it goes a long way to insure color unity. I try not to isolate colors but distribute them interestingly. Colors with brilliant chroma look even brighter when they're placed next to neutral hues. Light and dark is more a part of the value structure than the color. Warms, because of the atmospheric influence, feel better up close and cools belong in the distance. There are exceptional conditions in nature which can vary this sequence, but I deal with them when the occasion demands it. The intensity of my colors depends upon the mood of my painting. I don't follow any absolute rule here either.

Texture is last in your four-point compositional system. How do you achieve a variety of textures in your paintings?

Texture is the spice in a painting. I like to take advantage of granulating or separating combinations of colors when I can. I also love the texture my painting knife can create, both with applied or lifted out technique. Salt, wax, and of course very frequently drybrush, are a few of my favorite tools. I really elaborated on these and many more techniques in my other three books. I use them when the occasion calls, but I don't allow any of them to be an unconditional crutch.

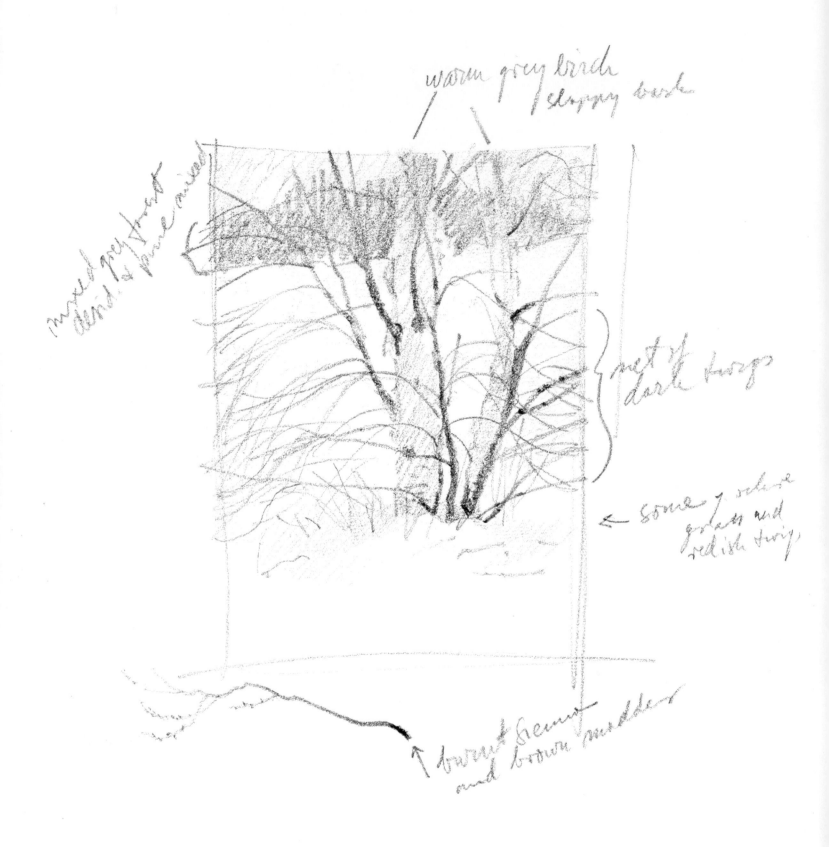

warm grey birch
slippy bark

mixed grey trees
dead & pine wood

{ not't
dark twigs

← some ochre
grass and
reddish twigs

↑ burnt sienna
and brown madder

PROCEDURE

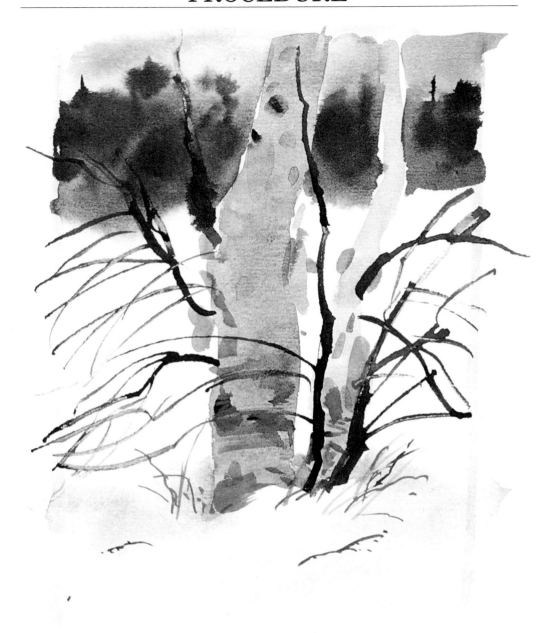

How do you start a painting?

I make a plan. If I'm not sure of the *general* composition, I do a small decision-making sketch in my sketchbook. I record shapes and values first and either paint the colors, or if I draw, I write down the names of the colors in the margins.

What medium do you use?

I like the feel of pencil, felt-tip pen, lamp black sumi ink drybrush, and watercolor. I don't know why I switch from one to another. I like the variety, I suppose. The black and white is very sensitively capable of recording shapes and values. I favor pencil or sometimes felt-tip pen for subtle things. I like lamp black ink (applied with a brush, as drybrush) for high-contrast subjects with bold shapes. On the other hand, when color is very important to register, watercolor is my choice. One of these preliminary sketches is usually

lumpy oak

hazy sky

smoky blue hills

layers of snow
with protruding
twigs

Soft lit
snow

light blue boat
with snow.
low tip of nose
faded red up to water line

warm grey
forest

old planks
(green-red-brown)

grey sky
with pink at lower
edge.

reddish
brown
shrubs

birch trunk

powder blue hill

high snow banks

Snow covered road

warm grey
forest

Snow covered
spruce

warm sienna
grey forest
with oak
leaves stuck

enough, but sometimes I need to make two or three. If the subject is not familiar to me, I do my sketch in detail. But if I'm in familiar territory, I may not even do a sketch, or I'll do just a rough one relating to shapes and value. Details belong to the finished work. I don't spend much time on sketches because I don't want to divert my emotional excitement from the actual painting itself.

Do you always make a sketch before you paint?

In the studio, I'm likely to do several sketches, each with a drastically different composition. On location, I do a sketch first only if there's a chance that the subject will change before I'm finished or when the composition is so tricky that I must plan it visually. In the latter case, the visible reality of these sketches increases my confidence in doing the larger painting, and whatever doubt I may have had at first disappears by the time I'm finished with my mini sketch.

Do you ever combine several sketches into one painting?

It depends on the individual painting. Art is a creative process, and when I paint, I try to express the feeling or emotion that occupies my intellect while I'm painting. Whether the originating influence is an experience with nature (finding a subject on location), a photograph that I took, one or several reference sketches, or just a purely creative idea doesn't make any difference. A painting has to be the product of my mind. The sketches or whatever triggered my mind into the action that eventually results in a painting are only the start. I never know how I'll start. The painting always ends up as my idea based on elements in one or another form of reference. My sketches relate to nature. I refer to the sketches in the final paintings, but change them to give me the maximum technical and compositional opportunities for an emotionally expressive personal statement.

Do you ever transfer or project your sketch onto the watercolor paper?

Project? Never! That's nothing but psychological plagiarism. I never draw on my paper at all—at least not for the past ten years, and before that only a few times. I do all my thinking in my sketches, then paint on the white paper. A pencil line isn't necessary. I draw with my brush as I paint and the free action of watercolor often suggests details. Draftsmanship is essential, but I can visualize the major composition and "imagineer" the details as I design with my brushstrokes to complement my idea.

Do you paint landscapes in the studio from memory or from photographs?

Yes, on both counts. After thirty years of painting, the old memory bank gets filled with stored experiences. This is the most important reference file I own. I work a little from memory each time I paint, and often purely from imagination. Photographs are helpful, too, particularly for capturing short-lived action; for example, ripples in water caused by a pebble or falling leaves, the last moments of an exciting sunset, or the flight of a bird. I like to use black and white photographs, and I never paint from anybody else's shot. If I use color slides or prints, I ignore the colors on them because they're never the way I like them. All color photographic processes are limited to their chemically engineered maximum potential, while my imagination is not. I prefer to use my own colors, since they're much more personal.

How do you use photographs?

I use them as I would a square little piece of nature. It is the first decision I make as far as the mood and composition of a particular painting is concerned. This is one reason why it must be my own photograph. About a third of the way into the painting, I might as well discard the photograph. I hardly use it after that. The rest of the painting is all memory work, as creative as I can make it. Sometimes I do a little sketch on a separate paper first to clarify my idea visually, but I do this only on the more complex things, and not every time.

What are the potential pitfalls of working from photographs?

Szentendre

I see no traps for myself any more. I was always conscious of the tendency of painters to take photographs too literally and paint everything in them. But since I've never done this from nature (I have for many years instinctively avoided the literal copy of life), I wouldn't do it from a photograph. Some painters are afraid to change a landscape and only feel comfortable photographing it with their brush. I think at best they're only good technicians, not artists. The creative part of art is to make constant decisions throughout the work, and I for one prefer to leave out everything I find unnecessary.

Do you follow any particular procedure of painting?

I like to work from area to area. While one shape is complete but wet, I go to another spot. While I work in one section, I watch the action of the drying colors in others. If they start to do something undesirable, I intervene. To be able to work this way, I trained my mind to visualize the result of the whole painting, and not to be distracted from this goal as I go on with the details. In beginning a painting, I let technical necessities dictate the sequence. Again, each painting is a new plan. I keep an open mind and use my experience to choose the best possible order to start, continue, and complete my paintings.

What role do accidents play in your paintings?

Accidents are extremely important. I count on them each time I touch the paper. Accidents are wonderful little design helpers when they happen in the right places. However, they have the impish nature of leprechans. Sometimes they start off well and turn ugly later. I constantly keep my eyes on these active wet accidents which are so rich and fresh at the end, but can't be trusted until the wash has lost its shine and is no longer active. A backrun (the wet touch on semi-dry paint) is one of these; splatter, salt, and many other techniques offer design suggestions as they happen. I love the challenge of going along with these opportunistic moments, and to make them work for me. I don't hesitate to change my approach in minor details, but I don't let these happy accidents dictate the important elements of my composition.

Do you use big brushes first, then smaller ones?

Yes. As a matter of fact, I try to use smaller brushes only for touches of detail at the end to suggest texture, or for calligraphy, or such. The reason for this order is the physical necessity of laying down the larger shapes first, which requires larger tools. I like to start with bold washes and refine them later. I use large, soft-haired brushes (1 to 3 inches—2.5 to 7.5 cm) for the first wet-in-wet delivery. Then, for the slightly better defined but still soft forms, I use a

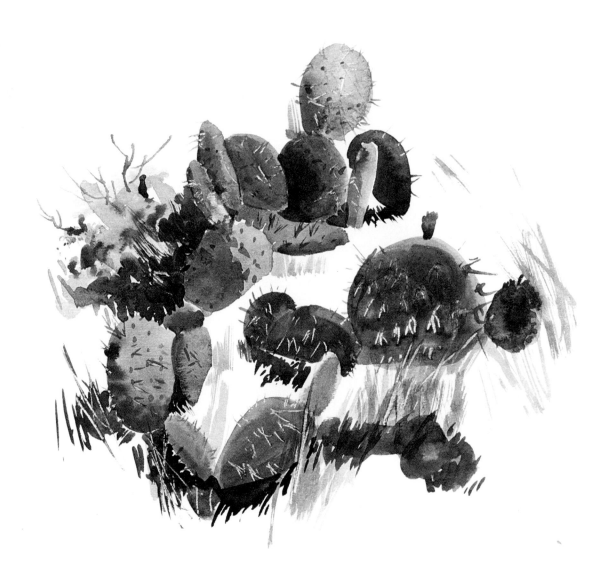

large bristle brush (1 to 2 inches—2.5 to 5 cm). The wide, soft brushstrokes ooze further and the bristle brushmarks hold their shape better on wet paper. This is because the soft brushes hold more water and the bristle ones less water.

How do you decide how much detail to add to a painting?

Each painting requires different decisions in many areas, including the amount of detail to add. While I can't offer a fixed rule, I tend to favor treating closer elements with more definition and leaving more distant ones simpler. For example, the painting of a distant mountain will contain less detail (texture) than one of the pebbles at my feet. I also like to emphasize my center of interest with a little extra detail and play down the complementary shapes with less. The rest goes by feeling. If it feels right, I add details. But I consider simplicity a virtue, so I always leave out more than I paint in. This particularly goes for details.

Do you try to save a problem painting, or do you just start again?

If the problem is minor and it occurs where I used pigments that can be lifted out, I'll correct the trouble. However, if the error is of major proportions, I don't go any further, but just start another fresh sketch. This is usually the better approach, because the immediacy of a newly learned lesson gives me a

little extra confidence on a fresh paper. The result is the best proof. I don't like beating horses, and I never beat a dead one.

Do you ever look at a painting in a mat while you're working?

No. The dress up is "show-biz." I mat my sketch or painting at the end of the raw finish. When I've painted the excitement out of myself, my work is finished in the raw. I put my mat on and look at it anew. Usually I discover a few little spots needing improvement. A neat mat makes a painting look better by surrounding it with restful space (just as oasis in a sea of sand is more exciting than a tree in a forest).

Do you ever put a painting aside for a while before finishing it?

Budapest St. Stephen's Statue

Of course. The more creative a painting is, the more time it takes, within reason. The thinking time has no limit. Ideas are seldom complete instantly. They grow and need molding and development. Even location work requires second, third, or more looks at home, when I'm no longer under the overwhelming influence of nature's beauty and my judgment is more objective. I truly enjoy adding the refining touches that complete the painting. It's never too late for additional clarification, but I must be absolutely convinced that it's needed, and that it won't overwork my painting.

How do you know when a painting is finished?

When I hesitate to add the next brushstroke, *I don't do it.* Instead, I put the painting down and wait, or just consider it finished. For me, a painting starts with an emotional need to express a feeling. When this feeling is spelled out technically well enough to satisfy me, I stop. Work beyond this point would be superfluous frill and clutter, and would no longer be me. Every artist knows when he's said enough emotionally. Your technique must be disciplined to stop in time. I'd much rather stop too soon than too late, so I watch for the warning signs of emotional hesitation and don't go beyond them.

Do you have any preferences for matting and framing your paintings?

Just subtle good taste. I prefer the clear warm complement of off-white neutral mats or frames. Linen or museum board are my favorites. I don't like colored mats, since they usually take away from the painting. If I use them, I only use them as a fine ⅛-inch (0.3-cm) liner. In my earlier years, I used colored mats often, particularly the darker neutrals, to bounce up a mood. In those days, all boards had acid in them. Now the paper industry has very fine all-rag boards, which I use for my final mats. I usually use two, three, or even four liners—all-rag boards cut by a master cutter for perfect sculpturing. They enhance my paintings and protect them permanently with a refined complement that's also a morale booster, truly justifying the extra expense.

What makes a painting successful?

Aesthetic quality, technically and emotionally. If it excites me when I'm physically tired after having just finished it, it means emotional success. If it looks technically as exciting or more so the next day as it did when I finished it, it's a technical success. If both, I usually have trouble parting with it, and if and when I sell it, a little of me goes with it. However, I try to keep my own excitement a personal, private experience, and enjoy the viewers' response. If they also agree, we've really got a winner.

GENERAL ADVICE

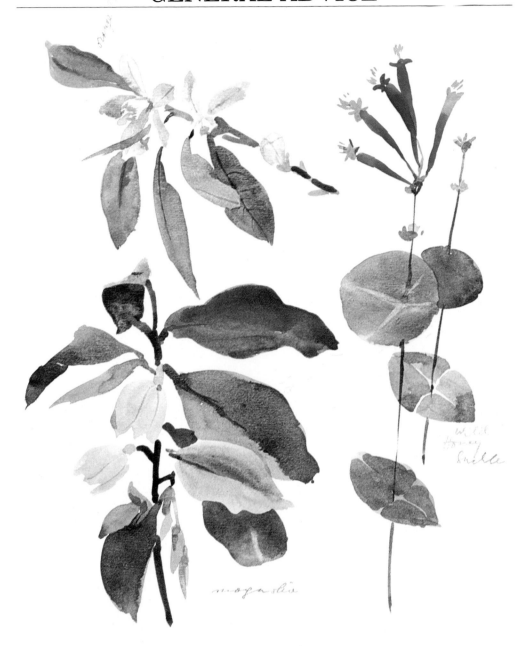

How does an artist develop a style?

Style is the result of a lot of sweat. You can't speed it up. It comes slowly and grows like the pearl in an oyster. The little creature is not even aware of the beauty of the pearl it's building; it only feels the irritation and tries to smooth out the coarse sand. Consistent, steady, and *individually* thought-out work will surely end up with a lovely pearl. The longer and harder you work, the better and bigger the gem. Learn all you can from every source, and be influenced too if you like, but *never try to copy* anyone's style. It simply can't be done, and you'd only fool yourself if you got close to it anyway. Sooner or later you'd realize the frustration of trying to be someone else and go back to being yourself again, starting where you left off. By then you'd have wasted valuable time. Style is a slowly changing experience. Throughout your lifetime, by working and being yourself, it evolves gradually. The reward, however, is worth it. Because of this growing process, it can't be copied, even technically. It's yours alone, forever.

How do you keep your work fresh and vital?

I constantly search for new ideas and technical improvements. Polishing a technique, which is my own, requires concentration. I try to make discipline my guide, to say the most with the least amount of technique possible. I don't use two brushstrokes if I can get away with one. I think and plan my procedure one brushstroke at a time. "Thinking before doing" is a simple way to put it. This discipline offers great rewards and makes constant growth and freshness possible.

What do you do to grow as an artist?

Just work. I don't believe it's possible to force growth. I try to do my best each time I paint, and when my hands quit for a while, my mind is still continuing to think about painting problems. With an alert mind, I get creative ideas at the most unexpected times and in the least likely places. However, these ideas are dormant until they land on the paper. Somehow, by working with keen interest and enjoying it all, time takes care of my growing constantly. The trick is to live long enough to be able to develop my potential. I guess this is what each artist reaches for.

How long should a watercolor take?

I certainly subscribe to the most popular answer, that of thirty years and two hours. But however catchy it sounds, this is an over-simplification. Time really shouldn't have anything to do with aesthetic quality. I like to divide the time it takes to complete a painting into two parts: working time (when I'm actually touching the paper and working on it) and thinking time (when I am developing the ideas and planning my approach). The physical work has to be quick in order for the painting to end up fresh, since watercolor dries as fast as the water can evaporate. It's during this drying period that the most exciting action-filled miracles happen to a watercolor—and happen quickly. However, the artist's experience, the complexity of the subject, and the drying conditions are the main factors that determine how long it should take to complete a watercolor. I would say that, for me, between one and a half hours to three hours is a good average painting time. However, my thinking time varies tremendously. I'm simply not aware of time while I paint. I'm too busy with my idea and too involved with the technique to be aware of anything else, least of all time.

Why do you paint in watercolor instead of any other media?

It's more fun. Watercolor is active even after I've lifted my brush. The challenge of painting with watercolor is like that of controlling a rambunctious colt. I have to show it who is the master. At times, it tries to help me; other times it fights me. The action of the flowing wet paint is an exciting reward each time I paint. Other major media simply don't do this. Another reason is permanence. Watercolor is the oldest and most permanent *proven* painting medium. I use the best paper and the best paint, so the lasting quality is beyond question. My only concern is that my work be as aesthetically worthy of lasting as the ancient watercolors have been.

Why do you prefer transparent watercolor?

Although its transparency is difficult to control, watercolor is the media that offers the greatest flexibility. First, by simply diluting the paint with clean

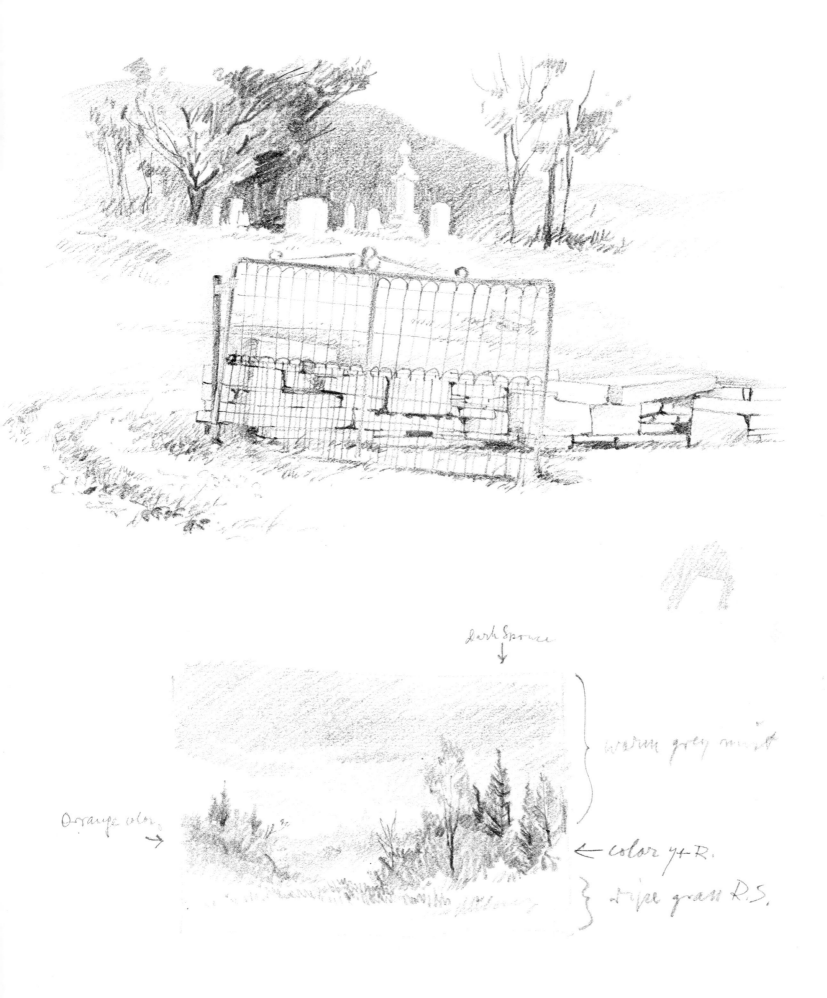

dark Spruce
↓

} warm grey mist

Orange color →

← color y+R.

} ripe grass R.S.

47

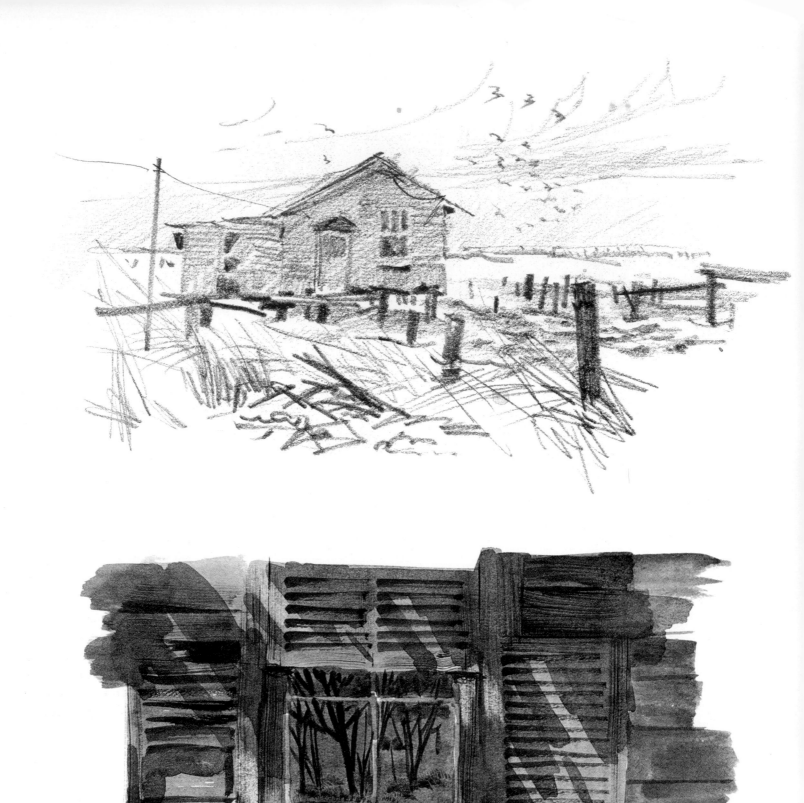

water, you can get an exciting glow of colors. Then, because watercolor can be redissolved when dry, it also has the potential for recovered luminosity. That is, you can lift out darker values from a wet or dry wash in order to regain the brilliant transparent light colors that lie beneath them. The transparency of watercolor also allows the white paper to shine through behind the color, brightening colors without adding white paint, which would dull them. Also, the action and speed required in doing a watercolor gives the media a temperament that I love. It doesn't just sit where I put it, it fights back a little. It demands respect and concentration, like a chess game. One wrong move and I lose the game. Because the possibility of losing always hangs over my head like the sword of Damocles, winning is that much sweeter.

Do you ever use opaque watercolors or acrylics?

As a designer in commercial work, I used to work with designers' colors and acrylics, and I must confess, I gained good skill with them. After all, I used them every day. However, because of those years of commercial application of these mediums, I still associate them psychologically with the limitations of commercial work. On the other hand, I enjoy unlimited freedom with transparent watercolor because I associate it with my "free-as-a-bird" painting emotions. I also prefer another media—casein tempera, for the same reason: I learned to use it for fun, and the result is more creative.

Do you ever combine them with transparent watercolors?

I never combine other media with transparent watercolor in my paintings. However, I love playing with all kinds of mixed media in my sketchbooks or on-the-spot doodles, where speed is essential. My studio doodles for paintings in the planning process may be done in any media. These are reference sketches, and I don't care how I get my ideas down as long as I get a visual image. After all, I wrote a book on this subject, *Creative Watercolor Techniques*. These mixed techniques loosen me up and prevent me from getting tight, but they can't replace my first love, transparent watercolor. All the while I'm using these mixed techniques, my mind is constantly thinking about how I'll approach these subjects in the final painting with pure transparency.

What is your philosophy on art?

It's a long list of principles. First of all, I feel obliged to be myself, completely and absolutely, to the best of my ability. My idea is presented my own way each time. I owe this to my viewers, whom I respect, and of course, I owe it to myself. I attempt to communicate my ideas and emotions through the painting itself, and try to infect my viewers with them.

I do my best on each painting, but as I get better through the years, I don't excuse my older work, which by then will be inferior. At the time when I painted them, they were the best I could do. My conscience is always clear. The value of an artist's work gets higher as he gets better, and mine is no exception.

I don't believe in "artistic temperament." Temper tantrums are no more excusable for artists than for anyone else. The rewards of social acceptance are no excuse for ill temper or rudeness. On the contrary, because of the necessity of public communication, an artist must learn to discipline himself

socially if he expects his public to believe that his creations are truly representative of himself.

Would you have suggestions about ethics?

Ethical behavior starts with unconditional honesty in an artist's work. I try to mold whatever influence is affecting my creative growth to blend with my thinking and technique. During the student years, copying is necessary for learning purposes only. Student copies are usually only as valuable as the amount of knowledge resulting from them. I consider it wrong and unethical to sign them.

Because of the eventual necessity for an artist to do business with the buying public, good taste and fairness both ways is a good guideline. It certainly is for me. But sometimes misunderstandings (usually innocent) occur. For example, buyers may ask me to copy my own or someone else's work for a commission. The temptation, of course, is money. But in this and similar situations I explain, calmly and without accusation, that I don't do it, and a better understanding usually results. I don't allow myself to be tempted by the temporary success of other artists where it is based on poor ethics. Instead, I try to listen to my own conscience and do to others as I really would like them to do to me.

Are there any artists you particularly admire?

Of course, there are many. I don't think I should mention names, but I love to look at good paintings, particularly good watercolors. They all leave a little impression and serve as proof that each plateau of standard can be surpassed, so I can aim high enough to best my own highest standards and break my own records. Other artists supply thoughts to the creative process like food offers relief to hunger. Being a social creature, like my fellow man, I relate to others' work, but I try to limit my influences to the level of my intellect. I wouldn't copy or try to copy their ideas or technique. I think my originality is a sacred responsibility that I enjoy and demand from myself. Sharing a creative kinship with others is an exhilarating experience. I try to keep it from going any further than that.

What are the rewards of being an artist?

For me, there are many. To be able to communicate my ideas and feelings to others is the real driving force behind my life as an artist. To see the expression on faces that say something like, "I understand what you meant when you painted this" is more important than if they say that they like it. This positive response is addictive. Other rewards also enrich my life, like teaching and helping others grow, being able to observe a few more secrets of nature than unaware bystanders. Monetary rewards are also contributors to a good present and future, but money is last in order of importance. Spiritual and intellectual awareness is probably the first.

What are the drawbacks in being an artist?

For me personally, not having as much time to spend with my family and friends as I'd like is one drawback, though people in other professions may have even less time. I'm lucky, though. My wife Linda is also an artist and has her own need for self-expression, and so understands mine. Another drawback for artists in general may lie in their own nature. Some artists are

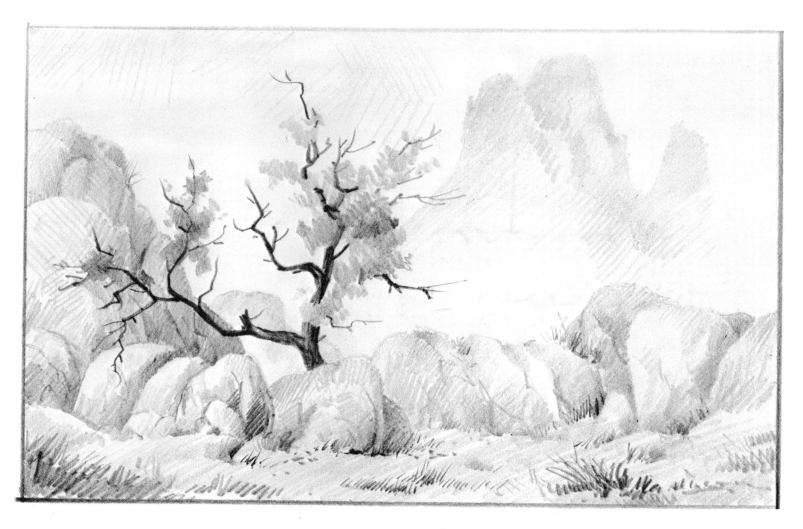

trusting to the point of gullability, which may occasionally make them vulnerable to people with questionable motives. There's also the pressures society creates to make money from art, which may choke creativity and tempt an artist to violate his integrity. It may be hard to turn down a fat commission, for example, to paint a relative in her pink hat with a bumble bee on top, or to flatter a politician by painting his portrait from an old photograph where he was much younger, or giving him hair when he's bald, or leaving off his glasses. These traps are real and dangerous, whether they come from a relative, a friend, or a president. An artist's integrity must be above reproach. Every business has its temptations, and like other professionals, artists must know when to accept and when to refuse commissions.

Do you have any special plans for the future?

I intend to do justice to my principles and share my ideas with society. I hope that my work will contribute in some way to the culture of my adopted countries, Canada and the United States, and will further the development of watercolor as a major media, or one at least equal to all the others. I certainly hope to do a little teaching and writing, but first and foremost, I want to be known as a painter. Writing and teaching aren't worth anything if I can't do it with a brush. Painting is my life and I must give it all I've got. I owe it to Linda, the rest of my family, and most important of all to my Creator who entrusted me with such a rewarding life. What more can I say? Keep on painting.

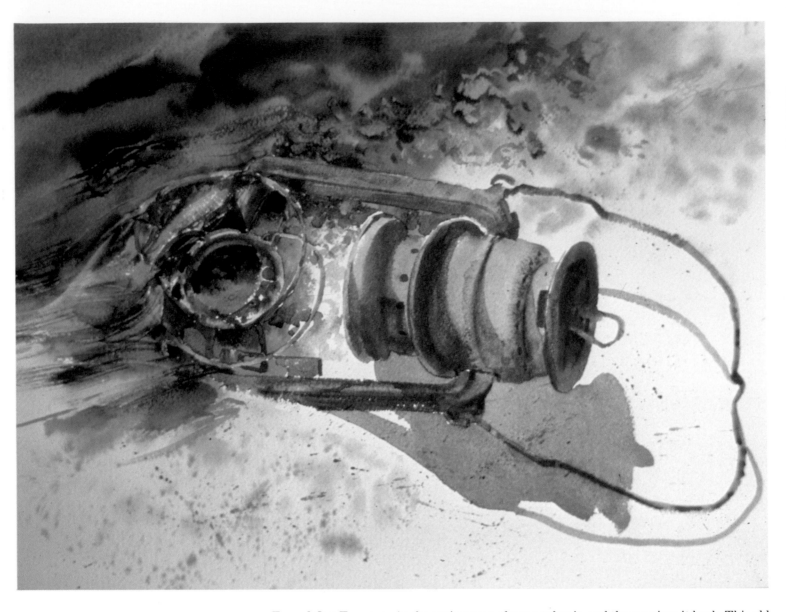

B. SIENNA
ULTRA
SEPIA
PRISAP GREEN

Tossed-Out Treasure. As the saying goes, the sea takes it, and the sea gives it back. This old lantern was tossed to shore by the tide in St. Andrews, New Brunswick, Canada. By using fresh glazes of transparent colors and by carefully selecting my values, I make one shape stand out in front of another. The different textures describe their material nature. I began the twisted old lamp on white paper with a mingled combination of burnt sienna, French ultramarine blue, some sepia, and, most important, the rusty color of burnt sienna, which predominated. I painted the still-wet seaweeds with sap green, sepia, and French ultramarine blue. I touched up the edges of the pebbles and added some light lines in the dark mass of green weeds with my palette knife. I wet the paper and splattered some texture into the sandy white shore. Finally, I painted the complex cast shadow of the lantern with sepia and French ultramarine blue as a single tone, indicating a continuous shape.

Step-by-Step Demonstrations

Diffused Winter Light
WET-IN-WET

R. SIENA = WARM
B. " "
BR. MADDER

ANT. BLUE : COOL
ULTRA

This is a winter landscape, done in neutral tones, of a dreamy subject. The typical warm gray overcast sky that precedes a quiet snowfall tends to warm up the colors of the landscape. Even the snow, which we normally think of as being blue because the blue of the sky is usually reflected down on it, has a warm quality here because the sky is warm-colored. I decide to paint this landscape wet-in-wet because it offers the advantages of subtlety and softness. With this softness in mind, I also select my palette, choosing five colors: three warms (raw sienna, burnt sienna, and brown madder), which dominate, and two cools (Antwerp blue and French ultramarine blue), which complement them.

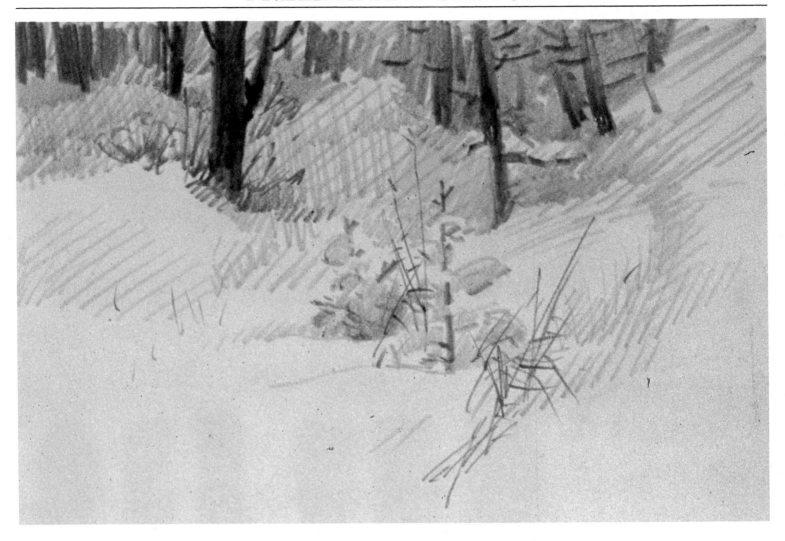

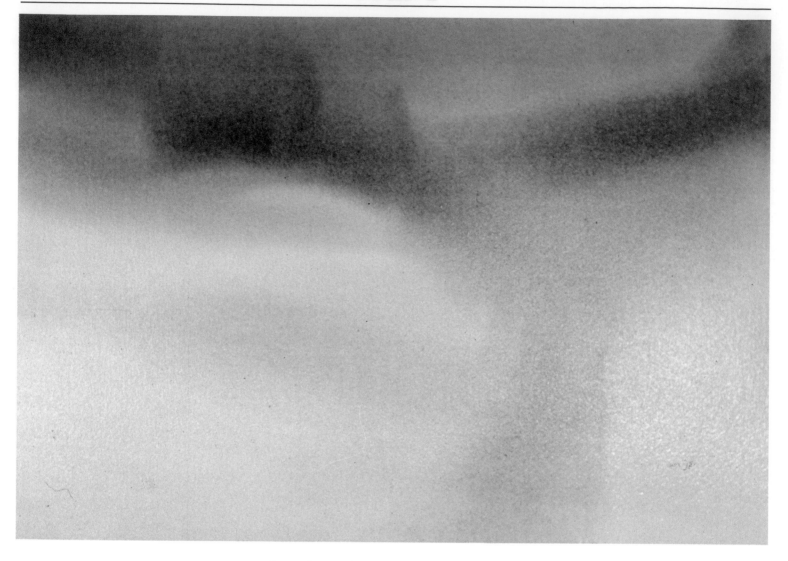

I start by wetting the paper completely. I establish the mood of my painting first by adding neutral and warm gray washes of light to medium value. I work darker in the distance and fade them slightly as they advance until they're lightest in the foreground, hinting at some modeling in the middleground by not applying my light gray wash too evenly. I allow the brush to release varying amounts of paint in each brushful, suggesting difference of elevation in the snow. (Later I plan to paint stronger images, such as trees and weeds, into these areas.)

STEP 2

Next I paint the sketchy elements of the distant forest, letting the cool color of some evergreens contrast against the warm opening in the sky that hints of sunshine above the clouds. By adding just a little more detail and warming my colors slightly as I work toward the foreground, the gray, deciduous forest appears to advance. The nearby trees are strongly defined with crisp drybrush touches of French ultramarine blue and burnt sienna at their snow-covered bases. Then, I knife out the texture of the trunks from the rich, still damp pigment by gradually releasing pressure on the knife. This exposes the strong stain of burnt sienna, which is the dominant color. I call this technique "recovered luminosity." By scraping or lifting out dark colors to expose a lighter staining color below, the luminous color gives the effect of light being reflected from the white snow into the dark side of the tree trunks. (For more information on specific techniques, see *Zoltan Szabo Paints Landscapes.*)

Detail. I drybrush the tree trunks on the unevenly drying paper. Where the brushstrokes touch a wet area, they soften and blend; where the paper is dry, the edges stay sharp. Note the luminous effect I get by knifing out color.

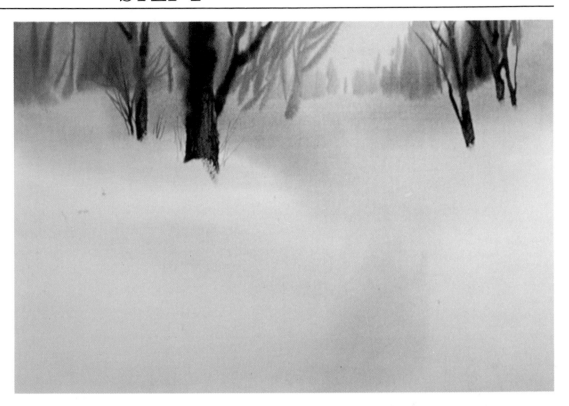

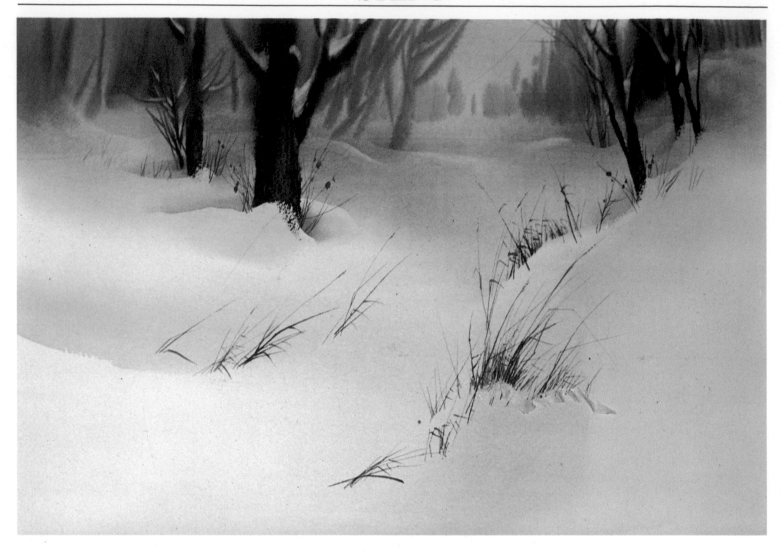

Hidden Creek. Finally, I glaze on some subtle values for mounds and dimples in the snow, further developing the rolling nature of the middleground. I am still using French ultramarine blue and burnt sienna, with a tiny addition of Antwerp blue. I add a few small twigs and dry weeds to carry the dark, warm color into the foreground and define the patches of snow on them.

The finished study is full of the subtleties I wanted to capture. The contrast between cool and warm color is limited to the distance and hints of oncoming sunlight, adding another mood to the painting. The clusters of weeds in the foreground subtly lead into the wet snowy area, the hidden creek. The calligraphic brushstrokes I use complement the soft wet-in-wet technique of the snow, without the transition between them being too obvious.

Detail. To form the lost-and-found edges of these brushstrokes, I work on dry paper. Leaving one edge of the brushstroke sharp, I softly blend the other edge into the white paper with a thirsty wet brush. (To do this, I wet the brush with clean water and squeeze the water from it with my thumb and index finger; the brush will now draw the excess water from the paper.)

Detail. At the same time that I model the snow, I wet-lift out a few highlights from the clumps of snow in the grass and on the heavier branches of the trees to complement the lost-and-found edges of the brushstrokes in the preceding detail.

Shadows on Snow
GRANULATING WASHES AND LIFTING OUT

In this painting of a snowy scene, I take advantage of the sedimentary and lifting qualities of manganese blue when used by itself or mixed with another color. Had I painted the subtle details into the even shadow washes instead of lifting them out, I would have found it more difficult to control them. But by lifting them out after the paper has dried, I can be much more accurate because I have unlimited time to think out every brushstroke. My palette is manganese blue, Antwerp blue, and French ultramarine blue on the cool side, and raw sienna and burnt sienna on the warm side.

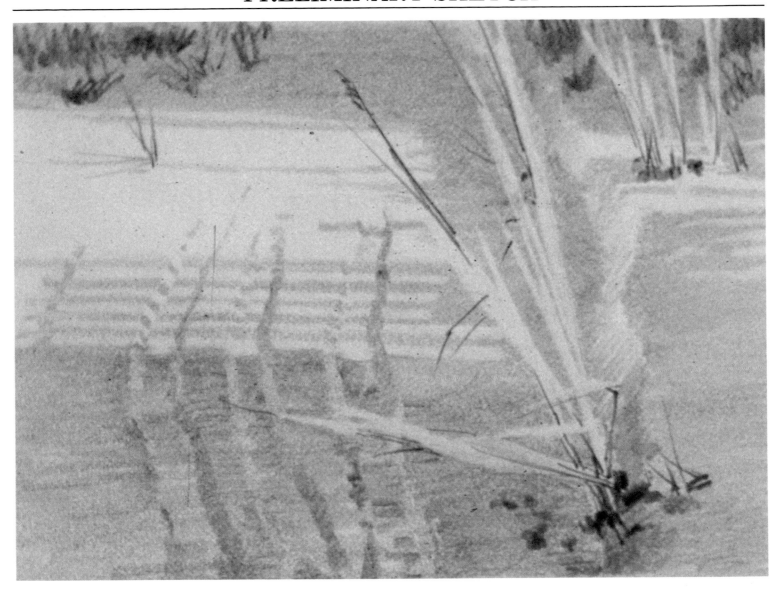

MANG. BLUE
ANTW. " COOL
ULTRAMI.
R. SIENA WARM
B. SIENA

Starting on wet paper, I apply varied values of a shadow color made up of manganese blue, French ultramarine blue, and Antwerp blue, with a little burnt sienna. I also hint at the distant weeds, blurred slightly out of focus, with various combinations of raw sienna, burnt sienna, manganese blue, and French ultamarine blue. The shadows cast over the tire tracks by a picket fence provide me with the opportunity to design exciting shapes. I deliberately make my shadow wash light so it can be lifted off more easily, leaving the pure, almost white color. I model the darks and medium darks in the shaded areas in order to show differences in ground elevation through varied values of a shadow color made up of manganese blue show differences in ground elevation through varied reflected lights in the shadow. I want to make the little hoarfrost-covered weeds very important despite their innate subtlety.

Detail. While the color of the distant weeds is still wet, I lift out some of the hoarfrost-covered weeds and introduced light values into a predominantly dark area with a small, clean, thirsty bristle brush.

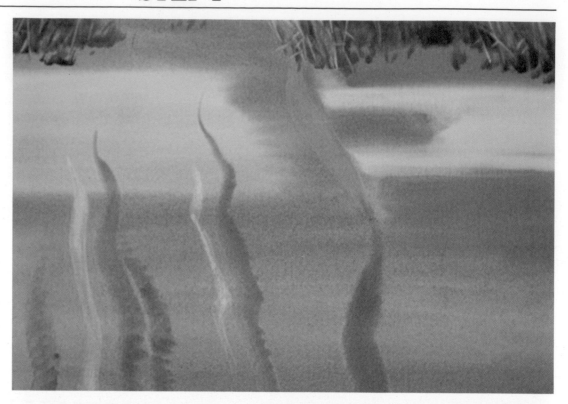

Next I lift out the shape of the sharp, brightly lit hoarfrost-covered weeds in the middleground, removing as much color as possible. Then I paint the warm color of the base of the weeds into this glowing negative shape. I also paint the shadow these weeds cast in the snow and lift out the sun-filled areas between the shadows of the weeds and the picket fence. As I lift out the shadow color, exposing the sunlit snow around the shadow shapes, enough color remains to give the snow some value and sparkle.

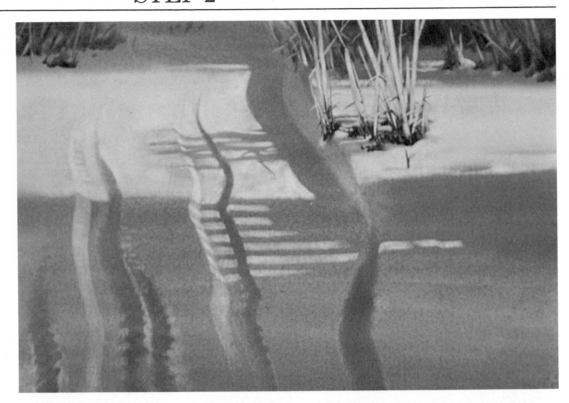

Detail. Because the frost on the weeds is in strong sunlight, I scrub off all the color from the background area that they cover. Then I work the warmly lit base structure of the weeds into these thin shapes.

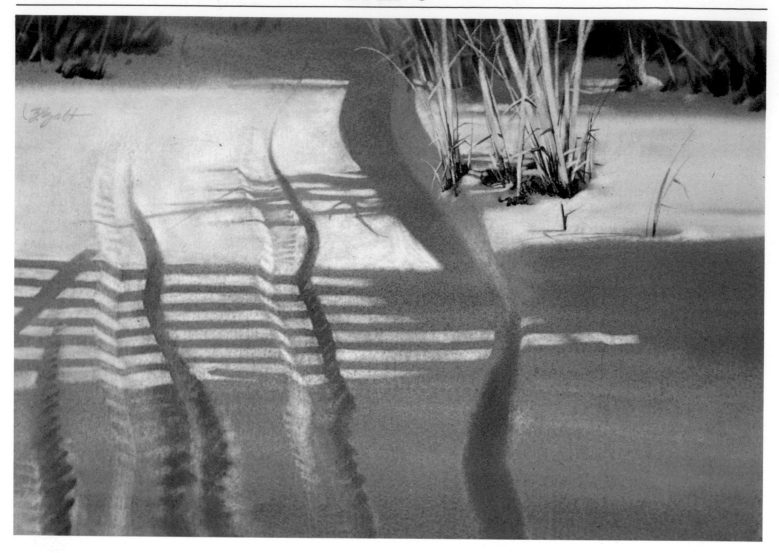

Snow Fence. Adding the details in the shadows comes last. The values within the cast shadows on the snow and the reflected light on the slopes of the tracks vary according to the strength of the light. The tire tracks complement the perpendicular images of the ice-frosted weeds, repeating their dynamic curving lines and shapes, and contrast with the crisscrossing, horizontal fence shadows. The lines balance each other, creating a quiet, solitary mood.

Detail. I place delicate details at the center of interest, where extra attention is required. Note the variation in the amount of color I lift out for the middleground weeds in the center of interest, which are struck by more sun than the background weeds, where there is less contrast.

Detail. I am extremely satisfied at having painted the shadow shapes in a single wash. The sparkle in the shadows in the snow is caused by the grains of manganese blue, which separate from the other colors in the wash.

Icy Creek
LIFTING OUT
AND SUBTLE GLAZING

I based this demonstration on a drawing in my sketchbook of a creek bed with stones exposed under the water. In the scene, a little ice on the water's edge created a contrast in value with the snow and weeds, drawing attention to the underwater detail. My palette is sepia, raw sienna, burnt sienna, Antwerp blue, and French ultramarine blue.

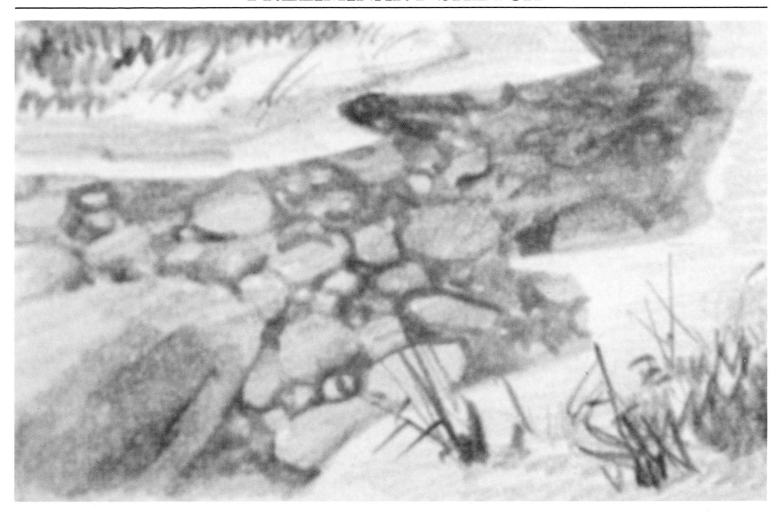

First I establish the approximate shape of the water area with a very light wash of sepia, just enough to act as a guide to where the ice stops and the riverbed begins.

I tape out the icy edges around the riverbed with masking tape. Then I paint the rocks and pebbles with a drybrush technique, using a thick application of sepia in the foreground, thinning and lightening it slightly as I move into the background. I underpaint the texture on all the pebbles in this loosely painted manner, making sure that the sepia stain is sufficiently dark to survive the light scrubbing I plan to give it later when I lift out the ripples on the water covering the pebbles.

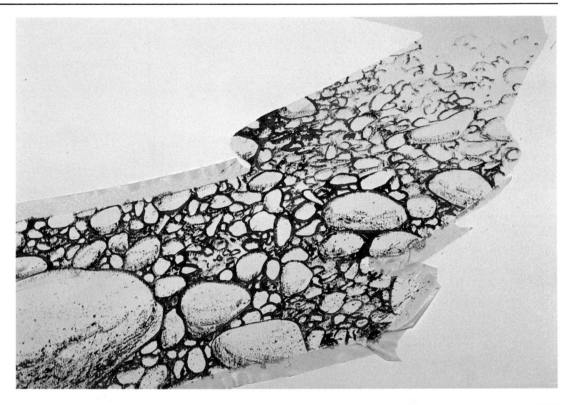

Detail. The masking tape, which protects the drybrushed edges where the pebbles touch the icy river bed, is still on the paper. I also splatter a little sepia on the near side of the larger rocks in the foreground for added texture.

I remove the tape and paint the ice on the left-hand bank with several extremely light glazes of raw sienna, Antwerp blue, and French ultramarine blue, with the Antwerp blue dominating the wash. I also add a bit of salt at the lower left center, near the water, to give a frozen texture to the ice. Then I paint the clumps of dry weeds into the snow on the left bank.

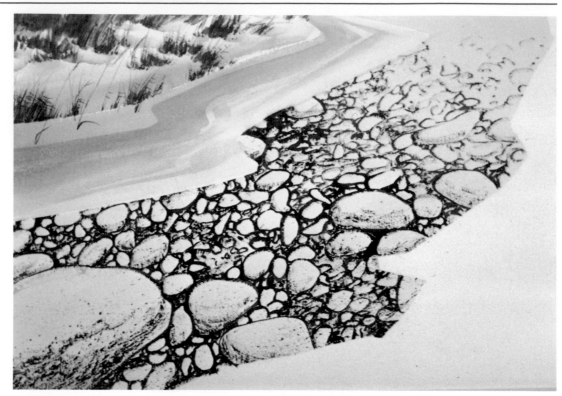

Detail. French ultramarine blue tones tend to dominate the color of the snow here, but the combination of colors still remains the same. The dry weeds were drybrushed on and then knifed out. The occasional individual leaf received special attention.

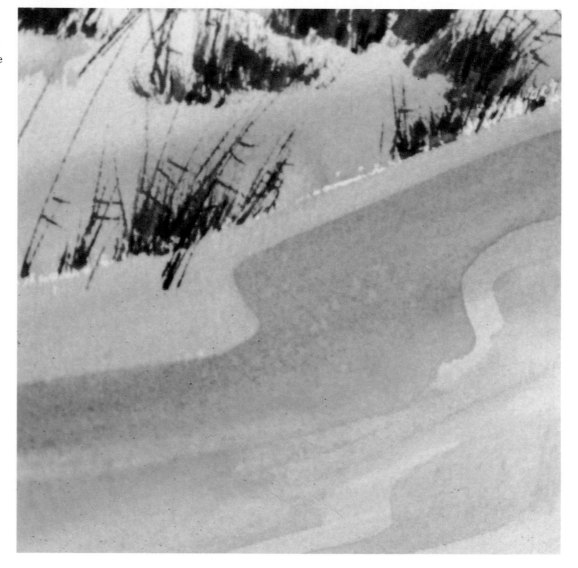

Working on top of the drybrush-textured creek bed, I glaze on a strong, medium-value wash of raw sienna, burnt sienna, and French ultramarine blue to represent the dark, warm color of the water. I continue to glaze on the pattern of the ice and the subtle hollows of deep snow covering the bank. I also add a few more clumps of weeds, as I did in the preceding step.

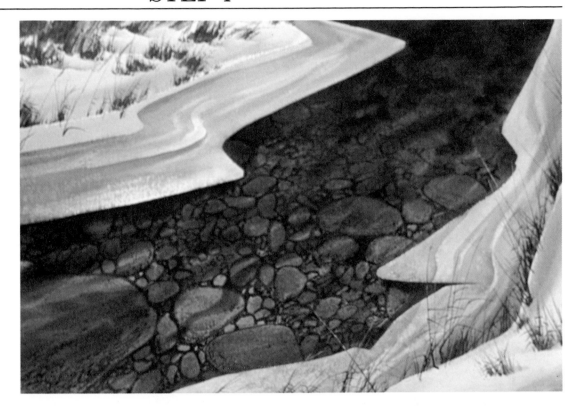

Detail. The glazed-on ice pattern not only hints at the direction of the waterflow, but it also contrasts sharply in color, value, and texture with the soft snow next to it. The delicate weeds on the slope of the bank also help to give the illusion of depth.

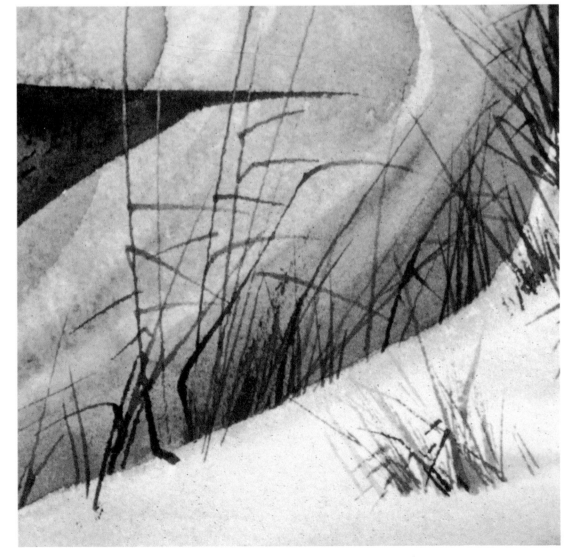

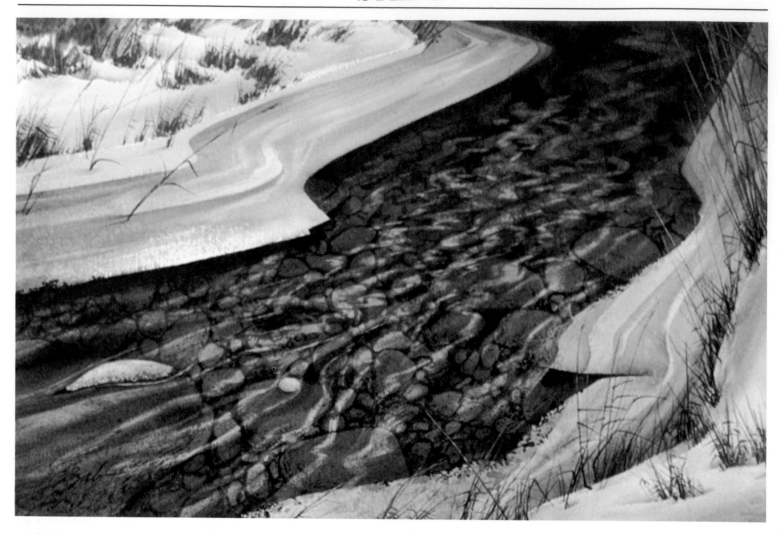

Northern Runner. I paint warm color on a few edges of the ice to cut down their harshness and to give a swift direction to the water flowing over the ice. I use a wide, 1-inch (2.5-cm) soft brush and glaze on one layer at a time in very light values of raw sienna, Antwerp blue, and French ultramarine blue. I also continue to lift out the reflections of light in the water. In fact, the lifted-out reflection is what makes this study seem complex. Note how the foreground area is tied to the background through the warm color spots of the weeds.

Detail. By glazing warm strokes of color on the distant ice, I relate it to the color of the flowing creek below it. My rhythmical brushstrokes also echo the flow of the light-struck ripples I just lifted out.

Detail. I use both a bristle brush and a no. 6 sable pointed brush to lift out the ripples on the water. Where the form is sharper, I take more care to keep the edge I lift out sharp and contrasting. Where the edge is soft, I use more water and apply less pressure to the brush.

Mist and Ground Fog
WET-IN-WET AND DRYBRUSH

This demonstration painting is an exercise in painting a misty scene. In this case, unevenly distributed patches of ground fog move in and around objects in the landscape. The colors I use in this painting are raw sienna, burnt sienna, new gamboge, cerulean blue, French ultramarine blue, and Antwerp blue.

R. SIENA
Br. II
NEW GAMBO.
CERULEAN
ULTRAM.
ANT. BLUE

Working wet-in-wet, I soak the paper thoroughly and establish the fog pattern and, at the same time, the most distant rim of the hill on the wet paper. I use a little raw sienna in the mist as a warm touch, hinting that the sun is not far from bursting through. To paint the distant hill I use raw sienna, burnt sienna, French ultramarine blue, and a touch of cerulean blue.

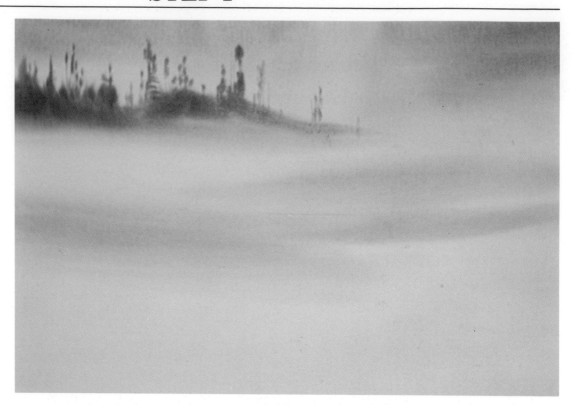

Detail. The softly contrasting washes on the wet paper contain more paint in the darker strokes and more water in the lighter ones. In painting the misty trees, I use a bristle brush and very little water.

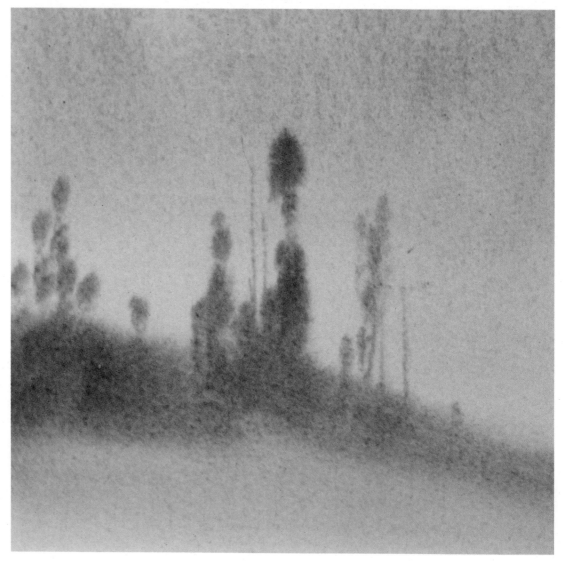

I paint the middleground trees with the same color combination, but in a stronger value and with a little more definition. The paper is gradually drying and by now some of the trees are painted on dry paper.

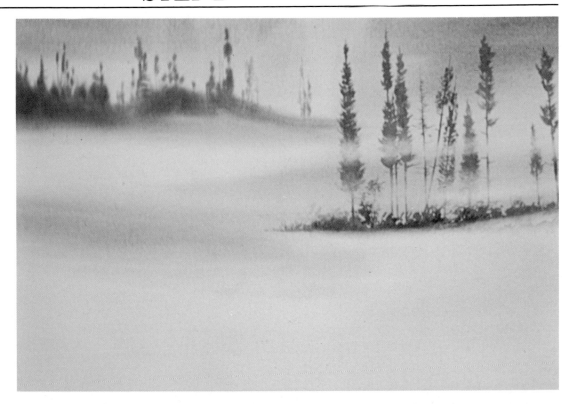

Detail. The background trees actually remain warmer than those in the middleground because of the yellowish glow from the sky, which affects the local color of these trees in spite of their distance from the viewer. In definition, however, they still remain soft.

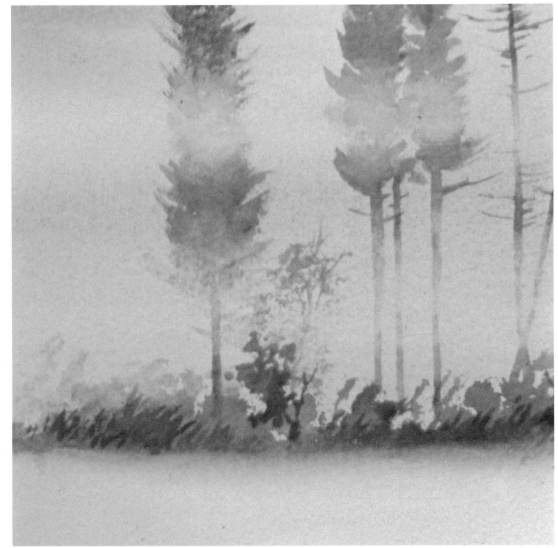

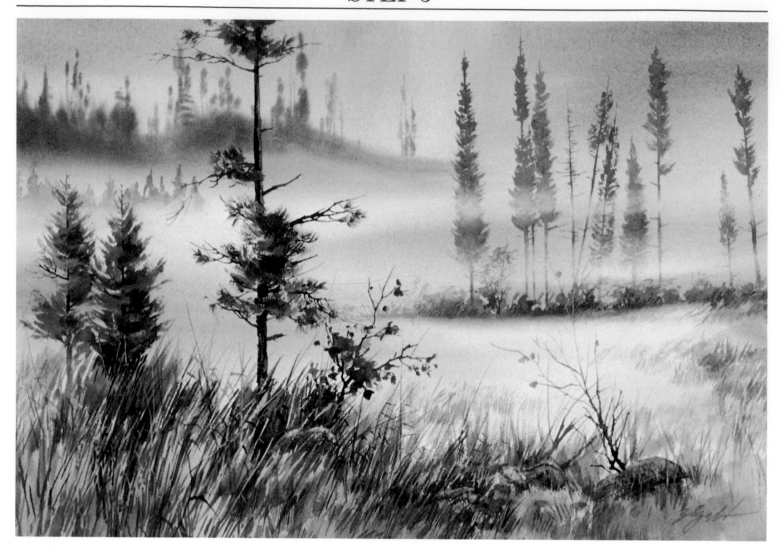

Lifting Mist. I paint the foreground last, taking extra care to get the correct value and color. The colors here are warmer, details are sharper, and wherever the images are silhouetted against the misty background, their value is a little darker.

R. SIENA
B "
NEW GRAB.
CERULEAN
& LT.RED.
WHITE. BLUE

Detail. There is a slight interplay of values in the drybrushed pine tree branches. The woody twigs are carefully designed and positioned and the little clumps of pine needles at their tips are well defined. All in all, the fine details in the foreground, with their increased definition, warmer colors, and deeper values advance in perspective. In contrast, the softer background forms established earlier recede.

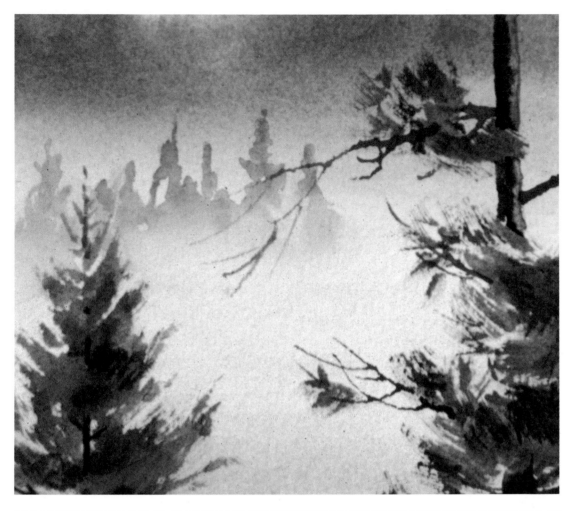

Detail. I start painting the foreground grass with drybrushed strokes of raw sienna, burnt sienna, and a little Antwerp blue. I use a bristle brush. When its firm split hair is used in drybrush fashion, it tends to look the way grass grows. I brush the same colors over the rocks, but knife out the highlights there with uneven pressure. I also glaze in negative shapes, knife on branches, and drybrush on more foliage.

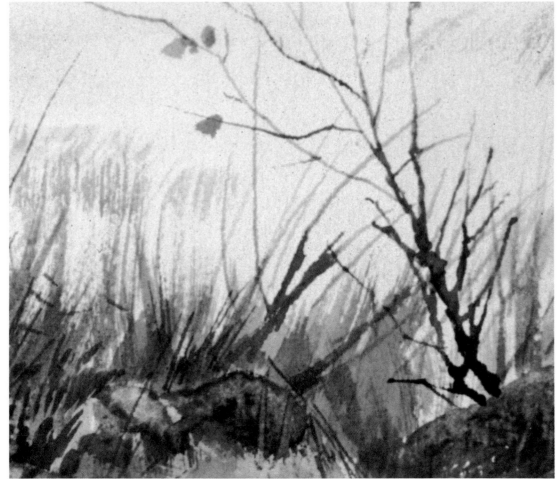

Woodgrain
STAINING, DRYBRUSH AND LIFTING OUT

The following demonstration is a study of several textures—wood, grass, and paint—in bright sunlight. My palette is burnt sienna, raw sienna, sepia, cobalt blue, and Winsor blue.

On the dry paper, I start work on the first wooden board. First I mask out the borders on both sides of the board with masking tape. Then, with a mixture of sepia and Winsor blue, I use a combination of stain and drybrush to underpaint the texture of the woodgrain and cracked paint. Where the aged wood is exposed, I only use sepia. I paint the twig that is in front of the boards first, then mask out the bordering edges of the wood behind it when it's dry.

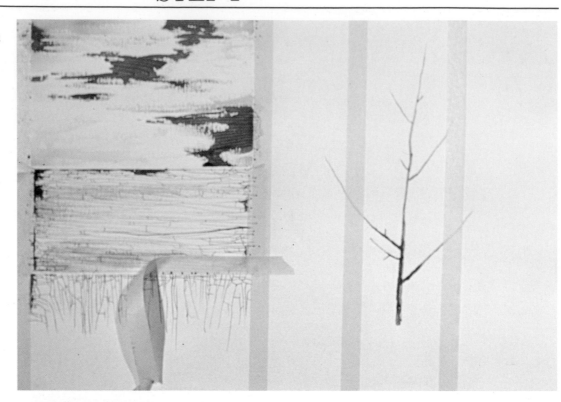

Detail. I paint the texture of the wood directly on the dry white paper with a combination of sepia and Winsor blue or sepia and burnt sienna using drybrush strokes and light washes. The staining strength of these combinations plays an important part in the painting. The sharp, strong lines in the brown tone or on the white paper are scraped in with the pointed tip of the brush handle or cut in with the pointed edge of the palette knife, using rich pigment.

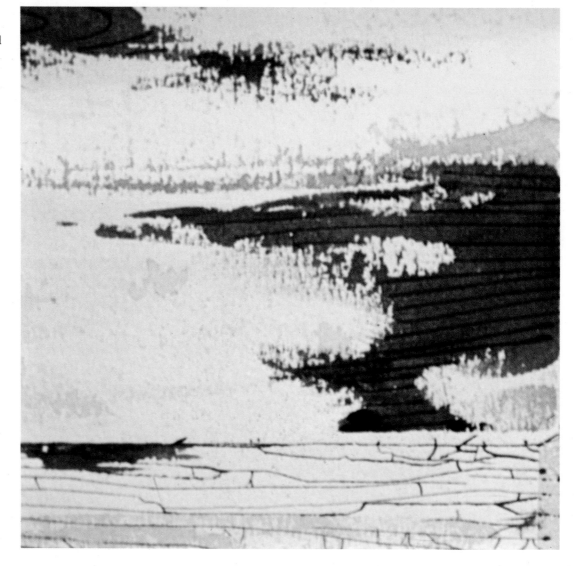

I apply Miskit over the shape of the young tree so I can freely model the woodgrain behind it. There isn't much indication of value at this point; I'm only interested in texture.

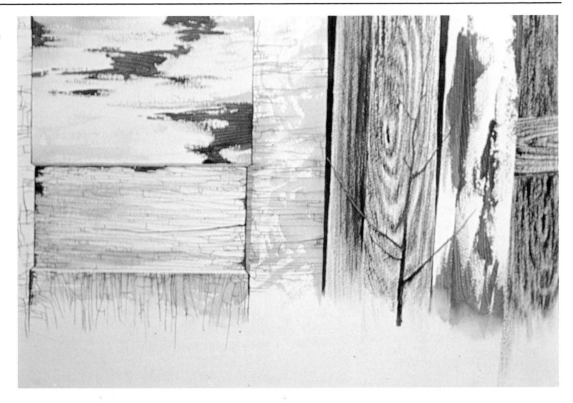

Detail. This is a closeup of the woodgrain. Before I paint each board, I mask out the edges on either side of it. When I'm finished and the paint is dry, I remove the tape and repeat the process so I can paint the next one.

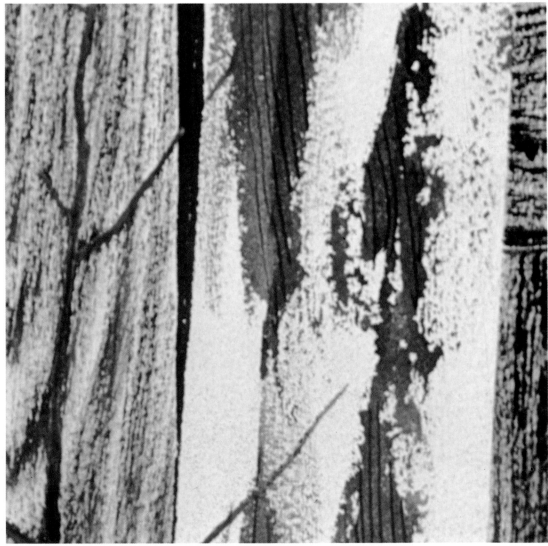

After I peel off the masking tape, I glaze the shadow colors over the established textures with a wash of cobalt blue, burnt sienna, and a bit of raw sienna. I paint around a few large sunlit spots so I don't have to lift them out later. I make no attempt to paint the more delicate shadows yet; I just wash in the shadow as a broad mass. While the wash is still wet, I paint the dry grass below it with a bristle brush and texture it with my palette knife. My colors here are raw sienna, burnt sienna, sepia, and a little Winsor blue.

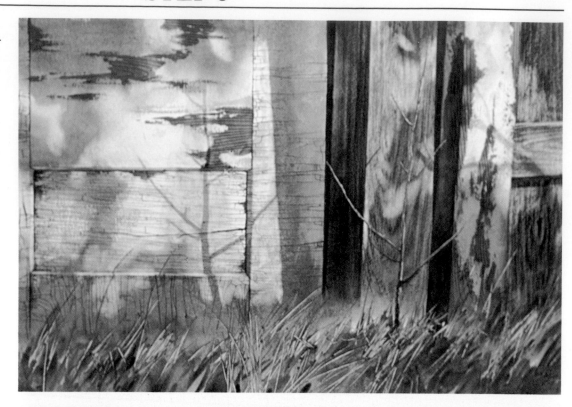

Detail. The luminous blue-gray shadow color glows with reflected light and displays the underlying texture clearly. The warm colors of the textured weeds offer a pleasant contrast to the cool shaded surface of the wood.

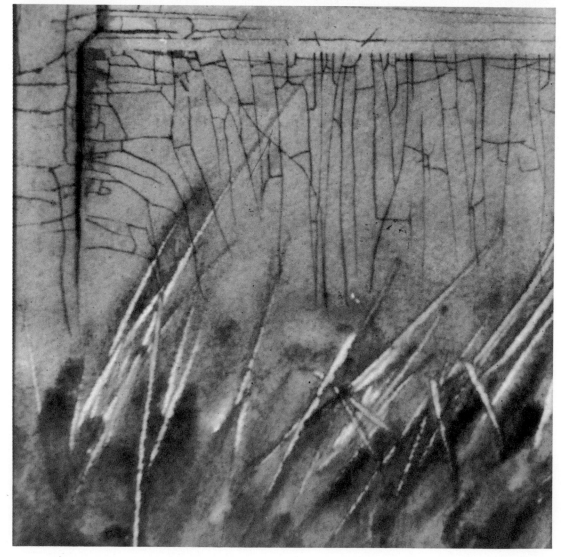

After these colors are dry, I lift out the sunlight around the delicate shadows by first wetting the area, scrubbing it with a bristle brush, then blotting off the loosened paint. The young tree is still protected by a layer of Miskit. The shapes of the patches of sun are very important to the design, and when the shadow wash is lifted, the staining texture of the woodgrain and cracked paint shows through. Fortunately, I am able to remove most of the cobalt blue in the shadow wash. The nearly white paper gives me just a little bit of the dilapidated but sun-lit texture on the surface I want.

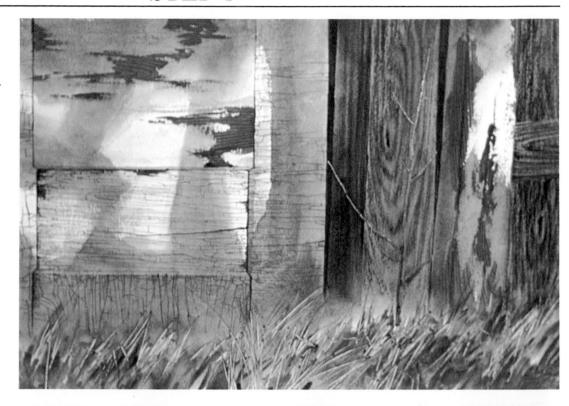

Detail. I paint the foreground weeds and grass with various brushstrokes of raw sienna, sepia, and Winsor blue. Then, while it's still damp and tacky, I knife out individual blades of grass with my nail clipper.

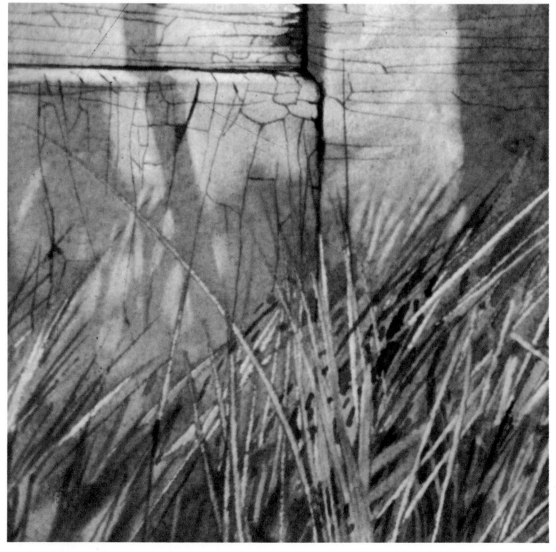

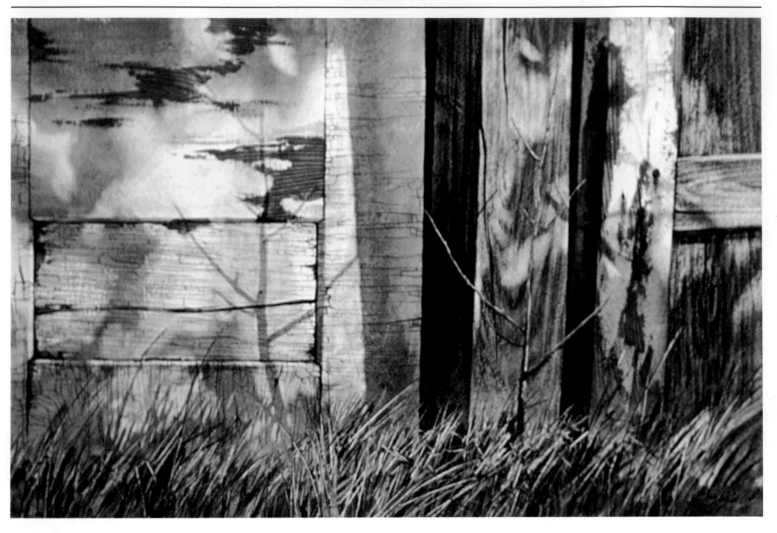

Sun Pattern. Now I finish the details. I paint around the delicate shadows, then remove the Miskit and paint the sunlit tree with burnt sienna and raw sienna. I refine the grass, glaze the dark spaces between the blades of grass, and lift out a few highlights. I also lift out the shadow wash for the tallest blades of grass that lie in sunlight, in front of the shadowed wood. I also refine the wood and paint a few nails in it. The warm and cool colors in the painting now balance each other. The texture is now subordinate to the design and the shapes are much more evident.

B. SIENA
R. "
SEPID
COB BLUE
W. BLUE

Detail. This detail illustrates the chipped and cracked paint and the worn joints between the boards, both in sunlight and shade. As you can see, they survived the scrubbing very well. Also, because the texture was applied equally to both sunlit and shaded areas, the continuity of texture is assured under both conditions.

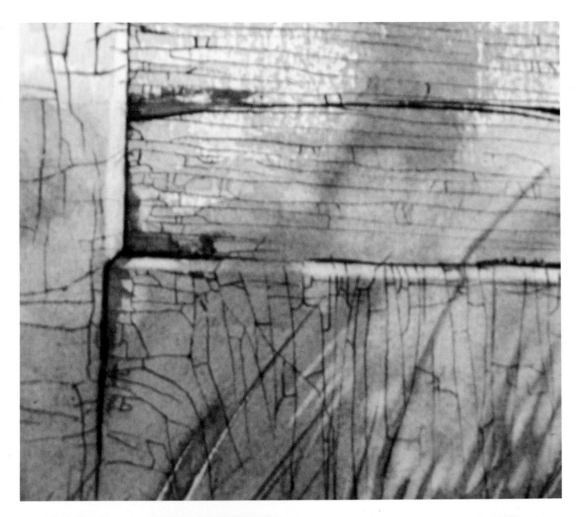

Detail. As I finish the last refining touches, I pick out the cracks in the wood and darken them with more sepia. I also put in a few nails and add the typical rusty streaks beneath them.

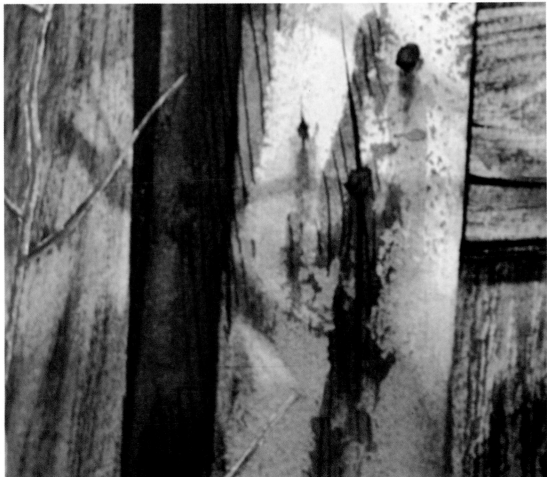

Atmospheric Perspective

WET-IN-WET, GLAZING AND KNIFING OUT

R. SIENA
B. "
BR. MADD.
ANTW. BLUE
ULTRAM.

This is a study in soft colors of gently moving water. There are also several elements above the water. These land elements and their reflections vary according to their position in the foreground, middleground, and background. My palette is raw sienna, burnt sienna, brown madder, Antwerp blue, and French ultramarine blue.

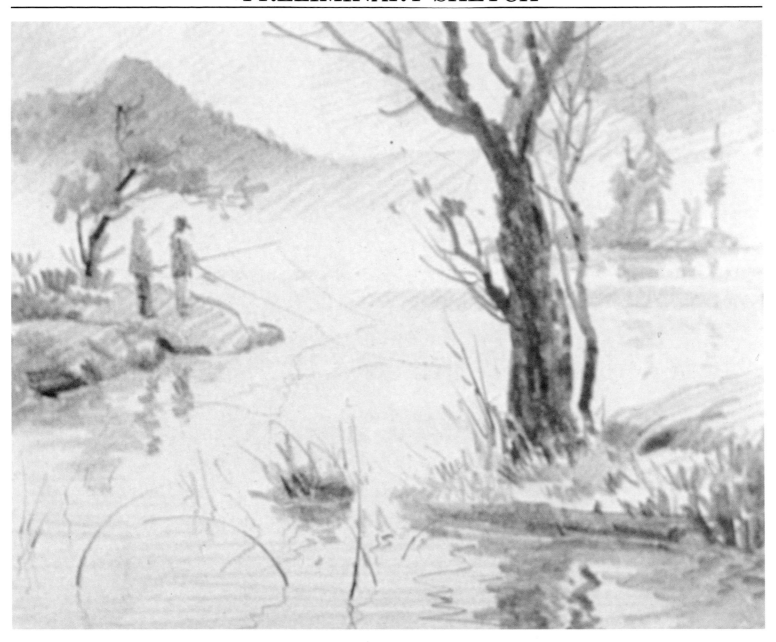

I wet the paper and establish the sky and distant mountains with a wash of raw sienna, the two blues, and a touch of brown madder, in varying combinations. In the wet foreground, where the waves are gently rolling, I use a light combination wash of Antwerp blue, French ultramarine blue, and brown madder. The result even at this point shows the moody play of cool and warm color that hints of a rain shower coming from the right-hand side. The light comes from the left rear center. The raw sienna in this area indicates a thin cloud formation with some strong sunlight behind it.

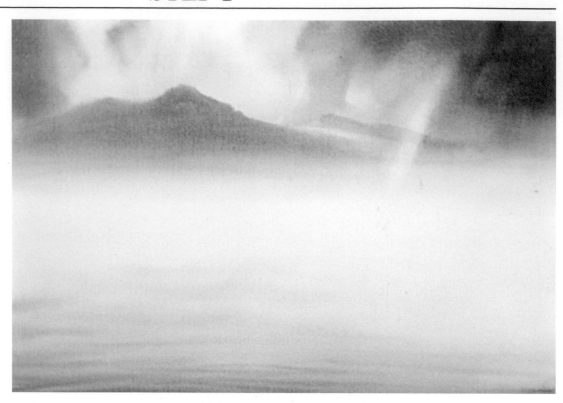

Detail. I carefully time painting the mountains into the wet sky wash, waiting until the first wash loses its shine. Because of this, edges of the distant mountains are soft and furry, which makes it look like they're covered with trees.

STEP 2

When the paper is dry, I paint the bluish gray silhouette of the evergreens and rocks on the distant tree-covered island with burnt sienna and Antwerp blue.

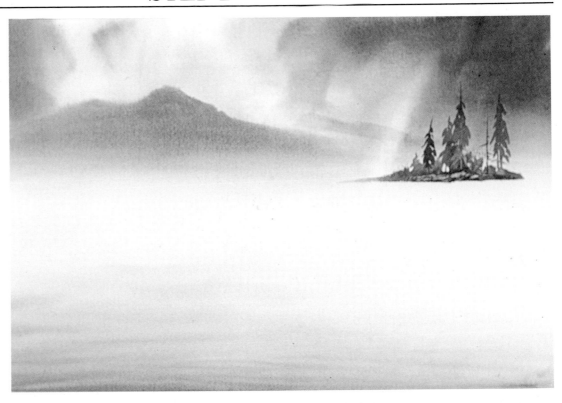

Detail. The single value of the island's silhouette dominates, except for a few modeled details, such as the knife-textured rocks.

Now I paint the land mass on the left-hand side. Since it's closer, the elements there are better defined (with sharper edges), warmer in color and darker in value than anything painted thus far. I leave room for its reflection in the water, which I plan to paint later.

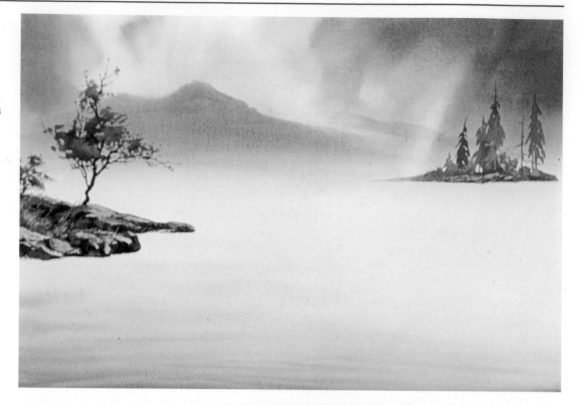

Detail. I painted the rocks with a single-value, heavy wash of raw sienna, burnt sienna, and French ultramarine blue, and modeled the highlights on them with my palette knife.

I now paint the closest land mass, with its big tree and fluffy grass. I texture the trunk and branches with a palette knife using raw sienna, brown madder, and French ultramarine blue. I drybrush in the grass with raw sienna, burnt sienna, and Antwerp blue and, while it's still damp, knife out individual blades.

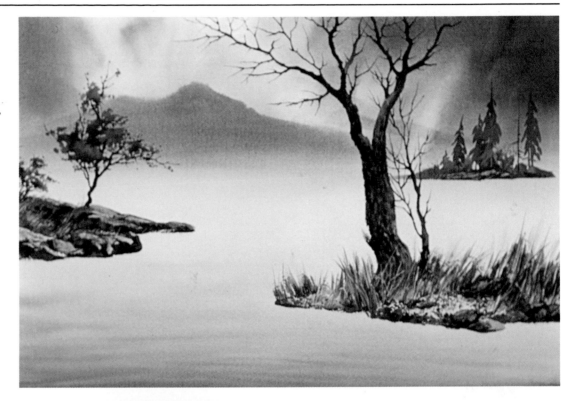

Detail. By texturing the foreground, I enhance the three-dimensionality of the painting. It helps make the foreground *look* close.

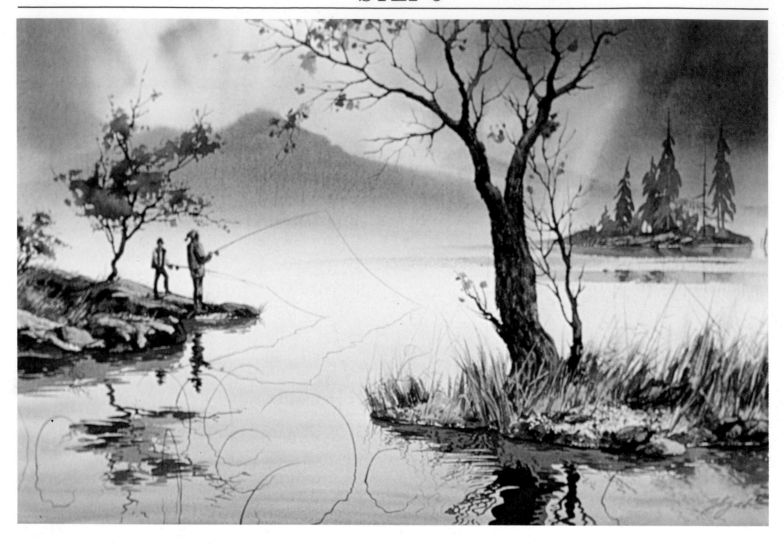

The Waiting Game. I wash in the lightest reflections of the distant island and the two land points first. The wash, a mixture of burnt sienna and Antwerp blue, represents the local color of the water. When it dries, I glaze the darker details on top of the lighter wash with the same color. I also add the thin, curling weeds and paint the two fishermen and their reflections.

Detail. The center of interest in this painting is the two fishermen. They are silhouetted against the light background water, but I paint enough detail on them to make them important and interesting in that position.

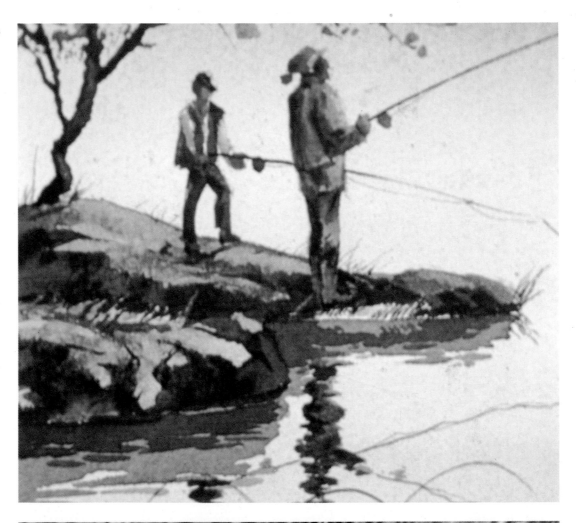

Detail. This detail shows how the light and dark reflections move gently on top of the rolling water. The reflected images are wiggled, not straight.

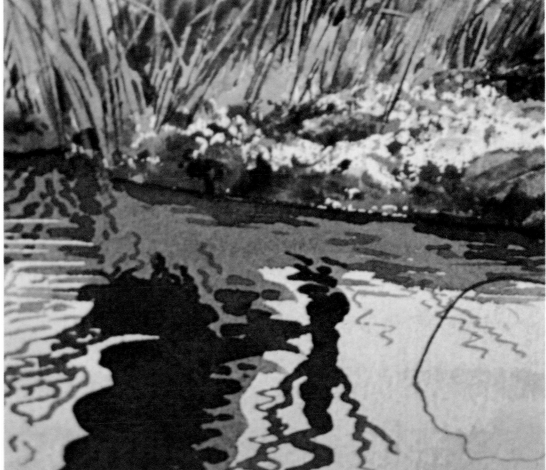

Dramatic Sky
CONTRASTING COLOR AND VALUES

This is a study of a very stormy, moody sky, painted mostly on wet paper. I use five colors: raw sienna, burnt sienna, brown madder, Winsor blue, and French ultramarine blue. Winsor blue is the key to the dark values in this painting because it's capable of going extremely dark, yet still remaining luminous, even in the sky, where it's mixed with brown madder.

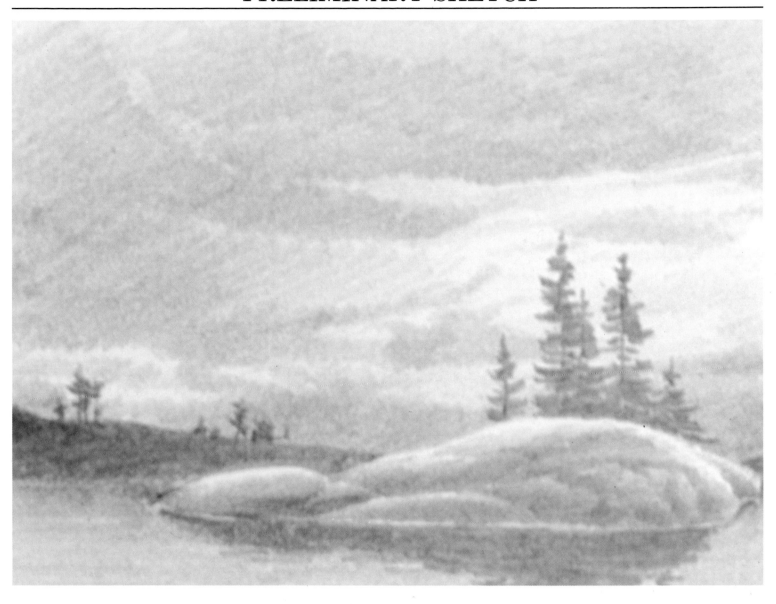

I start on wet paper with a thin wash of raw sienna and a touch of burnt sienna to give a luminous glow to the warm skybreak. This wash represents the stratosphere, the highest part of the sky.

STEP 2

The low-lying storm clouds are dark and forboding. I paint them first with French ultramarine blue and burnt sienna, then I blend brown madder and Winsor blue into the wet washes to give the dramatic darks additional strength and variety.

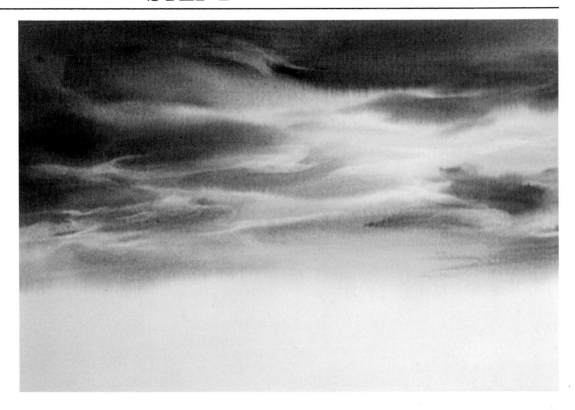

Detail. The blended colors are subtle, but varied. Their value is stronger than their hue. Note the play of warm and cool grays. As the paint was drying and about to lose its shine, I lift out some of the highlights in the windswept clouds by rolling a soft, thirsty brush into the wet paint.

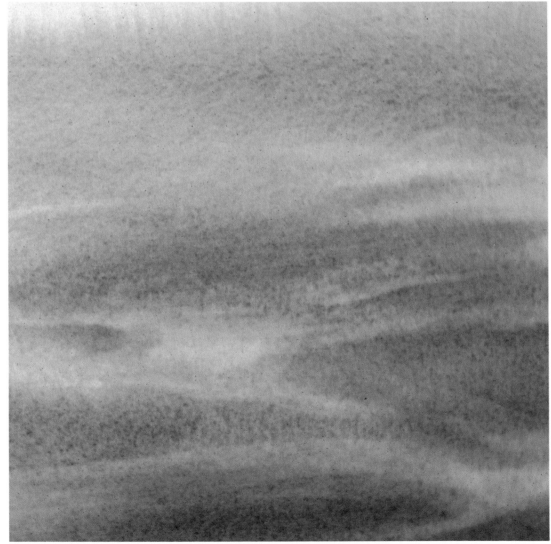

When the paper is dry, I mask out the shape of the rocks on the island to protect their edges while I paint the water and the strongly silhouetted land masses. I use Winsor blue and burnt sienna for the water.

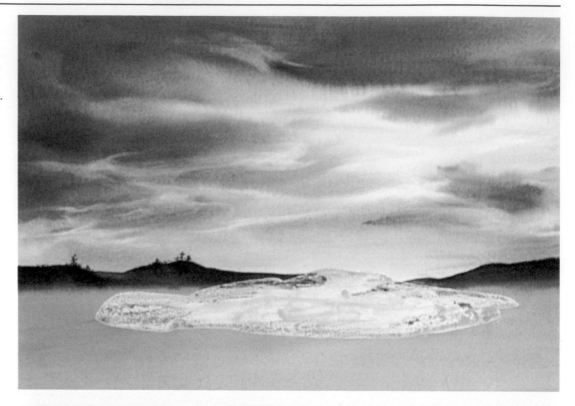

Detail. The contrast between the dark pattern of the solid-colored hilly area and the light, active, subtly detailed sky is strong. Note how the Miskit, which repels water, protects the paper from the staining washes that surround the masked-out shape.

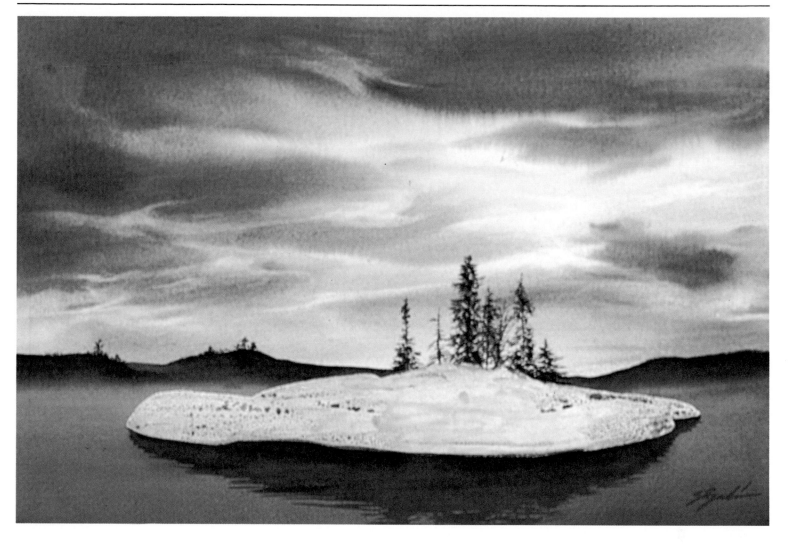

I darken the water further with another glaze of Winsor blue and burnt sienna. After it dries, while the Miskit is still on the paper, I add the dark reflection of the main island and trees.

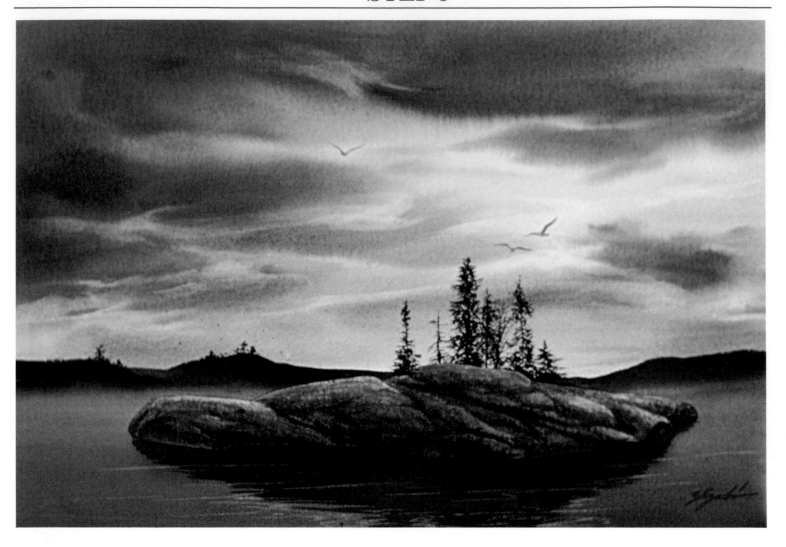

Summit Meeting. I remove the Miskit and paint the rocks with a rich, thick consistency of raw sienna, brown madder, and Winsor blue, and model the highlights on them with my palette knife. Finally, I add a few soaring birds as simply painted accents against the light sky in order to further dramatize the powerful sky.

Detail. The knife-modeled rocks look natural, solid, and contrasty next to the sky and lacy evergreens.

Detail. The textured rocks are warm in color, while their reflections and the water are cool. Accuracy in value is crucial.

Sand Dunes
GRANULATING WASHES AND CALLIGRAPHY

This last demonstration stresses the finishing stages of a painting and the thinking that goes into it. I plan to paint windswept sand dunes and, knowing the nature of my paints as I do, I decide to take advantage of the granulating nature of some of my pigments. As a matter of fact, the sedimentary qualities of raw sienna, when combined with sepia and French ultramarine blue (I also used a little Antwerp blue), are the key to this painting's success.

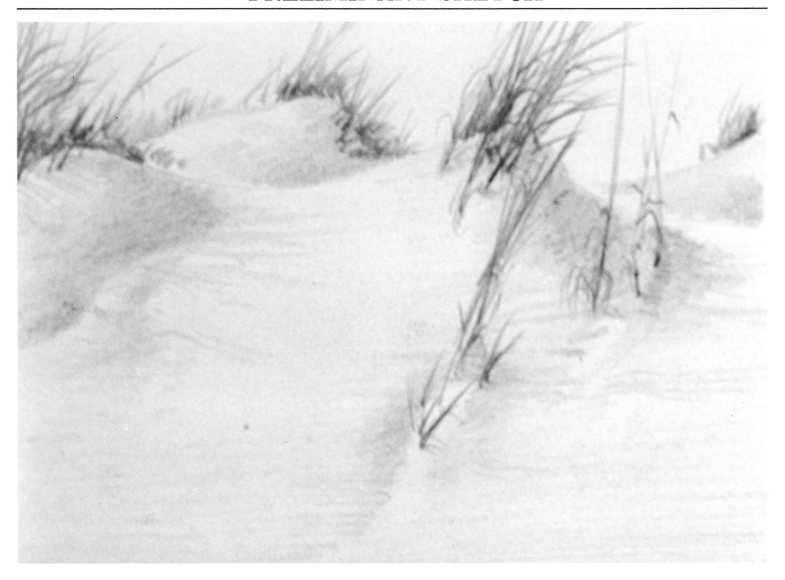

I wet the paper and paint the sky with light washes of raw sienna and Antwerp blue. While the paper is still wet, I establish the sand, using brown washes of raw sienna and sepia with burnt sienna, mixed with French ultramarine blue, its cool complement. The blue neutralizes the brownish color and exaggerates the granular effect, giving the washes the appearance of fine grains of sand. It's particularly successful near the center of interest, the dune at the center right. I record the main values and take the direction of the light (which comes from the upper left) into consideration. Where the light strikes the sand directly, I leave the paper white. I also note the effects of the wind, which ripples the sand in short horizontal stripes.

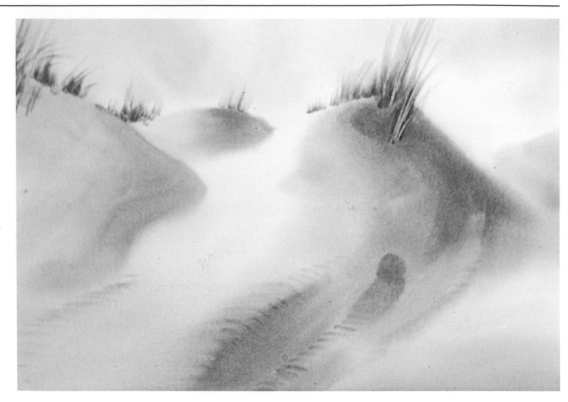

Detail. When the paper is dry, I paint the grass with washes of raw sienna, burnt sienna, and French ultramarine blue, knifing out some of the closest blades with my palette knife. The light-colored sky behind the dunes hints at a sky condition dominated by warm colors that relate well to the sand.

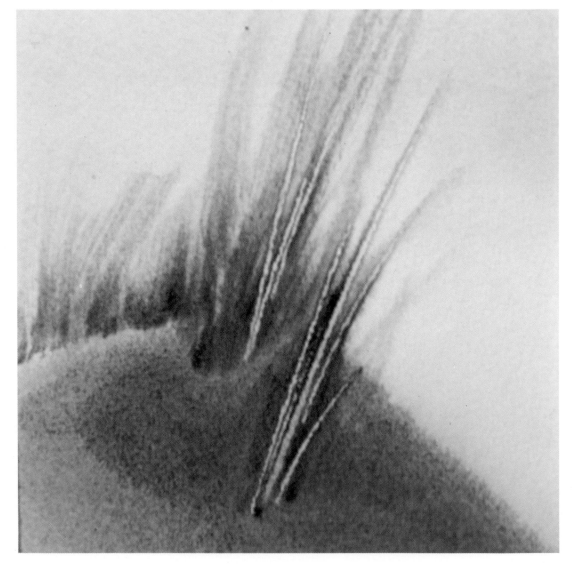

I wipe out the highlights on the ripples of sand and paint some soft, lost edges on the dark side of the ripples. I also contrast the curving path of the dunes with some long dark blades of grass. These vertical weeds help the predominantly horizontal composition, too.

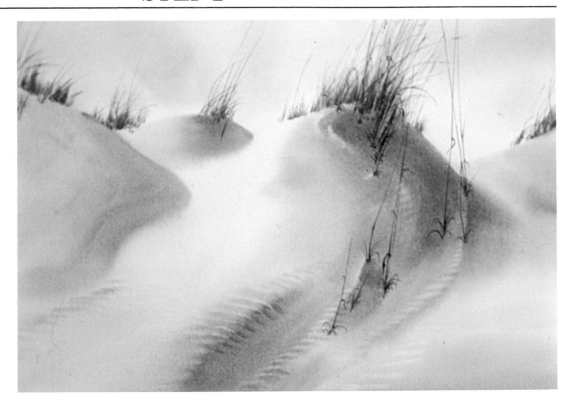

Detail. I further refine the weeds to offer more contrast. I add some darker blades, and indicate smaller shoots at their base, and I bend a few blades to the right to indicate the force and direction of the wind. There is now a greater range of values and texture in this area.

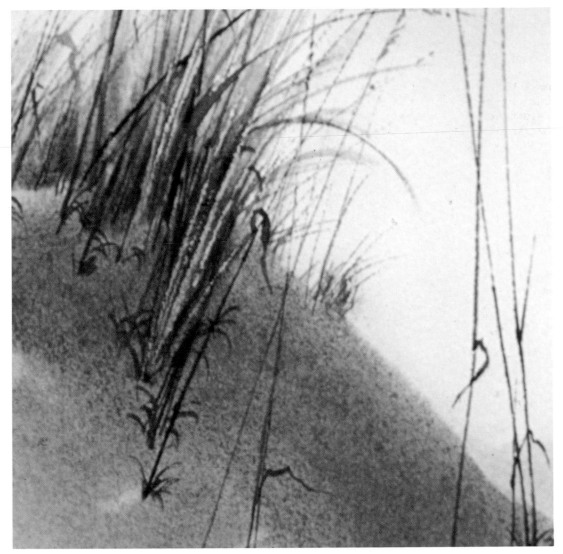

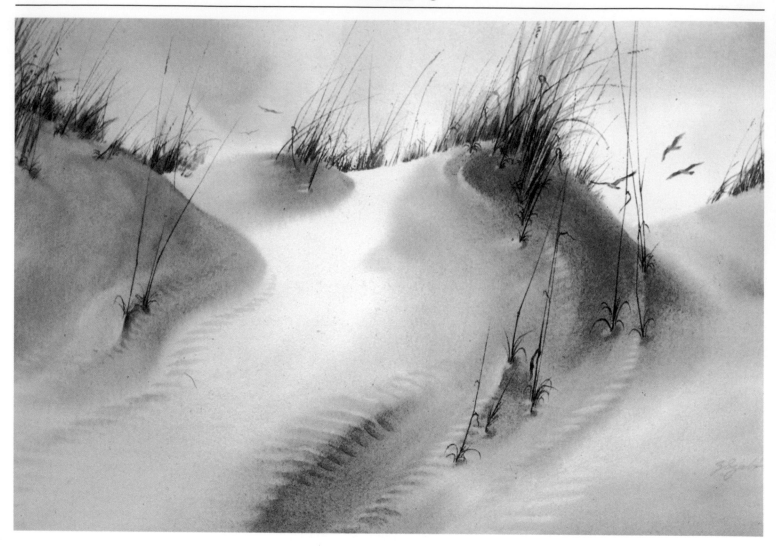

Touch and Go. I glaze a darker value over the sand on the upper left-hand side of the painting in order to reduce the volume of light in that area. I also place additional ripples in the sand, representing the wind's directional rhythm. I add more weeds to the tops of the dunes. To attract attention to the center of interest, I place three fairly good-sized seagulls there. They read as dark shapes against a light background. I also add two smaller, lighter gulls in the distance at the left to create a seaside mood.

Detail. The delicate weeds are painted in with calligraphic strokes. They contrast with the smooth sand and tie the sky and middleground together. I lift out subtle light areas at their base where the light hits tiny mounds of sand that have collected there. The contrast between light and dark areas and between soft washes and hard-edged calligraphy, plus the action of the gulls all draws attention to the center of interest.

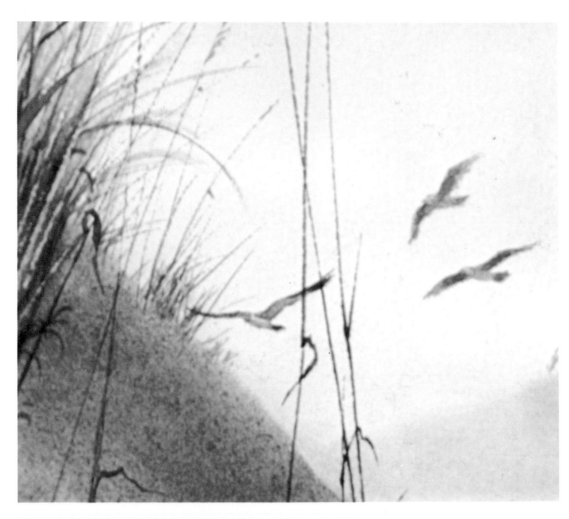

Detail. The same elements as in the detail above are here, but are less emphasized. This area thus complements rather than competes with the center of interest.

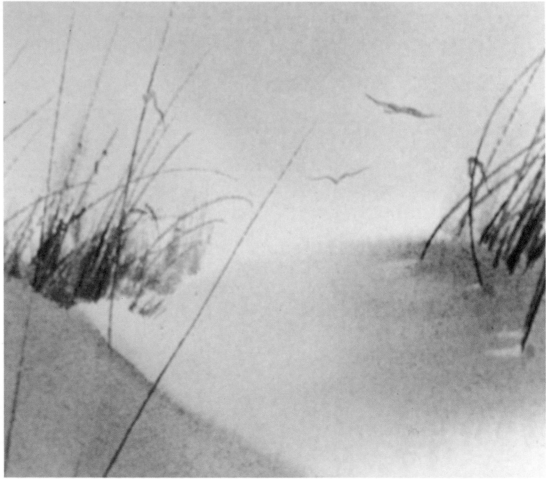

One-Man Show

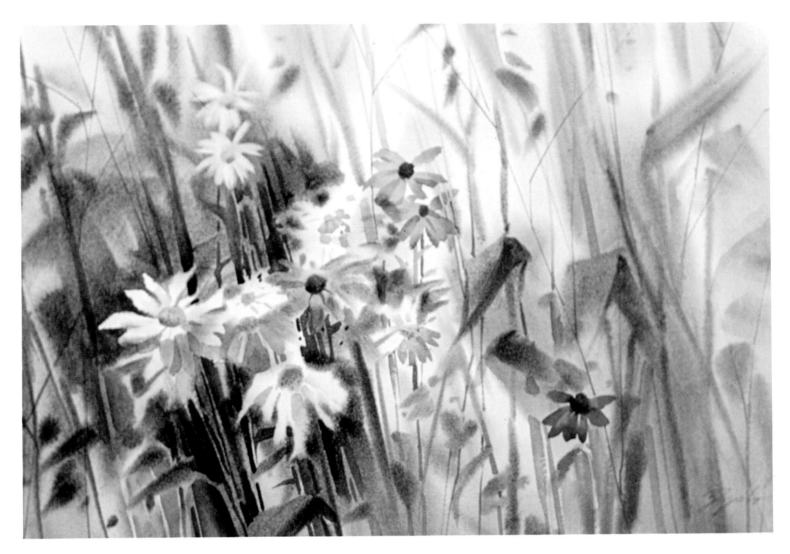

Palette
Burnt Sienna
Raw Sienna
Brown Madder
Sepia
French Ultramarine Blue
Antwerp Blue

Happy Integration. Working on wet paper, I painted the medium-dark soft weeds with a 1-inch (2.5 cm) bristle brush. I worked around the large flowers, keeping their white edges soft by lifting out corrective edges as the paint was drying. As the paper dried, the images I added gradually became sharper. I saved the colored flowers and calligraphic touches for the end. The interplay between positive and negative shapes and warm and cool colors creates excitement and tension in a subtle area. Into the wet softness I glazed on dark shapes, indicating light stems and the depth behind them. The contrast in value and texture favors interest in the white flower. Warm touches of color carefully placed in a large area unite the composition in color. But these touches of color, however subtle they may be, must be planned.

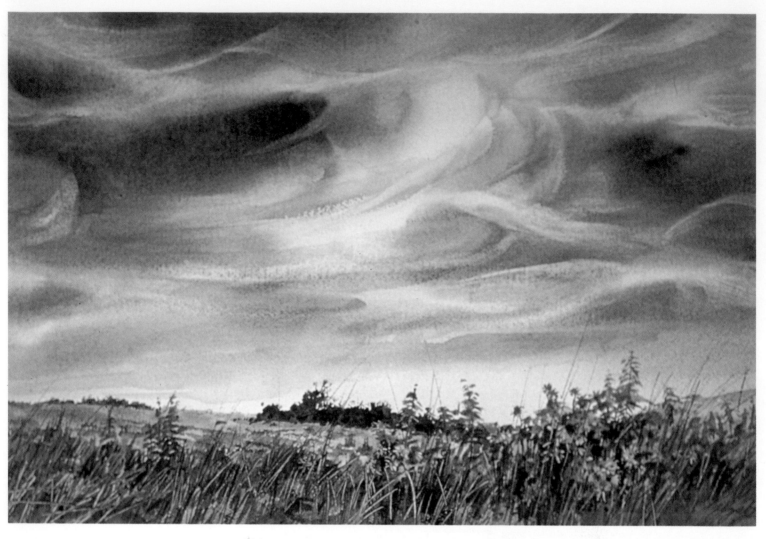

Palette
Raw Sienna
Burnt Sienna
Antwerp Blue
French Ultramarine Blue

Bouquet to the Sky. To create the effect of a big sky, all you need is a small, humble subject to scale it against. A field of autumn weeds worked very well in this case. I painted the sky in wet-in-wet, softly rolling shapes and lifted out the light clouds from the dark background with a rolling motion of a clean, large, soft, thirsty brush. I contrasted these soft edges with other sharp, glazed-on edges of large lost-and-found brushstrokes. Next I painted the shape of the ground surface with a medium-light value of raw sienna, burnt sienna, and a little French ultramarine blue. Into this, I painted the weeds and flowers with raw and burnt sienna. The flowers look yellower because of the dark, cool sky of French ultramarine blue and raw sienna next to them. But, in fact, raw sienna was my brightest yellow.

For the distant, dark clumps of shrubs and the foreground mass of dark weeds, I applied raw sienna and French ultramarine blue, and knifed out the light stems with my palette knife. Their edges are lacy, but not opaque. It's the value contrast between overlapping shapes that creates the feeling of depth. Finally, I accented the flowers with tall, thin blades of grass to encourage a vertical balance.

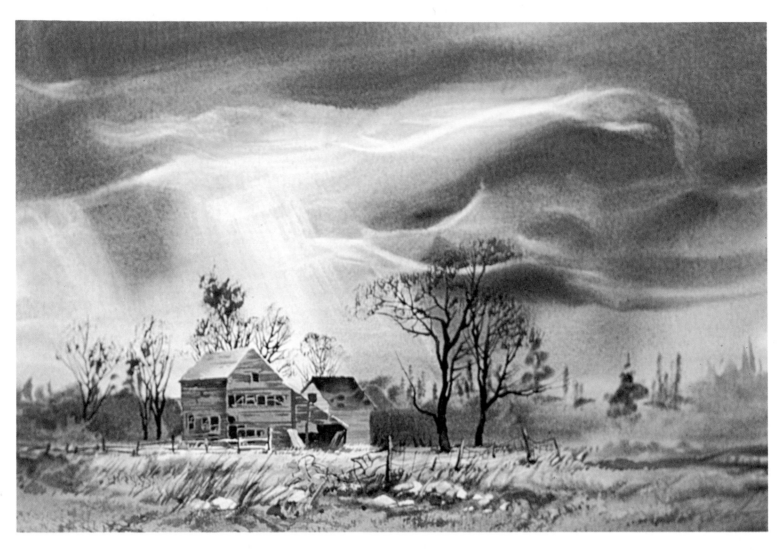

Palette
Raw Sienna
Burnt Sienna
Sepia
French Ultramarine Blue
Antwerp Blue

Heaven's Smile. An angry sky seems even more threatening when a lonely, defenseless corner of God's country is placed beneath it. The abandoned buildings, dying old trees, and broken-down fence speak of better days, and the boiling gray clouds tell their own story. On wet paper I painted the sky with French ultramarine blue and burnt sienna. To indicate the whirling nature of these fast-moving clouds, I rolled a thirsty, soft, wide brush into the dark wash of the sky just as it lost its shine. At the same time, I lifted out some rays of light. The straight, light lines of the rays offered relief and contrast to the swirling, dark clouds above. Next I added the shrubs and foreground with raw sienna, French ultramarine blue, and Antwerp blue. I then painted the soft weeds into this wash with a rich brushload of raw sienna and sepia and a little Antwerp blue, and knifed out the light, cream-colored shapes of the rocks from this wash with my palette knife. I glazed on the color and texture of the buildings and, after the paint dried, I knifed in the trees, and drybrushed on their outer twigs.

Contrast in value, color, texture, and softness guarantees the illusion of depth. In this painting, there's a light warm foreground, a dark middleground, and a lighter, cooler background. The shapes of the buildings stand out in sharp contrast to each other and the background. Their isolated, static, stable edges also contrast with the dynamic activity in the rest of the painting. A glazed-on touch of warm brown color breaks into the soft blades of grass with its sharp repeating edges and is sufficient to advance this foreground area toward the viewer in terms of color perspective.

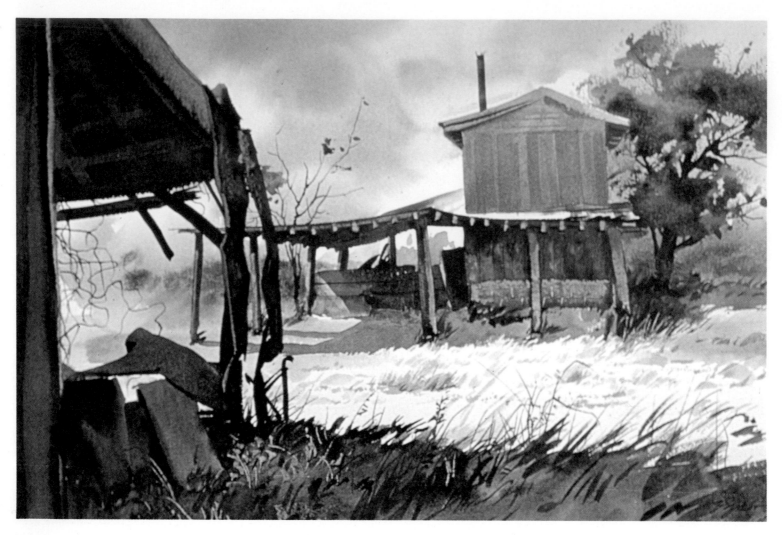

Palette
Raw Sienna
Brown Madder
Sepia
French Ultramarine Blue
Antwerp Blue

Hot Morning. These North Carolina tobacco barns reminded me of happy, tipsy vagabonds. I painted one while sheltered from the blinding sun by the shade of the other one. I painted the humid sky on wet paper, leaving room to add the old structure and tree later. I left the sunlit middleground pure white paper, adding only a few hints of grass to the area. The dark shadow and silhouette of the broken-down structure in the foreground was gently modeled with varying amounts of Antwerp blue and brown madder. I glazed on the shaded part of the building with burnt sienna, brown madder, and Antwerp blue, then knifed out the lighter pillars, cement blocks, and beam ends. I left the brightly lit roof white, as I had the ground area. I applied a second glaze to the upper part of the building, then darkened the wash with sepia and painted the shaded area under the shed. Then I knifed out a few weeds for texture. Sunlit and shaded forms within the same plane are separated by contrasts in color and value.

I painted the tree foliage with a wet soft brush, held loosely so the outer edges of the foliage stayed lacy. Then I painted the branches, weaving them through the foliage shapes to unite them into one tree. I judged all values carefully, using enough water, even in the darkest areas, to keep them from becoming opaque. Where shapes overlapped in different planes, I avoided tension spots by making sure that edges didn't line up with other edges and corners didn't point to or touch other corners. I also changed the values enough to give the painting a three-dimensional feeling.

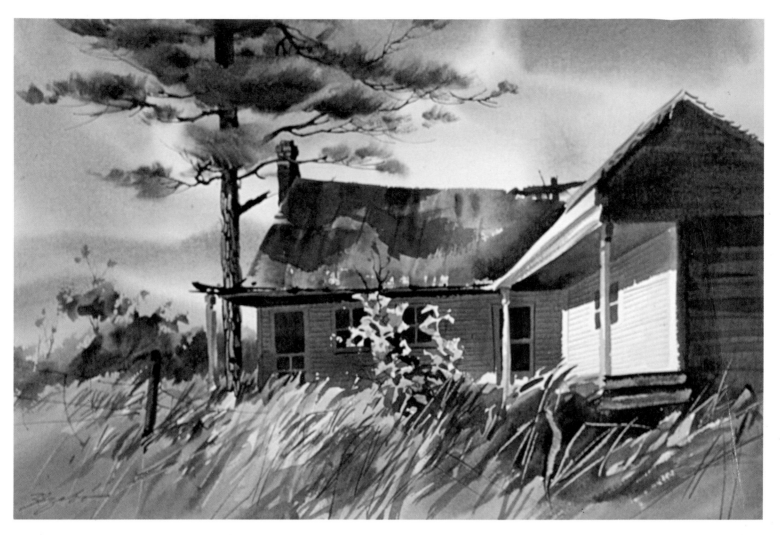

Palette
Raw Sienna
Burnt Sienna
Brown Madder
Antwerp Blue
French Ultramarine Blue

Carolina's House. This was the start of a hot summer day in North Carolina. Before air conditioning, shade offered the only relief to the discomfort of the summer heat. The shade now presented me with lovely shapes contrasting in value and definition. Painting outdoors in the bright sunlight, I wet the paper and painted in the sky, distant hills, and clumps of pine needles. I had to work fast in the scorching heat to paint around the edges that defined negative shapes, yet keep the dark shadow color even, without dry edges in the wrong places. In this case, the foliage represents large shapes that carry the weight of the design. I painted it first on wet paper, and when it dried, inserted the supporting trunk and branches softly in and out of the loose washes. I also textured the sunlit side of the rough bark with my knife.

Then I glazed on the house. I painted the shaded walls with a wash of Antwerp blue and brown madder, carefully avoiding the sunlit tips of the weeds, pillars, and leaves on the young tree, which I left white. I also used the knife to paint the darkest shapes on the house. Then I glazed the shadow on the roof. Under fast-drying conditions like this, glazing is an ideal technique. I freely designed the sharp edges of the weeds, but carefully watched their developing shape. The foreground brushstrokes consisted of various combinations of mixed greens, softly blended. I applied them fast enough so that the previous stroke was still wet when the next one touched it. I then squeezed out the light-colored weed shapes from the wet washes with a palette knife.

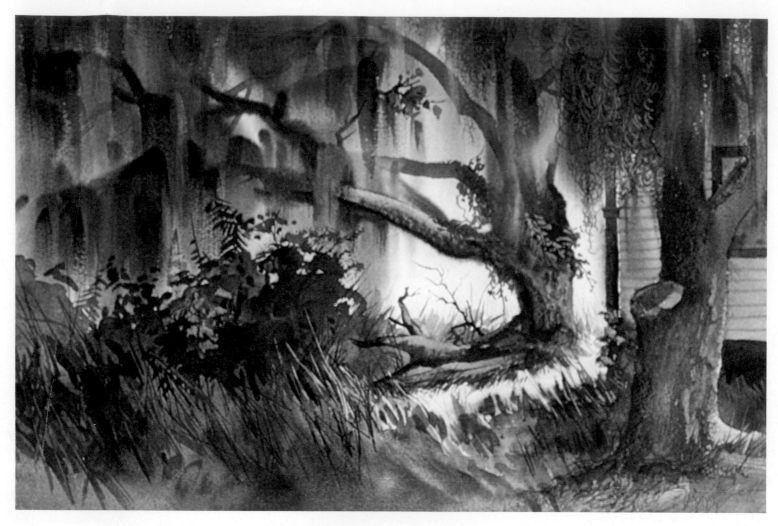

Palette
New Gamboge
Burnt Sienna
Brown Madder
Sepia
Winsor Blue

Palette
Raw Sienna
Burnt Sienna
Brown Madder
Sepia
French Ultramarine Blue
Antwerp Blue

Hot, Hot Morning. This was my first real confrontation with masses of Spanish moss in the deep South, and I was intrigued by the spooky quality of its soft growth. By using soft and hard edges, and medium and dark values in two different planes in this painting, I give depth to these even, patternlike shapes. I painted the masses of moss and the branches on wet paper with downward brushstrokes of rich color: brown madder, Winsor blue, and sepia. Then I textured the foreground moss with the tip of my nail clipper, and carried the same curly pattern into the lighter background with the dark, thin, curved lines of a thin rigger brush.

The coarse bark of the sunlit oak was painted with raw sienna, burnt sienna, and sepia. Where I textured it with my palette knife, the burnt sienna predominated. The dark value of the distant tree contrasts with the humid yellow background and grass. I painted the few green blades of grass in this area with Winsor blue and new gamboge. Here, light and dark knifestrokes really paid off. Then, with Winsor blue and brown madder, I glazed the shadow on the house and painted in the medium-dark shapes in the foreground grass. I later applied an additional dark glaze of Antwerp blue, brown madder, and sepia to the area and knifed out the thin tall weeds. They lead the eye into the bright sunlight. Then I glazed a light wash of new gamboge over the sunlit area, blending it up into the moss.

Raggedy Friends (Right). I painted this on location in northern Ontario. Although the white paper predominates, the painting looks warmer than it really is because of the contrasting influence of the glowing warm trees and cool shadows.

I started by painting the reddish birches on dry paper. My brushstrokes blended softly as they touched because they were wet. Wherever the snow was piled on the trunk, I left a white space. After the paper dried, I drybrushed more texture on the bark with sepia. Then I painted the shadows on the snow with French ultramarine blue, burnt sienna, and Antwerp blue. I knifed in the young trees in the foreground, then painted the flat, elongated tree shadows on the right-hand side quickly so the brushmarks wouldn't show where they overlapped, at the junction of the shadow branches. Finally, I painted the heavy shadows and the distant islet in the snow-covered lake with Antwerp blue, brown madder, and sepia, leaving the sunlit edges of the foreground birches pure white. I painted the delicate needles on the young spruce trees with a split, dry brush and Antwerp blue and burnt sienna.

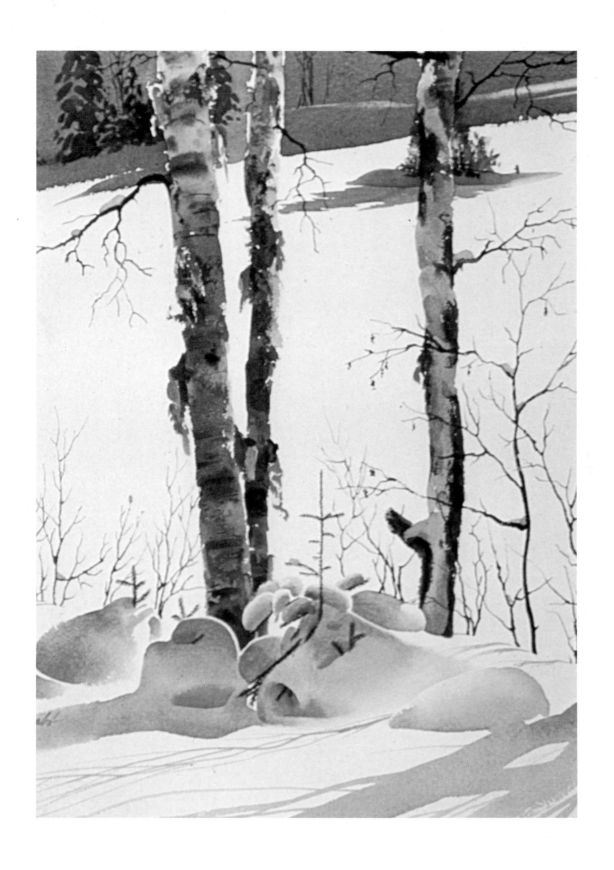

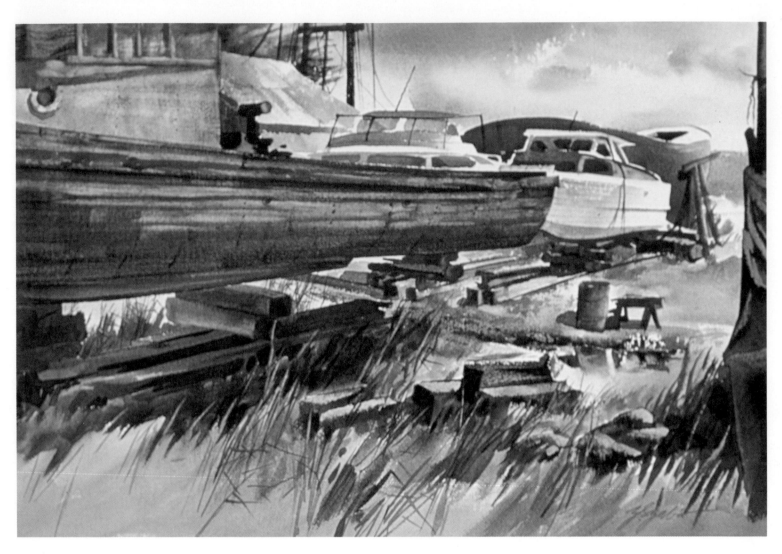

Palette
Raw Sienna
Burnt Sienna
Brown Madder
Sepia
Antwerp Blue
French Ultramarine Blue

Boat Clinic. This old boatyard supplied me with interesting shapes, particularly because the sun was out. Bright sunlight creates great contrasts in value. Also, the difference in surfaces between the new and old boats offered exciting textures to work with. I painted the scene in sections, which allowed one area to dry while I worked in another. I worked the background around the sunlit roof and white boats. I painted the new white boat by glazing on a light shadow color, then textured the large old hull with sepia drybrush on white paper before glazing the shadow color of the aging wood over it. When it dried, I wet-lifted off the textured sunlight portion. The sepia under the shadow color of Antwerp blue and brown madder survived the scrubbing. Where the rust stained the wood, I allowed brown madder to dominate the wash. This concentrated color also survived the scrubbing.

I painted the weeds and clutter on the ground loosely, knifing out some blades of grass and glazing on a few dark accents where necessary. I placed a dark vertical shape at the left-hand side (the foreground boat in shadow) to keep the many receding horizontals from forcing the eye out of the composition. Fast-painted, angled weeds break up the static stability of the square lines of the logs. I brush-lifted and knifed out some light logs and glazed on others as dark background shapes among the light, slender weeds. Subtle details, such as the reflections of the barrel and saw horse in a little puddle, add interest.

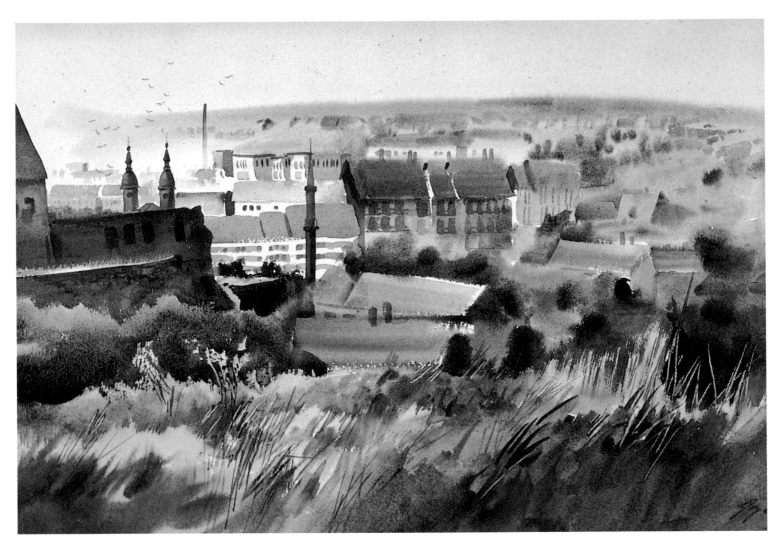

Palette
Raw Sienna
Burnt Sienna
Brown Madder
French Ultramarine Blue
Antwerp Blue

History's Mark. The old Hungarian city of Eger displays centuries of different cultures. The morning mist, weaving around various buildings, exposed the silhouetted shapes of the ancient fort wall, the steeples of a Catholic church, and an ancient Turkish minaret. Where the minaret, which is a strong shape, joins the other buildings, sharp contrast and active, angled shapes dominate. But I painted the rows of buildings on wet paper, which made their edges soft and blurred, in order to reduce their impact in an unimportant, secondary location. A strong contrast in value demands attention and strongly suggests differences in perspective.

For example, the neglected weeds, strongly lit in the middleground, contrast with the dark wall behind them, which helps give an illusion of depth. The warm sunlight on the tiled roofs was carried into the distance without much definition.

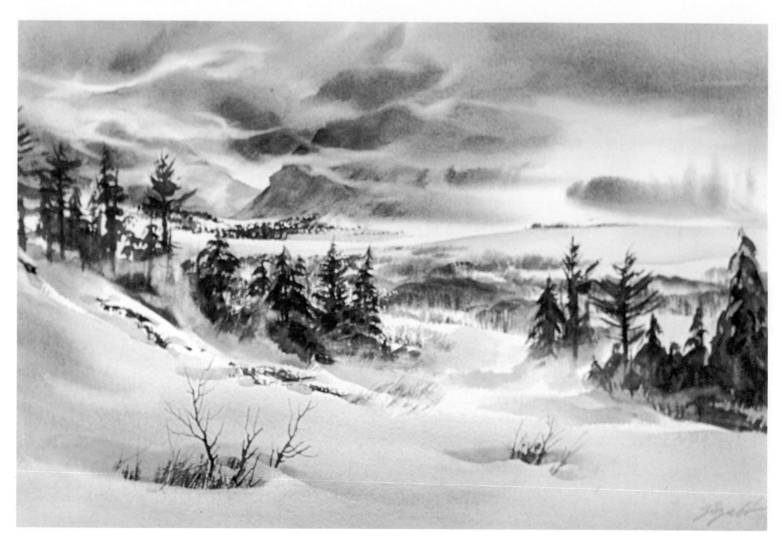

Palette
Burnt Sienna
French Ultramarine Blue
Raw Sienna
Antwerp Blue

Winter Songs. Winter bares its teeth in the threatening mood shown here. Windblown snow and clouds compete for the greatest movement. French ultramarine blue and burnt sienna in varied combinations give a gray mood. The soft shapes are the result of wet-in-wet painting, while lost-and-found edges give form and definition to the mounds of snow above the partially exposed rocks. In the middleground, I lifted out the shapes of the blowing snow from the already dry, dark tones with a wet bristle brush. The foreground weeds and shrubs were made with linear strokes of drybrush and touches of a palette knife in a dark tone. Their warm color and textured shapes make them feel near in perspective. In contrast, the cooler colors and less textured shapes of the distant mountains make them recede. To give the illusion of three dimensions, values and scale must be consistent within each plane of distance.

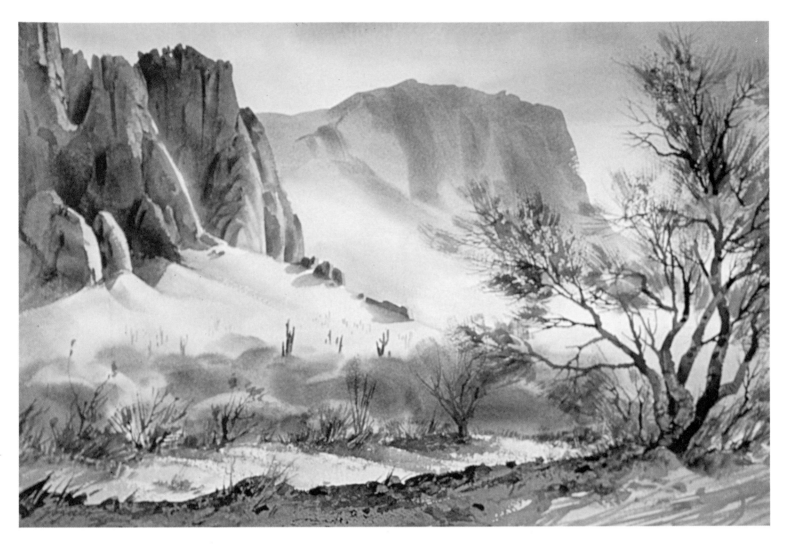

Palette
Raw Sienna
Burnt Sienna
Sepia
Antwerp Blue
Cerulean Blue

Magnificent Superstition. The Superstition Mountains in Arizona have a fascinating quality: they hardly ever repeat the same mood. Here, in the morning light, some mist has softened the rear mountain. The magnificent mountains are awe-inspiring, but their size is deceptive; they appear smaller than they really are. The saguaro cacti creeping up the slopes of the nearest mountain gives a clue to their relative size and scale. I painted the sky on wet paper with cerulean blue, Antwerp blue, and light raw sienna. I followed this with the distant mountains, working on dry paper with fast brushstrokes blending with each other, gradually losing the bottom edge for a feeling of mist. I painted the nearer mountain with separately applied glazes of burnt sienna, sepia, and cerulean blue, then painted the soft shrubs in the middleground on wet paper with cerulean blue and burnt sienna.

The tall saguaros climbing the lower slopes rise above the mass of shrubs. To give the effect of more cacti getting smaller in the distance, I placed a diagonal drybrush accent in the middle of the light slope. Note the brown glow around the soft brushstrokes; it's caused by the burnt sienna and cerulean blue separating on the wet paper. I drybrushed the palo verde trees, rocks, and shrubs in the foreground with raw sienna, Antwerp blue, and sepia, and textured the larger trunks and rocks with my knife. Burnt sienna gave the rocks a warm glow, and the granulating nature of sepia and cerulean blue textured the rocks and made them look coarse and lumpy. The branch structure and green color of the palo verde tree make it a delicate contrast to the massive mountains. I knifed out some textured highlights on the bark and spotted in a few dark contrasting accents on an occasional branch and rock. I glazed on the shadows with Antwerp blue and sepia at the end.

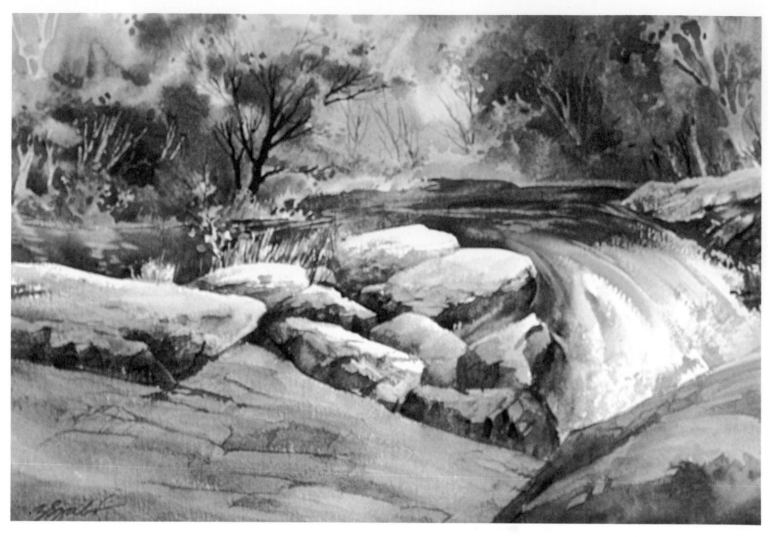

Palette
New Gamboge
Raw Sienna
Brown Madder
Sepia
Cerulean Blue
Sap Green
Antwerp Blue

Down the Hatch. With the coming of autumn, nature has dressed up in bright colors and the creeks have turned into churning waterfalls. Clean, sparkling colors dominate. I kept the bright colors in the distance and the neutrals up close. I painted the scene in sections, one at a time. First I roughly painted the boulders and textured them with my palette knife. When they were dry, I applied a blue-gray glaze of brown madder and Antwerp blue over them. The gushing water was painted with a wash of raw sienna, brown madder, and sap green, using fast brushstrokes applied upward, against the current. The lacy droplets of water were dry-brushed on at the same time with the curved belly of my side-held brush.

Warm colors blending on wet paper unite the tree areas. I clarified some details by glazing on lost-and-found shapes. First I painted the foliage of the trees. Later, after the paint dried, I put in the dark tree trunk and interwove the branches into the soft foliage with my palette knife. I lifted out the reflections of the trees in the water. The brownish color came off and the sap green stain showed through in a bright, light value. The distant misty area contrasts in color and value with the foreground, forcing your eyes to travel into the distance.

Palette
New Gamboge
Raw Sienna
Burnt Sienna
Brown Madder
Antwerp Blue
French Ultramarine Blue

Breathing Gorge (Right). Mountain streams are sometimes forced to squeeze through narrow cracks between rocks. There they turn into vaporized falls, forcefully eroding the rocks and dragging debris with them. I painted this on location in Glacier National Park, Montana. I started the top third on wet paper and established the sunlit forest in the mist. I painted the rocky mounds next and textured them while wet with a palette knife. I left the sunlit spot on the center rock bright and well textured. I knifed out a few weeds and painted on the silhouetted (backlit) trees after the paper dried. Finally I glazed on the swirling water, indicating the changes in the direction of flow with quick drybrush strokes that moved upward from the darker waterholes toward the lighter peaks. Then I lifted out a few highlights.

Contrasts in texture and value not only explains the difference between materials but create depth as well. Diminishing values and fewer details give birth to mysterious shapes interlocked into a unit receding deep into space. The tormented tree skeletons appear to advance in contrast to the colorful background that has little definition. Because of the isolated nature of the tree, I added just a few light spots on the trunk with my palette knife. I treated the partially exposed trunk caught in the tumbling water similarly. I also painted the branches with my knife.

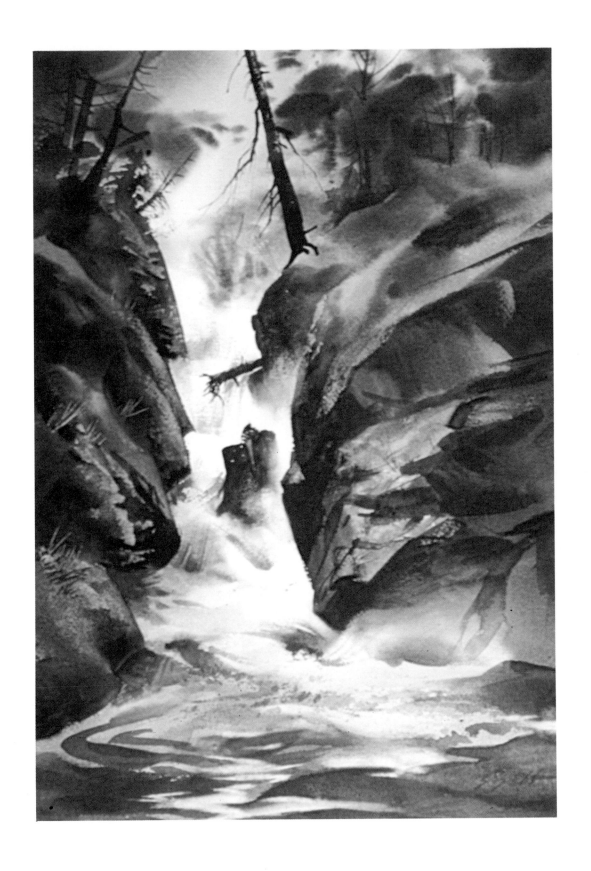

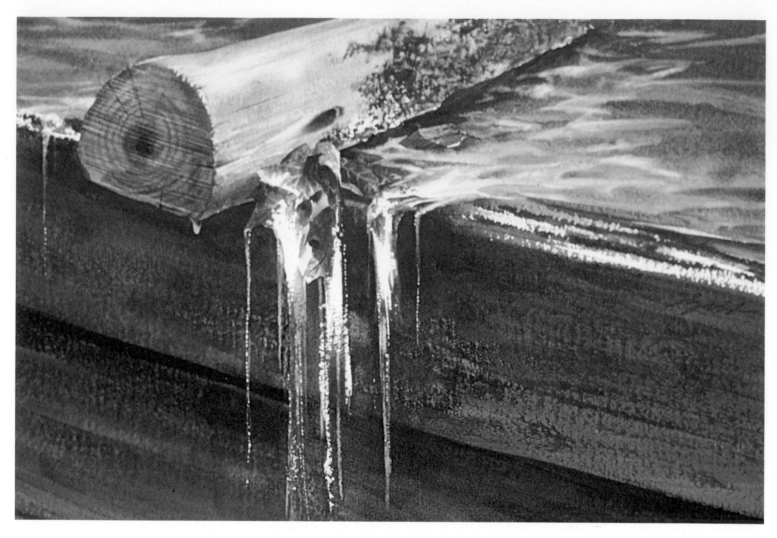

Palette
Raw Sienna
Burnt Sienna
Brown Madder
French Ultramarine Blue
Antwerp Blue

Unintended Bath. My intention in this painting was to capture a moment in time. I painted the center of interest, the clump of leaves jammed against the wood, first. The force of the overflowing water was ready to toss them over and thus destroy my subject, the beautiful shapes of the dripping white water. I quickly snapped a black and white Polaroid photograph before the scene was washed away. I paid more attention to the design and detail of the leaves than to the other, complementary elements. My rapid brushstrokes struck the right note for the painting. The resulting freshness survived to the end. I painted the other areas last: the shaded trough, mossy wood, and shimmering water next to the leaves.

I began the texture of the wood with a smooth wash of brown madder and Antwerp blue. I painted the shaded cut end with the same color, but scratched dark saw marks into the wet wash. When it dried, I wet-lifted highlights from the grooves in the wood and blot-lifted out the single droplet of water next to the dripping leaves. Finally, I tapped drybrush touches of raw sienna, French ultramarine blue, and Antwerp blue onto the damp surface of the wood to represent moss. The water was painted around the leaves with burnt sienna, French ultramarine blue, and raw sienna, with the latter dominant. I wiped out the highlit ripples with a damp brush and glazed on the water's color over the submerged part of the leaf. I wet the paper and lifted out the translucent shapes of the dribbles from the dark drybrushed wood. Finally, I scraped out thin beaded lines of dripping water with the corner of a sharp razor blade.

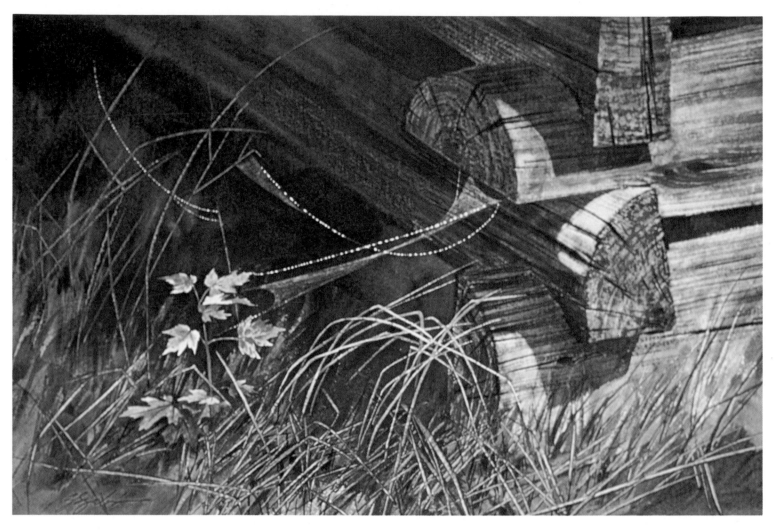

Palette
Sepia
Raw Sienna
Burnt Sienna
Brown Madder
Antwerp Blue
French Ultramarine Blue

Ties of Friendship. I discovered this little 'live still' in Gatlinburg, Tennessee. Here was a little touch of young Canada in the tiny maples leaves tied to an old America log cabin by spider webs, and it struck home instantly. First I drybrushed on the texture of the logs on the dry white paper with a dark value of sepia. Then I masked out the baby maple and some accompanying weeds in the sunlight with a carefully painted coat of Miskit while I finished the dark area behind it with free, vigorous brushstrokes and dark paint. I glazed on the shadow value of the log, with French ultramarine blue, burnt sienna, and raw sienna. When it dried I added the lush weeds in contrasting values of raw sienna, burnt sienna, Antwerp blue, and French ultramarine blue, and worked the handle of my nail clipper into the wet washes to get light, crisp lines. When the paper was dry, I lifted and blotted out the sunlight on the logs. The drybrushed sepia survived my glazing and scrubbing out in the sunny area and shows off the lovely aging texture of the wood. I touched up only a few dark cracks with sepia later. I also lifted and blotted out the soft transparent shape of the cobweb.

Note how I varied my technique according to whether the cobweb was in sunlight or shade. I painted the shaded areas with carefully controlled, soft, wet-in-wet washes and masked out the shapes in the sunlight so I could get sharp, hard edges. I then removed the Miskit and finished painting the young maple with washes of raw sienna, brown madder, and Antwerp blue. Last, I scraped out the highlight on the cobweb with the tip of my razor blade. Note the different textures achieved through recovered luminosity and masking out. Lightening an area by blotting and lifting out color produces softer edges and more subtle coloration, while sharp edges and clear hues are obtained by first masking out an area, and painting the background, then removing the Miskit and glazing on a clear transparent wash.

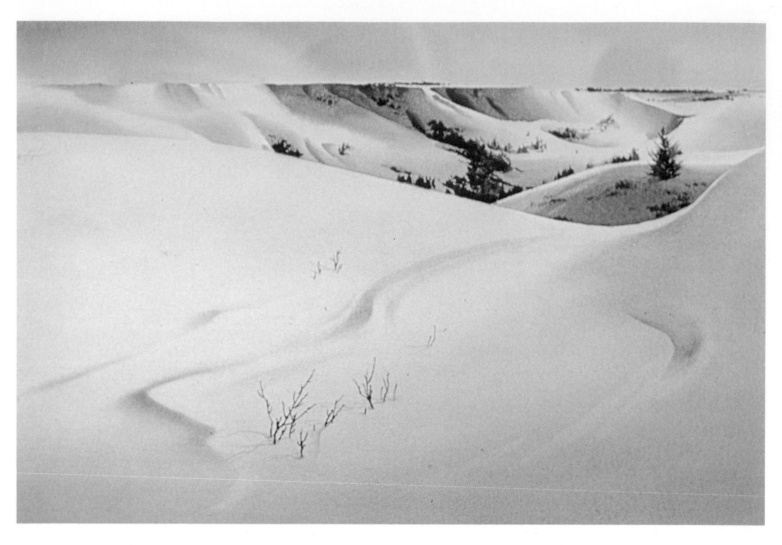

Palette
Burnt Sienna
Raw Sienna
Sepia
French Ultramarine Blue
Antwerp Blue

Hushed Majesty. Rolling hills of snow like these create abstract shapes and reflect the most unusual colors. This Montana scene was like a porcelain masterpiece sculptured by God. The country was massive, and I had to pay careful attention to scale. I wet the sky area and painted it only to the horizon with Antwerp blue, French ultramarine blue, and raw sienna. I gave the huge white hill in the left foreground a soft glow with a raw sienna wash. Then I painted the large snowdrifts on the distant hill. Both the large hill and snowdrift were painted wet-in-wet with lost-and-found edges. I lifted out the highlit edges with a wet brush. There are clearly defined differences in color temperature between the lower sky and the snow in the valley. The soft shadows in the valley reflect the deeper blue sky directly above.

I painted the evergreens and the tips of the foreground shrubs on dry paper using Antwerp blue and raw sienna in the sunlight, and Antwerp blue and sepia in the shaded parts. The scale of the descending trees was correct in perspective. Except for the static horizon, every line here is dynamic. The delicate details in the foreground are designed to lead the eye toward the center of interest in the middleground, and the curving shapes lock into each other as they move into the distance. The changing values on the horizon line prevent it from leading the eye out of the picture.

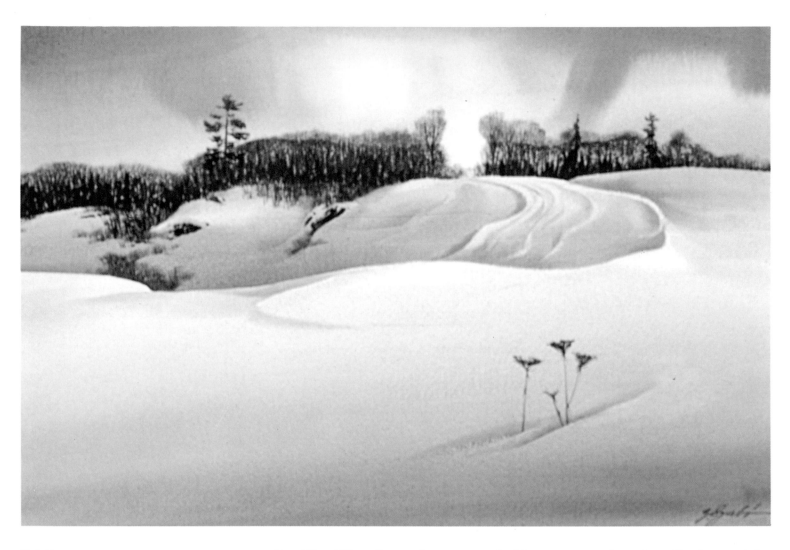

Palette
Alizarin Crimson
Raw Sienna
Burnt Sienna
Sepia
French Ultramarine Blue
Antwerp Blue

East View, Winter Sunset. As you can see in this snowy scene, the eastern side of a sunset sky is often as spectacular as the west. Here the tips of the shadowed trees are lit by the setting sun, while the snow and sky are bathed in a glowing warm light and pale cool shadows. I painted the sky and foreground shadows on wet paper. I started the warm glowing light with a pink (alizarin crimson) underwash onto the wet paper. After I glazed on the blue shadows and lifted out the highlights on the heavy snowdrifts, the pink came through. The sunlit peaks of the trees show the sharp shadow line cast by the edge of the hill behind me.

The sharply defined hollow at the upper right was obtained by painting a large wash on dry paper, then modeling and softening the top edge. The shrubs and distant forest were dry-brushed on in a dark shadow value of sepia. They complement the colorful sky and snow and provide a contrast in texture. The lost-and-found shadows on the little drifts under the weeds are deepened by their contrast with the light areas, which I gently lifted out with a damp brush. I placed the snow-embedded cluster of Queen Anne's lace in the foreground for scale.

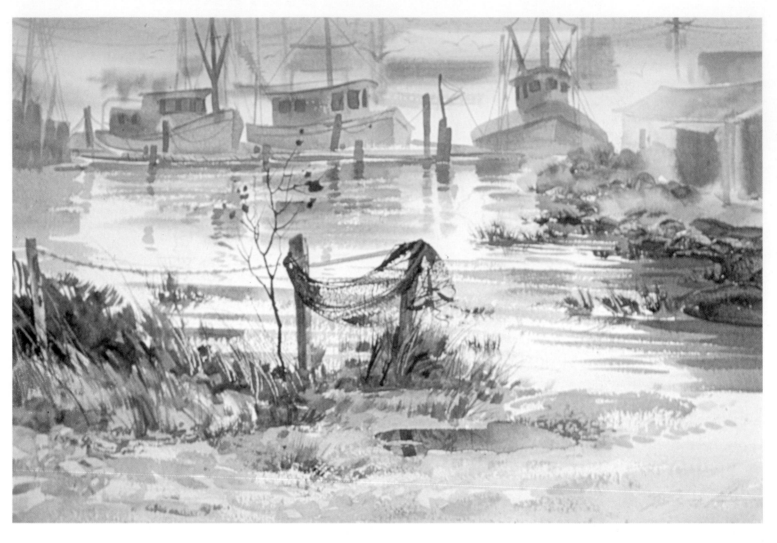

Palette
Raw Sienna
Burnt Sienna
Sepia
French Ultramarine Blue

A Day Off Work. This quiet shrimp harbor was enveloped in mist. I painted this scene on location, working wet-in-wet. That is, I soaked the paper thoroughly and worked from background to foreground items; as the paper slowly dried, my edges gradually changed from soft and blurred to hard hard and sharp. Finally, when the paper was completely dry, I drybrushed on the closest, most crisply detailed elements. The crispest drybrush strokes are on the old net and are surrounded by slightly less defined drybrush strokes. I used a soft wide brush that was well loaded with French ultramarine blue and sepia, starting slowly and speeding up for a drybrushed effect. The slow-painted area is more solid in color, while the more quickly painted area has an open, spotty, netlike texture. I also knifed out a few lights and painted in the strings of the net with a rigger brush.

The soft, light value and smooth surface of the water makes it appear farther away than the darker, more textured foreground in spite of the neutral color of both areas. I made the foreground a little warmer, however. I glazed the boats on top of the softly blurred images in the background in washes of almost the same value. But because their edges were slightly harder, they appear to advance slightly. The warm touches of color in the middleground boat indicate rust. The color was grayed slightly, however, so it stays in perspective and doesn't appear to advance.

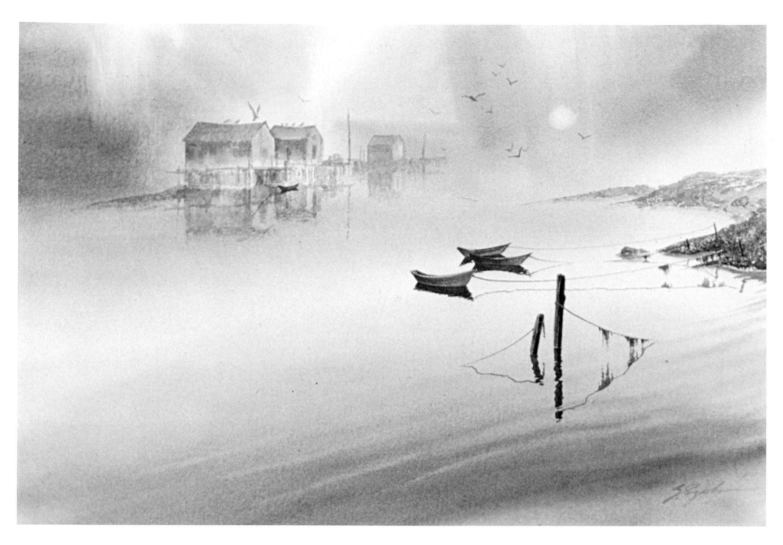

Palette
Raw Sienna
Burnt Sienna
Sepia
French Ultramarine Blue

Distant Watch. Quiet and tranquility set the mood for this painting. I established the soft values on wet paper. The warm color in the sky is raw sienna alone, the grays are burnt sienna and French ultramarine blue. My emphasis is on the distant single dory and the three closer ones, which are related in value. The little group of contrasting images show the surface of the water by their wiggly reflections. The shore rocks decrease in color, value, and texture as they move into the distance. The buildings were painted on dry paper; their details were carefully simplified. The huge gull landing on a roof adds a touch of dynamic movement to the area. The warm color in the distance indicates that this fog is merely a local condition; the sun is slowly burning off the fog. I lifted out the sun behind the mist by gently moving a wet brush around and around until the pigment was loose. Then I quickly blotted it up with a paper tissue.

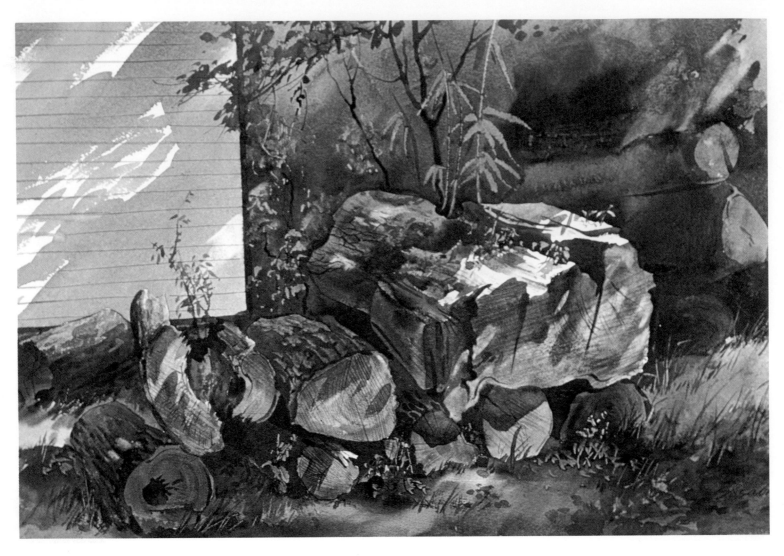

Palette
Burnt Sienna
Raw Sienna
Sepia
Sap Green
French Ultramarine Blue
Antwerp Blue

Surprise in Light. This is essentially a painting of interesting natural shapes, sunlit in spots, near the corner of a white wall. The mood is happy and quiet. First I carefully painted the logs, one at a time, in rich detail, and textured them while the paint was still wet. Since the logs were the focal point of the painting, they contain the richest definition of texture, color, and design, and the greatest contrast. I played with cool and warm, and light and dark shapes. But by carefully recording their values and textures, these flat shapes became three-dimensional forms. Recovered light shapes and glazed darks offered different textures.

I scraped in the saw marks first, while the shadow color was still wet, then lifted out the patches of sunlight. The saw marks survived the scrubbing and continue uninterrupted through both light and dark areas. Then I wet and painted the background. I painted the shadows on the wall to minimize the impact of the shape of the house by toning down the large mass of white. Then I knifed out the foreground weeds from the darker sap green-dominated washes. I glazed on the large cast shadow on the lower log, leaving the edges sharp. Finally, I glazed on a few details of dark grass and scratched in the edges of the white boards while the shadow wash of brown madder and Antwerp blue was still quite wet.

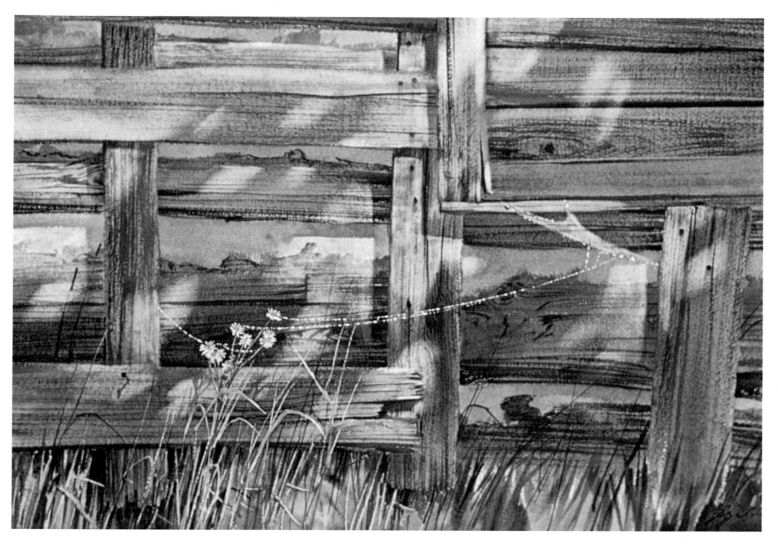

Palette
Burnt Sienna
Sepia
Raw Sienna
Antwerp Blue
French Ultramarine Blue

Play of Light. The focus of this nostalgic painting is the shaded section of a dignified, old building. I defined the shapes through recovered luminosity—that is, lifted-out color—and rich texture. I masked out the flowers first in order to permit free brushwork directly behind them. Then I painted the rich woodgrain with pure sepia on dry white paper first as drybrush. When it dried, I covered it with the shadow color of the wood—burnt sienna, French ultramarine blue, and raw sienna—and lifted out the color where the sunlight struck. The sepia texture of the wood remained, though in a lighter value. The clear, sharp edges of the masked-out flowers contrast with the softer, dark background. I scraped a razor blade on dry paper to get the beadlike character of the cobweb.

The sunlit areas were originally as dark as the shadow areas. I lightened them by lifting them out with a short-haired, firm, bristle brush. You can see the dramatic effect of recovered luminosity. It was helped here by a touch of sepia afterward to accentuate the deeper cracks and inner spaces between the boards. The edges of the shadows vary from sharp to soft depending upon their distance from the object casting the shadow.

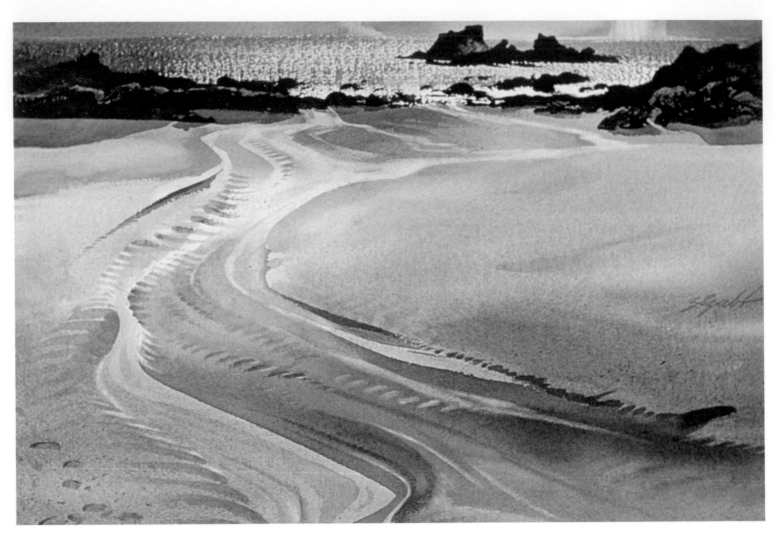

Palette
Sepia
Raw Sienna
Burnt Sienna
French Ultramarine Blue
Winsor Blue

Calm Rivals. Receding tides left this exciting, free pattern in the California sand. I painted the large sand area with a granulating wash of raw sienna, sepia, and French ultramarine blue. I modeled the soft shapes in the sand while the color was wet, but added the darker glazed definitions and wet-lifted some soft highlights after it dried. In addition to the granulating washes, I spattered paint on the foreground sand for a coarse texture. The shadowed footprints show that the sand is wet, and the dark areas in the sand supply drama to the otherwise subtle sand shapes.

I painted the shimmering highlight on the water by dragging a flat brush rapidly on the surface of the paper. I dragged it again for the darker areas. Later, when the paper was dry, I applied the color of the dark rocks (Winsor blue and sepia) and knifed out their edges to model them. I painted their cast shadows last. The long shadows and shimmering (drybrushed) water indicate the low position of the sun. Except for a few drybrush touches in the background, the dynamic design is expressed through glazes and lost-and-found brushstrokes.

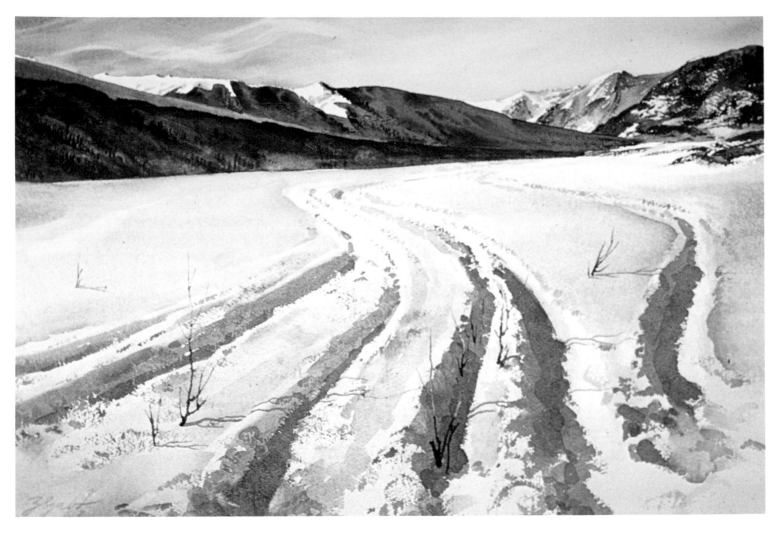

Palette
Raw Sienna
Burnt Sienna
Brown Madder
Antwerp Blue
French Ultramarine Blue

Stage Lighting. The high wind sweeping down over the mountains of Montana constantly reminds me of the battle between sun and snowstorm. The low angle of the winter sun allows the light tone of the blue sky to reflect on the flat surface of the snowfields. I wet the paper and painted the active sky with Antwerp and French ultramarine blues, and with a little raw sienna near the edges of the center peaks—to echo the warm colors on the ground. I then lifted out the streaky clouds from the wet wash. I shaded the dark mountainside and the flat surface of the snowfield with a rich wash of brown madder and Antwerp blue, then painted the forest ascending the slopes with taps of a wet, firm bristle brush loaded with a thick mixture of burnt sienna and Antwerp blue. These overlapping shapes, and the dark wedge-shaped incline on the right, appear to ascend mainly because of a contrast in value. When the paper dried, I drybrushed more of the same color on top to further texture it.

I carefully avoided painting the left-hand slopes of the mountains and the snow tracks where the low sunlight reflected most brightly, but left them white. The shadows of the deep snow tracks were drybrushed and glazed on in several layers of French ultramarine blue and burnt sienna, and a touch of Antwerp blue. I knifed in the sunlit weeds everywhere except where they crossed the dark blue shadows. There, I first scrubbed out the blue before painting them.

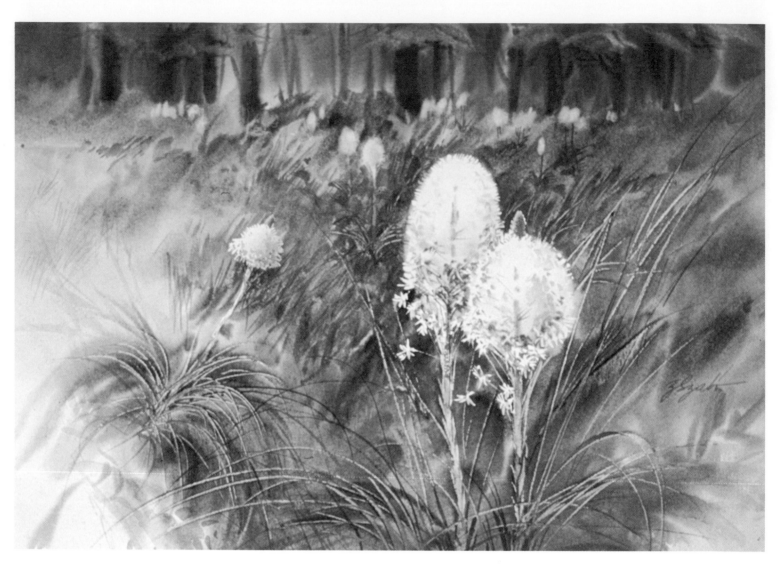

Palette
Raw Sienna
Burnt Sienna
Brown Madder
French Ultramarine Blue
Antwerp Blue

Forest Lanterns. I found yet another surprise in the mountains of Montana: bear grass! These beautiful, little-appreciated wildflowers stole my heart. From a distance they look like bright torches in the dark forests, but seen up close their structure is truly delicate. Receding color (warm in the foreground, cooler in the background) and the correct scale set the scene for a deep, three-dimensional composition. The raw sienna color dominated the flowers, but the color of the rest of the weeds and forest consisted of a neutralized combination of my entire palette.

Before I started to paint, I masked out the outer edges of the main flower and its stem with Miskit. Then, on wet paper, I painted the distant forest and the lush, tall grass, adding more defined brushstrokes as the surface was drying. When the paint was damp, I knifed out the thin grass from the dark background. Through all of this I avoided touching the inner parts of the large area near the blooms. While the paper was still damp, I softly wiped their outer edges, working over and next to the Miskit pattern to indicate soft transitions in value. At the same time, I wet, then lifted out the heads of the distant blooms. Later, after I removed the Miskit, I glazed on delicate flowers within the blooms, hinting at their shapes rather than giving literal details. For example, I modeled the tight little bud on the left-hand side with just a few form-giving soft washes and glazes. The masked-out silhouette carried most of the form. I let tiny masked-out shapes, knifed-out flowers, or carefully glazed on lost-and-found edges define the lacy fragility of the plants' structure. Also, the softly blending values within the flowers make them glow in warm (raw sienna-dominated) light next to a rich, dark, cooler mass of weeds in which Antwerp blue and French ultramarine blue predominate.

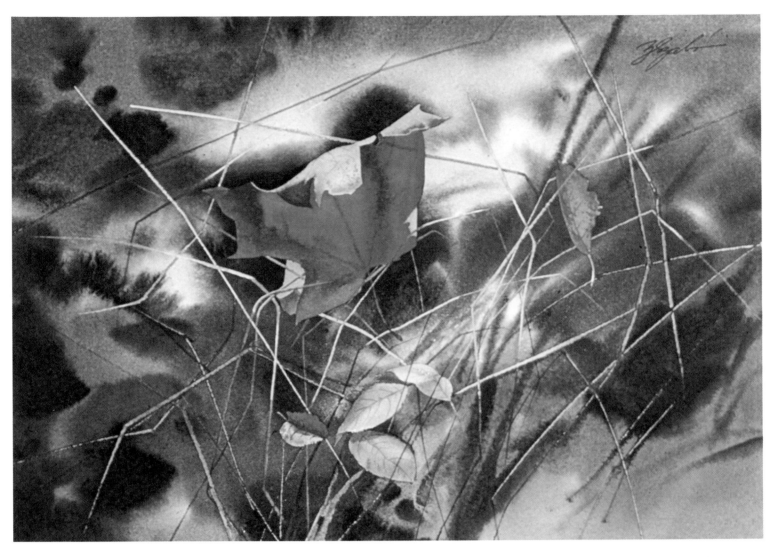

Palette
Raw Sienna
Burnt Sienna
Sepia
Cadmium Red Medium
Antwerp Blue
French Ultramarine Blue

Tangled Resting Place. Momentary frozen abstracts, such as this leaf composition, happen all around us in nature, but we have to take the trouble to look for them. In order to freely apply the background colors on the wet paper, I masked out the sharp-edged leaves and some of the crisscrossed, thin grass stems with Miskit. While the background was still damp, I knifed out more of these stems. Next I removed the Miskit and painted the large leaf with cadmium red, raw sienna, burnt sienna, and sepia. The bright cadmium red color gave the red leaf the feeling of being backlit.

I then painted the smaller leaf and scraped veins into the wet paint with the tip of my brush handle. I colored in the grass stems and added a few thin, dark blades of grass for contrast. The pattern of soft and sharp edges and light and dark shapes in this painting has a harmonious balance. Even the smaller, less significant details are balanced in shape and consistent in treatment with the rest of the painting.

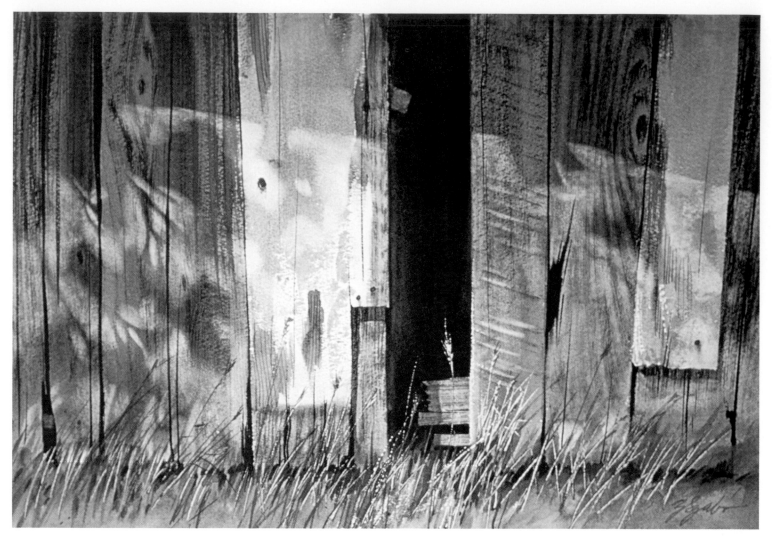

Palette
Raw Sienna
Burnt Sienna
Sepia
French Ultramarine Blue
Antwerp Blue
Manganese Blue

Sunny Boy. The dappled shadow pattern on the textured old wood in this almost abstract painting created interesting shapes and gave me the opportunity to use recovered luminosity to the fullest extent. I first masked out the clearest light weeds near the center of the painting with Miskit, then drybrushed on the woodgrain on dry white paper using a heavy consistency of sepia. I painted the shadow value of the old, natural wood with French ultramarine blue and burnt sienna. To create the effect of woodgrain on the isolated patches of raw wood on the white-painted board, I scraped the tip of my brush handle into the wet sepia drybrush brushstrokes.

I painted the shadows on the white boards with manganese blue, French ultramarine blue, and a touch of burnt sienna, then wet and blot-lifted off the sunlight carefully leaving the shadow shapes intact. The continuous sepia woodgrain established first shows through the glazed, shaded areas as well as in the brightly lit sunny areas, where the glaze overwash was lifted out. Scrubbing off part of the top color only lightened the value of the sepia slightly. I was careful only to wipe out only the *sunny* patches of light, not the darker shadowed areas—a mistake often made by students. I painted the dark opening in the wall with a combination of sepia and Antwerp blue. I then removed the latex mask from the central weeds and painted them and the other weeds raw sienna, burnt sienna, and a little sepia. Finally, I touched up the deep cracks between the boards with sepia and added the rusty nails with burnt sienna and sepia.

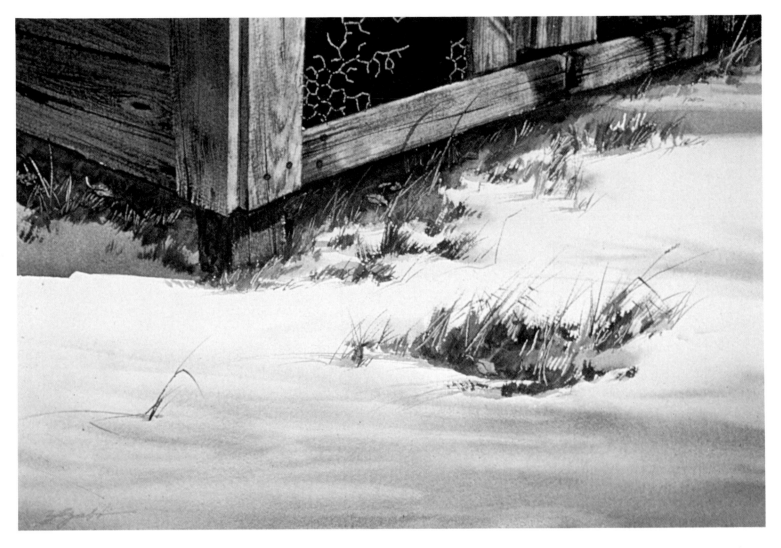

Palette
Sepia
Brown Madder
Raw Sienna
Burnt Sienna
French Ultramarine Blue
Winsor Blue

Abandoned Cage. Each of these differently textured surfaces required a different application of paint. I textured the woodgrain on the wooden structure with a rich value of drybrushed sepia on the white paper first and when it dried, glazed over it with a wash of the shaded wood color—burnt sienna and French ultramarine blue. When it was dry, I wet and wiped out the sunlit portion, exposing a light value of the weathered wood beneath. The rich texture of the woodgrain remained after scrubbing because of the staining strength of the sepia drybrush.

I painted the clumps of grass with a drybrush technique with fast, upward bristle-brush strokes, using raw sienna and burnt sienna and a little sepia. I added a few random knife-strokes for the lighter blades. Where the knife carried the excess color into the dry area, it looked like dark weeds. I added a few more weeds with a rigger brush and painted the leaves. I painted the soft shadows on the snow on wet paper, but carefully kept the edges of the weeds and of the shadows cast by the shed's corner sharp because it and the neighboring objects were close to the surfaces casting them. Finally, I knifed out the chicken wire fence from a dark wash of brown madder and Winsor blue while it was still damp.

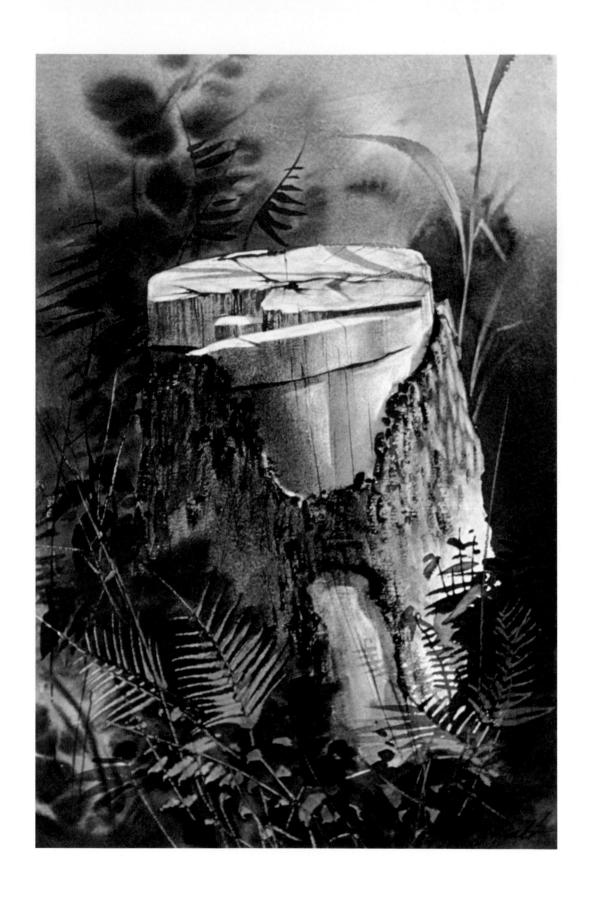

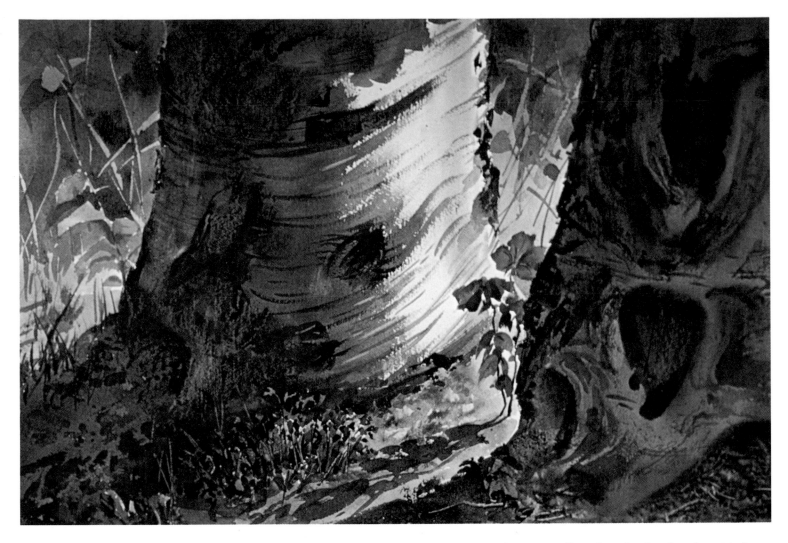

Palette
Raw Sienna
Burnt Sienna
Cadmium Red Medium
Brown Madder
French Ultramarine Blue
Antwerp Blue

Palette
Raw Sienna
Burnt Sienna
Sepia
French Ultramarine Blue
Sap Green

Sanctuary of Innocence. Small objects look even smaller when they're placed next to large objects. This little knot of colorful flowers at the roots of the old birch was well sheltered and quite tiny in contrast to the overpowering birch. I textured the gnarled old birches with sepia and glazed the shadow color over them with Antwerp blue, brown madder, and burnt sienna. The drybrush strokes on the white sunlit birch curve with the form. I painted the red petunias with light glazes of cadmium red medium, brown madder, and a touch of French ultramarine blue. I painted the dark background around the tiny blue violets and left them exposed as negative shapes. Later I glazed French ultramarine blue over the entire area, which tinted the flowers blue. I treated the background weeds loosely with glazes of raw sienna and French ultramarine blue, knifing out sections here and there.

Stripping (Left). Here was a good opportunity to paint texture: an old stump, covered with saw marks, cuts, and chips on its hard wood, encased in a half-torn sheath of bark. The lush green weeds at its base are richly alive and surround what was once a proud old tree. Before I textured the grain of the split wood shapes, I masked their edges with masking tape on dry paper. I painted the texture of the wood and bark first with sepia drybrush on the white paper. Then I glazed the darker wood color on top of it, and lifted it off later to model the light side. (I painted deep cracks later, recovering their dark value, which was lost during the scrubbing procedure.) For the dark green weeds, I used a dark wash dominated by sap green, letting the brushstrokes blend as they touched one another. Just as the shine of the wet paint was disappearing, I knifed out the light weeds, exposing the sap green-stained paper in a light value. The firm palette knife can remove leaflike shapes beautifully.

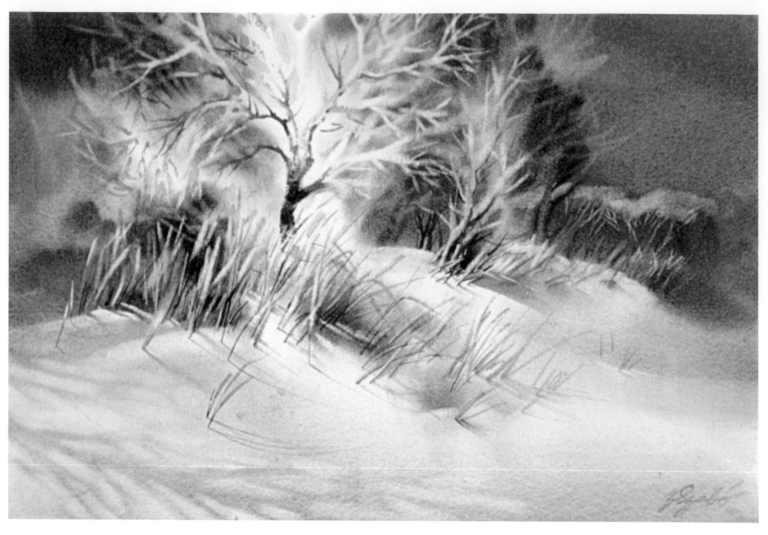

Palette
Manganese Blue
French Ultramarine Blue
Antwerp Blue
Raw Sienna
Burnt Sienna

Snow Flash. Hoarfrost is one of winter's beautiful gifts. When fog condenses on cold, solid objects, they become covered with a furry coat of white frost. After the fog lifts and the sun bursts through, these frosty trees and weeds light up like white torches. I painted most of this study on wet paper. I worked around the largest white shapes, and wet-lifted others from washes containing manganese blue. (Manganese blue in a wash makes most other colors it's mixed with lift off easily.)

First I applied a dark background wash of manganese blue, French ultramarine blue, and burnt sienna. When the paper was dry, I lifted out the fluffy white branches. I added the dark, warm-colored twigs last, on dry paper. To define the large white shape of the tree, I glazed some background color around the white branches. The lost edges of these brush-strokes blended softly into the wet-in-wet shapes. The surface of the snow was painted a dark shadow color. I gently lightened it as I lifted out the sunlit areas from the cast shadow of the tree at the lower left, until it looked sunny, but textured. I painted the weeds and their shadows with fast brushstrokes to keep them brittle, but delicate-looking.

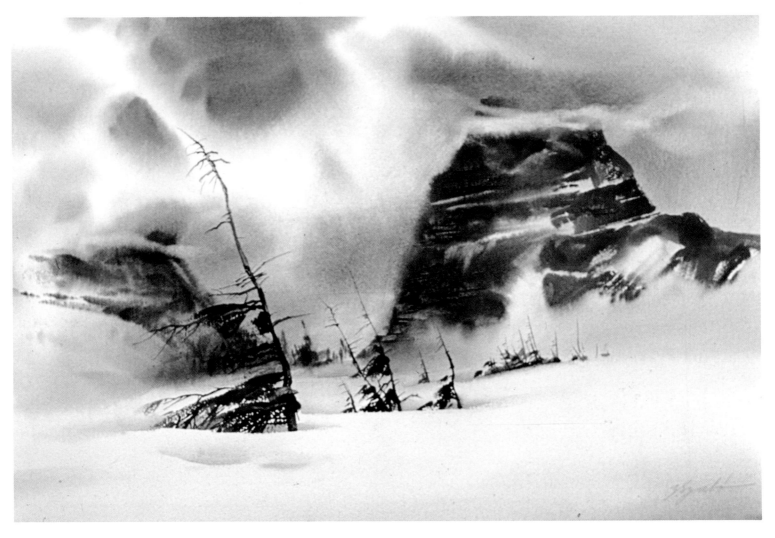

Palette
Brown Madder
Raw Sienna
Antwerp Blue
French Ultramarine Blue

Indian's Spring. In July, Logan Pass in Glacier National Park is still a winter wonderland. There is a 10-foot (3-meter) layer of snow covering the incredible peaks surrounding the pass, and only the tips of the battered alpine first stick out. The clouds are constantly ripped open as they roll and crash into the jagged rocky peaks. On wet paper, I washed in the blue sky, which shows through the roaring storm clouds, with Antwerp blue and just a touch of brown madder. I slapped these shapes onto the drenched white paper and allowed them to spread freely, while carefully reserving white spaces for the clouds. Then I painted the simple shape of the distant mountain on wet paper and quickly lifted out the cloud covering it with a thirsty brush while the paint was wet. I painted the peaks with brown madder and Antwerp blue and, before the color had a chance to stain the paper, I knifed out the sharp-edged white snow by firmly pressing my palette knife into the wet washes.

The trees and snow were added last, on dry paper. Before beginning the trees, I masked out the lower edges with tape where they're covered by snow. Then I drybrushed on the green foliage with raw sienna and French ultramarine blue, and knifed in the scrawny branches with Antwerp blue and brown madder. The shaded snow beneath them was created by lost-and-found brushstrokes of Antwerp blue and brown madder. By carefully scaling the clusters of trees to the peaks and to each other I help provide the illusion of depth.

Index

Edited by Bonnie Silverstein
Designed by Bob Fillie
Production by Hector Campbell
Set in 11-point Century Schoolbook

ANNUALS

1001 Gardening Questions Answered

by
The Editors of Garden Way Publishing

Foreword by Henry W. Art

STOREY

Storey Communications, Inc.
Pownal, Vermont 05261

Produced by Storey Communications, Inc.
President, M. John Storey
Executive Vice President of Administration, Martha M. Storey
Executive Vice President of Operations, Douglas B. Rhodes
Publisher, Thomas Woll

Written by Ann Reilly and the Editors of Garden Way Publishing
Cover and interior design by Andrea Gray
Edited by Gwen W. Steege
Production by Andrea Gray, Ann Aspell, and Rebecca Babbitt
Front cover photograph by Madelaine Gray
Back cover photograph by Ann Reilly
Interior photographs by Madelaine Gray, Positive Images (Jerry
 Howard and Gary Mottau), Ann Reilly, and Martha Storey
Chapter opening photographs by Ann Reilly (1, 2, 3, 4) and
 Madelaine Gray (5).
Typesetting by The Best Type and Design on Earth, Burlington, VT.

Library of Congress Catalog Card Number: 88-82823
International Standard Book Number: 0-88266-547-2

Library of Congress Cataloging in Publication Data

Annuals : 1001 gardening questions answered.

 Bibliography: p.
 Includes index.
 1. Annuals (Plants)—Miscellanea. I. Garden Way
Publishing.
SB422.A575 1989 635.9'312 88-82823
ISBN 0-88266-547-2

Contents

Annuals are probably the most diverse and adaptable group of garden plants in use today. Their rapid growth rates, abundant and long-blooming flowers, diversity of colors, and wide range of forms have long made these plants special favorites of gardeners. From African daisies to zinnias, there is an annual for everyone's garden, whether it is a formal landscape with large, complex flower beds, a small but well-tended border, or a window box.

Annuals offer the gardener enormous flexibility. You don't have to wait long to see the fruits of your creativity and labor, since seeds that are properly planted bear flowers within the same growing season. Annuals' varied textures and palette of colors provide myriad garden possibilities. Chapter 1, "Designing with Annuals," is filled with creative designs and uses for versatile annuals in your garden.

Chapter 2, "Basics of Growing Annuals," discusses the best ways of starting and growing annuals. Although one of the joys of annuals is that they are easy to grow, in some geographic regions certain annuals may need a head start indoors in order to grow to sufficient size to flower by the end of the growing season, whereas other annuals can, or should, be planted directly into the garden. In this chapter you will find information about these requirements, as well as about propagation, prolonging flowering seasons, growing some species of perennials as annuals — in short, everything you need to know to establish annual plants successfully in your garden.

Various annuals are suited to a staggering range of garden conditions. Some are appropriate for shady areas; others grow best in bright sunny locations. Some prefer sandy, well-drained soils; others are better suited to damp, loamy soils. Some can be best used in gardens with ample organic matter and nutrients in the soil; others flower most prolifically in rather infertile, nutrient-poor soil. Chapter 3, "Gardening with a Purpose," gives specific examples of annuals that you can select to thrive under *your* garden's conditions and location, along with helpful suggestions for using annuals in beds, borders, containers, and dried flower arrangements.

Even easy-to-grow annuals will have problems from time to time. Chapter 4, "Common Problems and How to Solve Them," advises you on how to prevent or, if necessary, diagnose and treat disease and pest problems that you may encounter. Some annuals can even be used as companion plantings to help control pests and diseases in your garden by biological means.

Chapter 5, "Favorite Annuals," is the heart of the book. Some are familiar plants, but others are sure to bring new, fresh ideas to your attention. Specific questions pertaining to over 100 species of annuals, listed in alphabetical order, are clearly answered. Their individual needs and peculiarities are addressed in sufficient detail to ensure success in any garden.

Annuals are quick and colorful, prolong your season of gardening pleasure with abundant flowers, and are relatively inexpensive. *Annuals: 1001 Gardening Questions Answered* will enhance your gardening enjoyment, whether you are a novice or expert.

Henry W. Art

A. Blake Gardner

1 *Designing with Annuals*

Your landscape may seem complete: tall trees providing a strong and stately framework; attractive foundation plantings enhancing the areas near the house; a comfortable patio or deck; ground covers and a lush, green lawn. Yet, something is lacking—and the crucial, missing element is *color*. Although flowering trees and shrubs and perennial flowers enliven the home landscape, there is no simpler, quicker, or more dependable source of color than those most versatile of plants, the annuals.

Whether you desire a subdued atmosphere or an exciting one, you will find annuals to suit your purposes. Throughout the growing season, no matter what the climate, there are annuals that will thrive: from forget-me-nots and pansies in the cool moistness of spring and early summer to verbenas and zinnias in the hot sun of midsummer. The smallest of properties, even balconies high over city streets, can benefit from the colors of container-grown geraniums, nasturtiums, and lantana. Annuals can be used to define areas or to add accents to them, to fill in large spaces, and to make the garden appear larger or smaller. One of the nicest things about them is that as your tastes or needs change, so too can your garden design and color scheme: go wild this year with brilliant gaillardia and California poppies; be subdued the next with gentle sweet peas, stock, and lobelia.

Designing with annuals involves determining the size and shape of planting beds or borders, locating them to their best advantage, using them in combination with other plants, selecting colors, and choosing plant sizes and shapes. Although

◆ *A sunny display of bright-colored zinnias and marigolds enlivens the home landscape quickly, inexpensively, and dependably.*

1

gardening with annuals can be easy and pleasurable, you will find that the more avidly you garden, the more questions you may have. We hope that in the pages that follow you will find both the questions you raise and the answers to meet them.

UNDERSTANDING THE BASIC TERMINOLOGY

What is an annual?

An annual is a plant that is sown, flowers, sets seed, and dies all within one season.

Why should I include annuals in my garden design?

Annuals are the best way to achieve summer color for long periods of time. Whereas most trees and shrubs blossom in spring, and even summer-blooming perennials last only three to four weeks, annuals produce color all summer. Creating a festive mood and thus enhancing the beauty of your home, they offer one of the easiest and most effective means of enlivening a landscape. Best of all, the color scheme can be altered from year to year as your tastes change.

In California I have seen plants such as geraniums, snapdragons, and begonias that are perennials, yet in Pennsylvania they are called annuals. What is the difference?

The term "annual" is often applied to plants that are perennials in warm areas but cannot survive cold winters. These tender perennials are not technically annuals because they do not die after they set seeds. In cold climates, however, they must be treated as annuals in the garden.

What is meant by a hardy annual? A half-hardy annual? A tender annual?

Hardy annuals are those whose seeds can be planted in the fall or in very early spring, because they are not injured by frosts. *Half-hardy annuals* are cold-resistant and seeds of these can be planted early in the spring. The seeds are frost hardy, but the plants are not. Although they will not survive heavy frost, they do not mind cool temperatures. *Tender annuals* are easily injured by frost and must be planted only after the ground has warmed up and all danger of frost is past.

What is a hybrid?

A hybrid is a new plant created by the successful cross-pollination of two plants with different genetic traits. Many of today's better flowering annuals are hybrids.

Why should I grow hybrids?

Hybrids are improvements over nonhybrids, including both of their parents. They may possess one or more desirable

characteristics, such as improved disease resistance, increased flowering, or higher heat tolerance.

Can I collect seeds from hybrid plants to grow the next year?

No, seeds from a hybrid will not produce a new plant like its parent and you are likely to be disappointed in the results.

Why are seeds of hybrids more expensive?

Many hybrids are created by hand in greenhouses, and so are very expensive to produce. Others are grown outdoors, but in controlled conditions, and they, too, are therefore more expensive to produce. The results, however, are worth it.

Should I look for annuals by variety name, or is it enough to know that the plant is a marigold, an impatiens, or a petunia, for example?

By all means, shop for annuals by variety name. Knowing the variety can tell you something about the height, flower size, and disease- and heat-resistance of the plant. When you find a variety that does well for you, note what it is so that you can buy it again the following year.

What is the difference between a "variety" and a "cultivar"? I have seen both listed in seed catalogs.

A variety is a plant that is different from the true species occurring in nature. A cultivar is short for "cultivated variety." It is a variety developed by a plant breeder by crossing two different plants. However, the terms are often (incorrectly) interchanged.

What is a series?

The word "series" has been given to those annual varieties in which the same type of plant is available in a range of different flower colors. Series are very common in impatiens, begonias, petunias, marigolds, geraniums, and several other popular garden flowers.

What is the advantage of growing plants from the same series?

If you wish to grow a mixed garden of impatiens, for example, select plants from the same series to get plants of the same height and growth habit and flowers of the same size.

Is it better to buy seeds from a local store or from mail-order catalogs?

Mail-order catalogs usually have a larger selection and a more complete description of the individual varieties. They may also be available earlier, an important factor if you are beginning seeds indoors. Racks at the garden center are good for last-

minute purchases. If you plan to start seeds indoors, be sure to order or buy early, especially such annuals as petunias, begonias, impatiens, and geraniums that require twelve to sixteen weeks of growing inside before being transplanted outdoors. Ordering early also saves you the disappointment of finding a variety sold out.

In mid-spring, I noticed small seedlings that I did not plant growing in my flower garden. Where did they come from?

Some annuals freely reseed, especially where winters are not severe and soil is porous. These include sweet alyssum, browallia, lobelia, four-o'clock, morning-glory, moonflower, ageratum, nicotiana, nasturtium, petunia, scabiosa, spider flower, hollyhock, salvia, and impatiens. What you see are seedlings growing from seeds that dropped the year before. They are sometimes called *volunteers*.

Is it a good idea to leave volunteers in the flower bed?

Not necessarily, for at least two reasons. If the seedlings grew from hybrids, they will not come true and you will probably be disappointed. Except in areas with long summers, volunteers may not grow large enough to produce a good flower display. If you want to be certain to have the flowers of any of these, it is best not to rely on the happy chance of volunteers but to sow seeds each spring.

If such seeds as petunia, impatiens, salvia, and phlox are permitted to self-seed, is there a true-to-original-color reproduction?

Not usually. Many annuals grown today are hybrids, and the seeds will not produce plants that are the same as the parents.

CREATING A GARDEN DESIGN

What is the difference between a bed and a border?

Flower beds are plantings, such as those in the middle of your lawn, that are accessible from all sides and intended to be viewed from all sides. *Borders* are at the edge of an area and are approached and viewed from only one side in such locations as along a fence, driveway, or foundation or in front of shrubs or a hedge.

How large should beds be?

This depends on the size of the surroundings. Keep them in scale with the rest of the property. Any bed that takes up more than one-third of the area in which it is placed is likely to look out of proportion.

What shape should beds be?

This depends on your taste and the style of your home. Formal beds are square or rectangular. Informal beds are round, oval, kidney-shaped, or free-form. Do not make the curves too sharp: the bed will appear too busy, and it will be difficult to mow the grass bordering it.

How large should borders be?

There are two considerations. First, as with flower beds, borders should be in proportion to their surroundings. A very wide border would not look good next to a very short walkway. A good rule of thumb is to make a border no wider than one-third its length. Second, because borders can be worked from one side only, they should be no wider than five feet, no matter how long they are, or maintenance will be too difficult.

Flower beds are accessible from all sides.

Ann Reilly

Where can I locate beds and borders?

Anywhere: along the driveway, in front of the foundation planting, along the patio, under the mailbox, at the base of the flagpole, in raised beds, by the driveway, along a fence, at the edge of the pool, accenting statuary, by the front door, next to garden benches. When deciding where to put your beds and borders, consider the points from which they will be viewed. If you want to see them from the dining room, locate them near those windows. If you want to see them from the patio, place them around it or in viewing line of it. Create beds or borders in the front of the house if you want people driving or walking by to share in the enjoyment of your flowers.

What else should I consider when deciding where to locate my beds and borders?

You should look at existing permanent features, such as the house, large trees, and fences, and if feasible, blend these into the flower planting. For example, carve out a circular or oval area under a stately tree, and fill the bed with shade-loving plants like impatiens or begonias, or turn a fence into an asset of the garden by highlighting it with a flower border. If you are planting flowers near the house, be sure the flower colors complement the house.

I want to have a large garden, but I have a small piece of property. What should I do?

In this case, design a free-standing garden with pathways in it, perhaps encircled by a decorative fence with a gate. You will be creating a flower garden that is more than a bed or border, one that needs no surrounding lawn.

I don't have the time for a large garden. What would be the best place for a single flower bed or border?

Select a spot where either you or your neighbors can enjoy the garden most, perhaps somewhere near the way in and out of the house or in view of a favorite indoor or outdoor sitting area.

I'm not sure how large a flower bed to create. I have never gardened before. What do you suggest?

If this is your first time, start small; you can always increase the size of the garden next year. The amount of space you devote to your garden is determined by how much space there is on your property, as well as how much time and energy you have for the garden. Particularly if you have a full-time job, and can garden only on weekends, start small—perhaps about seventy-five to one hundred square feet. If you have no trouble maintaining that, increase the size or add another bed next year. On the other hand, if even that sounds too ambitious, plant annuals in containers along the walkway or driveway, or in front of shrubs in the foundation planting.

Ann Reilly

A fence becomes a highlight of the garden and provides a decorative background for tall foxglove and a wide border of pansies.

I'd like to grow annuals in my garden this summer, but don't know where to start. What advice can you give me?

There are two things to consider before anything else in deciding which plants you want to grow: which annuals it is *possible* to grow in your garden, and which ones you would *like* to grow. First, match the plants to your growing conditions. Is your garden sunny or shady? Is your climate hot or cool? Is there a water shortage where you live? After you have determined that, you can make a list of plants that will grow well in your garden. From that list, choose those you like for their appearance or for how they will fit into your plan. Perhaps you want a particular color, or group of colors. Maybe you want only short plants, or a variety of heights. Many choices are available, but using these criteria you will soon have an interesting and varied list of annuals that you will want to try. Visit gardens in your area and study which do best there and which you like the most.

What are the differences to be considered in designing a formal garden versus an informal one?

Formal gardens are usually created with straight lines in symmetrical arrangements, quite often on flat areas with no large trees or shrubs. Formal gardens look best with more formal homes.

An informal garden is the natural choice for a cottage-style home, where the ground is hilly, where there is a stream or

Formal gardens are created with straight lines and geometric shapes in symmetrical arrangements.

Ann Reilly

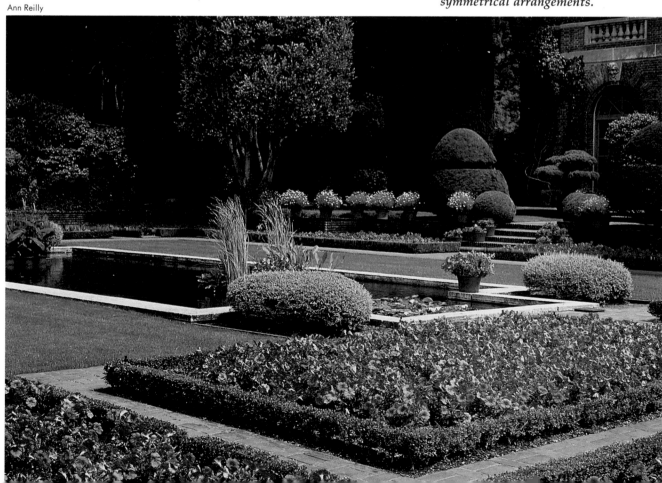

brook, or many trees and shrubs. In such situations, create an informal garden with curving lines around the trees or shrubs.

On a trip to Europe, I saw formal gardens in *fleur-de-lis* patterns, as well as other designs, and liked the effect. How do I recreate this?

Draw a plan on paper to scale, then transfer your design to the garden bed, using strings or cord to lay it out before you plant (see page 33).

What types of annuals do best in these formal types of designs?

Choose plants of contrasting colors with tidy and trim growing habits. Spreading annuals such as sweet alyssum and lobelia are not good choices. For flowering plants, use begonia, candytuft, phlox, and ageratum plants; for foliage plants, alternanthera, iresine, and dusty miller.

Should beds and borders have plants of the same height or varying heights?

That depends on the size of the bed or border. In small beds, choose plants of the same or only slightly varying heights; tall plants would be out of place. In large borders, use a variety of heights to make the planting more interesting. Place tall plants in the background, with intermediate-sized plants in the middle, and low-growing annuals in the front.

A large flower border with tall foxglove in the background, medium-sized dahlias in the middle, and low-growing nasturtiums along the edge.

Ann Reilly

Should I vary the heights of annuals I select for planting on a hillside?

Since the hill itself gives height to the planting, a hillside looks best with plants of approximately the same height.

My property is flat and uninteresting. How can I use flower beds to make it more attractive?

Use tall plants in the center of a bed, with lower plants in the front. You might also consider creating a *berm*—a rounded mound of earth—to vary the topography.

How many gradients of height should I use?

It is good to work in threes. Use three different plants, or different varieties of the same plant in different heights—marigolds and zinnias have nice selections of the latter.

Please give me a list of tall annuals to use as the background in a border or as the center plant for a free-standing bed.

Hollyhock, spider flower, sunflower, Mexican sunflower, tall snapdragon, and tall zinnia are all excellent choices.

What plants are suitable for the middle of the border?

In addition to the marigolds or geraniums already mentioned, grow anchusa, amaranthus, calendula, China aster, clarkia, dahlia, California poppy, globe amaranth, snow-on-the-mountain, strawflower, impatiens, four-o'clock, petunia, Gloriosa daisy, medium-height zinnias, and African marigold.

What are good plants for edging the flower bed or border or a shrub planting?

Good low-growing plants are ageratum, dwarf snapdragon, begonia, dwarf China aster, dwarf celosia, ornamental pepper, China pink, candytuft, dwarf impatiens, lobelia, linaria, phlox, French marigold, pansy, periwinkle, nemesia, cupflower, baby-blue-eyes, portulaca, verbena, and dwarf zinnia.

Should plant shapes be varied in a bed or border?

Yes, within size limits. There are basically three different plant shapes: tall or spiked, rounded, and ground-hugging. A combination of all three is most attractive.

What are examples of plants I can use to vary plant shapes?

In the background, use spikes of tall snapdragons or salvia. In the middle, use a rounded marigold or geranium. In the foreground, finish the planting off with lobelia or petunias. Or for a more informal look, mix plumes of celosia, globes of gaillardia or African daisy, trumpet-shaped petunias or salpiglossis, flat and single begonias or impatiens, daisy-shaped dahlias, and wispy spider flowers.

The three basic shapes of flowers add variety to beds as well as to fresh bouquets: for example, tall, spiked snapdragons, rounded marigolds, and open, cascading petunias.

A brilliant display of annuals forms a border for the vegetable and herb garden.

If space is limited, try growing a vertical garden along a fence or wall. Here, begonias, impatiens, lobelia, and coleus provide a colorful display in a planter made of vertical boards and hardware cloth.

Which annuals are good where spiked shapes are desired?

These are hollyhock, snapdragon, Canterbury bells, celosia, larkspur, stock, bells-of-Ireland, nicotiana, mignonette, and salvia.

Some annuals don't seem to fall into these categories. What do I do when designing with these?

Some annuals have an upright but loose, open form. These include Swan River daisy, bachelor's-button, calliopsis, cosmos, love-in-a-mist, mignonette, salpiglossis, pincushion flower, and blue lace flower. They are best mixed into the border with other plants.

Must I combine different flowers to achieve an attractive effect?

No, the choice is up to you. A planting of the same type of annual, known as a *massed planting*, has a sleek, modern appearance that is very attractive. Good plants for massing are periwinkle, impatiens, geraniums, and multiflora petunias.

What other plants can I combine with annuals?

Almost anything. Combine spring bulbs with early annuals such as pansy or forget-me-not (see pages 140-42). For a mixed flower bed or border, plant annuals among perennials or tender bulbs. Annuals look beautiful as a border or ground cover in a rose bed, or with any shrubs.

Can I use annuals in my herb garden, or herbs in my annual garden?

Yes, they mix together quite nicely. Some herbs, such as parsley, basil, lavender, chives, rosemary, thyme, sage, and chamomile, are particularly well suited.

Can I combine annuals and vegetables?

Most definitely. A border of annuals in a vegetable garden is most attractive. Some annuals, such as marigolds, even help to repel insects. Conversely, small vegetables, such as red-leaved lettuce, make a nice border to a flower garden. If you enjoy the unusual, use eggplant and peppers, both of which develop into attractive plants with shiny, colorful vegetables, or Swiss chard for its attractive foliage.

My backyard is very small. How can I increase the space for an annual garden?

Plant a vertical garden. There are several ways to do this. Look for special pots that are flat on one side and hang them on the fence. Or construct a vertical planter with chicken wire, line it with sphagnum moss, fill it with potting medium, and plant it with flowers.

Are there qualities of foliage that I should think about other than color?

Yes, strive for a variety of kinds and textures as well. For example, Gloriosa daisies and zinnias have large, coarse foliage compared with annual chrysanthemum and cosmos, which have finely cut, lacy foliage. The foliage of periwinkle is quite glossy, while that of petunia is fuzzy and dull.

Will you give me a list of annuals requiring the least care in home gardens?

Marigolds, verbena, gaillardia, cosmos, spider flower, calliopsis, salvia, scabiosa, annual phlox, sweet alyssum, impatiens, begonia, nicotiana, periwinkle, and coleus.

I planted a large flower garden last year, but it was disappointing: it looked like a patchwork quilt. How can I avoid this next year?

Your problem was most likely in not dealing with color properly. Color is the most critical aspect of flower bed design. When planning a flower bed or border, avoid the busy "patchwork" look by choosing a color scheme. Allow your color choices to reflect your personality. If done with care, a color scheme will make your planting look more professional.

How do I choose a color scheme?

That depends on you, your home, and the look you want to achieve. Warm tones are happy, active, cheerful. Cool tones are relaxing.

After I have selected the main color I want to use, how do I select the others?

Use a color wheel to select several possible color schemes or *harmonies*. Say, for example, you choose yellow as your primary color. Directly across the wheel from yellow is violet. This is called *complementary harmony*. Another complementary harmony is orange and blue. One caution: complementary harmony is a strong harmony and may be too overpowering for a small garden.

Split complementary harmony is another possibility. In this case, you choose a primary color, say yellow, and work with the color on either side of its opposite (violet). With yellow, you would thus use blue or red. Red with blue or orange with violet are other split complementary combinations.

A third type of color harmony is *analogous harmony*. This harmony uses three colors in a row on the wheel, such as yellow, gold, and orange; or orange, russet, and red; or differing tones of violet and blue together.

USING COLOR FOR MAXIMUM EFFECT

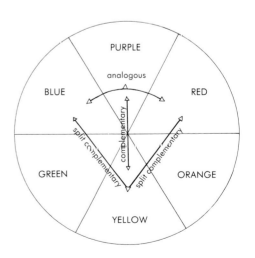

A color wheel can help suggest possible color schemes, or color harmonies.

What are examples of plant combinations using complementary harmony?

Use yellow with violet pansies, orange marigolds or Mexican sunflower with blue lobelia, or orange calendula with blue ageratum.

What are examples of split complementary harmony?

Try red zinnias with blue ageratum, yellow marigolds with red sweet alyssum, red and blue salvia together.

Ann Reilly

An analogous harmony, such as this one composed of red, red-purple, and purple cineraria, consists of hues that appear in a row on the color wheel.

What are examples of analogous harmony?

Plant yellow, gold, and orange marigolds or calendula, orange and red zinnias, or violet pansies with blue forget-me-nots.

What is monochromatic harmony?

Monochromatic harmony is a garden of only one color, such as all pink, all yellow, or all blue. To avoid monotony, use several different kinds of plants, or different varieties of the same plant, so that you have different shades of the same color. For example, plant pink geraniums, pink zinnias, and pink petunias together, or try a bed of impatiens using varieties with pale, rose, and bright pink flowers.

How many colors can I use in the garden and yet avoid a "busy" look?

Select one primary color and add one or at the most two other colors. You can use plants such as tall Mexican sunflowers, cosmos, or spider flowers across the back of the border and a mixture of colors in front of the unifying background. Even better is to use different colors of the same plant, such as mixed zinnias, celosia, or dahlias.

When I choose a color scheme, must I use the same one all around the property?

No, you can have different color schemes in front, side, and backyard as well as in different beds or borders.

Should I plant mixed beds, or beds of all one color?

That depends on your personal preferences, as well as on the style of your home. Sleek, one-variety beds and borders may be more appropriate for a contemporary setting. Massed plantings in many colors are well-suited to a traditional home, such as a New England colonial.

I want to attract attention to a lovely statue I just bought for the garden. What color annuals should I plant around it?

The eye immediately goes to red and bright orange, so these are the best colors to draw attention to your new statue. For the

same reason, do not use bright colors where you are planting to hide something. Choose pastels or blues and violets for these areas.

My garden is quite large and I want to give the impression that it is smaller. What annuals should I plant?

Warm tones of red, maroon, gold, orange, and yellow will make a garden look smaller than it is. Dark-colored foliage, such as bronze-leaved begonias, dark coleus, iresine, or red alternanthera, will help, too.

I'd like a bright yellow and gold garden. What would be good choices?

Try calendula, California poppy, Cape marigold, Iceland poppy, pansy, celosia, sunflower, monkey flower, portulaca, marigold, nasturtium, snapdragon, and zinnia.

What orange flowers combine well with yellow ones in the garden?

Select different varieties of snapdragon, calendula, poppy, pansy, celosia, gaillardia, strawflower, impatiens, portulaca, marigolds, nasturtium, zinnia, and Cape marigold.

What do you think of an all-red garden?

All-red gardens are very attention-getting, so they are best if small and discreet. They make an especially nice effect against a white wall or fence. Use salvia, geranium, petunia, snapdragon, dianthus, poppy, pansy, amaranthus, China aster, celosia, gaillardia, strawflower, impatiens, begonia, nicotiana, portulaca, nasturtium, verbena, or zinnia.

Where does pink fit into the color wheel?

Pink is actually a *tone* of red, created by mixing red and white together. Pink may thus be used in the color scheme the same way as red. Excellent blends are made with pink and blue for a split complementary harmony and pink with clear red for a monochromatic harmony.

What annuals do you suggest I use for a pink garden?

Pink gardens tend to be delicate and feminine. Use begonia, impatiens, geranium, candytuft, sweet alyssum, stock, ageratum, China aster, cosmos, spider flower, baby's-breath, petunia, phlox, portulaca, zinnia, snapdragon, dianthus, or sweet pea.

My garden is quite small. How can I make it look more spacious?

Use blue and violet flowers, such as ageratum, lobelia, and blue salvia.

Complementary harmonies are strong, but can be extremely effective, as in this garden of yellow marigolds and purple ageratum.

I have created a small garden with a bench where I would like to spend summer afternoons reading. What colored annuals should I plant?

Use blues and violets, as well as white. These colors are cooling, soothing, and restful, and therefore perfect for a small garden or sitting area.

What colors should I choose for a garden that will usually be viewed at night?

Dark colors will blend into the background and not be visible, so use colors that will be seen at night, such as white or pale pink. Light-colored flowers also add a safety feature at night if planted along walkways; use garden lighting as well, to increase visibility.

What can I use in a blue or violet garden?

Many flowers come in shades of blue or violet. Although any one of them used alone makes a nice effect, the shaded combinations of two or more can be stunning. Select from bachelor's-button, larkspur, sweet pea, sweet alyssum, stock, forget-me-not, baby-blue-eyes, love-in-a-mist, browallia, China aster, morning-glory, lobelia, petunia, phlox, salvia, scabiosa, verbena, and pansy.

I have heard that white is a good buffer between strong-colored plants. I tried this last year, but it looked spotty. What did I do wrong?

White is a good buffer color, but if you use only one plant here and there to break up other colors, you will get a spotty effect. Instead, plant a large mass of white between bright colors, or, better yet, use white plants along the front of the border.

I'd like to plant an all-white garden. What could I use?

There are white flowers of certain varieties of ageratum, China aster, cosmos, baby's-breath, impatiens, begonia, lobelia, nicotiana, snapdragon, dianthus, sweet alyssum, stock, pansy, candytuft, petunia, phlox, portulaca, scabiosa, geranium, verbena, and zinnia.

My garden is on the south side of the house, and the house is a light gold in color. Should I use yellow, orange, and red annuals to complement the gold?

This would probably not give the best effect, even though the colors blend well. On a hot summer day, a garden of all warm colors against a warm-colored house may actually make you feel more uncomfortable in the heat. Use blue, violet, and white annuals instead: it won't be any cooler in your garden, but it may give the impression that it is.

Ann Reilly

Plants with white flowers or foliage, such as the dusty miller, impatiens, and zinnias shown here, are most effective if used in masses.

Ann Reilly

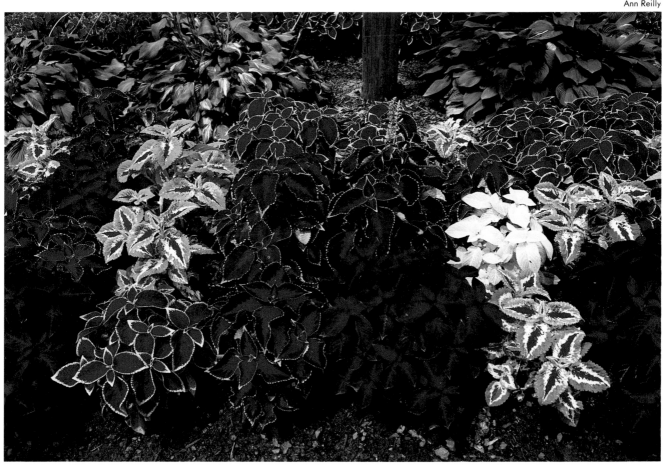

Coleus and other foliage plants can make a very colorful display.

Are there any rules about using color in relation to the size of the garden?

Yes, because warm colors make a garden look smaller, use them for dramatic displays. Conversely, because cool colors make the garden look larger, they are best for plantings that will be viewed close at hand. When cool colors are used in the distance, they become almost invisible.

Are there any other plants I can grow for their foliage only?

Yes, try amaranthus, flowering cabbage and kale, snow-on-the-mountain, kochia, and iresine.

How do I design with plants with colored foliage?

Treat them as though they were colored flowers. Use red-leaved coleus and alternanthera as you would use red zinnias. Use yellow-leaved forms of these same plants as you would yellow marigolds, and dusty miller, with its silver or gray foliage, as you would white-flowered begonias.

2 *The Basics of Growing Annuals*

The first step toward success with anything is equipping yourself with knowledge about how to do it properly. The same holds true for annual flower gardening. While some annuals naturally require less maintenance than others, there are a few basic rules to follow that will make the difference between a good garden and an outstanding one.

The annual garden starts with the seed or the plant. Depending on your time constraints and your preferences, you may enjoy the creative aspects and greater flexibility of growing your garden from seeds, or you may opt for the convenience of purchasing bedding plants. Either way, your garden will be no better than the soil in which it is planted. Although maintenance is not difficult, you should learn and follow a few basic rules regarding soil, fertilizer, water, and "housekeeping" to keep your garden at its prime.

Why should I start plants from seed? Purchased bedding plants are so much easier.

Yes, they are, but there are a number of reasons to start your own seeds. Each year, there are new varieties that you may want to try, but garden centers may not carry what you want. Old favorites are often equally difficult to find. Growing plants from seed is also more economical, which is a serious consideration if you have a large garden. Plus, starting plants from seeds can be fun!

INDOOR PROPAGATION

◀ *Gardeners will be most successful with some annuals, such as pansies, if seeds are sown indoors before outdoor planting times.*

Why do I need to start seeds indoors? Can't I sow seeds into the garden in spring?

Some seeds can be sown directly into the garden, but for several reasons, others can't. Some have a long growing season and will not have time to germinate, mature, and flower if you wait until the outdoor weather is mild enough to start them in the ground. Others may not require a long period of growth before bloom but *will* flower much earlier if they are begun indoors. Plants with fine seeds should be started indoors both because they can easily wash away in the rain outside and because they will have a difficult time competing with weeds when they are young.

What are the annuals that I should start inside?

Unless you start them indoors, or buy bedding plants (see pages 35-36), you will not have success with begonia, coleus, geranium, impatiens, lobelia, African marigold, petunia, salpiglossis, salvia, browallia, ornamental pepper, periwinkle, gerbera, lobelia, monkey flower, nierembergia, poor-man's orchid, wishbone flower, pansy, or verbena.

What are the basic requirements for starting seeds indoors?

A sterile sowing medium (see page 20), steady moisture (see page 25), good air circulation, suitable temperature (see pages 25-26), and adequate sunlight or fluorescent lights (see pages 27-28).

What is the proper time to plant indoors the seeds of pansy, petunia, and other annuals that should be started early but not too soon? We often have frost in New Hampshire in May.

Pansies can be sown inside in January, but the best plants for spring display come from seed sown in July or August and overwintered in the garden or a cold frame. The pansy can stand some frost. March is a good time to sow petunias for good plants that can be set out as soon as the weather is warm enough. For

A variety of containers may be useful for starting seedlings, from flats, divided flats, and peat pots that are manufactured for this purpose to recycled cartons and cans. Use containers that are not too shallow, and be sure to provide drainage holes.

advice about when to start other annuals, see the chart on pages 140-42.

How can I start seedlings indoors so as to prevent too-rapid growth and decline?

Too-high temperatures and too early a start often account for the conditions described.

What is a flat?

A shallow, topless box (usually about three inches deep) with slits or holes in the bottom to allow for drainage of water from the soil. It is used for sowing seeds, inserting cuttings (see page 35), and transplanting young seedlings. Avoid shallow flats without drainage holes; the soil in such flats is easily over-watered. Flats that are too shallow dry out quite quickly. Various discarded kitchen containers, such as aluminum foil pans in which bottom drainage holes can easily be punched, make good flats.

Is there any rule about the dimensions of flats?

There is great variety in flat sizes. Usually they should be not less than two and one-half inches or more than four inches deep. If more than fourteen by twenty inches, they are likely to be too heavy to carry easily.

Can I purchase flats?

Specially designed units sold for the purpose help simplify the process, and are especially good for beginners. All are really just modifications of the traditional system. One such unit consists of a small plastic tray filled with a sterile planting medium (usually peat moss and vermiculite with nutrients) plus seeds that adhere to the plastic cover. To activate the tray, all one does is to punch holes in special indentations in the cover to release the seeds and then add the specified quantity of water. Such a unit eliminates the handling of seeds, provides a sterile starting medium, spaces the seeds a reasonable distance apart, and helps to avoid the danger of over- or underwatering.

Another system involves trays containing six or more compressed blocks of a special peat-based growing mixture in which one or two seeds per block are either presown or sown by the gardener. The unit is then watered.

Still another popular variant is the Jiffy-7, which when dry is a flat peat-moss wafer, but when moistened expands to form a small, filled pot in which a seed or seeds are sown. The wafers are usually placed side by side in a flat or other container. Large seeds can be sown one to a wafer and then left to grow until the plants are ready to be transplanted outdoors. Small seeds are usually sown several to a pot or seed tray and transplanted once before being set outdoors.

TIPS FOR STARTING SEEDS INDOORS

- Use a porous growing medium such as a mixture of equal parts of loam, peat moss, and sand, or a purchased soilless mix. A sterile growing medium prevents such soil-borne diseases as damping off, which can kill your seedlings.
- Keep the growing medium just moist but not sodden.
- Don't cover the seeds too deeply: fine seeds should be left uncovered, and larger seeds should be sown no deeper than twice their diameter.

Are there advantages to using flats made of compressed fiber?

Yes, they are very porous, which ensures good aeration and lessens the chance of overwatering. However, they dry out very quickly and so you must watch carefully to keep the soil moist. Do not reuse these flats as they are not sterile after their first use.

Are there any special techniques necessary when using fiber or peat flats or pots?

Yes, make sure these containers are completely soaked in water before you fill them with planting medium and sow your seeds. Otherwise, the container will act as a wick and pull moisture from the medium.

What are the reasons for sowing seeds into individual pots or Jiffy-7's?

Use these containers for seedlings that do not transplant well, because it's fairly easy to transplant from them without disturbing fragile plant roots. Some plants that do particularly well include California poppy, lavatera, love-in-a-mist, poppy, phlox, blue lace flower, larkspur, nolana, sweet pea, and creeping zinnia.

Can seed flats be reused from year to year?

Yes, but only if they are of a material such as plastic or foil that can be thoroughly cleaned to prevent transmission of disease. Those made of compressed peat or fiber should not be reused as they cannot be cleaned properly.

How should I clean flats before reusing them?

Wash them thoroughly with soap and water and rinse them in a bleach solution (1 ounce, or one-eighth cup, of bleach per gallon of water). This disinfectant is important in order to prevent damping off and other diseases.

What sowing medium is preferable for seeds sown indoors?

Use a soilless mix such as half sand, perlite, or vermiculite and half peat moss; or pure fine sand, vermiculite, or sphagnum moss watered with nutrient solution. The most convenient material is a prepared mix sold for this purpose and containing sufficient nutrients to carry seedlings through until transplanting time.

Why do seedlings begun in the house grow to about an inch, bend over, and die?

This is due to a fungus disease called *damping off*. Damping off can be virtually eliminated if you use the sterile soilless mixes. You can also help prevent it by treating the sowing medium with

Damping off, a fungus disease that frequently kills young seedlings, can be prevented by using only sterile soilless mixes for seed germination.

a fungicide containing benomyl, thinning seedlings properly, not overwatering, and giving seedlings fresh air without drafts.

How should I apply benomyl?

After you have filled the flats with growing medium, but before you sow the seeds, drench the flat with a solution of benomyl, mixed at the rate of one-half tablespoon per gallon water. Allow the flat to drain for about two hours, and then proceed with sowing.

What is the procedure for raising seedlings in sand with the aid of nutrient solutions?

Take a flat three to four inches deep, with drainage holes, and fill it with clean sand. Soak the sand with water, then with the nutrient solution (liquid fertilizer) mixed at one-quarter the strength recommended on the label. Sow seeds thinly; cover with sand unless the seeds require light to germinate; pat them in firmly with your hands or a small board. Keep the sand moist with the dilute nutrient solution. Once the seedlings have produced *true leaves* (those that appear after the seed leaves, or *cotyledons*, that spring from the plant embryo), gradually increase the strength of the nutrient solution to full strength.

How much sowing medium will I need?

About four cups of medium will be needed for each 5½-by-7½-inch flat.

I filled my flats with sowing medium and then watered the medium prior to sowing, but all the perlite floated to the top, and the medium didn't moisten evenly. What went wrong?

The medium must be moistened *before* it is placed into the flats. Put it in a large bowl or plastic bag, and use about one and one-half cups of warm water for every four cups of medium. Stir thoroughly.

Can I reuse sowing medium?

No, you should not reuse sowing medium for seeds, as it will no longer be sterile. You can reuse it, however, for transplanting seedlings from flats into intermediate pots before they are set into the ground, for container plants, and for your houseplants.

Should I use a seed disinfectant?

For most dependable germination and growth, instead of garden soil, use a sterile sowing medium, which can be purchased ready to use. If, however, you sow seeds indoors in untreated garden soil that may contain such fungus diseases as *damping off* (see page 20), you should use a soil disinfectant. This is available in powdered form. Place a small amount of the

True leaves appear after the seed leaves, or cotyledons.

powder in a paper or plastic bag, add the seeds, shake lightly with the bag tightly closed, and then plant the seeds immediately.

I have heard that some seeds should be soaked before sowing. Why is this?

Some seeds have a very hard seed coat that must be softened before the seed will germinate. Soaking these seeds in water prior to sowing softens the seed coat and hastens germination.

How hot should the water be for soaking seeds?

Use hot (190° F.), but not boiling, water, and cover the seeds two to three times their size in a shallow dish or container.

How long should seeds be soaked before they are sown?

Most seed coats will be soft enough after twenty-four hours of soaking. Change the water several times, and sow the seeds immediately after soaking so that they do not dry out.

Which seeds should be soaked?

Morning glory, hibiscus, and sweet peas are the primary annuals that benefit from soaking.

Is there any way other than soaking to treat seeds with a hard seed coat?

You can also try *scarification*, which entails nicking or breaking the seed coat slightly with a file or small scissors prior to sowing. Be careful not to cut too deeply into the seed coat, or you may damage the interior and prevent germination.

What is pelleted seed?

Some seed companies pellet, or coat, seeds that are very fine to make them easier to handle and to increase germination. Pelleted seeds should not be covered when germinating, unless otherwise instructed on the packet. Merely press them into the surface of the sowing medium with a tamper.

What is a tamper?

An oblong piece of board with a handle attached (similar to a mason's float), used for tamping soil firmly in flats. The base of a tumbler or flowerpot can be used when sowing seeds into pots or bulb pans.

What other accessories will I need to germinate seeds indoors?

So that you don't have to rely on your memory, use labels to record the type and variety of plant and the sowing date. Keep a record book as well to help you decide next year which annual seeds to buy, how long it took for the seeds to germinate,

Scarification entails nicking the seed coat slightly with a small file prior to sowing.

whether you started too early or too late, and whether you grew too few or too many of a particular plant.

I have had problems germinating pansy and phlox seeds indoors. What might be the cause?

Seeds of some annuals, including pansy, phlox, blue daisy, bells-of-Ireland, verbena, and ornamental cabbage, require chilling before they are sown. This process is known as *stratification*. Seeds must also be moist during the chilling, so do not chill them in the seed packet. Mix the seeds with two to three times their volume in moistened sowing medium and place in the refrigerator for the necessary time period (see the specific plant listings in Chapter 5).

Can seeds be stratified outdoors?

Yes, you can prechill your seeds outdoors provided the temperature is constantly below 40° F. for the necessary chilling period. You may wish to sow right into their flats and place them outdoors for the necessary time.

Stratification involves mixing seeds with growing medium in an amount equal to two to three times their volume, and then chilling them in the refrigerator.

How do I go about sowing seeds of annuals indoors in a flat?

If the drainage holes in the flat are large, cover them with moss or pieces of broken flowerpot. Fill the flat to within one-quarter inch of the top with moistened sowing medium that has been rubbed through one-quarter-inch screening. Level and gently firm the surface with a flat board or tamper, and sow the seeds.

How deep should seeds be planted in flats and pots indoors? How deep in rows outdoors?

Indoors, very small seeds are merely firmly pressed into the sowing medium with a tamper, or covered with a dusting of the medium, sand, or vermiculite; medium-sized seeds are covered one-eighth to one-quarter inch; and large seeds, about two to three times their diameter. Outdoors, seeds are customarily covered a little deeper.

Are there any rules about which types of seeds to sow together? I want to grow several types of seedlings in the same flat.

Yes, combine those seeds that have the same requirements, such as temperature, the amount of light (or dark) required for germination, and the length of time needed for germination.

Is it better to scatter the seeds or to sow them in rows?

When flats are used, it is preferable to sow in rows. You can judge the rate of germination better, cultivate lightly without danger of harming seedlings, and transplant with more ease. When pots are used, seeds are generally scattered evenly and thinly. Further, when sowing very fine seeds, it is often difficult to sow them in rows and broadcasting may be easier.

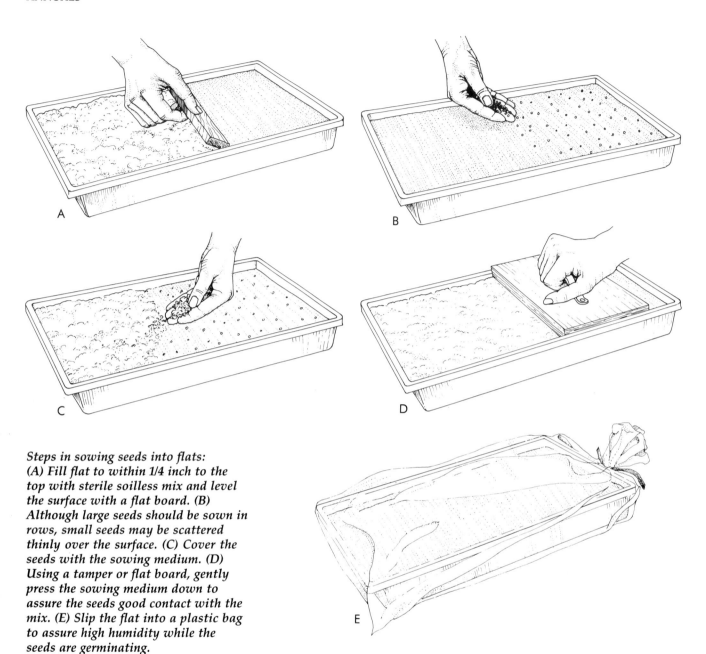

Steps in sowing seeds into flats:
(A) Fill flat to within 1/4 inch to the
top with sterile soilless mix and level
the surface with a flat board. (B)
Although large seeds should be sown in
rows, small seeds may be scattered
thinly over the surface. (C) Cover the
seeds with the sowing medium. (D)
Using a tamper or flat board, gently
press the sowing medium down to
assure the seeds good contact with the
mix. (E) Slip the flat into a plastic bag
to assure high humidity while the
seeds are germinating.

How can very small seeds be sown evenly?

Seeds that are too small to handle may be mixed thoroughly with sand before sowing.

How do I plant larger seeds?

First, tear a piece off the corner of the seed packet. Then, holding it between your thumb and forefinger, tap it gently with your forefinger to distribute the seed.

Should I sow more seeds than I need?

Definitely! Not all of the seeds will germinate, and some will be lost in transplanting. If you have extra plants, you can share them with your neighbors and friends.

Is it a good idea to sow all of my seeds?

No, save a few, just in case something goes wrong and you have to start over.

After I sow my seeds, how should I treat the flats?

It is important to keep humidity high around a seed flat so seeds will germinate properly. The best way to do this is to slip your flats into a clear plastic bag or cover them with a pane of glass until germination occurs. Once the seeds have germinated, remove the plastic or glass. This technique also eliminates the need for watering and the possibility of dislodging the seeds during the germination period.

I placed my flats in plastic bags, and then noticed a great deal of condensation inside. Is this a problem?

When this happens it is best to remove the flats from the bag for a few hours to let the medium dry out. Although condensation can be caused by a change in room temperature, it may also be a sign that the flats are too wet. In this case, allow the flat to dry out a little by removing the bag.

How should seed flats be watered after the seed is sown?

Water thoroughly after seeding with a fine overhead spray from a watering can or a bulb-type or mist sprinkler (see page 26) until the soil is saturated. Subsequently, water when the surface soil shows signs of dryness. It is important neither to overwater nor to permit the flat to dry out.

Can seed flats be watered by standing them in a container of water?

Yes, if more convenient, but do not leave the flat in water any longer than necessary for moisture to show on the surface. Place the flat in water about one inch deep. If you submerge the flat, water will wash in and displace the seeds. Many growers prefer this method to watering the surface, as it lessens the danger of washing out fine seeds.

What temperatures do seeds need to germinate properly indoors?

Most seeds require a temperature of 70° F. within the medium. (See next questions.)

Do some seeds require a cool room for germination?

Yes, some seeds require a temperature of about 55° to 60° F. These include California poppy, sweet pea, bells-of-Ireland, baby-blue-eyes, penstemon, blue daisy, linaria, forget-me-not, and annual phlox. An unheated sun room, attic, or basement might be the perfect place.

Two watering methods: (above) by sprinkling with a fine overhead spray, or (below) by placing the flat in a larger pan containing about 1 inch of water.

I have had trouble germinating seeds of double petunias indoors. Any suggestions?

Double petunias, as well as hybrid petunias, lobelia, and geraniums require temperatures that are higher than normal household temperatures to germinate properly.

I keep my house very cool in winter. What can I do to give my seeds the warmth they need to germinate?

Give the seedling flats bottom heat during the germination period. Garden centers offer heating cables or trays to place under the flats for warmth. Some have a thermostat that automatically keeps the flats at the proper temperature. In lieu of a thermostat, use a soil thermometer to check the temperature. If you don't have heating cables, the outside top of your refrigerator is often warm enough to germinate seeds.

Once the seeds have germinated, move them into good light so they will grow properly.

Are heating cables needed during the summer to germinate seeds?

No, probably not, unless your house is air conditioned.

What is the best germinating temperature for annual nicotiana and annual gaillardia? I have planted both late in the spring with dubious results. Must they have a cooler temperature to start?

Indoors in the spring, a night temperature between 50 and 55° F. is suitable. The fine seeds should be barely covered and, in fact, need light for adequate germination. Annual gaillardia germinates well outside in late spring. Self-sown nicotiana often germinates in early June, but this is a bit late for best effect in most northern regions.

I sowed snapdragon and begonia seeds last year, and did not cover them with a growing medium as they were very fine in size. However, germination was poor. What did I do wrong?

Fine seeds must be in contact with the moistened medium to germinate. Those that failed to germinate may have been caught in small air pockets. After sowing fine seeds, gently press them onto the medium, or water them with a very fine spray of water to ensure that they are touching the medium. A rubber bulb sprinkler will ensure a fine spray of water that will not dislodge the seeds.

I saved seeds from last year. Is there any way to tell if they are still good before I sow them?

Yes, take ten seeds and place them in a moistened paper towel. Place the paper towel in a plastic bag. Set it in a warm spot (unless it is an annual that likes cool temperatures to germinate).

A bulb-type sprinkler ensures a fine spray of water that will not dislodge even very tiny seeds.

Consult the chart on pages 140-42 to see how many days are normally required for germination. After that time, start checking the seeds. If eight or more have germinated, the seeds are fine. If five to seven have germinated, sow more seed than you normally would. Fewer than five, and you won't have good results. Fewer than two, don't use these seeds at all.

How much light is needed during germination?

That depends on the type of seed you are sowing. Since many seeds are covered with sowing medium during germination, they do not need to receive any special light until after they have germinated, when they must be moved into a sunny windowsill or under fluorescent lights. Yet there are some seeds that do specifically need light to germinate, and others that require darkness. See the accompanying list for advice.

How do I ensure that seeds requiring darkness do not get any light?

If you cover the seeds with sowing medium, this is all the darkness they require. Because very fine seeds such as salpiglossis, poor-man's orchid, and ice plant should not be covered with medium, their flats must be covered with black plastic during germination. Check the flats every day and remove the cover as soon as the seeds have germinated.

When starting seeds in the house in the winter, what do you put in the soil so that plants will be short and stocky, not tall and spindly?

No soil treatment will prevent this. Good light, moderate temperature, and uncrowded conditions are the preventives. Rotate the pots daily to keep the plants from turning to the light. If your windows supply insufficient light, use fluorescent lights.

What unit is best for starting seeds under fluorescent lights?

The most commonly sold unit consists of two 40-watt fluorescent tubes four feet long. Most seedlings will grow satisfactorily under such lights until they reach a sufficient size for planting outdoors. However, for superior results (or to force many annuals and houseplants to flower indoors), use a larger unit, such as one with four 40-watt fluorescent tubes four feet long. The light unit should be adjustable so that it can be raised or lowered according to the needs of the plants. When the plants are small, the lights are set about three inches above them and then gradually raised as the plants grow.

How can I tell if my seedlings are receiving the proper amount of light?

If the plants show signs of burning (foliage darkens and curls), the lights should be raised. If seedlings are growing tall and

SEEDS THAT REQUIRE LIGHT TO GERMINATE

ageratum
begonia
bellflower
bells-of-Ireland
browallia
coleus
creeping zinnia
flowering cabbage and kale
gerbera
impatiens
Mexican sunflower
nicotiana
ornamental pepper
petunia
red-flowered salvia
snapdragon
stock
strawflower
sweet alyssum

SEEDS THAT NEED DARKNESS TO GERMINATE

bachelor's-button
calendula
forget-me-not
gazania
ice plant
larkspur
nasturtium
nemesia
pansy
penstemon
periwinkle
phlox
poor-man's orchid
poppy
sweet pea
verbena

Two 4-foot-long fluorescent light units provide enough light for a substantial number of seedlings.

spindly, they are not receiving enough light, and the lights should be lowered. See the list of suggested readings in the Appendix for more information on raising both indoor and outdoor plants under lights.

Are fluorescent lights left on constantly or should plants have a dark period?

The lights are generally left on around the clock until the seeds germinate. After that, leave them on from fourteen to sixteen hours per day, during the daytime. An automatic timer is a great convenience for this purpose.

What are the advantages of growing seedlings under fluorescent light as compared to growing them in a sunny window?

Fluorescent bulbs give a steady supply of light at all seasons, whereas if you depend on natural light, cloudy days and the low intensity and short duration of light in winter can cause disappointing results.

When should I start to fertilize my seedlings?

Begin fertilizing when the first set of *true leaves* have developed (the first growth you will see are *cotyledons*, which are food storage cells, and not leaves). Use a soluble plant food at one-quarter label strength at first, gradually increasing to full strength as the plants mature.

Can I transfer my seedlings to the garden from the flat in which they were sown?

This is generally not a good practice, unless the seeds were sown into individual pots or into flats divided into cells. Once two sets of true leaves (see page 21) have developed, it is best to transplant seedlings into individual cells or pots so their roots can develop properly and thus not be subject to transplanting shock later on.

What is the best mixture for transplanting seedlings from flats to pots?

Four parts garden soil (two parts sand, if the soil is heavy clay), two parts peat moss, and one and one-half parts dried manure or compost. Add one-half cup of 5-10-5 fertilizer to each peck of mixture, and mix all ingredients well. Even better, use soilless mix, and apply a fertilizer according to the recommendations on the container.

What is the proper method of transplanting seedlings into pots from flats?

First, water the seedlings well. Next, prepare the cells or pots and fill them with moistened growing medium, making a hole in the center into which the seedlings will be placed. Gently lift the seedling from the flat using a spoon handle or similar tool. To avoid breaking the stem, always handle the seedlings by their leaves and never by the stem. Lower the seedling's roots into the hole and gently press the medium around the roots.

After I transplanted my seedlings, they wilted. What went wrong?

Wilting is normal after transplanting. Place newly transplanted seedlings in good light, but not full sun, for a few days before returning them to full light. If transplants wilt severely, place them in a plastic bag or mist them regularly until they recover.

Do seedlings need to be pinched after being transplanted?

Some, especially snapdragon, lisianthus, dahlia, and any other seedlings that are growing too tall, benefit from pinching at this point to keep them from becoming too leggy. Simply reach into the center of the plant with your fingers and pinch out the growing tip.

How do you make new plants blossom early in the spring?

Unless plants are begun in a greenhouse where they can be forced (pushed to earlier development than would occur at that time of the year if they were growing outdoors), there is not much that can be done to make them bloom early; most have to reach a certain age before they will flower.

Steps in transplanting seedlings into divided flats:

A

B

(A) After watering seedlings well, gently lift them from the flat using a spoon handle or similar tool. (B) Holding the plant by a leaf, gently place the seedling into a preformed hole in the flat.

To encourage bushy growth, pinch out the growing tip of such plants as snapdragons, lisianthus, and dahlias.

OUTDOOR PROPAGATION

I have very little room in my house to start seedlings indoors. Which annuals can be started directly in the garden?

These include African daisy, amaranthus, China aster, calendula, California poppy, candytuft, Cape marigold, celosia, spider flower, calliopsis, cornflower, cosmos, dahlia, dusty miller, gaillardia, kochia, larkspur, French marigold, nasturtium, nemesia, cupflower, love-in-a-mist, four-o'clock, phlox, portulaca, scabiosa, stock, sweet alyssum, sweet pea, Mexican sunflower, zinnia, lavatera, mignonette, sunflower, and clarkia.

Which flower seeds should be sown where they are to grow because of difficulty in transplanting?

Poppy, larkspur, California poppy, nasturtium, portulaca, mignonette, lavatera, love-in-a-mist, phlox, blue lace flower, nolana, sweet pea, and creeping zinnia.

How can I tell when my soil is ready to be worked?

To test soil for readiness, take a handful of it and squeeze it. If it stays together in a ball, it is too wet and cannot be worked or its structure will be ruined. Wait a few days and try again. If it crumbles, however, it is ready.

What should the temperature be before planting annuals in the garden in New York?

There can be no set temperature figure. Hardy annuals can be seeded as soon as the ground is ready to work; half-hardy annuals, about four weeks later. For tender annuals, wait until all danger of frost is past for the region; in and around New York State, this is usually during the second week of May.

I understand some annuals can be planted in the fall for bloom the following summer. Which annual seeds are suitable for autumn planting in the north?

Larkspur, annual poppy, California poppy, sweet pea, portulaca, nicotiana, salvia, celosia, spider flower, sweet alyssum, cornflower, calliopsis, kochia, spurge, balsam, cosmos, candytuft. Sow them sufficiently late so that they will not germinate before freezing weather, and plant them slightly deeper than you would with spring sowing.

Which annual seeds are suitable for autumn planting in the south?

You can plant the same type of plants that are recommended for the north, but they should be planted early enough so that they germinate in the fall. In the fall, mulch the plants with leaves, straw, or pine needles if freezing temperatures will occur over the winter, and remove the mulch in early spring.

Is it advisable to sow seeds of cosmos, zinnias, and marigolds in late autumn, so that they can germinate the first warm days of spring?

They won't germinate until the soil is warm—considerably later than the "first warm days of spring," so early planting won't give you any earlier germination and growth with these particular annuals.

How late is "late" when we are told to plant seed in late autumn?

Usually about the average time of killing frost. Some seeds (sweet peas and other hardy annuals) can be sown after the frost, provided the ground is not frozen.

Is it necessary to prepare the soil for seed planted in the fall?

For best results, yes. However, for an informal garden, seeds can be scattered on lightly raked-over soil.

I have purchased a self-ventilating cold frame. When can I sow annual seeds in it?

These solar-powered frames usually open automatically when the temperature reaches around 70° F. and close when it drops to 68° F. In most northern areas, hardy annuals can be sown into it in March, half-hardy annuals in early April, and tender annuals a few weeks later.

How should I prepare my outdoor seed beds? I am creating a new flower garden.

Remove the grass and any stones or debris that are in the soil. Soil must be dug to a depth of eight to ten inches. If you have a rotary power tiller, this will make the job easier. If not, use a spade or fork to turn the soil over.

How deep should the soil be prepared for annuals?

Nine inches for good results. Some growers go twice this depth to assure maximum growth.

Do annuals have decided preferences for acid or alkaline soil?

Most popular garden flowers like a soil that is slightly acid to neutral. Those annuals that like alkaline soils are China aster, dianthus, salpiglossis, scabiosa, strawflower, and sweet pea.

How do I know whether my soil is acid or alkaline?

You should test the soil to determine its pH, or acidity/alkalinity level. You can do this yourself with a soil test kit available at your local garden center, or have it tested by your local Extension Service. Most annuals like a pH of 6.5 to 7.0. If

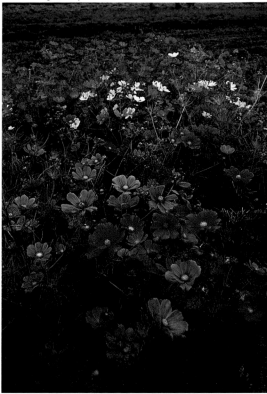

Cosmos seeds may be planted in fall for bloom the following spring.

the pH needs to be raised, use lime; if it needs to be lowered, use sulfur. If the pH needs adjustment, do not add fertilizer to the bed for two weeks after the adjustment.

I have heard there are different types of lime. Which is best for the garden?

To avoid burning, apply hydrated lime, which is quick acting, several weeks prior to planting and water it in well. For less risk of burning, use crushed limestone, which is much slower acting and longer lasting, but requires a heavier application than hydrated lime. Dolomitic limestone is particularly good as it contains the essential trace element magnesium.

What sort of amendments should I add to the soil?

Prepare the seedbed by adding organic matter such as peat moss, compost, leaf mold, or well-rotted manure. If drainage is poor, also add perlite, vermiculite, gypsum, or coarse sand. A complete fertilizer such as 5-10-5 should also be added at this time, unless the pH needs adjustment (see above). Work the material into the soil and rake it smooth and level.

How much organic matter should I add to the soil?

After you have removed the grass, stones, and any debris, add a layer of organic matter, at least two inches thick, on top of the soil and then work it in. If a flower bed has been in the same area and improved each year for several years, less organic matter will be needed.

Why is it important to add organic matter to the soil?

Organic matter not only increases the soil's fertility because of the nutrients it contains, but it also improves the soil's texture. Organic matter makes clay-like soils more friable (more readily crumbled) and it aids sandy soils in retaining moisture.

What is meant when soils are termed "heavy" or "light"?

A heavy soil is one that is very clay-like and sticky, especially when wet. A light soil is dry and sandy. The ideal soil, often called loam, is something between the two.

How do I go about planting an annual garden from seed sown directly into the ground? The garden is about four feet wide and fifteen feet long and receives sun all day. What annuals would be the most reliable to sow?

After raking the soil as smooth as possible, use lime or string to outline the various sections where the seeds are to be planted—as though you were making a giant plan on paper. If you first draw your garden plan on graph paper, you can transfer the design quite simply in this manner.

The easiest annuals to sow directly in place are sweet alyssum as an edging, nasturtium and several varieties of French marigolds and zinnias for medium height, and spider flower and tall zinnias for background. Most seeds can be *broadcast*—scattered freely over the seedbed and then covered with the designated amount of soil. Once the seeds germinate, you can transplant or thin your plants; but in a display of this sort, a certain amount of crowding is permissible and even desirable. If one kind of seed doesn't germinate, you can spread out those from other sections to fill in its space.

Should the seed bed be wet before seeds are sown?

Definitely. Water the beds first to ensure they are evenly moist before sowing. After sowing, water again.

How deep should I plant my seeds?

Instructions are usually given on seed packets, but a good rule of thumb is to plant them to a depth equal to their thickness.

I have trouble planting my seeds at the proper depth. Any ideas?

Make a furrow in the soil at the proper depth with the side of a trowel or a yardstick. After sowing, pinch the soil together with your fingers and firm it well. Seeds will not germinate unless they are in contact with moist soil.

How close together should I plant my seeds?

Although instructions are usually given on the seed packet, a rule of thumb applies: sow them twice as close as the final recommended planting distance.

How does one sow seeds of annuals in patches outdoors?

Fork over the soil, then rake the surface to break lumps and remove large stones. If the seeds are small (sweet alyssum or portulaca, for example), scatter them evenly and pat down the soil. For medium-sized seeds, rake the soil lightly again after sowing and pat it down. For seeds that have to be covered one-quarter inch or more, scrape off the soil to the required depth, sow the seeds, and return the soil that was removed or cover the area with fine vermiculite.

I have seen seed tapes in a seed catalog. What are these?

Some seed companies implant their seeds, especially fine seeds, into tapes. Merely cut the tapes to the desired length and place them on the ground. The tapes will dissolve as the seeds grow. Their advantages are that the seeds have been properly spaced in advance, you do not have to handle fine seeds, and there is no chance that they will wash away.

Steps in making a garden plan:

(A) Draw your garden design on graph paper. (B) Following your graph paper plan, transfer your design to the prepared bed by outlining each area with string; broadcast seed in the designated areas.

English sparrows take dust baths in my newly planted seed patches. How can I prevent this?

Lay pieces of burlap or fine brush over the seeded areas. Keep the seedbed constantly moist. When the seeds have germinated, remove the protective covering.

What is the best method of ensuring germination of small flower seeds in a heavy clay soil that consists mostly of subsoil excavated when the house was built? It grows plants very well once they get started.

First, work in a generous amount of peat moss, sifted compost, or rotted manure to improve the general texture of the soil. Then hoe out rows two inches wide and deep, fill the hollows with good screened compost, and sow the seeds into that.

How often should I water my seedbeds?

Until the seeds germinate, the bed should never be allowed to dry out; water every day if it doesn't rain. When seeds first germinate, they will still need daily watering. After a week, reduce the watering gradually until you are watering once a week. This encourages deep roots and plants better able to withstand heat and drought when summer comes.

What other care do I need to give my flower beds at this time?

Keep the beds well weeded, as weeds compete with annuals for light, water, and nutrients. Weeds also cause crowding and the possibility of disease. Remove them carefully so that the annuals are not disturbed, and water after weeding. Watch for signs of insects and disease. Slugs and snails are very damaging to young seedlings, especially marigolds and petunias. Trap them with slug bait after every watering or rain.

When should I thin my seedlings?

After seedlings are two to three inches high, or have developed two or three sets of true leaves, it is time to thin them.

What is the best way to thin seedlings?

Water the ground first to make it easier to remove unwanted seedlings. Choose cloudy weather and spread the operation over two to three weeks or as necessary as the plants develop. Pull up the weakest seedlings before they crowd each other, leaving two to six inches between those remaining, according to their ultimate size. Pull them carefully so that the ones that remain are not disturbed. When those left begin to touch, again remove the weakest, leaving the remainder standing at the required distance apart. You can use the seedlings that you remove in another part of the garden or share them with friends and neighbors.

For a bountiful display of geraniums, take cuttings from mature plants and root them.

Ann Reilly

In addition to plants begun by sowing seeds, either indoors or out, you may also begin some annuals by taking cuttings from mature plants.

How are plants like snapdragon, petunia, verbena, coleus, impatiens, geraniums, and other annuals started as cuttings from the original plant?

Root short side or tip shoots, three to four inches long, by placing them in sand in a closed container in July and August. If the shoots have flower buds, these should be pinched off. Alternatively, the cuttings—called *slips*—can be taken in the fall or through the winter if you pot up plants from the garden and bring them indoors.

Why does coleus wilt so badly when I try to start new cuttings in soil?

The air around the cuttings may be too dry. Cover them with a preserving jar or polyethylene bag until they have formed roots. Trim large leaves back one half. A soilless medium is better than garden soil for rooting.

How are geranium cuttings rooted?

Geranium cuttings may be rooted in sand or in a peat pot almost any time of year indoors and in late summer outdoors. Take a four-inch cutting one-quarter inch below a leaf attachment. Remove lower leaves and stipules. Insert about one-third of the stem into the growing medium. Keep the medium moist, but not soggy.

What is the best method of handling lantana cuttings? Our cuttings this year rooted well and seemed to be off to a good start. Soon after potting, however, they wilted and died. We kept them shaded and did not overwater them.

After potting them, water them thoroughly and keep them in a closed, shaded propagating case for a week or two. Then gradually admit more air and remove the shade.

It is now that time in spring when new life is showing everywhere: trees are leafing out, flowering trees and shrubs are in bloom, bulbs are at their peak, your hardy annuals that you began outdoors are off to a healthy start, frost danger is past. You have prepared your beds as for seeding, and it is time to plant the seedlings you began indoors as well as the bedding plants you purchased.

When should flat-raised seedlings be transplanted?

You may wish to transplant seedlings into larger flats indoors when they form their first true leaves in order to give them better

CUTTINGS

To take geranium cuttings, cut a four-inch piece one-quarter inch below a leaf attachment, remove lower leaves, and insert about one-third of the stem in soilless growing medium.

TRANSPLANTING ANNUALS INTO THEIR PERMANENT LOCATIONS

spacing. Alternatively, you may simply thin them and allow the remaining plants to grow in the original tray or flat until they are ready to go outdoors. Many plants benefit from a second transplant to individual pots when they are two or three inches high, before they are moved outdoors. In either case they may need a light feeding before being set in the garden.

When should annual seedlings be moved outdoors?

Most seedlings require six to eight weeks of growth time indoors before being transplanted into the garden. The timing is the same whether the seedlings are grown under fluorescent light or on a windowsill, provided the window supplies enough light. Plant hardy annuals outdoors as soon as they are large enough and the soil can be worked. Tender annuals must wait until all danger of frost is past.

Do any seedlings require more than six to eight weeks indoors?

Wax begonia, dianthus, geranium, impatiens, lobelia, pansy, petunia, salvia, wishbone flower, and snapdragon require ten to twelve weeks indoors before being transplanted into the garden.

Is there anything I need to do to get my annuals ready to be moved outside?

Yes, you must put them through a progress called hardening off. One week before transplanting plants into the garden, move them outdoors and place them in a shady, protected spot or a cold frame. Bring them back inside at night. Each day, increase the amount of light and time outdoors, and toward the end of the week leave the plants out all night.

Nurseries often advertise "bedding plants." What does this term mean?

Bedding plants are those raised indoors specifically for the purpose of planting in open-air beds.

If I purchase my bedding plants, when should I set them?

Wait until proper planting time, and then purchase them as close to the time that you are going to plant them as possible. If you can't get them in the ground right away, be sure to water them daily.

I like to buy my bedding plants in bloom so I know what color they are. Is this a good idea?

No. Plants do not need to be in bloom; in fact, most annuals grow better and bloom earlier if they are not in bud or bloom when planted. An exception to this is the African marigold, which must be planted in bud or bloom (see page 106).

What should I look for when buying bedding plants?

Look for healthy, dark green plants that show no sign of insects or disease and that are not too tall or spindly.

I have difficulty removing annuals from flats without ruining their root systems. Any pointers?

Water your annuals thoroughly before transplanting. This makes it easier to remove the plants without disturbing their root systems. Most purchased bedding plants today are grown in individual cells. Removal is easy; if the plants don't fall out easily, they can be pushed up from the bottom. If your plants are not in individual cells, with an old knife or a small mason's trowel, cut the soil into squares, each with a plant in the center. The plants can easily be removed with their root systems almost intact.

Annuals that have been grown individually in peat pots can be left in the pots when being planted, but it is advisable to break the pots in a few places to help the roots penetrate into the soil more readily. Be sure to set the top edge of the pot *below* the soil level or it will draw water from the soil like a sponge; the water will then evaporate, instead of nourishing the plant.

What is the right technique in setting out (planting) annual plants?

Water the ground, then stab the trowel in the soil and pull the earth toward you. Set the plant in the hole, remove the trowel, and push the soil around the roots. Press the soil down firmly, leaving a slight depression around the stem to trap water.

How much space should be given annuals when thinning them or setting them out?

The distance varies according to the variety and growth habit of the plant. A rough rule is to set them a distance equal to one-half their mature height. Look for directions on the seed packet, or follow the guidelines on the chart on pages 137-39.

What is the best time of day to transplant annuals?

To reduce transplanting shock, do your planting late in the afternoon, or on a cloudy day. The one exception to this rule is multiflora petunias, which do not mind being transplanted in full sun during midday.

How should I care for my transplants?

Water well after transplanting and again daily for about a week until the transplants are well established and show signs of growth. Gradually reduce watering until about once per week, which should be sufficient for the remainder of the summer unless it becomes quite hot. Keep the beds well weeded

Steps in transplanting seedlings: (A) Water plants thoroughly, then push them up out of divided flats. (B) Water the ground where the plant will be set, pull the earth toward you with a trowel, and set the plant in place, pushing the soil in around the roots. (C) Firm the soil around the plant, leaving a slight depression around the stem to trap water.

and watch for signs of insects and diseases, especially slugs and snails. Some transplants may wilt at first, but daily misting and/ or shading will help them to revive quickly.

After I transplanted my seedlings, we had an unexpected late frost, and I lost all of my seedlings. Is there anything I could have done?

Yes. If frost is predicted, place hot caps or styrofoam cups over the seedlings in the evening, and remove them in the morning.

GENERAL CULTURE

Is it wrong to plant the same kind of annuals in the same space year after year?

As long as the soil is well dug each year and the humus content is maintained, there is nothing wrong with the practice. However, China asters, snapdragons, and marigolds are susceptible to some soil-borne disease problems, and thus should not be planted in the same spot in consecutive years.

What type of soil and what fertilizing programs are best for annuals?

Most annual flowers do best in a well-drained, rather light (as opposed to clayey) soil in full sun. Unless the soil is really rundown and deficient in plant nutrients, or you are starting a new bed, only a light annual application of rotted manure, peat moss, and/or compost, plus some standard commercial fertilizer, is advisable. (See also pages 31-32.)

What do the numbers on a fertilizer label mean?

The numbers indicate the percentage of nitrogen, phosphorus, and potassium (the chemical symbols N,P,K) present. For flowering annuals, it is important that the second number, or the phosphorus percentage, be higher than, or equal to, the nitrogen percentage. If it is not, you will have a lot of growth but few flowers. For this reason, lawn fertilizer, which is high in nitrogen, should not be used on your flower beds.

Nitrogen is necessary for foliage and stem growth and for the dark green leaf color. Phosphorus is necessary for root development and flower production. Potassium (sometimes referred to as potash) is necessary for plant metabolism and the production of food.

How much fertilizer should I use?

That depends on the type of fertilizer. Read the label, which will give you detailed instructions. As a general rule, use one to two pounds of 5-10-5 per one hundred square feet on a new bed and one pound per one hundred square feet on an established bed.

What is the best fertilizer for annual and perennial flower beds?

For most annuals and perennials, a 4-12-4 or 5-10-5 fertilizer is satisfactory. It should be worked into the beds before planting. Those annuals that like to be fed during the growing season as well can be fertilized very effectively with a soluble fertilizer such as 20-20-20. Check individual plant entries in Chapter 5 to determine which annuals like additional feedings during the summer.

What is slow-release fertilizer? Can it be used on annuals?

Slow-release fertilizer is a special type that is inactive until released by water or temperature. It works very well on annuals as long as you buy the three- or six-month formulation. Apply it in early to mid-spring; no additional feedings will be necessary.

I like to apply liquid fertilizer to my annuals, but I have a big flower bed, and mixing large amounts of solution is very time-consuming. Is there another method?

Yes. You can purchase a device called a proportioner. One end of the proportioner is inserted into a container of concentrated fertilizer solution and the other end is fastened to the garden hose. As you water, the proportioner automatically dilutes the solution to the proper level.

Which annuals should not be fertilized?

There are some annuals that must be grown in infertile soil, or they will not bloom. These include nasturtium, spider flower, portulaca, amaranthus, cosmos, gazania, and salpiglossis.

How often should I water my annual flower beds?

Under normal circumstances, apply one inch of water once a week. If it becomes very hot during the summer, or if your garden is in a windy spot, or if your soil is very sandy, you may need to water more often.

How can I determine whether my soil is receiving one inch of water?

Place an empty coffee can halfway between the sprinkler and the furthest point it reaches. Time how long it takes for one inch of water to accumulate in the can. Presuming the water pressure remains constant, run your sprinklers for the amount of time it took for one inch of water to collect in the can.

Why do I need to water my flower beds only once a week? Couldn't I sprinkle them lightly every day?

This is the worst thing you could do. Light, frequent watering encourages shallow roots. When it becomes hot or if you go

A proportioner, which is attached to your garden hose, automatically dilutes fertilizer solution to the proper level as you water.

Nasturtiums do best in infertile soil and should thus not be fertilized.

Ann Reilly

away for a few days, shallow-rooted annuals will not survive. Deep watering encourages the roots to grow down deep rather than along the soil surface.

Is it a good idea to water my flower bed with an overhead sprinkler?

Overhead watering is perfectly acceptable in most instances, and actually cools off the plants and washes dirt off the foliage. For plants such as zinnia, calendula, grandiflora petunia (see page 116), and stock that are susceptible to disease, however, water in the morning so the foliage is not wet during the night. In addition, you might not want to water your cutting garden overhead as the water could damage the flowers. In this case, soaker hoses laid on the ground are the best method.

My community has imposed severe watering restrictions. What can I do to have a flower garden in spite of this?

Prepare the soil well with abundant organic matter and use an organic mulch (page 32), both of which will help keep the soil moist. Plant drought-resistant annuals like portulaca, celosia, cosmos, sunflower, amaranthus, candytuft, dusty miller, gazania, spider flower, sweet alyssum, or periwinkle.

How shall I top annuals to make them bushy?

Pinch out no more than the growing point with your thumbnail and index finger. This technique, aptly called *pinching back* (see page 29), induces branching.

Which annuals, and at what stage, should be pinched back for better growth and more flowers?

These annuals can be pinched to advantage when they are from two to four inches high: ageratum, snapdragon, cosmos, nemesia, petunia, phlox, salvia, poor-man's orchid, marigold, and verbena. Straggly plants of sweet alyssum can be sheared back in midsummer for better growth and to induce flowering later in the season.

Is it true that if flowers are picked off they bloom better?

On plants that continue to make flowering growth, it is best to pick off flowers as soon as they fade. Known as *deadheading*, this prevents the formation of seed, which is a drain on the plant's energy.

What would cause annuals to grow well but come into bud so late in the summer that they are of little use? The seed was planted late in April.

Most annuals bloom at midsummer from April-sown seed, but lobelia, scarlet sage, wishbone flower, and Mexican sunflower are examples that should be sown indoors in March for a

To prevent seed production and a consequent drain on plant strength, remove the faded flowers from annuals that continue to produce bloom.

head start. The late, older varieties of cosmos usually do not have time to flower in the North, even if sown early indoors. There may be another problem, as well. Did you fertilize heavily? This could cause strong leaf growth at the expense of flowering.

Why do I have to stake so many plants—zinnia, marigold, and other common plants? They grow well and bloom generously, yet if not tied, they do not stay erect.

It could be insufficient phosphorus in the soil or inadequate sun. Perhaps they are exposed to too much wind, or heavy rains could have beaten them down.

What type of material can I use as a stake?

Almost anything that will hold the plants up, such as bamboo sticks or metal poles. Tie the plants loosely to the stakes with a twist tie or a string so the stems of the annuals will not be pinched or damaged. Or place three or four stakes around a clump of plants and circle them with string high enough up to support the stems and form a kind of fence around them.

What is meant by succession planting?

Some annuals have a short blooming time. To have a continual supply of color, plant several batches of these one to two weeks apart from spring planting time through early to midsummer.

Most of our annuals cease blooming about August, leaving few flowers for fall. Is there any way we can renew our plantings so that flowers are available until late in the season?

There are numerous annuals which, sown in the summer, will provide bloom right up until the frost. These are browallia, calendula, celosia, marigold, sweet alyssum, wishbone flower, verbena, and all types of zinnias. (The following dates for sowing apply to the New York City area and are thus applicable to a large portion of the United States. Use the average date of the first killing frost in fall as a guide in more northerly sections.) With care, many seeds can be sown outdoors and seedlings can be transplanted directly to their flowering quarters. Plants such as torenia and browallia do better when transplanted into temporary pots until their permanent location is ready. Sow these the first week in June and then transplant them to three-inch pots. At the same time sow celosia, nicotiana, dwarf scabiosa, and tall marigolds. The third week in June sow candytuft, phlox, and marigold; this is the time, too, to sow California poppy, either where it is to bloom or in pots. None of these will grow to the size of spring-sown plants. The last week in June to the first week in July sow calendula, sweet alyssum, and zinnias of all types. Sweet alyssum, calendula, and verbena will survive light fall frosts.

To support a group of tall annuals such as cosmos, place three or four stakes around the plants and circle them with string placed high enough to support the stems and form a fence around them.

Individual plants such as larkspur can be supported by tying stems loosely to a stake with string or a twist tie.

Ann Reilly

Gazania, neatly mulched with bark chips.

How can I save the seed from annual flowers?

Select healthy plants of the best type and allow the seeds to mature on the plant. Gather them before they are shed, then dry them in a dry, airy place that is safe from mice. (But see page 3.)

Will seed from hybrid annuals flower the following year?

Seeds of annual hybrids saved one year should give flowers the next. Some may come close to true (resemble their parents), but it is more likely that there will be wide variation. (See page 3.)

When different shades of the same flower are planted together, which ones may I save seeds from and have them come true to their parent?

You don't have much chance of getting seed that will come true from any of them.

I realize that it is important to keep weeds out of flower beds because weeds harbor insects and disease and compete with the flowers for light, water, and nutrients—but it is hard work. Any suggestions?

Weeding is a chore nobody likes to do. Since many weeds are spread by seeds, it is important to pull weeds before they flower and the seeds fall and sprout. In addition to hand-pulling, you can weed around mature plantings with a hoe, use a pre-emergent herbicide to prevent seeds from germinating, and apply mulches to discourage weeds.

I have read about using black plastic as a mulch. Does this prevent weeds?

Yes, it does, and quite well. Be sure to punch holes in the plastic, though, so water can penetrate to the plants' roots. Porous fabric mulches are now available that are better than plastic. If you don't like the looks of black plastic, cover it with a mulch of leaf mold, bark chips, pine needles, or other unobtrusive material.

What is a preemergent herbicide?

This is a granular herbicide that is applied to the soil and watered in. It prevents weed seeds from germinating and is thus effective against annual weeds. Several on the market (Dacthal and Treflan, for example) are safe for most annuals. When using such a product for the first time, try it in a test plot before using it widely in your garden.

Can I apply liquid weed killer to the flowers in my garden?

We do not recommend this practice as liquid weed killer is likely to do as much harm to the flowers as to the weeds.

What are the other advantages of mulch in addition to controlling weeds?

As well as adding a decorative finish to the flower beds, mulch keeps the soil cool and moist and thus reduces the need for watering.

What materials make good mulches?

Use an organic material, such as shredded leaves, bark chips, pine needles, or hulls of some kind. Each spring, before adding new mulch, mix the old mulch in with the soil to enrich it.

Can I use grass clippings as mulch?

Yes, provided you dry them first. As they decompose, grass clippings give off a great deal of heat, which could damage annuals' roots. Grass clippings contain some nitrogen and so are beneficial to the soil.

I read that mulches rob the soil of nitrogen as they decompose. Is this true?

Yes, it is. When adding fresh mulch, add additional nitrogen in a readily available form, such as ammonium nitrate, at the rate of one to two pounds per one hundred square feet.

3 *Gardening with a Purpose*

A nnual gardens must be suited to the growing conditions of the area in which they are planted; yet, equally important, they can be made to serve a variety of purposes within the home landscape. To be a successful gardener, you need to learn to deal with sun and shade, with too much water or a lack of it, with very hot or very cool climates. Once you have met the inherent needs of your own garden, however, you can go on to reap the ultimate enjoyment of creating unique gardens for specific purposes.

My garden is very shady. Even if I plant annuals recommended for shade, they don't do as well as I wish. What can I do?

If the shade is from trees, remove some of the lower branches or thin out some of the upper ones to allow more light through. As a last resort you may even choose to have some of the trees removed. Add a mulch of white marble chips around the flower beds to increase reflected light. If the flower border is against a dark wall, paint the wall white, to gain light reflection.

What annual flower would you recommend for planting in a completely shaded area?

There are no annual flowers that will grow well in total shade. A perennial ground cover such as pachysandra, bugleweed, or periwinkle would be more suitable for such conditions. Your best choices, if you want to try annuals in *partial* shade, are

DEALING WITH LOCAL CONDITIONS

◆ *When designing a new garden, consider the style of the surroundings; an old-fashioned garden such as the one on the left would be especially suitable for a country home.*

cleome, lobelia, nicotiana, wishbone flower, impatiens, begonia, browallia, fuschia, monkey flower, and coleus.

Are there any special care tips for planting in the shade?

Plants that receive less light require less fertilizer and less water, so be very careful not to overfertilize or overwater annuals growing in the shade, unless they are competing with trees and shrubs for nutrients and moisture. Some gardeners mistakenly think that heavy feeding will compensate for lack of light. This is simply not true.

My flower beds receive only half a day of full sun. What plants should I use in them?

Any of the plants suitable for heavy shade would also do well in this partial shade condition. In addition, ageratum, China aster, balsam, black-eyed Susan vine, dianthus, dusty miller, forget-me-not, lobelia, nicotiana, ornamental pepper, pansy, periwinkle, salvia, and sweet alyssum will do well in partial shade.

I am considering adding a new flower bed. Of the two possible locations for it, both are in partial shade. One is on the east side of the house, and one on the northwest side. Which one would be better?

The one on the east side. Wherever possible, locate beds in morning sun. This will allow foliage that became moist during the night from rain or dew to dry out sooner, thus lessening the chance of disease. Plants also generally prefer the cooler morning sun to the hot afternoon sun.

We have very little rain and watering restrictions during the summer. Can I still have a flower garden?

Yes, there are many annuals that actually prefer dry conditions. Plant African daisy, amaranthus, celosia, dusty miller, globe amaranth, kochia, petunia, portulaca, spider flower, statice, zinnia, or strawflower.

My three-year-old garden is on a slight slope and has sun all day. The first year, cosmos and pinks did fine. Now everything dwindles and dies. Even petunias won't grow. What can I do?

Dig deeply and add a three-inch layer of well-rotted manure, compost, or peat moss. Set the plants as early as you can, depending upon your conditions. A sloping site, particularly a hot sunny one, dries out very quickly and thus many plants in that situation will be starved for moisture. Keep moisture down around the roots of the plants by placing a heavy mulch of partly decayed leaves, grass clippings, or other material over the soil in the summer.

Is there anything I can do to help my garden along? It is very dry where I live.

There are several things you can do. Prepare the soil well, adding extra organic matter, which will retain moisture. Because plants set into the garden need less water than seeds germinated outside, buy bedding plants or grow your own seeds indoors. Space plants very close together so there is no exposed soil. The foliage will shade the ground and keep it moister since water won't evaporate so quickly. Mulch well around plants to conserve soil moisture and keep roots cooler. When you water, water deeply to encourage deep roots. Collect rain water in barrels, and save rinse water from the laundry and kitchen (as long as there is no bleach or other potentially harmful chemicals in it) to water the garden.

We have a lot of rain during the summer. Which annuals like these wet conditions?

There are many plants that do well in moist areas. These include China aster, balsam, tuberous begonia, black-eyed Susan vine, browallia, calendula, flowering cabbage and kale, forget-me-not, fuchsia, gerbera, impatiens, lobelia, monkey flower, nicotiana, ornamental pepper, pansy, phlox, salpiglossis, stock, and wishbone flower.

What annuals will do best in my very hot, sunny garden?

Plant amaranthus, anchusa, balsam, celosia, coleus, creeping zinnia, Dahlberg daisy, dusty miller, gaillardia, gazania, gloriosa daisy, globe amaranth, kochia, triploid marigolds (see page 105), nicotiana, ornamental pepper, periwinkle, petunia, portulaca, salvia, spider flower, statice, strawflower, verbena, or zinnia.

Is there anything I can do to make my plants grow better in the heat of summer?

Yes. Start your own seedlings indoors before the planting season or purchase bedding plants so they are well established before the summer's heat. Select flowers that are heat-tolerant. Prepare the soil well, and mulch to keep the roots moist and cool. When you water, water deeply. If possible, grow the flowers in morning sun rather than afternoon sun. If your beds are in afternoon sun, some sort of a shade, such as a trellis, will help them grow better. If you also have drying winds in summer, plant a hedge or put in a fence to shelter the flower beds from the wind.

The desert soil of Arizona is quite alkaline. What should I do to have a nice garden there?

Incorporate extra organic matter into the soil; this will lower the pH. For even better results, have the pH tested and lower it

Many annuals, such as strawflower, actually prefer dry conditions.

Ann Reilly

further, if necessary, with sulfur (see pages 31-32 for further information about pH). Plant annuals, such as dianthus, salpiglossis, scabiosa, strawflower, and sweet pea, that will tolerate alkaline soil.

Be aware, however, that because it is also hot and dry where you live, all of these flowers except strawflower will need to be watered regularly. Plant them only if you have the capability of doing this. Dianthus, salpiglossis, and sweet pea do not like heat, so you will be able to grow them only as winter flowers.

I live in Maine, and summers are cool. What should I grow in my garden?

Try African daisy, tuberous begonias, browallia, calendula, clarkia, dianthus, flowering cabbage and kale, forget-me-not, lobelia, monkey flower, pansy, phlox, salpiglossis, snapdragon, stock, sweet pea, and wishbone flower.

My soil is very heavy and clayey and retains a lot of water for a long time. What should I do?

Plant one of the flowers listed under the previous question that will tolerate moist soils. At the same time, improve your soil's drainage by incorporating perlite, coarse sand, or gypsum (see page 32 for more information about soil texture). In extreme cases, you may have to install drainage tiles, or you could try growing your plants in raised beds.

Raised beds allow the gardener to provide a deep, enriched soil, even in areas where soil is poor.

Positive Images, Jerry Howard

What are the advantages of raised beds?

Raised beds are easily made with railroad ties or wood from the lumberyard. Fill in the raised area with a soilless mix or improved soil with extra organic matter, perlite, coarse sand, or gypsum. By creating this deep bed of improved and enriched soil, you are providing the plants' roots a better medium in which to grow. In addition, raised beds are often easier to take care of, as you don't need to bend over as far to weed or pick off faded flowers; this is of particular benefit to elderly or handicapped gardeners.

How deep should raised beds be?

At least eight inches is best.

I'd like to have some color in my garden earlier than mid-June, which is when my bedding plants first have good color. What do you recommend?

Plant some hardy annuals, which can be combined with spring bulbs and flowering trees and shrubs to give color in spring until the tender annuals take over. Plant hardy annuals as soon as the soil can be worked in spring. Choose from among African daisy, calendula, clarkia, cornflower, forget-me-not, lavatera, pansy, phlox, snapdragon, stock, sweet alyssum, and sweet pea.

When planting a garden for spring color, can I grow the garden from seeds sown outdoors?

You can, but you will have a more attractive and earlier blooming garden if you start the garden with plants.

Can I use these same hardy annuals for a fall garden, when summer flowers have ceased to look their best?

Yes, but again, you'll have better success with plants. If you start your own seeds outdoors, grow them in a cool spot and keep them shaded from the hot summer sun. Add chrysanthemums and ornamental cabbage and kale to your list of annuals for a fall garden.

We use our patio at night a great deal. What types of flowers are best for around this area?

Choose white, pale pink, or yellow flowers so that they can be easily seen at night. The silver foliage of dusty miller is also effective. In addition, recessed lighting in the flower beds shows blossoms up more effectively and increases the safety of walking around outdoors at night as well.

CHOOSING ANNUALS FOR SPECIFIC GARDENING PURPOSES

A stone wall attractively planted with ageratum, geranium, marigold, and trailing periwinkle.

I have an area in the backyard where our propane tanks and trash cans are stored. It is an eyesore, and we want to hide it, yet still have it accessible. What should we do?

Purchase or make a trellis and enclose the area on three sides. Grow an annual vine such as morning-glory on the trellis to hide the eyesore and at the same time beautify the area.

What other types of vining annuals can I choose?

There are many. The quickest growing, in addition to morning-glory, are cardinal climber, moonflower, sweet pea, scarlet runner bean, and vining nasturtium. Black-eyed Susan vine is charming but smaller in size and slower in growth rate.

I have a retaining wall at one side of my property and want to make it more attractive. What can I do?

Along the top of the wall, plant annuals that will cascade down over it. These include ivy geranium, sweet alyssum, lobelia, nasturtium, black-eyed Susan vine, petunia, and candytuft.

My living room window looks out over a sloped area down to the street below. What type of annuals should I use there?

When looking down on a sloped area, choose low-growing types so your view will not be obstructed. This would be an excellent place to create a rock garden.

My property is flat and open. What can I do to gain a more private feeling?

To create a homey, intimate look, place flower borders around the property. Use tall plants at the back to define the area but still allow you to view what is beyond. Warm tones of red, orange, gold, and yellow will make the area seem smaller.

What annuals make good ground covers?

Select from periwinkle, portulaca, petunia, and sweet alyssum if your climate is hot, or phlox and lobelia if your climate is cool.

My home is a large ranch-style house. What type of flower beds should I use?

A modern ranch home looks best with a formal, straight-lined bed with a sleek appearance.

What type of design would look best at my Cape Cod house?

A tightly packed, cottage-style garden is particularly appropriate for country, or farm-style, houses. Mix a variety of colorful, old-fashioned annuals, such as bachelor's-button, calendula, calliopsis, campanula, cosmos, dianthus, English daisy, gaillardia, geranium, hollyhock, larkspur, marigold, mignon-

ette, nasturtium, pansy, petunia, phlox, poppy, snapdragon, stock, sweet pea, verbena, zinnia.

Which annual flowers are best for flower borders along sidewalks and along the side of a house?

Ageratum, wax begonia, dusty miller, lobelia, French marigold, petunia, and sweet alyssum.

What annuals would you suggest that I plant in the borders around my terrace? The area is partially shaded.

Impatiens should do very well. They are available in a wide color range and in heights from six inches to one and one-half feet. Furthermore, you can count on the plants' remaining in good condition all summer. Wax begonia varieties should also do well.

I would like some fragrant flowers in our garden so that we can enjoy their aroma when we sit on our patio. What are good plants for this?

Choose from dianthus, scabiosa, snapdragon, spider flower, blue petunias, four-o'clock, stock, and sweet alyssum. These are also nice to plant under windows that will be open in the summer so you can enjoy the fragrance indoors.

Which are the easiest annuals to grow in a sunken garden? I prefer fragrant kinds.

If low-growing varieties are needed, use ageratum, sweet alyssum, calendula, bachelor's-button, dianthus, four-o'clock, candytuft, lobelia, dwarf marigold, nasturtium, nicotiana, petunia, phlox, portulaca, stock, wishbone flower, pansy, or dwarf zinnia. If height is unimportant any variety of annual is appropriate.

Will you give me the names of a few unusual annuals, their heights, and uses?

Bells-of-Ireland is a green, twenty-four-inch-tall flower, popular for arrangements. Nemesia is available in almost any color except blue; eighteen inches tall, it is often used in edging and bedding. Cupflower is a lavender-blue, twelve-inch-tall plant frequently used in window boxes and for edging. Blue, pink, or white love-in-a-mist grows twelve inches high and is used in bedding. Both summer poinsettia and Joseph's coat have colorful foliage. They grow two to four feet tall and make nice background plants.

I would like some quick-to-flower annuals that I can sow directly into my terrace garden. Any suggestions?

Sweet alyssum, California poppy, certain dwarf marigolds (such as Lemondrop, Yellow Boy, or Golden Boy), annual phlox,

Ageratum makes a tidy, colorful edging for a bed along a walkway.

Ann Reilly

portulaca, or annual baby's-breath. The phlox and baby's-breath may not last the summer; sweet alyssum will need some shearing back to stimulate new flowering growth; and California poppy seeds must be sown early for best germination.

I just planted some new shrubs, which are quite small. The ground between them is quite bare. What could I do to make the area look more attractive?

You could lay a bark-chip mulch, but an annual ground cover would make a more colorful filler. Replant annuals every year until the shrubs fill in enough that the ground cover is not needed. Good choices are sweet alyssum, lobelia, portulaca, creeping zinnia, forget-me-not, ivy geranium, nasturtium, and periwinkle. These same kinds of flowers may be used as a border in front of the mature shrubs.

I work and don't have too much time for the garden. Which annuals require the least amount of time to care for?

Choose those annuals whose flowers fall naturally and cleanly from the plant after bloom so that you don't have to spend time removing faded flowers. These include begonia, impatiens,

Easy-to-care-for impatiens blooms freely and vividly throughout the season, with no need for spent flowers to be removed.

Ann Reilly

ageratum, sweet alyssum, salvia, nicotiana, lobelia, periwinkle, and spider flower.

My children constantly cut across the lawn instead of using the path to the front door, and the lawn is wearing thin. Is there anything I can do to stop them from doing this other than putting up a fence?

Create a living fence of tall annuals, such as zinnia, marigold, spider flower, or cosmos.

I'd like to get my children interested in gardening and want to start them with something easy to grow. What should I buy?

If they will be growing their own plants from seed, children especially enjoy sunflower, nasturtium, four-o'clock, and zinnias, as they grow quickly and bear showy flowers. Any of the low-maintenance plants listed in the previous question will also do very well. If you want to teach them garden maintenance, add marigolds and geraniums as well.

For something different this year, I thought I'd try an all-foliage garden. Will this work?

Yes, it will. You can use coleus, dusty miller, alternanthera, iresine, kochia, or basil. Even without flowers, the bright colors of the foliage will result in a garden that is colorful, varied, and attractive.

I saw a newspaper article about letting your flower garden do double duty by growing edible plants in it. What is this all about?

Some flower favorites are also edible. The leaves, buds, and seeds of nasturtium are often used in salads. Calendula petals are most attractive when used as a garnish for fruit salads and hors d'oeuvres. Flowers of impatiens and pansies can be used as a garnish for soup. Sunflower seeds have long been a favorite snack. Parsley and basil, especially the purple-leaved varieties of basil, make excellent edgings to the flower garden. If you're going to eat flowers from your garden, be sure to spray only with pesticides safe for vegetables

I'd like to achieve a "wildflower" look in my garden. What plants should I use?

Although most wildflower gardens are perennial gardens, many annuals can also be used. American natives such as California poppy, gaillardia, sunflower, baby-blue-eyes, blue salvia, and phlox are particularly suitable. Other favorites are calendula, clarkia, cornflower, cosmos, four-o'clock, and gloriosa daisy.

A wildflower meadow, including poppies and bachelor's-buttons.

What is the best way to plant a wildflower garden?

To make it look the most natural, mix the various kinds of seeds together and scatter them about the area.

Will I have to replant my wildflower garden every year?

Some of the suggested plants will reseed themselves, so it may not be necessary. After a few years, however, you may find that not all of the plants are coming back every year. At that time, remove some of the more aggressive plants and resow.

I love cut flowers in the house, and would like to grow my own. What do you suggest?

For a cutting garden, grow ageratum, China aster, calendula, cornflower, cosmos, dahlia, gerbera, marigold, salvia, snapdragon, spider flower, stock, African marigold, or zinnia.

I don't have room for a cutting garden, but would still like to have flowers for the house.

It isn't necessary to create a separate cutting garden, for all of the flowers mentioned above also look beautiful in flower beds and borders.

I have read that the best flower arrangements have a variety of flower shapes within them. Could you explain this?

Make use of the three basic flower shapes as you do when planning your garden. Elongated, or spiked, flowers give a feeling of movement, develop the structure of the arrangement, and give the arrangement its line. They include bells-of-Ireland, celosia, larkspur, snapdragon, stock, and salvia. Round flowers naturally become the focal points of the arrangement by joining lines, stopping your eye, and getting your attention. They include China aster, dahlia, geranium, gerbera, marigold, zinnia, calendula, gazania, and scabiosa. Filler, or transition, material softens the arrangement and gives it fullness. These are the feathery or airy flowers such as baby's-breath, spider flower, ageratum, bachelor's-button, cosmos, and coleus flowers.

How do you cut flowers for maximum life indoors? Is there anything I can do to make my cut flowers last longer?

Flowers should be picked as the buds are opening, either early in the morning or late in the afternoon when moisture and sugar content are high. Cut the stems at an angle with a sharp knife or scissors and place them immediately into warm water. Bring the flowers into the house and recut the stems under water to bring maximum moisture to the petals. Remove any foliage that will be under the water and "harden off" the flowers by placing them in a cool, dark area for several hours or overnight before arranging the flowers.

To help cut flowers last the longest possible time, do not place them in full sun or in the draft of an air conditioner. Change the water every day and add a floral preservative to the water. This prevents the buildup of bacteria in the water, which will cause the flowers to deteriorate quickly.

PRESERVING ANNUALS FOR DRIED ARRANGEMENTS

I'd like to grow some flowers for dried wreaths and arrangements. Which annuals are good for this?

The easiest to dry are the "everlastings," such as cockscomb, globe amaranth, baby's-breath, strawflower, everlasting, statice, money plant, bells-of-Ireland, love-in-a-mist, and immortelle.

What type of growing conditions do everlastings like?

Most everlastings like full sun and dry, sandy soil. Although the seeds can be started directly in the garden where the plants are to grow, it is better to sow them indoors or to buy bedding plants. Fertilize monthly with soluble fertilizer.

Strawflower is a favorite and dependable everlasting.

These statice, with their blooms fully open, are ready to be cut and dried.

Ann Reilly

At what point should I cut flowers for drying?

That depends on the flower. Cut celosia when seeds begin to form in the flowers at the bottom of the plume. Cut globe amaranth when it matures in late summer. Cut statice when blooms are fully open. Cut money plant when the plants start to brown, but before seeds drop; rub off the outer petals to expose the central translucent disks before drying. Cut bells-of-Ireland when the flower spikes are mature and open; remove leaves and spines before drying. Cut love-in-a-mist when seedpods are mature but before they burst open. Cut immortelle when flowers are fully open. Cut strawflower just before the central petals open. Cut everlasting as soon as the buds show color; the flowers open during drying.

Which flowers can I air dry? How do I do this?

Any of the above varieties air dry. When cutting flowers for drying, make sure they are not wet with dew or rain. Strip the leaves and tie the flowers in small bunches. Hang them upside down in a dark, ventilated attic, basement, or other out-of-the-way place and let them dry for two or three weeks. Wrap fine wire around the stems of strawflower and everlastings before drying, so they will be strong enough later on. Store them away from dampness.

I have seen flower drying kits. How do these work?

Flower drying kits contain a dessicant called silica gel. Flowers such as zinnias, marigolds, dahlias, snapdragons, as well as strawflower and love-in-a-mist, can be effectively dried with desiccant. As blooms do not change during drying, pick them at the stage you want them to be after they are dried.

Place two inches of silica gel in the bottom of a cake tin, cookie container, or some other glass or metal sealable can, and lay the flowers on it face up. Do not let the flowers touch each other. Then sprinkle additional silica gel over the flowers until they are completely covered. Cover the container tightly and seal shut with tape for two to six days. When the flowers are ready, they will feel crisp or papery to the touch. When finished, blow or brush away any extra silica gel.

I have heard about drying flowers in borax or fine sand. Is this possible?

Drying with borax or sand works in a similar manner to silica gel drying. It takes at least twice as long as drying with silica gel, and the color is not as vivid.

Can I dry flowers in the microwave?

Yes. Place a few flowers at a time in a small microwaveable dish. Place the dish in the microwave with a cup of water and

use fifty-percent power for from thirty seconds to three minutes, depending on the thickness of the flower and the wattage of your microwave. You will have to experiment somewhat with timing because conditions are so variable. Flowers can also be placed in silica gel during the microwaving.

My dried flowers do not stay crisp. What should I do?

Some dried flowers pick up moisture from the air when it is very humid during the summer. Although they can be redried, you can prevent this problem by storing them in a closed jar along with some silica gel and use them in arrangements only in winter. Protect pressed flower pictures with a pane of glass.

Can silica gel be reused?

Yes, but first reactivate it by baking it in a 250° F. oven for an hour. Some silica gel sold for drying flowers is mixed with blue crystals that turn pink, indicating that it needs to be oven-dried.

To dry flowers in silica gel, place flowers face up on a bed of silica gel, then sprinkle with additional silica gel until the flowers are completely covered.

I live in a small townhouse, but I would very much enjoy gardening. Can I grow annuals in containers?

Yes. Almost any annual except the taller types will do very well in pots, planters, hanging baskets, and window boxes.

What specific annuals should I select for containers?

When selecting, make sure the container is in proportion to the plant. Place a spiked plant, such as salvia, or a mounded plant, such as zinnia, marigold, or geranium in the center. At the edges, plant something that will cascade over the edges, such as sweet alyssum, lobelia, or petunia.

What shade-loving plants grow well in containers?

Begonia, coleus, impatiens, and browallia are always nice. The last two are especially good for hanging baskets.

Where can I place containers?

Containers can be used anywhere—on patios, porches, decks, balconies, along a walkway, at the front door. Put them in reach of the garden hose to make care easier for yourself.

What should the containers be made of?

Containers are available in wood, clay, plastic, ceramic, and metal. Make sure they have drainage holes. Wood and es-

CONTAINER GARDENING
·

pecially clay containers dry out the fastest, so are least desirable in very hot areas or where daily watering is a problem. Metal containers heat up very fast and are therefore an asset in cool climates.

My grandmother left me a large, copper urn into which I would like to plant annuals. Can I use this as a container?

Containers should have drainage holes. Unless you are willing to punch holes in the bottom of your urn, add a thick layer of gravel to the bottom so that the roots won't become waterlogged.

What type of soil should I use in containers? Is it all right to dig soil from the garden?

No, garden soil should not be used. It is too heavy, and root growth will not be good. It also often contains insects and diseases. Use a soilless mix of peat moss with perlite and/or vermiculite.

How often should my containers be watered?

That depends on the size of the container. Small ones will need to be watered more often than large ones. Check every day to be sure. When it is very hot or if it is windy, you may need to water daily, or sometimes even twice a day. It will be convenient to have a water source nearby if you have a large number of containers.

How much and how often should I fertilize my container plants?

Containers, because they are watered more frequently, will *leach out* fertilizer very quickly; that is, as the water percolates down through the soil, it washes out the nutrients. Therefore, feed lightly but more often than you would fertilize the same annuals in the ground.

The annuals in my containers did not grow evenly. What should I do this summer?

They probably were growing toward the light. Rotate containers regularly so this does not happen. If the container is large and heavy, place it on a dolly so it can be turned more easily.

Can I bring my containers inside for the winter?

If they are small enough, and if you have a room with enough sun. Chances are, however, that you will do better if you begin new plants next spring. Coleus will continue to flourish if you keep the growing tips pinched to keep it compact, and if you pinch off the flower heads as they form, but few other annuals

PLANT COMBINATIONS FOR HANGING BASKETS

- begonias, sweet alyssum, and vinca
- verbena and geranium
- begonias and browallia
- marigolds, alyssum, and lobelia
- petunias, geraniums, and lobelia
- impatiens and browallia
- ivy geranium and sweet alyssum
- coleus and sweet alyssum

will live successfully from one year to another. Geraniums may, but after a short time they become woody and do not bloom as well.

My patio has an overhang and I would like to add some hanging baskets for extra color. What are good plants for this?

The best plants for hanging baskets are begonias (including tuberous begonias), black-eyed Susan vine, browallia, coleus, creeping zinnia, fuchsia, impatiens, ivy geranium, lobelia, periwinkle, petunia, portulaca, sweet alyssum, verbena, nasturtium, and lantana.

How do I plant a wire hanging basket?

For a striking flower-ball of color, purchase a wire hanging basket and line the inside with moistened sphagnum moss. Fill the center of the basket with commercial soilless mix or a homemade one of peat moss and perlite. Poke holes into the moss all the way around the sides and bottom of the basket, and insert plants. Set plants into the medium in the top as well. Water well when finished.

Do hanging baskets require any different care than the same plants in the ground?

Yes. Because root space is limited and the container surfaces are exposed to the drying effects of air, they will need to be watered more often, and because they are watered more often, they will need to be fertilized more often.

What should I use to suspend my baskets?

Anything that is strong and durable, including heavy wire, chain, or strong ropes, as well as heavy fishing line, which, because it is invisible from a distance, gives the illusion that your plants are floating.

Line a wire basket with sphagnum moss, fill it with soilless mix, and insert plants from the outside all around the basket as well as in the top.

Can I use coarse sand in my potting medium for hanging baskets?

This is not recommended. Sand is very heavy, and a hanging basket should be as light as possible.

Can coarse sand be used in other containers?

Sand is a particularly good idea in small containers as its weight will keep them from falling over in the wind.

I'd like to plant a container garden using something unusual as a novelty. What do you suggest?

Anything that can hold medium can be used, from the bird cage and an unused barbecue, to drainage tiles or a wheelbarrow. You can also make forms with chicken wire, line them with sphagnum moss, fill them with soilless medium, and plant them. Let your imagination go wild!

I have a strawberry jar I'd like to plant with annuals. How should I do this?

Don't use plants that will grow too large or you'll hide the pretty jar. Good plants are candytuft, ageratum, lobelia, periwinkle, portulaca, pansy, marigold, begonia, or sweet alyssum. Choose colors such as white or blue that will complement the color of the jar.

Provide a growing medium that drains well so the plants at the top don't dry out while the bottom ones are still wet, and place a layer of gravel in the bottom of the jar to help drainage further. Fill the jar with medium, and plant the jar from the bottom up. When you place plants into the holes, be sure the roots are pointed downward, not sideways, so the plants will be secure.

Annuals such as alyssum and lobelia are especially effective planted in a strawberry jar.

I'd like to make some window boxes to brighten up the outside of the house. What type of wood should I use?

Use a high-quality grade of lumber such as redwood, cedar, or pressure-treated pine that will be resistant to water and weather.

How large should the window boxes be?

The boxes should be at least eight inches wide and eight inches deep. The length depends on the length of the window. Several smaller boxes are easier to handle than one large one. Wood should be about one inch thick to insulate the potting medium and keep it cool and moist.

What type of plants should I use in a window box?

Choose with care plants that are compact and have a long season of bloom. Place taller flowers such as geraniums, salvia,

Martha Storey

Container plantings of begonia, geranium, fuschia, and pansy, in both hanging baskets and sturdy pots, enhance a deck.

marigolds, or zinnias in the back. Petunias, ageratum, and nasturtium can fill out the center, and ivy geranium, lobelia, or sweet alyssum can cascade over the front. Be sure to plant so that your window boxes look attractive from the inside of the house as well as from the outside.

Should I plant flowers directly into the wooden flower box?

As long as the box has drainage holes, you can, or you can plant the flowers in a metal liner available at garden centers. For small boxes, place individual flowerpots in the box. Then if one of the plants should fail, it is easy to replace.

How do I plant my window box?

Be sure there are drainage holes in the box, and cover the holes with window screening, pieces of broken crock, or gravel. Fill the box to within one inch of the top with soilless growing medium. Space plants somewhat closer together than you would if they were in the ground; strive for a full effect. Water well and place the box in the shade for a few days until the roots have a chance to become established.

4 Common Problems and How to Solve Them

Unfortunately, there are some pests and diseases that enjoy our gardens as much as we do. Keeping a beautiful garden entails a combination of recognizing these problems and learning how to avoid or solve them. Fortunately, in spite of many potential problems, it is unlikely that you will have to deal with more than a few of them in any one growing season. By learning to recognize the possibilities and symptoms of problems, you equip yourself to deal with them properly. Preventive or curative sprays, the avoidance of certain types of annuals, and preventive maintenance are all ways of combatting problems in your garden.

Certain annuals are particularly susceptible to attack by specific pests and diseases, and those are discussed under individual plant entries in Chapter 5. But those same pests and diseases may at times afflict other plants as well, and the techniques for combatting them are similar. The following problems are especially common to a variety of plants.

What are the tiny green, yellow, black, brown, or red semitransparent insects that appear along stems and flower buds? The plants are distorted and withered, and their leaves are curled and have black, sooty substance on them.

RECOGNIZING TROUBLE

The insects are aphids, also called plant lice. They suck juices from plants. Wash them off with a stream of water, or use insecticide or insecticidal soap.

◄ *Healthy gardens are the result of good preventive maintenance.*

TIPS FOR SAFE USE
OF PESTICIDES

- Follow container instructions carefully.
- Protect your skin, particularly your face and eyes, from contact with pesticides; pour liquids at a level well below your face and wear goggles and a respirator, if recommended.
- If you spill pesticide on yourself, wash your skin immediately and thoroughly.
- If you must mix the pesticide for use as a spray, maintain a separate sprayer for each different product.
- Avoid inhaling the pesticide.
- Avoid using pesticides where they may drift to other areas, particularly outdoor living areas or vegetable gardens.
- Do not apply pesticides where people and animals are present, and keep children and pets away from treated areas until after rain or watering has washed pesticides off plants.
- Do not eat, drink, or smoke after using a pesticide until you have washed yourself thoroughly and changed your clothing.
- In case of contracted pupils, blurred vision, nausea, severe headache, or dizziness, stop using the pesticide and contact a physician.

Holes are being chewed in the leaves and flowers of some of my annuals. I can see small, hard-shelled insects on the plants.

There are a number of beetles that attack annuals. If they are few in number, they can be hand-picked. Traps sometimes work, but they often attract beetles from a neighbor's garden as well. Spray with Sevin or Orthene, or treat the ground with a grub-proofing insecticide to kill the grubs.

I see small, light green, triangular-shaped insects on my plants, which are becoming stunted and losing color. What are these?

These are leafhoppers, which suck plant juices and also carry disease. They can be controlled with chemical insecticides and organic pyrethrin.

The foliage of some of my annuals have serpentine, colorless markings on them. What can I do about this?

Leafminers tunnel into leaves and create "mines," the trails you observe. Remove and destroy infested leaves and keep the area weed-free so the insects have nowhere to lay their eggs.

Some of my plants wilted and lost their color. When I dug them up, I noticed swellings on the roots. Is this what caused their demise?

Yes, this was no doubt nematode damage, but only a soil test determines this for sure. Avoid this problem by not planting the same kind of plant in the same space for three to four years. Plant marigolds in infested areas to kill nematodes.

After I planted my bedding plants, something ate them at night. What is this?

If the plants were cut off at the soil surface and left lying on the ground, cutworms were at work. Prevent them from doing

damage by inserting a plastic or cardboard collar around the plants when you plant them. If the foliage is being eaten and you see silvery streaks nearby, there are slugs or snails present. Use slug bait or small saucers of beer to lure and trap them.

I see webbing between the leaves of my annuals. The leaves also have black specks on the bottom, and have turned a dull color. What can I do?

You have spider mites, and if you can see webbing, the infestation is very advanced. Spray with a miticide every three days until no new symptoms appear. Keep the plants well watered, and syringe the undersides of the leaves every few days.

Some of my flower buds do not open; those that do, produce flowers with brown edges or blotches. The foliage is also distorted and discolored. What is the problem?

You have thrips, which are tiny insects that bore into plants at the base of the flower buds. Remove and discard all buds and damaged growing tips. Treat with insecticidal soap or a chemical insecticide.

When I brush against some plants in the garden, a cloud of tiny white insects appears. What are they?

These are whiteflies, which damage plants by sucking juices from them. They can be controlled with insecticidal soap, pyrethrin, or a chemical insecticide. They also like the color yellow, and you can purchase sticky yellow traps to attract them.

Place a cardboard collar around seedlings when you plant them as a defense against cutworm damage.

Aphids

Leafhopper

Thrip

Whitefly

Cutworm

Tarnished plant bug

Mealybug

Black blister beetle

What triangular, brown or gray spotted insect stings the tops of marigolds before buds appear so that they are flat and empty?

This is the tarnished plant bug, which "stings" the buds of many flowers. It is a sucking insect and can be subdued by sabadilla, malathion, or carbaryl (Sevin). Remove all nearby weeds.

What is the scale-like insect that appears on the leaves and stems of plants?

Mealybugs are a common garden pest. As they suck sap from leaves and stems, plants often wilt, and if the insects are allowed to increase unchecked, plants may die. Spray with malathion, followed an hour later by a strong spray of water to rinse the plant and thus prevent damage from the insecticide.

What is the black beetle that is so destructive to the petals of many of my annuals?

The black blister beetle is a common pest of asters and zinnias, particularly, as well as of other flowers. Unfortunately, it does prefer the petals to the leaves. Kill the beetles with stomach poisons or contact insecticides or by brushing them into cans of kerosene. Avoid touching the insects, as their secretions can cause a blister.

I have found caterpillars boring inside and damaging the stems of some annuals. What are these?

Both corn borers and common stalk borers attack annual plants as well as vegetables. Often, individual insects can be discovered and disposed of. The best prevention is to clean up and dispose of the stalks of all herbaceous plants in the fall. Spray or dust stalks with malathion or *Bacillus thuringiensis*.

I sowed seeds in flats this spring. The seedlings germinated, started to grow, and suddenly fell over and died. What did I do wrong?

This is the damping-off fungus, which can be lethal to seedlings grown in flats. Use only sterile medium that has not been used before. Drench sowing flats with benomyl before sowing (see page 21). Do not overwater and provide good air circulation.

Some of my annuals lost their color and stopped growing. When I removed them, I found the roots were dark in color and appeared slimy. What happened?

This is root rot, caused by a number of fungi. Improve the drainage, and drench the soil with a fungicide before you replace the plants.

My annual flower leaves have developed an orange powder on the undersides. What is this?

This is a fungus called disease rust. Remove all infected leaves, and water only in the morning. Sulfur and a number of fungicides will control it.

What is the white powder that develops on foliage in early fall?

Powdery mildew is a fungus disease that is most prevalent when days are warm and nights are cool. Cut off infected plant parts and water only in the morning. Do not crowd plants too close together. Spray with benomyl, Funginex, or sulfur.

There is a grayish brown powder on the flowers and flower buds in my garden. How do I stop this?

This is botrytis blight, which usually occurs when it is cool or cloudy. Cut off infected plant parts. Spray your plants with fungicide.

Spots have developed on the foliage of some of my annuals. What should I do?

Remove the spotted leaves from the plant and the ground. Water plants only in the morning. Sulfur and several fungicides control leaf spot.

5 *Favorite Annuals*

One of the steps in good garden design is selecting the right plant for the right place. Before making any final planting decisions, you must consider plant height, plant shape, flower color, flower shape, bloom time, climatic restrictions, and soil requirements. As with all endeavors, there are tricks to the trade. If you grew a plant in the past and it didn't perform well for you, maybe you weren't aware of a planting or maintenance need that would turn your success around. Study this list of favorite annuals to become informed about plant selection and care.

African Daisy *(Arctotis stoechadifolia)*

I would appreciate instructions for success with African daisies. Mine achieve the bud state but then fall off and never blossom. Can it be too much water, or are they perhaps pot-bound?

Dropping of buds can be caused by extremes, such as too much moisture around the roots or extended periods of drying out. African daisies do not like warm, humid conditions, *or* a sudden chill. Use superphosphate instead of high nitrogen fertilizer. Cultivate the soil and be sure it is well-drained. African daisies prefer being pot-bound, so don't plant them in very large pots. Give them full sun.

Can I sow seeds of Africa daisy directly outdoors?

It is better to start them indoors but you can seed them outdoors in early spring as soon as the soil can be worked.

◀ *From A to Z — from ageratum to zinnia — there is an annual for every taste and garden.*

In areas where summers are very dry, grow drought-resistant annuals such as amaranthus.

Ann Reilly

Ageratum *(Ageratum Houstonianum)*

How is ageratum started for outdoor planting?

Although seeds can be sown outdoors in early May when the danger of frost is past, it is best to sow them indoors in March. Sow them in either seed pans or small pots filled with sterile soilless mix available at garden centers. Do not cover the seeds with the growing medium as they need light to germinate. Set the pan in water until moisture is drawn up through the drainage holes and shows on the surface. Cover the pan with glass or polyethylene, and remove the covering when the seeds have germinated. Transplant the seedlings two inches apart or into separate pots when the first true leaves show (see page 21), and grow them under fluorescent lights or in a sunny window.

How can I achieve success with ageratum in the flower garden?

Although ageratum is not fussy about soil, it does best if the soil is rich, moist, and well-drained. Water when the ground starts to dry out, and fertilize monthly with a water-soluble plant food. If plants become leggy, they can be cut back, but no other maintenance should be necessary.

My ageratum do not do well during Florida summers. What could be the problem?

Ageratum does not like high heat or humidity and will not bloom well in areas where summers have these climatic conditions. Use them as a fall or spring plant in these locations.

Are all ageratum blue? I saw a plant I thought was ageratum, but it was white.

Most ageratum are blue, but there are also pink and white varieties. Summer Snow is one of the best whites; Pink Powderpuffs is a good pink. Popular among blue varieties are Blue Blazer, Blue Danube (also called Blue Puffs), Madison, North Sea, which is the darkest blue ageratum, and Royal Delft.

How can I keep woolly aphids, or milk cows, from my blue ageratum? I lose plants each year.

Ants feed on the milky honeydew that aphids excrete. They even herd the aphids together for efficiency. To fight aphids, make a shallow depression around each plant and pour in malathion solution.

Alternanthera *(Alternanthera ficoidea)*

What varicolored foliage plants can be used in garden designs?

Try alternanthera, which has foliage that is green, red with orange markings, yellow, yellow with red markings, rose, pur-

ple with copper markings, and blood red. Because the plants grow very neat and trim, they are perfect for creating designs, as well as for edgings to formal plantings.

How do I grow alternanthera from seed?

Alternanthera cannot be grown from seed, but instead must be propagated from cuttings (see page 35). Purchase plants the first year, take cuttings from them at the end of the summer, overwinter them in the house, greenhouse, or cold frame, and plant them out the following spring after all danger of frost has passed.

What growing conditions does alternanthera like?

Plant in full sun in a warm location with average garden soil.

Amaranthus, Joseph's coat, Love-lies-bleeding, Summer poinsettia (*Amaranthus* species)

My amaranthus do not have the brightly colored foliage for which the plant is famous. What is wrong?

Amaranthus foliage will lose much of its color if the soil is too fertile, so apply little or no fertilizer in early spring. Amaranthus also does best when soil is dry and temperatures are high.

Anchusa, Summer forget-me-not (*Anchusa Capensis*)

I like to grow anchusa as a summer ground cover, but by mid-summer it has stopped blooming. What can I do to encourage it to bloom all summer?

Plant anchusa in a poor soil and do not fertilize it or it will produce many leaves but no flowers. Water only when the soil has started to dry out. After the first heavy bloom, cut plants back to encourage continued bloom throughout the rest of the summer.

Aster, China. See China aster.

Baby-blue-eyes (*Nemophila Menziesii*)

Can I start seeds of baby-blue-eyes indoors?

Yes, provided you have a cool (55° F.) room. They grow quickly outdoors, and in early spring as soon as the soil can be worked they can be sown where the plants are to grow.

The pretty blue flowers and nice fragrance of baby-blue-eyes are very appealing. How do I grow them?

Plant baby-blue-eyes in full sun or light shade in a light, sandy, well-drained soil. Fertilize them every other month

Ann Reilly

Bugloss: Plant this annual in infertile soil and cut down plants after their first bloom to encourage flowering through the summer.

during the growing season. In mild areas, they self-sow readily and act as a perennial.

Baby's-breath (*Gypsophila elegans*)

I thought baby's-breath was a perennial. Isn't this the case?

Baby's-breath has both perennial and annual forms. The most well-known annual varieties are Covent Garden, the largest flowered white annual baby's-breath; Rosea, with deep pink flowers; and Shell Pink, with light pink flowers. Baby's-breath is often grown in the cutting garden, but is also useful as a bedding plant or in a border.

I grew baby's-breath last summer, but it bloomed for only a short period. What do you suggest?

Make successive sowings or plantings of baby's-breath every two weeks for a continuous supply of flowers. Start seeds indoors four to six weeks before outdoor planting, or sow directly into the garden.

What type of soil does baby's-breath like?

Soil must be loose, alkaline, and kept on the dry side. Add fertilizer before planting and feed the plants again monthly during the growing season.

How do I dry baby's-breath for indoor arrangements?

Pick long stems before the flowers are fully open, and hang them upside down in a cool, dark, dry area.

Pick long stems of baby's-breath before the flowers are fully open, and hang them upside down in a cool, dark, dry area.

Bachelor's-button. See Cornflower.

Balsam (*Impatiens Balsamina*)

What type of soil do I need to grow balsam?

Soil should be rich and heavily fertilized. It grows well in partial shade and in hot areas. Water well for best results.

Can I sow balsam seeds directly into the garden?

Yes, you can, and balsam also freely reseeds. For early bloom, use bedding plants or start your own plants indoors six to eight weeks before the last spring frost.

Basil (*Ocimum Basilicum*)

What is the best way to grow basil?

Most herbs like soil that is dry and not too rich or over-fertilized; basil is no exception. Give it full sun.

I recently saw a flower bed that was edged with a plant with purple leaves. I was surprised to discover this was basil. Is this the same basil that is grown as an herb?

Yes, it is, and both the purple and green-leaved varieties are quite attractive in flower beds. Although they do have small spikes of flowers in late summer, they are mainly grown for their leaves.

Beard tongue. See Penstemon.

Begonia, wax *(Begonia x semperflorens-cultorum)*

Can I sow seeds of wax begonia directly into the garden?

No, wax (also called fibrous) begonias have very small seeds and need a long time to develop into flowering plants, so you must start with purchased plants or start seeds indoors twelve to sixteen weeks before they are to be planted outdoors.

Why are begonias so popular as garden plants?

Wax begonias are neat, mounded plants with white, pink, or red flowers that bloom all summer with little care. They are one of the easiest flowers to grow. Although excellent for shade, they may also be grown in full sun if summer temperatures do not exceed 90° F. and if they are kept well watered.

What is the common name of the begonia with white-marbelled, green leaves?

This is calla-lily begonia, a wax begonia so called because as the young leaves emerge, they resemble miniature white calla-lilies. They are less hardy and more difficult to grow than other begonia cultivars.

I have a calla begonia that was healthy a month ago, but recently the leaves have withered and the tops of new branches are falling off. Why?

This is probably due to unfavorable environmental conditions rather than any specific organism. The calla-lily begonia is conceded to be difficult to grow. It needs cool, moist air, and fairly dry soil. Water the soil only, not the leaves. Allow the soil to dry out between waterings.

What makes the leaves of begonia turn brown on the edge and get lifeless?

This could be caused either by unfavorable environment or by injury from leaf nematodes, which cause irregular brown blotches that enlarge until the leaf curls up and drops. Prune off and discard infested portions; do not let the leaves of two plants touch; water from below instead of wetting the foliage.

Will begonias do well in the hot climate of California?

Yes. Where summers are extremely hot, use varieties with bronze leaves rather than those with green leaves. Soil should be rich in organic matter and kept well watered.

Dry spots form on the leaves of my begonias until they are almost eaten up. What is the cause?

There are three possibilities: sunscald, the leaf nematode just discussed, or lack of humidity.

Begonia, tuberous *(Begonia x tuberhybrida)*

How do I start begonia tubers?

Plant tuberous begonia plants that you have purchased or started yourself indoors eight weeks before setting them outside. Grow tubers in shallow flats of peat moss and perlite, planted round side down. Keep them in bright light, and do not overwater. When all danger of frost has passed, move them into the garden.

Is it true that tuberous begonias must be grown where summers are cool?

While they will not tolerate as high a temperature as wax begonias, newer varieties are more heat-resistant than former ones. For success, plant them in partial to full shade in a moist, rich, heavily mulched soil. Keep them well watered, and on hot days, mist the foliage to cool it off. An excellent, adaptable new series called non-stop can be started from seed and bloom all season.

Begonia: Masses of wax begonia bloom continuously over many weeks of the season.

Ann Reilly

How do I store begonia tubers over the winter?

Tuberous begonias must be dug from the soil after the first fall frost as they will not survive the winter in the ground. After digging them, remove all soil, allow them to dry, and store them over the winter in a cool but frost-free, dark, dry spot such as the basement.

When my tuberous begonia was budded to bloom, the leaves and then the stalk turned brown and dropped. What was the trouble?

It is hard to be sure without personal inspection, but it sounds like a soil fungus called pythium, which causes stem rot and may produce a soft rot and collapse of the crown and stalk. Avoid crowding the plants. Do not replant in infected soil without first sterilizing it.

A tuberous begonia rotted after a promising start. It wasn't overwatered. What could we have done wrong?

Tuberous begonias are sometimes attacked by larvae of the black vine weevil, which destroy the roots, so that the plants wilt and die. If white grubs are found in the soil and if a good root system exists, knock the soil off the roots and replant in a new spot. No insecticide is listed for this pest.

Black vine weevil

What blight or insect attacks tuberous begonias, keeping them from developing properly?

Insufficient light may be responsible even though these are shade-tolerant plants. The cyclamen mite or possibly thrips may cause deformation. Frequent spraying with Kelthane before blooming may be of some benefit.

What is the tiny white or transparent worm that gets in the stalks and roots of begonias?

It is probably only a scavenger worm feeding on tissues rotting from some other cause, possibly a fungus stem rot. If the plant is this far decayed, you should start over with a healthy plant in fresh soil.

What causes a sticky sediment on my begonia?

It is honeydew, secreted by sucking insects such as aphids, mealybugs, or whiteflies.

Bellflower, Campanula, Canterbury-bells (*Campanula Medium*)

How do I grow Canterbury-bells in the garden?

Plant in full sun or light shade in a moist, rich, well-drained soil. Feed monthly during the blooming period.

Are annual Canterbury-bells easy to raise from seed?

Yes, annual types bloom in less than three months from seed, but you must start them early indoors to get a good display in the North. Do not cover the fine seed during germination. In the South, seed may be sown outdoors in fall for growth and flowering the following spring and summer.

Why don't I have success with campanula in a dry soil? They rot away.

There are two soil fungi that may cause crown or stem rot under moist conditions, but your trouble may be physiological and due to insufficient water. Try another location and improve the soil with organic matter, such as leaf mold or peat moss.

Bells-of-Ireland *(Moluccella laevis)*

How are the seeds of bells-of-Ireland germinated? When I planted them last year they failed to come up.

Sow in a carefully prepared cold frame in May when the soil has warmed up. Do not cover the seed; it needs light to germinate. Keep the seedbed constantly moist until germination. Transplant seedlings to garden beds in late June. Seeds may be started indoors, but they require refrigeration for five days before sowing (see stratification, page 23).

How can I get my bells-of-Ireland to look like the ones in the flower-shop arrangement?

Groom flowering stems by removing all the foliage when you cut them, leaving only the bell-like bracts with the little flower "clappers" in the center of each. If you plan to dry the flowers, stake the plants during summer to produce long, straight stems.

Remove the foliage from bells-of-Ireland when you pick them for drying.

Black-eyed Susan vine *(Thunbergia alata)*

How should I use black-eyed Susan vine in the garden?

Black-eyed Susan vine is a neat plant that grows five to six feet tall. It is excellent on a trellis or lamppost, or in a hanging basket. The plants like a long growing season but will not grow well where it is excessively hot.

Blanket flower. See Gaillardia.

Blue daisy *(Felicia amelloides)*, Kingfisher daisy *(Felicia Bergerama)*

I would like to grow an all-blue garden this summer. Would blue daisy or Kingfisher daisy do well in Maine?

Yes, both of these annuals actually prefer cool gardens.

I've seen *Felicia* in two different sizes. Are these different kinds of plants?

There are two different *Felicia* species grown in the annual garden that are quite different in growth habit. *F. amelloides*, the blue daisy, grows three feet high and three feet wide. *F. Bergerana*, the kingfisher daisy, is a compact, bushy plant growing only six to eight inches tall. Both have blue, daisy-like flowers with yellow centers.

Can I sow seeds of blue daisy or Kingfisher daisy outdoors?

Yes, as soon as the soil can be worked in the spring, sow seeds outside where plants are to grow.

How do I start seeds indoors?

Seeds should be started indoors ten to twelve weeks before planting seedlings outdoors. Chill the seeds of blue daisy in the refrigerator for three weeks before sowing (see stratification, page 23), and germinate them at 55° F. Sow kingfisher daisy at room temperature. Both take thirty days to germinate.

What type of growing conditions does *Felicia* require?

Plant *Felicia* in full sun in a dry, sandy, well-drained soil. Water and fertilize sparingly.

Blue lace flower *(Trachymene coerulea)*

I've seen a plant similar to Queen Anne's lace, but blue. What is this plant?

What you saw was blue lace flower. Its lacy, sky-blue flowers have a sweet scent and make good cut flowers, too. The foliage is also quite airy and attractive.

How do I start blue lace flower from seeds?

Blue lace flower does not like to be transplanted, so seeds should be grown in individual pots if started indoors. Be sure to cover them completely as they need darkness to germinate. Seeds will also grow quite well if sown into the garden several weeks before the last spring frost.

When I grew blue lace flower in my cutting garden, I found that the stems were quite weak and the plants had to be staked. Is there anything I can do to eliminate this chore?

Blue lace flower does not mind being crowded, so they are self-supporting if planted close together. Give them full sun and a rich, sandy soil. They prefer cool weather and should be mulched to keep the ground cool and moist.

Ann Reilly

Black-eyed Susan vine: Excellent on a lamppost, black-eyed Susan vine prefers areas where summers are not excessively hot.

Browallia *(Browallia speciosa)*

When should browallia be sown for outdoor flowers, and which varieties do you suggest?

For early flowering, sow in late March indoors, or in a cold frame outdoors after mid-April. Outdoor sowing can be done about mid-May. These dates apply in the vicinity of New York City; farther north, plant seven to twelve days later and as much as seven to twelve days earlier farther south. Do not cover the seeds; they need light to germinate. Good varieties include Blue Bells Improved, Jingle Bells, and Silver Bells, a white variant.

How do I grow browallia outdoors?

Browallia prefers partial shade and a rich, moist, well-drained soil. Mulch the soil to keep it cool.

How do you treat the black spotty disease that infects the foliage of browallia?

It is possible that the plants are infected with smut, a common problem for browallia. The treatment is simply to remove the smutted leaves. However, the problem may also be a sooty mold growing in insect honeydew, in which case use contact sprays for the insects.

Calendula, Pot marigold *(Calendula officinalis)*

How did calendula get the name "pot marigold"?

Calendula was referred to in poetry in the 1600s as "Mary's Gold," which was contracted to "marigold." Because it was used extensively in cooking, it came to be known as pot marigold.

Can you tell me why my calendula, or pot marigold, plants are so feeble? I sow them outdoors at the same time I sow marigold and zinnia seeds, which do very well for me.

Try sowing the calendula seeds earlier so that their roots become established during the cool weather. They will withstand light spring frosts. Also, select varieties bred for heat resistance, such as Bon Bon and any of the Pacific Beauty strain.

What kind of care does calendula need?

Calendula likes full sun but will grow in light shade in soil rich in organic matter. Keep calendula well watered. Cut off flowers as they fade.

I have heard that calendula flowers are edible. Is this true?

Yes, the petals are edible and make a colorful garnish for

Calendula, or pot marigold: This hardy annual thrives in sunny, well-fertilized spots; its petals are edible.

Ann Reilly

soups, salads, and hors d'oeuvres. If you need to use pesticides, be sure to use one recommended for vegetables, and follow directions carefully regarding the required length of time between pesticide application and harvest.

California poppy *(Eschscholzia californica)*

Do California poppies reseed themselves?

Yes, usually, but if you cultivate the soil where reseeding took place you may bury the seed so deeply that it does not germinate.

When is the best time to plant California poppies?

As soon as the soil can be worked, sow seeds outdoors in early spring where plants are to grow. They can also be started indoors, but transplanting is difficult and not recommended.

What is the best way to achieve a long season of color with California poppies?

Plant in full sun in a light, sandy soil. Keep flowers picked off as they fade. Soil should be poor in nutrients; do not fertilize, or there will be few flowers. California poppy will withstand heat and drought, but it also does well in cool climates.

Calliopsis *(Coreopsis tinctoria)*

How does calliopsis resemble the perennial coreopsis?

Both are members of the same genus, and both have daisy-like flowers. Calliopsis, however, is available in red-, yellow-, pink-, or purple-flowered varieties, while perennial coreopsis flowers are golden yellow. Calliopsis, like the perennial coreopsis, blooms atop slender and wiry stems.

I'd like to have the earliest possible bloom from calliopsis. How can I achieve this?

Start with purchased bedding plants, or start your own seeds indoors six to eight weeks before the outdoor planting date, which is several weeks before the last expected frost. Seeds can be sown outdoors, but the plants will not bloom as early.

What type of growing conditions does calliopsis like?

Grow in full sun in a light, sandy soil with excellent drainage and low fertility. Water sparingly.

Campanula. See Bellflower.

Calliopsis: This cheerful annual prefers full sun and a sandy, well-drained but infertile soil.

Ann Reilly

Candytuft: This flower comes quickly from seed in spring and fall.

Candytuft (*Iberis* species)

My annual candytuft bloomed only a short time, then died. Why?

Annual candytuft blooms very quickly from seed but only for a short time. Cutting back after the first bloom fades may encourage a second bloom. Plant seeds at two- or three-week intervals for constant bloom during cool spring and fall weather. Annual candytuft does not do well in the heat of summer.

What are the different types of annual candytuft?

The rocket candytuft, *I. amara*, has large, upright, cone-shaped spikes of fragrant, glistening white flowers that look somewhat like a hyacinth. This is excellent as a cut flower. The globe candytuft, *I. umbellata*, is lower growing than the rocket candytuft and is dome-shaped. Fairy Mixed is the best known variety.

What is the cause of candytuft turning white and dying? The whiteness looks like mildew.

A white rust is common on candytuft and other members of the crucifer family. White pustules appear on the underside of the leaves, which turn pale. Destroy diseased plants or plant parts, and be sure to weed out such cruciferous weeds as wild mustard. Spraying with bordeaux mixture may help. Bordeaux mixture is a fungicide consisting of copper sulfate, lime, and water.

Canterbury-bells. See Bellflower.

Cape marigold (*Dimorphotheca* species)

How long can cape marigold be expected to stay in bloom? The plants I had last summer bloomed from about June 1 to July 15 and then died.

Six weeks of bloom is about all you can expect, although the time might be lengthened somewhat by snipping off all withered blossoms to prevent seed formation. To provide blooming plants for the second half of the summer, make a second sowing of seed four to six weeks after the first sowing.

What are the growing requirements for cape marigold? I have had trouble getting it to germinate, though I buy good seed.

Sow the seed outdoors in the spring when the ground has warmed up, or indoors four to six weeks earlier. Give the plants light, well-drained, but not specially enriched, soil. Be sure they get plenty of sun and not too much moisture.

Cardinal climber. See Morning-glory.

Castor bean *(Ricinus communis)*

Can you tell me about cultivation of the castor bean?

Castor bean plants grow best in full sun and a rich, well-drained soil. They prefer hot, humid weather, and they like to be heavily watered. Plant seeds in spring after frost danger has passed, where they are to grow, or start them earlier indoors and then set them out later.

Is there anything poisonous about the castor bean plant?

The seeds contain a poison called rincin. Plant them where children or pets cannot be tempted to eat the beans. Fatalities have been reported from eating as few as three seeds.

Celosia, Cockscomb *(Celosia cristata)*

Can you explain the difference between the two types of celosia?

Celosia is one of the most bizarre garden flowers, both in color and shape. The plumed type has long, feathery flower stalks. The crested or cockscomb type has round flower heads that are ridged and resemble the comb of the rooster.

I planted celosia plants last spring, but they quickly died. What might have happened?

Celosia plants should be set into the garden after all danger of frost has passed. If planted too early, they will flower prematurely, set seed, and die. For greatest success, plant celosia before they are in bloom.

How do I grow celosia?

Celosia likes full sun, a rich and well-drained soil, and very little fertilizer. It is very tolerant of heat and drought. Choose colors carefully as they are very bright and can be clashing.

What are the different celosia varieties I can buy for my garden?

Some excellent varieties among the plumed types are the tall Apricot Brandy and the Century series or the dwarf Geisha series and Kewpie series. Forest Fire is also very attractive, with red flowers and maroon foliage. Jewel Box is the shortest of the combed types; Fireglow grows eighteen inches tall; Red Velvet, Tango, and Toreador grow two feet tall.

China aster *(Callistephus chinensis)*

How should I choose asters?

Be sure to select wilt-resistant varieties. Once asters have bloomed, they will not rebloom, so look for "early," "mid-

Ann Reilly

Celosia: For best results, plant celosia, as well as marigold, directly in the outdoor bed where it will remain.

season," and "late" varieties in order to achieve continuous flowering. Consider, as well, their height. Tall (twenty-four to thirty-six inches) varieties include Super Giants and Totem Poles; medium (eighteen to twenty-four inches) varieties include Crego, Early Charm, Fluffy Ruffles, Powderpuff (also called Bouquet and Rainbow); dwarf (six to eighteen inches) varieties include Color Carpet, Dwarf Queen, and Minilady.

How do I start aster seeds outdoors?

Grow China asters in full sun. Prepare the seedbed by forking over the soil and working in well-rotted manure, peat moss, or leaf mold. Make drills (planting furrows) two to three inches apart and one-quarter inch deep; sow seeds, six or eight per inch, about mid-May. If you want cut flowers, set asters in rows eighteen inches apart, with the plants six to fifteen inches apart in the rows, depending on their size. Cover with a half-soil, half-sand mixture, and water with a fine spray. Apply light covering of hay or strips of burlap to help retain moisture just until germination, then remove this mulch immediately. Keep the seedlings well watered, and transplant them when they have formed their first true leaves (see page 21). Soak the soil for a few hours before transplanting; then lift the seedlings, taking care to disturb the roots as little as possible. Set the seedlings in the soil so that the bottom leaves are resting on the surface. Keep the transplants moist. When flowers show, feed with liquid fertilizer weekly.

What is the best method for growing asters?

Grow China asters in full sun. Before planting, enrich the soil with well-rotted manure, compost, or leaf mold. Start seeds indoors or outdoors, or purchase plants. If you want cut flowers, set asters in rows eighteen inches apart, with the plants six to fifteen inches apart in the rows depending on their size. Set the seedlings in the soil so that the bottom leaves are resting on the surface. Water well, and keep the soil cultivated or apply a mulch. When flowers show, feed with liquid fertilizer weekly.

We enjoy growing China asters in New York. Do they reseed themselves?

Yes, occasionally, especially the single-flowered kinds. However, it is better to raise new plants under controlled conditions annually.

What is the best procedure for disbudding asters? Should the tops be pinched out when they are young to make them branch?

Asters usually produce a number of branches naturally and do not need pinching. Each branch bears a terminal flower, together with numerous other buds on small side shoots. For choicest bloom, remove all side shoots and retain the main bud only.

For the choicest blooms, remove side shoots from China asters, retaining the main bud only.

Will paper collars adequately protect transplanted seedlings of China aster from grubworms?

Collars protect against cutworms (fat caterpillars that cut off plant stems near the surface), but they offer no protection against the white grubs, larvae of June beetles, which stay in the soil and feed on roots of garden plants. (See page 65.)

After reaching full growth and flowering size, my China asters dried up and died. What was the cause?

You are most likely dealing with aster wilt. This disease is caused by soil fungus, a species of fusarium, which grows into the roots and affects the vascular or water-conducting system of the plant. Young plants may be infected and not show symptoms until flowering, as in the case you describe. Plant wilt-resistant seed, many varieties of which are now on the market. No one knows exactly how long the fusarium wilt fungus lives in the soil, but it is best to wait several years before putting more China asters in a place where they have succumbed to this disease.

What can I do to prevent root rot in my China aster bed? I planted wilt-resistant seed, disinfected with Semesan, but I did not receive the desired results.

Certain soils are so infected with the wilt fungus that a percentage of even wilt-resistant plants will succumb; the situation is worse in wet seasons. Try sterilizing the soil in the seed bed. For a small area, spade the soil, and then saturate it with a solution of one gallon of commercial Formalin diluted with fifty gallons of water (use a proportioner for this process; see page 39). Apply one-half to one gallon per square foot of soil, cover with paper or canvas for twenty-four hours, and then air out for two weeks before planting.

What causes some China aster flowers to open greenish-white instead of coloring?

This is a virus disease called aster yellows and transmitted from diseased to healthy plants by leafhoppers. The leaves lose their chlorophyll and turn yellow, while the blossoms turn green. Plants are usually stunted. This is the most serious aster disease and occurs throughout the United States

How can I prevent China aster yellows?

Only by preventing insect transmission. Remove diseased plants immediately, so there will be no source of infection. Spray frequently with contact insecticides to kill leafhoppers. Commercial growers protect China asters by growing them in cloth houses made of cheesecloth or tobacco cloth with twenty-two meshes to the inch.

Ann Reilly

China aster: Grow these plants in full sun, and fertilize them regularly once flowering begins.

How can I get rid of the small root lice that suck life out of China asters and other annuals?

Make a shallow depression around each plant and pour in the same malathion solution used for spraying above-ground aphids.

How can I control the common black beetle on China asters?

You probably mean the long, slim blister beetle, which is very destructive to these asters. Dust or spray with carbaryl (Sevin).

China pink. See Dianthus.

Chrysanthemum (*Chrysanthemum* species)

I thought chrysanthemums were perennial plants that bloomed in the fall. But I have seen listings in seed catalogs for annual chrysanthemums. What are they?

A number of chrysanthemums are true annuals. These include the species *C. carinatum*, *C. coronarium*, *C. multicaule*, and *C. paludosum*. Most have single or double, daisylike flowers on tall plants; some have finely cut foliage. All bloom throughout the summer rather than in the fall as the perennial chrysanthemums do.

How do I grow annual chrysanthemums?

They can be grown from seeds or plants. Start seeds indoors eight to ten weeks before the last spring frost, or sow them directly into the garden where the plants are to grow. Give them full sun and an average soil. Fertilize monthly during the growing season, and keep faded flowers picked to ensure continuous bloom. Annual chrysanthemums do best where summers are mild and moist, although they will tolerate a moderate amount of heat and drought.

Cineraria (*Senecio x hybridus*)

When I visited a garden in Vancouver, British Columbia, last summer, I saw cineraria being grown as a bedding plant. Isn't cineraria a houseplant?

It is, but it can be grown as a bedding plant in climates such as Vancouver's, where summers are cool. Because they take six months to reach blooming size, it is best to start with purchased plants.

Besides cool temperatures, what other growing conditions do cineraria require?

Cineraria can be planted into the garden several weeks before the last expected frost. Soil should be rich, moist, and well-drained. Mulch to keep the soil cool and moist. Water heavily

and fertilize every other month during the growing season. Remove flowers as they fade to keep the plants neat and to extend blooming.

Clarkia, Godetia (*Clarkia* species)

Can I start clarkia seeds indoors to get a head start on the season?

No, clarkia seedlings very rarely transplant well, so after all danger of frost has passed, sow seeds where plants are to grow. In warm areas, sow in the fall for growth and flowering the following spring.

I planted clarkia seeds last summer, but they did not grow well. What did I do wrong?

Clarkia prefers cool temperatures, especially at night. In areas where summers are hot, grow it as a spring wildflower. Choose a location with full sun or light shade and a light, sandy soil with excellent drainage. Do not fertilize or there will be no flowers.

Cockscomb. See Celosia.

Clarkia: Sow seeds in the spot where plants are to grow, as clarkia does not transplant well.

Ann Reilly

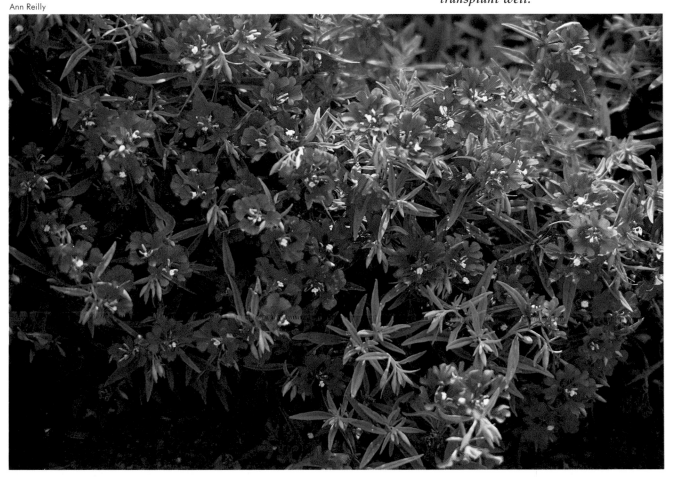

Coleus *(Coleus x hybridus)*

Is it possible to raise coleus from seeds?

Coleus are easily started from seeds sown any time indoors. Germination is rapid (about one week), and plants are ready for transplanting in another two weeks. Do not cover seeds; they need light to germinate.

Can coleus be rooted from cuttings? I have a favorite pink-leaved variety that I would like to increase.

Coleus roots very readily. Stem cuttings two to three inches long can be rooted in water, sand, vermiculite, or a regular rooting mixture.

How do I grow coleus outdoors?

Coleus likes partial to full shade and a rich, moist soil. If planted in full sun, the bright colors of the foliage will fade.

Do I need to remove the flowers of coleus as they appear in late summer?

That is up to you. Some people feel the flowers detract from the colorful foliage. If you remove them, the foliage will remain more colorful into the fall.

What are the differences between varieties of coleus?

Carefree has very small, deeply lobed leaves and forms a bushy plant that is excellent for small spaces and containers. Dragon has large plants with large leaves. Fiji has large plants and fringed, lacy leaves. With its pendulous branches and large leaves, Poncho is perfect for hanging baskets. Rainbow, with its large, heart-shaped leaves, was the original modern coleus. Saber has narrow, sword-like leaves. Wizard is similar in shape to Rainbow. All coleus are available in a multitude of foliage colors, with combinations of green, red, white, gold, bronze, scarlet, orange, salmon, yellow, pink, and purple.

Are mealybugs on coleus caused by too much or too little watering? They appear as a soft white, fuzzy scale.

Mealybugs, like most sucking insects, thrive in a dry atmosphere, but too little water cannot "cause" them. Also, if the plants are unhealthy from a waterlogged soil, they may succumb more readily to mealybug injury. Spray at the first sign of bugs with insecticidal soap, malathion, or Orthene.

What can I do to stop a white moldy rot on coleus, kept as a houseplant?

If this is not a mealybug infestation, it may be a black rot called "black leg" because it rots the base of the stalks. Destroy infected plants and pot new ones with fresh soil.

Cornflower, Bachelor's-button *(Centaurea Cyanus)*

Why do our bachelor's-buttons, or cornflowers, show retarded growth and weak flower stalks?

They may have been too crowded or sown too late in the spring. Sow the seeds in a finely prepared soil in the fall or as soon as you can work the soil in spring. Sow thinly; cover seeds about one-quarter inch deep as they must have darkness to germinate. When they are large enough, thin out the seedlings to nine inches apart. Yours may have been too crowded or sown too late in the spring.

What treatment do you prescribe for bachelor's-buttons to be assured of large blossoms and a long period of bloom?

Cornflower: For continuing bloom, keep the faded flowers picked off cornflower.

You should get good results by giving them a moderately rich, well-drained soil, and extra watering during hot, dry weather; do not overwater, however. Plant in full sun. Sow seeds every two weeks throughout spring and summer. Keep faded flowers picked off.

Cosmos *(Cosmos* species)

I understand there are two different types of cosmos. Can you explain the difference?

The Sensation type, *C. bipinnatus,* is tall, with lacy foliage and daisy-like single flowers of pink, lavender, or white. The Klondyke type, *C. sulphureus,* is shorter, with broad foliage and semidouble flowers of gold, yellow, or orange.

When should cosmos be started from seeds?

Sow seeds indoors five to seven weeks before the date of the last frost in your region, or use a cold frame. After all danger of frost has passed, sow seeds into the garden where plants are to grow.

Are cosmos easy to grow?

Yes. Give them full sun and a warm spot. They like a dry, infertile soil; soil too rich will produce lush foliage but no flowers. Do not overwater or overfertilize. To prolong bloom, cut off faded flowers. Tall varieties should be planted out of the wind, but should not need to be staked.

What is the cause of cosmos turning brown and dying?

It may be a bacterial wilt, but more likely it is a fungus stem blight. A grayish lesion girdles the stem and all parts above die. Spraying is of little value. Remove infected plants when they are noticed, and pull and destroy all tops after the plants bloom.

Creeping zinnia *(Sanvitalia procumbens)*

Is the creeping zinnia truly a zinnia?

No, it is not a zinnia. It is a low-growing, wide-spreading plant that makes an excellent annual ground cover, edging, or hanging container plant.

Can I start seeds of creeping zinnia indoors?

Yes, start them indoors four to six weeks before the outdoor planting date, but treat them carefully as they do not like transplanting. For best results, sow seeds directly into the garden where they are to grow.

How do I care for creeping zinnia?

Creeping zinnia is easy to grow. Because the flowers fall cleanly from the plant as they fade, maintenance is minimal. Plant them in full sun and a light, well-drained soil. They will tolerate drought and should be watered when the soil starts to dry out.

Cupflower. See Nierembergia.

Dahlberg daisy *(Dyssodia tenuiloba)*

What is the best way to propagate dahlberg daisy?

Begin seeds indoors six to eight weeks before date of expected last frost. Move seedlings outdoors when danger of frost is past.

Dahlberg daisy: This plant grows best in cool climates, but it does tolerate heat and drought.

Ann Reilly

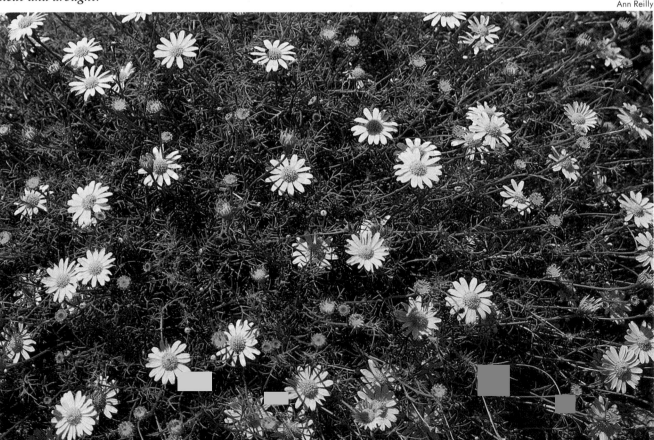

Will dahlberg daisy grow in my garden in Kansas?

Yes, dahlberg daisy will tolerate heat and drought, although it will grow better in cooler climates. It likes full sun, and average garden soil that is watered and fertilized very sparingly.

Dahlia *(Dahlia* hybrids)

Is it true that dahlias can be grown from seed?

Yes, especially the dwarf bedding dahlias like the All-American winner Redskin, as well as Sunny, Dahl Face, Figaro, and Rigoletto. Start seeds indoors four to six weeks before the last frost, when they should be moved outside. Except for Sunny, the flower color of dahlias grown from seed cannot be predicted in advance.

How do I grow dahlias from tubers?

Tubers may be started indoors four to six weeks before the last frost, or planted directly into the garden after all danger of frost has passed. If you are growing tall varieties that will need to be staked, place the stake in the ground at planting time so you do not damage the tuber later on.

What care do dahlias require?

Dahlias like full sun, although they also do well in light shade. Soil should be light, rich, and fertilized monthly during the growing season. Water heavily, never allowing the ground to fully dry out, and mulch to keep the soil moist. Remove flowers as they fade. Bedding dahlias require little additional work. Those grown for large, cut flowers should be *disbudded*: remove all buds but the one on the central stem, so that the strength of the plants goes entirely to the remaining flower.

How do I store dahlia tubers over the winter?

After frost has blackened the tops of dahlias, dig them, allow them to dry slightly, and store them in a cool, dry, dark place that is frost-free. A particularly good storage is a plastic bag filled with dry peat moss. Check them during the winter to make sure they are not drying out; a sign of this is shrinking. If they show new growth, they are receiving too much light or heat.

What causes dahlia roots to rot?

Any one of several fungus or bacterial diseases. Verticillium wilt causes the lower leaves gradually to lose their color, the roots to decay, and the stem to show black streaks when cut across. Stem rot and soft bacterial rot causes rather sudden wilting. A heavy, wet soil encourages stem rot and bacterial wilt, but the organisms are already present. Improving drainage and lightening the soil with sand or coal ashes will help.

Millipede

What is the little brown worm about one-half-inch long that eats my dahlia roots?

The worms you describe are probably millipedes. They look brown to some, grayish to others. They are hard, with many legs, usually coiled into a circle, and almost always scavengers feeding on rotting tissue. The most effective treatment is to apply systemic granules around the base of the plant and water them in thoroughly.

My dahlia tubers are drying up in storage and some show rot all the way through. How do you prevent this?

Botrytis, fusarium, and other fungi and bacteria may cause storage rots. Use care to avoid wounds when digging them up. Store only well-matured tubers, avoid any frost damage, and keep at 40° F. in sand that is only very slightly moist. Too much moisture will increase rotting. Dusting tubers with captan before storage may help.

Some dahlia leaves have bright yellow mottling; is that mosaic, and what can be done?

The mottling is a typical symptom of mosaic, a virus disease carried from one plant to another by aphids. Dwarfed or stunted plants is also a common symptom of this disease. Control aphids with contact sprays, and remove and burn infected plants.

What are the chief causes of dahlia "stunt"?

Either mosaic or the feeding of sucking insects, often leafhoppers, but sometimes thrips or plant bugs. Stunted dahlias are short and bushy with an excessive number of side branches. Leafhoppers cause the margins of the leaves to turn yellow, then brown and brittle — a condition known as hopper burn. Spray once a week with malathion or pyrethrum, beginning early in the season and wetting the underside of leaves thoroughly. If the stunting was due to leafhoppers and the tubers appear sound, the plants may be used the following year. But if the stunting was due to mosaic, a virus disease, the tubers should be destroyed.

My miniature dahlia is full of buds, but they rot. What is the matter?

It may be gold-gray mold, the same type of botrytis blight that affects peony buds. Remove all diseased buds and spray with captan. Burn all plant tops in the fall.

If dahlias mildew badly at the end of the season in California, will the tubers be injured?

Probably not, but mildew is a serious disease on the West Coast, and dahlias should be sprayed or dusted with one of the above fungicides.

Is the borer that attacks dahlia stalks the corn borer?

Yes, if the borers are flesh-colored when young and later turn smoky or reddish. If the caterpillar is brown, striped with white, it is the common stalk borer, also a pest of corn. Clean up stalks of all herbaceous plants in the fall. Include the weeds, for many of these harbor borers during the winter. Spray or dust stalks with malathion or *Bacillus thuringiensis,* if this has been a severe problem.

This year, grasshoppers ate our dahlia blooms. Is there any way to prevent this?

Spray or dust the flowers with diazinon. Keep down weeds.

Stalk borer

Delphinium. See Larkspur.

Dianthus, China pink *(Dianthus chinensis)*

Are China pinks so named because they are pink? I think I have seen white and red varieties.

You have — China pinks are red, white, pink, or lilac in color. They are called pinks because of the ruffled edges on the petals that look like they were cut with pinking shears.

China pink: This tapestry-like display vividly demonstrates the variety of colors in which China pinks are available.

Ann Reilly

What are the best annual pinks?

Look for varieties such as China Doll, an All-American winner with double flowers in mixed colors; Magic Charms, with large blooms on a dwarf plant; Princess, most reliable for compactness, neatness, and all-summer flowering; Snowfire, with white blooms that have red centers and good heat resistance; and Telstar, which is also heat-resistant.

What type of climate does dianthus prefer?

All dianthus are frost-tolerant and may act as perennials where winter temperatures do not drop below 0° F. The new varieties are more heat-tolerant than older dianthus, although they still prefer a cool to moderate temperature and high humidity.

What type of growing conditions do I need for dianthus?

Dianthus likes full sun or light shade, and a rich, well-drained soil that is alkaline. If necessary, adjust the soil pH by adding lime (see pages 31-32). Feed monthly with soluble plant food, and cut back plants after they have flowered, to encourage a second bloom.

Dusty miller, several different genera

I'm confused about dusty miller: I have seen several different plants, each called by the same name. What are they?

Dusty miller is a common name given to several plants that have white, silver, or gray foliage and no significant flowers. They may be members of the *Senecio*, *Centaurea*, or *Chrysanthemum* genera.

How do I grow dusty miller? I planted seeds in the garden last year but the plants did not grow well.

Dusty miller must be set into the garden as plants that you have purchased, or started indoors yourself from seeds. They like full sun or partial shade, light dry soil, and little fertilizer. If the plants become leggy, they can be cut back.

I saw a dusty miller with very fine foliage and would like to buy it for my garden. What was it?

It was probably Silver Lace, which has extremely lacy, finely-cut leaves. For an interesting contrast, plant the broader-leaved Silverdust or Cirrus along with the airy Silver Lace.

English daisy (Bellis perennis)

What growing conditions do English daisies like?

Plant them in full sun or light shade in a light, rich soil. Keep them well watered, and fertilize them monthly during the

blooming period. English daisy grows as a summer annual only in cool climates. Remove all flowers as they fade; English daisy can become weedy if seeds drop into the lawn.

I thought that English daisy was a biennial, but I have read that it can be grown as an annual. Is this true?

Yes. When grown as a biennial, English daisy blooms in the spring. When used as an annual, plants bloom during the summer.

How do I grow English daisy as an annual?

Start seeds indoors eight to ten weeks before planting the seedlings outdoors. The seedlings can be moved into the garden several weeks before the last expected frost.

Flowering cabbage and kale *(Brassica oleracea)*

On a visit to Mystic Seaport in Connecticut last fall, I was impressed by a display of chrysanthemums and brightly colored foliage plants I was told were flowering cabbages. Can I grow them?

Most seed catalogs offer the seed of flowering cabbage and flowering kale, which can be sown in early summer so that the plants reach maturity in the fall when the foliage color is most brilliant. The plants need the cold temperatures of fall to develop their intense white, pink, or purple coloration.

Flowering cabbage: The cool temperatures of fall bring out the subtle, rich foliage color of these unusual plants.

Ann Reilly

How do I grow flowering cabbage or kale?

Seeds must be started indoors. Flowering cabbage seeds should be chilled in the refrigerator for three days prior to sowing (see stratification, page 23); they need light to germinate. Their culture is the same as for regular cabbage, and both ornamental cabbage and kale are edible, although bitter. Plant outdoors in early fall in full sun in a moist, rich, fertile soil. Plants will last for several months, and even all winter where temperatures do not drop below 20° F.

Flowering tobacco. See Nicotiana.

Forget-me-not (*Myosotis sylvatica*)

I tried to grow forget-me-not last summer, but had no success. What did I do wrong?

Forget-me-not is a cool-temperature plant. Seeds should be sown outdoors in fall for growth and bloom the following spring. Be sure to cover the seeds completely as they need darkness to germinate. Seeds can also be started indoors in winter for spring transplanting, but this is not as easy a method, because they need cool temperatures for germination.

When hot temperatures arrive, all of my forget-me-nots die. Is this to be expected?

Unfortunately, yes, but forget-me-nots readily self-seed, so plants will appear every year once the bed is established.

The stems of my forget-me-nots turned black from the soil toward their tips. What caused this?

A wilt due to a fungus, probably sclerotinia, in the soil. All you can do is remove the infected plants, digging out all surrounding soil and filling the hole with fresh soil from another location.

Forget-me-not: Sow the seeds of forget-me-not in the fall for bloom the next spring.

Four-o'clock (*Mirabilis Jalapa*)

How and where should I grow four-o'clock?

Four-o'clock likes full sun and a light, well-drained soil. It tolerates poor soil and summer heat, although it will also do well where summers are cool. The plant itself is not attractive although its flowers are, so use it behind other plants.

I have been told that you get larger bushes and a greater number of flowers from four-o'clock roots the second season. In Missouri, can I leave them in the ground, or is it better to dig them up and dry them like certain bulbs?

Four-o'clocks are mostly used as annuals; the roots would be very unlikely to live through the winter outdoors in your region.

The large, tuberous roots can be lifted before hard frost and stored indoors for the winter, like dahlias. They will flower earlier and produce better blooms. Four-o'clock is so easy to grow from seeds, however, that this method is not necessary.

Fuchsia *(Fuchsia x hybrida)*

I have seen spectacular hanging baskets of fuchsia and would like to grow some this year. What do I need to do for success?

Grow fuchsia in partial or full shade in a rich soil with excellent drainage. Keep it well watered, and keep the humidity high by frequent misting. Fertilize every other week with a soluble plant food.

Is it possible to grow my own plants from seed or cuttings?

Yes. Seeds need to be started indoors six months before the desired blooming time. Do not cover them during germination, as they require light. Tip cuttings may be taken at any time and rooted in sand or a peat moss-vermiculite mixture (see page 35).

Black spots appear on the undersides of my fuchsia leaves, which turn yellow. What is causing this, and what is the remedy?

A rust disease causes brown spots on the underside of leaves. Yellowing of leaves, however, is probably due to sucking by whiteflies, and the black spots may be from parasitized whitefly nymphs or whitefly pupae. Control with an insecticide that combats whitefly.

Gaillardia, Blanket flower *(Gaillardia pulchella)*

I have enjoyed gaillardia in my perennial border for many years. Is there an annual form?

Yes, there is an annual gaillardia, but the flowers are ball-shaped rather than daisy-like. Lollipops is a favorite variety and very descriptive of the flower shape.

How do I grow annual gaillardia?

You can start with purchased plants or grow your own plants from seed. Gaillardia likes hot sun and dry soil. Fertilize it very little, if any, as it prefers infertile soil.

How can I keep grubs out of the stems of gaillardias?

Your grubs may be larvae of the common stalk borer. The best control depends on cleaning up all weeds and woody stems in autumn. Frequent spraying with malathion or bacillus thuringiensis may partly repel borers. (See also Dahlia, page 91.)

Gaillardia: This bright flower thrives in hot sun and dry, infertile soil.

Gazania *(Gazania rigens)*

I enjoy the daisy flowers of gazania in my garden all summer. Is it possible to grow it indoors as well?

Yes, dig some plants out of the garden in late summer, pot them up, and bring them inside for several months of color. Give them full sun and little water.

Can I grow gazania in my garden in Oklahoma?

Yes. Gazania prefers high temperatures and dry soil. Plant it in full sun in a light, sandy soil.

Geranium *(Pelargonium x hortortum)*

What growing conditions will be best for zonal geraniums?

Garden geraniums like full sun; rich, acid, well-drained soil; heavy fertilizing; and heavy watering. If possible, apply water to the ground and not to the foliage and flowers. Dead flowers should be removed immediately to keep the plants in full bloom. Geraniums grown in containers prefer to be pot-bound.

I have seen Martha Washington geraniums in the local botanic garden and admire their attractive flowers with the dark markings on the petals. Can I grow these at my home in Oregon? I have not seen them in seed catalogs.

Your climate is perfect for Martha Washington geraniums (*P. x domesticum*), for they prefer cool summers. They benefit from dappled sunlight, but are otherwise grown the same way as zonal geraniums. They can only be propagated from cuttings, so you will not find them in seed catalogs.

I see signs in the garden center for "cutting geraniums" and "seed geraniums." What is the difference?

Originally, all geraniums were propagated by cuttings, and many still are. Since the 1960s, there have also been hybrid geraniums that can be grown from seeds. Those grown from cuttings are best planted in containers and where they will be seen close at hand, whereas those grown from seeds are better for massed beds. Seed geraniums are also more tolerant of heat, high humidity, and diseases.

How do I grow geraniums from seed? Can I sow them directly into the garden?

Seed geraniums must be started indoors twelve to sixteen weeks before the last frost. The seeds are very fine and should barely be covered. Some of the best varieties to try from seed are the Diamond, Hollywood, Orbit, Pinto, Ringo, and Sprinter series, all of which are available in a large variety of colors.

Ann Reilly

Geranium: This familiar and colorful annual is an excellent container plant, here potted together with lantana.

How can I increase my geraniums by cuttings?

Take tip cuttings at any time, and allow the ends to dry out slightly before rooting them in coarse sand kept on the dry side to prevent disease (see page 35). At the end of the summer, cuttings can be taken from outdoor plants to grow inside over the winter. This method is more favorable than digging plants and bringing them indoors.

I would like to use geraniums in a hanging basket. What are the best types to use?

The ivy geranium, *P. peltatum*, is the best for use in hanging baskets because the stems naturally cascade over the sides of a container. They like dappled sunlight and moderate temperatures, and they can be propagated from either cuttings or seeds.

Is there any way to prevent geranium stalk rot? Some of mine rot each winter, but I do not think they are too wet.

Stem rot is usually associated with poor drainage or excessive watering. Start with cuttings from healthy plants placed in fresh or sterilized sand or a growing medium.

About a third of my geranium cuttings have shrivelled at the ground, turned black, and died. What is the cause?

Either a fungus or a bacteria stem rot. Take cuttings from healthy plants and place them in clean new sand. Keep them on the dry side.

After I prune geraniums at a 45° angle, the stems turn black and rot back four or five inches. What can be done?

Try frequent pinching back instead of occasional heavy pruning. When you prune, do it close to a node and disinfect your knife between cuts in 5-percent solution of Formalin or denatured alcohol.

Gerbera *(Gerbera Jamesonii)*

I have seen gerbera at the florist shop and very much like the pretty, daisylike flowers in their wide range of pastel colors. Can I grow them in my annual flower garden?

Yes. Gerbera grows easily in the garden and will last up to two weeks as a cut flower. The florist may also have potted plants that you can purchase, or you can grow your own plants from seed, provided you start them indoors ten weeks before the last frost. Seed is not long-lived and should be sown immediately. Do not cover seeds as they need light to germinate. Grow gerbera in full sun in a moist, very rich soil. Keep faded flowers removed.

Last year I planted gerbera plants that I purchased at a garden center, but they did not grow. What did I do wrong?

If you followed the instructions just given and still had problems, it's possible that you set the plants too deep. Be sure the *crown* (the point where the stem and root merge) is not planted below the soil level.

Globe amaranth *(Gomphrena globosa)*

I have seen small, cloverlike dried flowers of purple, lavender, white, orange, pink, and yellow in an arts & crafts store. Is it possible to grow these?

These are probably globe amaranth, an annual that dries well. Give them full sun and light, sandy soil; they like heat and drought.

Gloriosa daisy *(Rudbeckia hirta)*

Is gloriosa daisy sometimes a perennial?

There are both annual and perennial forms of gloriosa daisy; the perennial forms are often not long-lived and may also be grown as annuals. Both will reseed freely and act as perennials if you desire. Gloriosa daisy is easy to grow in full sun or light shade and will tolerate poor soil and drought.

Godetia. See Clarkia.

Hibiscus *(Hibiscus* species)

What makes the leaves on Chinese hibiscus dry up and fall off?

There are several possibilities. Fungus blight, stem rot, or leaf spot might cause such symptoms, but your trouble is more likely soil that is either waterlogged or too dry.

The buds on my hibiscus formed, but before blossoming they turned brown and dropped off. Why?

If you had a spell of rainy weather, it might have been botrytis blight, or gray mold, which possibly might have been prevented by spraying with captan.

I have admired hibiscus in southern gardens. Can I grow them in Minnesota?

Yes, there are several annual or perennial forms of hibiscus that bloom the first year and can be grown as annuals. To grow the perennial types as annuals, start seeds indoors three months

Hibiscus: The seeds of this dramatic flower must be nicked before being planted to assure good germination.

Ann Reilly

before the last spring frost. Start annual types eight weeks before planting date. The seed coat is very hard and must be clipped or soaked in water before sowing (see page 22). The perennial types will not survive your winters, however.

Hollyhock *(Alcea rosea)*

I always thought hollyhocks were biennials or perennials, yet I see annual hollyhocks listed in catalogs. Which are they?

Some hollyhocks are truly biennials or perennials, but there are some annual varieties. These include Majorette, Powder Puffs, and Summer Carnival.

How do I grow hollyhocks from seed?

Hollyhock seeds must be started indoors or they may not bloom during the summer. Sow seeds indoors six to eight weeks before the last spring frost. Barely cover the seed, for it needs light to germinate. Transplant outdoors after frost danger has passed.

How do I treat hollyhocks in the garden?

Plant hollyhocks in full sun or very light shade in rich, well-drained soil. Water hollyhocks heavily and fertilize monthly. Taller varieties will need to be staked.

Are all hollyhocks tall, stately plants?

No, some of the newer varieties are dwarf. Majorette grows only two feet tall and has large, double flowers in many colors.

Ice plant *(Mesembryanthemum crystallinum)*

When I was in California last year, I noticed a beautiful and colorful ground cover along the freeway and in many gardens. Can I grow this in Michigan?

Ice plant is a perennial in southern California, but can be grown as an annual if conditions are right. The plants must have full sun and a very dry soil. Fertilize every other month during the growing season.

I have not seen ice plant in my garden center, but would like to try some. How do I grow them from seed?

Seeds must be started indoors ten to twelve weeks before the last spring frost. Ice plant seeds are very fine, and therefore should not be covered. However, they need darkness to germinate, so cover the seed flats with black plastic until germination has occurred.

Ann Reilly

Hollyhock: The seed of annual hollyhocks should be begun indoors in order to assure summer bloom.

Immortelle: An excellent plant to be grown for drying, sow immortelle outdoors where the plants will remain.

Immortelle *(Xeranthemum annuum)*

The double flowers of immortelle dry so well, but I have had trouble growing the plants from seed. What am I doing wrong?

Immortelle does not like to be transplanted. After all danger of frost has passed, sow seed outdoors where plants are to grow. If you wish to start immortelle indoors, you must start it in individual pots.

My immortelle need to be staked each year. What am I doing wrong?

Probably nothing. It is normal to stake these plants. Give them full sun, lots of water, monthly feeding, and a light soil.

Impatiens *(Impatiens Wallerana)*

How much shade will impatiens endure?

Quite a bit. In fact, it is probably more shade-tolerant than any other annual. Bright light, with a few hours of direct sun, are needed for the best flowers, though.

Can impatiens seed be sown directly into the garden?

No. Although seed will germinate, it will not have enough time to grow into flowering plants in most sections of the country. Start seeds indoors ten to fourteen weeks before the last spring frost, or start with purchased bedding plants.

The foliage of my impatiens wilts during the day, and yet I water my plants well. What is wrong?

Nothing is wrong. Impatiens likes moist soil, and even when well-watered it often wilts during the day when it is very hot. Overwatering can cause impatiens to grow poorly. If the foliage perks up after the sun goes down, there is no need to water. Wilting can be reduced by using a mulch to retain moisture in the soil and to keep it cool.

My impatiens grew very tall and lush but did not flower well. I fertilized them again but it did not help. What do you suggest?

You have probably overfertilized your impatiens. Fertilize lightly before planting, but do not fertilize again during the growing season.

I saw a plant marked impatiens, but it did not look like the impatiens I am familiar with. There were few flowers, but the foliage was very colorful and brightly variegated. What was this plant?

It sounds as though you are describing a New Guinea impatiens, discovered in the 1970s by a team of plant explorers in New

Guinea. They are grown primarily for the brightly colored foliage that you describe. They require more sun than garden impatiens. Some varieties do have large, colorful flowers.

Why do my impatiens plants get a sticky substance on them? They have something like grains of sugar all over them.

These grains of sugar may be honeydew secreted either by scale insects or aphids, but they are more likely drops of exudate unrelated to insects.

Iresine *(Iresine Herbstii)*

I thought iresine was a houseplant, but I saw some growing in a flower bed in a public garden. Which is it?

Iresine is a houseplant, but its bright, deep red leaves make it a perfect plant for the annual bed or border. The red leaves are striking and should be used in any area where a red-flowered annual is called for.

Can I grow iresine from seeds?

No, you cannot. Buy a houseplant, and root cuttings from it in late winter (see page 35). After danger of frost has passed in spring, move the rooted cuttings to a sunny spot in the garden.

I have a small border along a stream in the back of my house. Can I grow iresine there?

As long as it receives full sun, yes. Iresine particularly likes moist soil.

Ivy geranium. See Geranium.

Joseph's coat. See Amaranthus.

Kingfisher daisy. See Blue daisy.

Kochia *(Kochia scoparia var. tricophylla)*

I have heard of a hedgelike annual that may be used instead of shrubs. What is it?

Burning bush or kochia. The rounded plants, which look much like sheared evergreens, grow three feet tall. During hot weather, the foliage is light green, but in autumn it turns a rich red. Plant in full sun in a dry soil. Kochia does best in areas where summers are hot. Acapulco Silver has white leaf tips and was an All-American award winner.

Lantana *(Lantana Camara)*

I recently saw a very neat plant with round flowers of pink, yellow, and orange on the same plant. What is it?

The very attractive multicolored plant you describe must be lantana, a particularly striking container plant. It is sometimes trained as a *standard*. This involves selecting the strongest stem, pruning away other stems and all lower foliage as the plant grows, and allowing the plant to fill out and bloom only at the top, like a small tree.

Can I grow lantana from seed?

Yes, but because seeds take six weeks to germinate, they must be started indoors three months before the last spring frost. You will find it easier to start with plants rooted from cuttings taken from your plants in the fall and grown indoors over the winter for use the following summer.

Larkspur, Annual delphinium *(Consolida* species)

Are there any tips for germinating larkspur seed? I have had little success in the past.

Start with fresh seeds every year, as larkspur seeds are short-lived. Be sure the seeds are completely covered in the seedbed; they need darkness to germinate. Because they transplant very poorly, sow the seeds where the plants will flower, and thin out the seedlings to nine inches apart.

What is the secret for successful larkspur? Ours start well but fade before flowering.

The secret is an early start in spring — about the time you sow peas. Larkspur grows best in cool weather, so in southern parts of the country it should be grown only as a spring plant. Grow plants in well-drained, moderately fertile, alkaline soil, in full sun or light shade.

Why do my annual larkspur plants turn yellow and die just before or after the first blooms appear?

This may be crown rot. The fungus starts working in warm, humid weather, which may coincide with the blooming time of larkspur. Remove infected plants.

Lavatera, Tree mallow *(Lavatera trimestris)*

I started lavatera seeds indoors last year, but had little success with them after I transplanted them into the garden. Any suggestions?

Lavatera seedlings do not transplant well, so seeds should be sown outdoors where the plants are to grow. Because lavatera is

Larkspur: Begin larkspur as early in spring as possible for most success.

Ann Reilly

tolerant of light frost, seeds may be sown as soon as the ground can be worked in spring, or in the South they may be sown outdoors in the fall for germination and growth the following spring. Lavatera grows best in regions where nights are cool. It likes a fertile, dry soil, and full sun.

Linaria, Toadflax (*Linaria maroccana*)

I enjoy the snapdragon-like flowers of linaria, but they do not do well in my Tennessee garden. How should I grow them?

Linaria prefers cool summers, so in your area it may grow best as a spring flower, and will make an excellent complement to bulbs and early perennials.

Can I sow linaria seeds directly into the garden in Oregon?

Yes, either in fall for germination and bloom in the following spring, or in early spring as soon as the soil can be worked. Seeds are very small, however, and may wash away in heavy rains, so you may wish to start seeds indoors four to six weeks before the outdoor planting date, if you can give them a cool (60° F.) room.

In addition to cool temperatures, what growing conditions does linaria like?

Plant them in full sun or light shade in a moist soil, and mulch them to keep the soil moist and cool. Fertilize every other month during the growing season.

Lisianthus (*Eustoma grandiflorum*)

What type of care does lisianthus require in the garden?

Plant them in full sun in average (neither clayey nor sandy) soil with excellent drainage. Soil must be fertile, so incorporate fertilizer before planting and feed again every other month during the growing season. Lisianthus is tolerant of heat, drought, and rain and prefers to be grown where summers are warm.

How do I grow lisianthus from seed?

With great patience. It takes seven months for seeds to reach blooming size, so it is better to start with purchased plants. If you do want to try growing your own plants from seed, give them a warm spot indoors and barely cover them as the seeds are very fine.

Are there both double- and single-flowered forms of lisianthus?

Yes, there are. Lion is a double-flowered series with blooms of blue, white, or pink. Yodel has single blooms in these colors as well as lavender.

Ann Reilly

Lavatera: Like larkspur, lavatera should be started very early in spring.

Ann Reilly

Lisianthus: Long-lasting as a cut flower, lisianthus should be pinched back at least twice, early in its development, in order to produce strong, compact plants.

I tried lisianthus in my cutting garden last summer, but the stems were weak and the plant flopped over. What should I do?

Lisianthus seedlings should be pinched as soon as they are transplanted, and again when two to three inches of growth have developed, to keep the plants compact and the stems strong. If this is not done, the plant will need to be staked.

How long does lisianthus last as a cut flower?

Lisianthus will last up to fourteen days.

Lobelia *(Lobelia Erinus)*

Will lobelia grow in partial shade?

Yes, the low-growing varieties are ideal for window and porch boxes or hanging baskets, as well as for partly shaded edgings around terraces. Choose trailing varieties for boxes and dwarf varieties for edgings. In hot areas, lobelia benefits from being planted in the shade; where summers are cool, it can be grown in full sun.

I have had problems germinating lobelia seed directly in the garden. Any suggestions?

Lobelia seed must be started indoors ten to twelve weeks before the last spring frost. The seeds should not be covered with potting medium; they require a warm (75° F.) place in the home for successful germination.

My lobelia plants become very leggy by midsummer. What can I do?

If it becomes leggy, lobelia can be sheared back to encourage compactness and heavier bloom. Keep plants well watered. Do not overfertilize, because this encourages growth at the expense of flowering.

What color are lobelia flowers?

Blue Moon has bright blue flowers and green foliage; Crystal Palace has bright, dark blue flowers and bronze foliage. Cascade, the best lobelia for containers and hanging baskets, is available in blue, red, white, purple, and lilac. White Lady is sparkling white.

Love-in-a-mist *(Nigella damascena)*

How did this plant get its name?

The pink, white, blue, or purple flowers of love-in-a-mist bloom within misty, delicate foliage. They make good cut flowers.

I would like to use the round, fragrant seed pods of love-in-a-mist in dried arrangements as their red markings on a green background are very attractive. How do I dry them?

Leave the flowers on the plant until the seed pods form, but cut them before they are fully mature. If left on the plant too long, the seed pods will burst. (If allowed to mature, love-in-a-mist freely self-seeds.)

I started seeds of love-in-a-mist indoors, but they did not grow well after I transplanted them into the garden. What do you suggest?

Because this plant resents transplanting, sow seeds in individual pots if you want to start seeds indoors. There is much less root disturbance to plants transplanted from pots than to those cut out of flats. Love-in-a-mist seeds grow well when sown directly into the garden; in mild areas, you can sow seeds in the fall for spring bloom. This plant likes full sun, fertile and moist soil, and cool temperatures.

Love-in-a-mist: Both the fresh flowers and the round, fragrant seed pods of love-in-the-mist are decorative in flower arrangements.

Love-lies-bleeding. See Amaranthus.

Marigold *(Tagetes* species)

What types of marigolds do you suggest for an all-marigold garden?

African marigolds (*T. erecta*) are tall plants for the back of the garden, with double flowers including carnation-flowered, chrysanthemum-flowered, dahlia-flowered, and peony-flowered types. Use French marigolds (*T. patula*) at the front of the border; these have either single, crested, anemone, carnation, or double flowers. A third type of marigold is known as a triploid and is a cross between the African and the French (*T. patula x erecta*); these are low- to medium-growing types that produce flowers all summer even in the hottest part of the country when other marigolds may lose their free-flowering habit. Because they do not set seed, the dead flowers fall cleanly from the plant, and they are easier to maintain.

I would like to try some of the triploid marigolds for their non-stop bloom. What are some of the varieties available?

The best known are the Nugget series, which includes Red Seven Star, and the single-flowered, orange and yellow Mighty Marietta.

What large-flowered, tall marigolds shall I grow for variety in color?

There are a number of African marigold series (see page 3) that contain varieties in yellow, gold, and orange. You could choose

one of these series and plant all three colors for variety in the flower bed. These include Climax, Crush, Discovery, Galore, Inca, Lady, Perfection, and Voyager varieties. All but the Crush series are hybrids.

Which French marigolds should I select for variety in color?

Again, there are a number of series of French marigolds with variety in color; in addition to the yellow, orange, and gold colors available in the African marigolds, many French marigolds are red, mahogany, or bi-colored as well. Recommended series include Bonanza, Boy, Janie, and Queen. Red Marietta is a red single, edged in gold. There are no hybrid French marigolds.

Can marigold seeds be planted directly into the garden?

Seeds of French marigolds can be sown in the garden and will germinate and grow quickly, but seeds of African and triploid marigolds must be started indoors four to six weeks before the last spring frost.

Would you tell me why my marigolds didn't blossom well last summer? Could it be the fault of the soil?

It may have been any of a number of reasons: too late sowing; too much rain; too heavy or too rich soil; pest and disease attacks; insufficient sun; overfeeding; overwatering; or failure to remove faded flowers. Also, some varieties (not triploid) of marigolds simply stop flowering in excessively hot weather.

My African marigolds did not bloom until late summer. What is the reason?

African marigolds are light sensitive, which means they bloom only when days are short and nights are long. Indoors, you can manipulate the amount of light your seedlings receive, so that they get proportionately more dark than light hours. Once they begin to bud under these conditions, they will continue to develop and bloom throughout the summer. If they receive more light hours than dark before budding, however, they will not produce blooms until late summer when nights get longer. For this reason, it is best not to plant African marigold seeds directly into the garden.

Do African marigolds need to be staked?

The new African marigold varieties are compact and should not need staking.

What is the benefit of planting marigolds in the vegetable garden?

Marigolds repel certain beetles and nematodes that afflict some vegetables.

African marigolds are one of the few plants that should be in bud when transplanted into the garden.

Ann Reilly

Why do my dwarf marigolds turn brown and dry up after blossoming well for a month? It is not lack of water.

Perhaps you cultivate too close to them and damage their roots with your gardening tools. A fungus stem, collar rot, or wilt may also be present. If the latter, you must remove diseased plants and either sterilize the soil or use another location for your next planting.

Mexican sunflower *(Tithonia rotundifolia)*

My Mexican sunflower plants never bloom. Can you tell me why?

The Mexican sunflower, with its handsome, single, brilliant orange or yellow blooms, must be started early indoors to give generous bloom in late summer and fall before frost arrives. Torch, a variety that grows only four feet tall, blooms earlier than the original species, which reaches six feet. Use it at the back of the border or as a screen plant. Goldfinger is smaller still (three feet tall) and has a longer blooming season than the species.

What growing conditions does Mexican sunflower need?

Plant Mexican sunflower in full sun in a dry soil, and do not overwater. Feed lightly each month with a soluble fertilizer.

I want to grow Mexican sunflower in my cutting garden. Any tips?

For the longest lasting cut flowers for the home, cut Mexican sunflower when it is still in the tight bud stage.

Mignonette *(Reseda odorata)*

Where in the garden should I plant mignonette?

The wonderful fragrance of mignonette calls for its being planted where its aroma can be enjoyed, such as on decks and patios or under windows. Because it is not an attractive plant, plant a lower growing annual in front of it to hide it somewhat.

Can I start seeds of mignonette indoors?

You can, but sow them into individual pots, as seedlings resent being transplanted. Do not cover the seeds; they need light to germinate. They grow very quickly outside, so not much is gained by starting them indoors.

Can I grow mignonette with spring bulbs in Alabama?

Yes. In your climate, they would not grow well in summer, as they like cool weather, but they would be perfect with spring bulbs. Plant in full sun or light shade in a soil that is kept moist and cool with watering and mulch.

Mignonette: Plant this wonderfully fragrant plant near decks or under windows where its aroma can be enjoyed.

Money plant (*Lunaria annua*)

I like to grow a few money plants for their dried branches, but the plants have sprung up all over the yard and are quite a nuisance. What should I do to prevent this?

Money plant reseeds very freely, so cut the seed pods off before they have a chance to fall onto the ground.

How do I dry money plant?

When seed pods are mature, but before the seeds fall, cut the branches, rub the covering off the seed pod, and hang the branches upside down, in a cool, airy place to dry.

How is money plant grown?

Start seeds indoors six weeks before planting outdoors, or sow seeds outdoors in mid-spring. Give them full sun or light shade in average garden soil. Little if any fertilizer is needed. Water plants when dry.

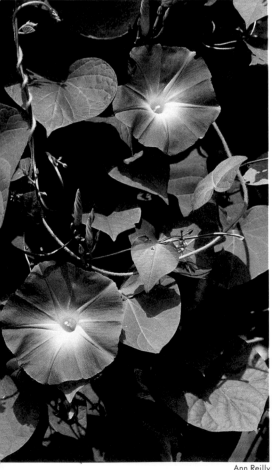

Morning-glory: For best results, plant morning-glory seeds directly in the place they will remain, in full sun, in poor rather than fertile soil.

Ann Reilly

Monkey flower (*Mimulus x hybridus*)

I planted monkey flower last spring where I live in South Carolina, but when summer came, they seemed to almost disappear in front of my eyes. What happened?

Monkey flower must be grown where the climate is cool and humidity is high. Grow it in partial or full shade in a moist, well-drained soil. Mulching will help to prolong the life of monkey flower in the garden.

I tried to start monkey flower from seeds, but did not have success. How should I do it in the future?

Do not cover seeds when sowing, as they need light to germinate. Seedlings also require thirteen hours of light per day to grow, so if they are begun indoors, they must be grown under fluorescent light. Set transplants into the garden as soon as the soil can be worked; monkey flower is quite tolerant of frost.

Moonflower. See Morning-glory.

Morning-glory, Cardinal climber, Moonflower (*Ipomoea* species)

How do you start morning-glory seeds?

Because morning-glory seeds grow quickly, they can be sown where the plants are to grow after all danger of frost has passed. If you want, you can start them indoors four to six weeks before

the last frost. They resent being transplanted, however, so handle their roots very carefully or sow them in individual pots. Morning-glory seeds have a very hard coat, so soak them in water for twenty-four hours before sowing, or nick or file the seed coat in order to help moisture get inside.

My morning-glories did not bloom well last summer, although they grew quite large. What was wrong?

Your soil was probably too fertile. Do not incorporate organic matter into the soil, and do not fertilize morning-glories, or you will have all vine and leaves and no flowers. Also, do not overwater, as dry soil is preferred. They do best in full sun, so if you tried to grow them in partial or full shade this may be another reason why they did not produce many flowers.

Nasturtium *(Tropaeolum majus)*

What nasturtiums shall I grow to produce seeds for pickles and salads?

The old-fashioned singles, either dwarf or tall, are best for seed production, whereas the much more beautiful and attractive, sweet-scented doubles produce few seeds.

I have heard that all parts of the nasturtium are edible. Is this true?

Yes, all parts — seeds, leaves, flowers, and buds — are often used in salads; flower buds and seeds can be pickled.

What shall I do to keep my nasturtiums free of little black bugs?

Spray young plants with malathion or insecticidal soap to kill aphids, but be sure to follow package instructions for application on vegetables if you are planning on eating your nasturtiums.

What is the benefit of planting nasturtiums in a vegetable garden?

Nasturtiums repel squash bugs and some beetles.

Should I start nasturtium seeds indoors?

No, nasturtium does not transplant well. Seeds grow quickly and should be sown outdoors where plants are to grow after all danger of frost has passed. Plant in full sun or light shade.

My nasturtium did not bloom well last year. What is the reason?

You probably overfertilized. Nasturtiums require a poor soil and should not be fertilized at all. In very warm climates, the bush-type nasturtiums will bloom better than the vining types.

All parts of nasturtium are edible, but be sure to use only pesticides suitable for vegetable crops if you are planning to use them as food.

Nemesia *(Nemesia strumosa)*

Nemesia does not do well for me. It grows tall and lanky and does not flower well. What is wrong?

There could be several reasons. Nemesia must have a cool, dry climate rather than a hot, highly humid one. Pinch it back at planting time to encourage bushiness. Give it full sun or light shade and a rich, moist soil that is mulched to keep it cool. Fertilize nemesia heavily.

How do I grow nemesia from seeds?

For best results, start seeds indoors four to six weeks before planting outside. Cover the seeds completely, as they need darkness to germinate.

New Guinea impatiens. See Impatiens.

Nicotiana, flowering tobacco *(Nicotiana alata)*

Nicotiana: Flowering tobacco, or nicotiana, does well in either sun or partial shade and prefers high humidity.

Ann Reilly

I have seen flowering tobacco in mixed colors. What variety is this?

There are several varieties of flowering tobacco in mixed colors. Nicki grows eighteen inches tall and is available in pink, red, rose, white, yellow, or lime green. Domino is a more compact plant, with flowers of purple, red, pink, lime green, crimson, and white.

How do I germinate seeds of flowering tobacco?

Seeds may be sown directly into the garden after all danger of frost has passed, but for best results, start seeds indoors six to eight weeks before planting outdoors. Do not cover the seeds; they need light to germinate.

I live in Florida and tried to grow flowering tobacco in my garden last winter, but the plants did not bloom well. What went wrong?

Nicotiana needs long days to bloom, so is not a good choice for a winter garden in the south.

Can I grow flowering tobacco in the shade?

Nicotiana grows well in partial shade or full sun. It tolerates summer heat as long as it is kept well watered and the humidity is high. Soil should be rich and well drained. Flowering tobacco is resistant to the disease botrytis and is often used as a substitute for petunias where humidity is high, as petunias are prone to this disease.

Nierembergia, Cupflower *(Nierembergia hippomanica)*

How shall I grow nierembergia from seed?

Start indoors in February or early March for early bloom, as seeds need ten to twelve weeks to mature into flowering plants.

How do I grow nierembergia in the garden?

Plant in full sun or light shade in a light, moist soil. Fertilize monthly with a soluble plant food.

Nolana *(Nolana napiformis)*

I saw a dwarf, spreading plant that had blue flowers that looked like a morning-glory. Is this a dwarf form of morning-glory?

What you saw was probably nolana, also known as blue bird. It doesn't grow over six inches tall and is useful as an edging or an annual ground cover.

How do I start nolana from seed?

Seeds germinate and grow quickly, so that after all danger of frost has passed, they can be sown outdoors where the plants are to grow. Transplant carefully into the garden, as the roots do not like to be disturbed. Nolana is one plant that benefits from being planted when it is in bloom: this keeps it from growing too vigorously.

What growing conditions should I give to nolana?

Plant nolana in full sun or light shade in an average garden soil. Water when dry, and fertilize little, if any. It will not grow well where heat is excessive.

Ornamental pepper *(Capsicum annuum)*

Is it true that there is an attractive pepper plant that can be grown in the flower garden?

Yes, the ornamental pepper is edible, but be careful, as most of them are very hot! Compact plants are covered with round, tapered, or cone-shaped fruit that changes color from white to cream, chartreuse, and then purple, red, or orange as they mature.

Can I start seeds of ornamental pepper in the garden?

No, ornamental pepper seeds must be started indoors six to eight weeks before the last spring frost, or start your garden with purchased plants. Don't cover the seeds; they need light to germinate.

Ann Reilly

Nierembergia: Known also as cupflower, because of its dainty cuplike blossoms, nierembergia prefers full sun or light shade.

Ornamental pepper: These unusual plants thrive in long, hot, humid summers.

What are the varieties of ornamental pepper that I should look for?

Fireworks has cone-shaped fruit; Holiday Cheer has round fruit; Holiday Flame has slim fruit; Holiday Time has cone-shaped fruit; Masquerade has long, thin fruit; and Red Missile has tapered fruit.

Will ornamental peppers do well in my garden in Texas?

Yes, ornamental peppers prefer a long, hot, humid summer and are very heat- and drought-resistant. Plant them in full sun or very light shade.

My ornamental peppers did not produce a heavy crop of peppers. What was wrong?

You most likely overfertilized. Feed the plants lightly at planting time and do not fertilize again during the summer. Soil should be watered more if fruits are not setting.

Painted-tongue. See Salpiglossis.

Pansy *(Viola x wittrockiana)*

When should I plant pansies in the garden?

Pansies prefer cool weather, especially cool nights, and should be set into the garden as early in spring as the soil can be worked. Where winter temperatures do not drop below 20° F., pansies can be planted and mulched in the fall for bloom early the following spring until the weather becomes hot. In colder climates, pansies can be overwintered in a cold frame for early planting the following spring.

What type of pansy should I plant for the longest possible bloom time in the spring?

The new hybrid pansies are more heat-resistant than the older types and should be selected for the earliest and longest blooming period. Pansies will do well where the days are hot and the nights are cool, such as along the coast. Bloom time will also be extended if pansies are heavily watered and mulched, and the flowers removed as they fade.

Can you suggest some pansy varieties of different colors, shapes, and hardiness?

There are a number of series of pansies, all of which are available in a large number of colors including red, white, blue, pink, bronze, yellow, purple, lavender, or orange. All of the following are hybrid pansies: Crystal Bowl is a multiflora resistant to heat and rain; Majestic Giant is a grandiflora; Mammoth Giant is a grandiflora that is not heat-resistant; Roc is extremely

cold-tolerant and a good choice for fall planting; Spring Magic is a multiflora; Springtime is a multiflora and among the most heat-tolerant; and Universal is a multiflora type that is very winter hardy.

I have heard that there are two different classifications of pansies. What are they?

The two types of pansies are known as *grandiflora* and *multiflora*. Grandifloras have larger flowers, while multifloras have smaller flowers, but a greater number of them. The multifloras also bloom earlier then the grandifloras.

How do I start pansies from seed?

Start seeds indoors fourteen weeks before the outdoor planting date. They will benefit from being placed in the refrigerator in moistened growing medium for several days before sowing. Be sure to cover the seeds completely; they need darkness to germinate.

What type of care do pansies need?

Grow pansies in full sun or partial shade in a rich, moist soil. Fertilize them at planting time and again every month during the growing season. If plants start to become leggy, pinch them back to keep them compact.

What is the white moth, similar to the cabbage moth, that lays its eggs on pansies? These hatch into small black hairless caterpillars that eat foliage and stems. During the day they lie on the ground, and then climb up the plants at night.

Violet sawfly

You have described the sluglike larva of the violet sawfly, the adult of which is a four-winged black fly, so the moth you mention must be something else. Spray with carbaryl (Sevin) or *Bacillus thuringiensis* for false slugs or sawfly larvae.

What is it that eats leaves and flowers of pansies? I have found one mahogany-colored worm with short hairs.

The woolly-bear caterpillar comes close to your description. It has a brown body, black at each end, and clipped hairs. It eats all kinds of garden plants. Spray or dust with *Bacillus thuringiensis* if large numbers occur, but woolly bears are seldom numerous enough to warrant spraying.

Woolly-bear caterpillar

Parsley (*Petroselinum crispum*)

I've seen parsley grown as a border to a flower garden, and thought it most attractive. I tried growing some from seed, but had no success. Any ideas?

Parsley seeds should be soaked in warm water for twenty-four hours before sowing. They do not like to be transplanted, so

Penstemon: Also known as beard tongue, penstemon prefers cool climates and light, rich, moist soil.

they should be started inside in their own individual pots, or sown where they are to grow outdoors. Cover the seeds well, as they need darkness to germinate.

Penstemon, Beard tongue *(Penstemon gloxinioides)*

I tried to grow penstemon seeds indoors, but had no success. What was wrong?

Penstemon must have a cool (55° F.) room to germinate indoors. If you don't have these conditions, sow seeds outdoors in early spring or, where winters are mild, in late fall. Outdoors, penstemon does best in cool climates in light, rich, moist soil.

Why didn't my penstemon bloom? The tips of the branches blighted and turned black instead of forming buds.

Crown rot, caused by *Sclerotium rolfsii*, a fungus infection, is common on penstemon and would blight the buds; but generally the whole plant wilts and dies. Penstemon likes a well-drained but not dry soil, and dies out in a year or two if not kept in full sun.

The tips of penstemon buds are webbed together and a small worm bores down the center of the stalks. What shall I do to prevent this?

The tobacco bud worm reported on some garden plants is probably the pest you have. Spray thoroughly with carbaryl (Sevin) or *Bacillus thuringiensis* as the buds form.

Periwinkle *(Catharanthus roseus)*

How and when should I plant the annual periwinkle (sometimes called vinca)?

Vinca is a native of the tropics and practically everblooming. Sow seeds indoors twelve weeks before the last frost. Be sure to cover the seeds completely; they need darkness to germinate. The seeds are sometimes difficult to germinate, and at first the seedlings are slow-growing. Transfer plants to the garden after all danger of frost has passed. Do not sow seeds directly into the garden as they will not reach blooming size during the summer.

What kind of growing conditions does periwinkle need?

Plant in full sun or partial shade in any well-drained soil. Although periwinkle prefers to be kept moist, it will tolerate drought and heat. Incorporate fertilizer into the soil before planting, and do not fertilize again.

Will periwinkle do well in my garden? I live near a freeway and exhaust fumes from the cars have damaged some of my plants.

Yes, periwinkle is one of the most pollution-tolerant annuals that you can grow.

I purchased periwinkle last year to grow as an annual ground cover, but the plants grew upright. Did I do something wrong?

You simply selected the wrong variety. Periwinkle, or vinca, comes in both upright and spreading forms. Carpet and Polka Dot are ground-hugging varieties. The Little series of Little Blanche, Little Bright Eye, Little Delicata, Little Pinkie, Little Rosie, and Little Linda are upright forms.

Petunia *(Petunia x hybrida)*

Can petunias be grown successfully with only four hours of afternoon sun?

Yes, provided other conditions are suitable.

How can I prepare a garden bed for petunias?

Plant in well-drained, moderately rich, and very thoroughly cultivated soil: its texture should be fine and light.

How do I start petunia seeds indoors?

Petunia seeds must be started indoors ten to twelve weeks before being planted outdoors. Because seeds are very fine and need light to germinate, they should not be covered. Seeds of hybrids and double-flowered petunias will need warm indoor growing conditions.

Can I sow petunia seeds outdoors?

Petunia seeds do not do well when directly sown into the garden. First, the seeds are very fine and can easily be washed away. Second, the seedlings take a long time to grow and thus rarely have time to develop into flowering plants during the summer even if they do germinate.

Can I take a chance and set my petunia plants into the garden before the last frost date? I'd like them to get a head start.

Petunias are slightly frost resistant, so you could safely plant them two weeks before the last frost date.

How long does it take petunia seeds to germinate, and when should one transplant them?

Viable petunia seeds sown on soilless medium, not covered, and kept at 70 to 75° F., should germinate in eight to twelve days.

Transplant them when the first true leaves appear. (The leaves that show at germination are only seed leaves; see page 21). This might be approximately ten to fourteen days after germination.

Is it advisable to plant petunias when they are in bloom?

It is better to plant petunias before they flower. They will grow better and come into full bloom more quickly.

At what time of day should I transplant petunias?

Most annuals prefer being planted on cloudy days or late in the afternoon when the sun is less intense. Multiflora petunias, however, will fully tolerate being planted in the sun and will not suffer transplanting shock.

Why can't I raise petunias? They are the only plants with which I am not successful. I buy good seeds but the plants that grow just get tall (leggy), with very small blooms.

There are several possible reasons for your problems. The plants may be too crowded, the soil may be too heavy or too shaded, or you may have planted them too close together. Finally, select compact-growing kinds and be sure to pinch back young plants.

What kind of growing requirements do petunias have?

They need soil that is not too heavy, claylike, or wet. A light (even sandy and dry) well-drained soil is best, and it should be only moderately rich. They also like full sun and high temperatures.

Why do petunia plants grow large but have no blooms?

The soil may be too rich, thereby forcing excessive stem and leaf growth at the expense of blooms. Try them in another place where the soil is poorer. Don't overwater.

I understand there are two different classes of petunias. Can you explain the difference?

The grandiflora class of petunias has very large flowers; the multiflora class has small flowers, but a greater number of blooms. The grandifloras are best for containers, and other plantings that will be viewed at close range. The multifloras are best for massed plantings. Multifloras are more disease-resistant and their flowers recover more quickly after a rain or watering. Both classes contain single and double varieties.

Which kind of petunias shall I get to grow against a small white fence? I prefer something bushy rather than tall.

Choose your favorite colors in the hybrid multiflora and grandiflora classes of petunias.

Ann Reilly

Petunia: Pink petunias are particularly tolerant of poor soil and other adverse conditions.

What type of petunia is best for all-summer beauty?

Select hybrids within the multiflora and grandiflora types.

I have at times noticed a delightful fragrance when I walked by a bed of petunias. Which varieties are the ones that are the most fragrant?

Any of the blue-flowered varieties are the most fragrant petunias.

My soil is especially poor and my growing conditions are not ideal. Can I still grow petunias?

Yes, especially if you choose pink varieties, which are most tolerant of adverse conditions.

What are the outstanding grandiflora petunia single varieties?

All of the grandiflora single-variety series come in a wide range of colors. The best of them are the Cascade and Super-cascade, the improvements to the Cascade series, which are ideal for containers; Cloud, which have ruffled petals and are also excellent for containers and baskets; Daddy, with petals

that are ruffled and deeply veined; Falcon, which will germinate better than others at low temperatures; Flash, which is one of the best grandifloras for weather resistance; Frost, which have white edges on the petals; Magic and Supermagic, best for bedding; Sails, with ruffled flowers; and Ultra, with a large number of blooms.

What are the best grandiflora petunia doubles?

Blue Danube has heavily fringed flowers. Purple Pirouette is the first double picotee (solid color with white petal edges); it has good heat resistance.

What should I grow if I want to grow multiflora petunia singles?

The Carpet series is low-growing and weather-resistant. Comanche is a brilliant crimson that does not fade in the heat. Joy is a series with early flowering characteristics. Madness is one of the best multifloras, with a wide variety of colors and ever-blooming characteristics. The Pearls are exquisite and tiny-flowered. All of these flowers have a white throat. The Plum series has veined flowers. Resisto was developed to resist cool, wet summers. Summer Sun is the best yellow petunia.

What would you recommend for multiflora petunia doubles?

The Tart series is early blooming, and excellent in containers.

What makes petunia plants turn yellow, especially if grown two years in succession in the same soil?

Petunias are subject to several virus diseases that discolor the leaves. The condition may also be due to a highly alkaline soil. Dig in peat moss or leaf mold, change the location, and prepare the soil well by digging it deeply.

The petunias in my flower boxes dry up and don't bloom well near the end of the season. What is the trouble?

It may be purely cultural difficulties — not enough water or poor soil conditions in the crowded box — but it may also be due to one or two fungi causing basal or root rots. Next time, be sure to use fresh soil, and continue to feed and water well throughout the season.

By the end of June, insects start to eat petunia leaves in my window boxes. What kind of spray should I use, and how often?

Spray with carbaryl (Sevin) or insecticidal soap often enough to keep the new growth covered. Look for hairless caterpillars feeding after dark. These may be climbing cutworms, which can be controlled with *Bacillus thuringiensis*.

Phlox *(Phlox Drummondii)*

When do I plant annual phlox into the garden?

As phlox is slightly resistant to frost, seeds may be sown outdoors where plants are to grow; sow them in early spring as soon as the soil can be worked. Bedding plants can also be planted at that time. When transplanting seedlings, select some of the weaker-looking ones, as these will produce more interesting colors. Select a spot in full sun.

How do I start phlox seeds indoors?

Sow seeds inside ten weeks before the outdoor planting date. A cool room is critical for germination. Cover the seeds completely, for they need darkness to germinate. Be careful not to overwater the seedlings; they are very prone to damping-off disease. Phlox resents being transplanted; it is best, therefore, to sow seeds into individual pots.

How do I keep phlox growing well in the garden?

Fertilize monthly with a soluble plant food. Keep it well watered, but try to water only in the morning to reduce disease incidence. Keep faded flowers removed; cutting the plants back will encourage compactness and further bloom. Phlox is fairly heat-tolerant, although some decline may be seen in mid-summer.

Pincushion flower *(Scabiosa* species)

I thought pincushion flower was a perennial. Is this true?

There are both annual and perennial pincushion flowers. *S. atropurpurea* looks most like the perennial form, having dark, silvery-gray filaments extending from blue, pink, purple, rose, or white flowers. These blooms are fragrant and make excellent cut flowers. Dwarf Double and Imperial Giants are widely available varieties. *S. stellata* is grown for its dried flower heads. Light brown balls of little florets with dark maroon, starlike centers remain atop stiff stems after the flowers are dried. Ping Pong is a well-known variety.

What is the best method of culture for *Scabiosa?*

Sow seeds indoors four to five weeks before the last frost, after which they may be transplanted outdoors. Sow them outdoors after all danger of frost has passed. Give the plants a sunny position where the soil is rather light in texture, moderately rich, and alkaline. Fertilize monthly with a soluble plant food. Water when dry, but do not overwater. Because scabiosa can be prone to diseases, water them in the morning so that the foliage will dry before night.

Pincushion flower: This striking plant adds an interesting shape and texture to the flower border.

The stems of my pincushion flower did not grow straight and so were not very useful in flower arrangements. What can I do?

Tall pincushion flowers need to be staked. Plant them in masses so that the stakes will not be visible.

I had disease problems with pincushion flower. What can I do?

Although they should be watered when the soil becomes dry, be careful not to overwater. Water them in the morning, and if possible, don't get the foliage wet. Plant in full sun.

Poor-man's orchid, Butterfly flower *(Schizanthus x wisetonensis)*

The exotic look of poor-man's orchid is most attractive. How can I grow it in my window box?

Poor-man's orchid likes full sun or light shade and a rich, moist potting medium with excellent drainage. Temperatures must be cool for it to thrive. In a window box or other container, it does best if it is pot-bound. Pinch the plants when they are set out (planted in the garden), and feed them every other month during the growing season.

I tried to grow poor-man's orchid from seed, but had little success. What do you suggest?

Seeds are very fine and should not be covered with growing medium during germination. However, they need darkness to germinate, so cover the seed flats with black plastic until germination occurs.

Poppy *(Papaver* species)

I have grown perennial poppies in my garden. Does this plant also have an annual form?

Yes: Iceland poppy (*p. nudicaule*) and Shirley poppy (*P. Rhoeas*). Both resemble the perennial poppy, with paperlike flowers of red, purple, white, pink, salmon, or orange with large, black centers. The Iceland poppy is actually a perennial that can be grown as an annual if it is started early in areas where there is a long growing season.

When is the best time to plant poppies? Can they be successfully planted on top of the snow? I live in Kansas.

If in your region the poppy usually reseeds itself and plants come voluntarily the following spring, you can very well sow on the snow. Otherwise, sow the seed just as early as you can work the soil. Seeds may also be sown outdoors in late fall for germination and growth the following spring. Be sure to cover the seeds completely as they need darkness to germinate. Seeds

cannot be started successfully indoors as they require cool temperatures to germinate and, furthermore, do not like to be transplanted.

I tried to grow Shirley poppies last year, but the bloom was disappointing. What happened?

Shirley poppies do not have a long blooming period. Sow seeds every two weeks during spring and early summer for continual flowering. They will not do well if temperatures are high. Be sure not to overwater.

Portulaca, Rose moss (*Portulaca grandiflora*)

How can I make portulaca germinate and grow?

Portulaca is usually easy to grow from seed sown outdoors after all danger of frost has passed. It should have a well-drained, dry, light, but not rich soil, in full sun. Water very lightly.

Does portulaca self-sow? Someone told me to let my portulaca go to seed and I'd have plenty of plants next year.

They self-sow readily, but seedlings generally don't appear until fairly late in the spring after the soil has warmed. If they are crowded, they should be thinned or transplanted.

Pot marigold. See Calendula.

Rose moss. See Portulaca.

Salpiglossis, Painted-tongue (*Salpiglossis sinuata*)

How can I grow large, healthy salpiglossis plants?

For earlier bloom and a greater chance of success, start seeds indoors eight weeks before the outdoor planting date. Both seeds and plants may be set into the garden in mid-spring, several weeks before the last expected frost. The larger the plants are when they are set out, the better they will grow and bloom.

Seeds are very fine and should not be covered with growing medium. Since they need darkness to germinate, however, cover the seed flats with black plastic until germination occurs. Plant seedlings in full sun and a rich, moist, cool, alkaline soil.

I have heard that salpiglossis makes a good substitute for petunias under certain conditions. Why is this?

Petunias prefer hot, dry weather; salpiglossis prefers cool, moist weather. Since they are similar in appearance, salpiglossis can be used where petunias won't grow.

Ann Reilly

Portulaca: Easily grown from seed outdoors, volunteer portulaca seedlings may spring up in areas where planted the previous year.

Ann Reilly

Salvia: An excellent, stocky variety of salvia is Carabiniere.

Salvia, Scarlet sage (*Salvia* species)

I am familiar with the red salvia known as scarlet sage, but recently have seen a blue-flowered plant, also called salvia, that has a different appearance. The flower stalks are blue or purple, long and thin.

The red salvia is *S. splendens*; it also has forms in blue, purple, white, and salmon. The second plant you refer to is *S. farinacea*. It grows as a perennial in mild climates; in other areas it has become a popular annual.

How do you start red salvia seeds?

All red salvia seeds must be started indoors eight to ten weeks before the last frost, and those of *S. farinacea* must be started even earlier: twelve weeks before outdoor planting. Seeds of red-flowered varieties need light to germinate; the others do not. Salvia should be planted into the garden before it is in bloom for best results, so don't start seeds or buy plants too early.

What growing requirements do salvia have?

Salvia like full sun or partial shade and a rich, well-drained soil. Although they will tolerate dry soils, they do better if kept evenly watered. Salvia is very sensitive to fertilizer burn, so feed often, but very lightly, throughout the summer.

I have noticed that my salvia often reseed. Can I leave the seedlings in the garden beds?

Salvia does reseed under certain conditions, but the plants rarely grow large enough to bloom during the summer.

What are good varieties of salvia to shop for?

Look for tall Bonfire; stocky Carabiniere; early-blooming and heat-resistant Hotline; compact Red Hot Sally; and dwarf St. John's Fire. Good varieties of *S. farinacea* are Victoria and Rhea; there is also a white form.

Scarlet runner bean (*Phaseolus coccineus*)

Is the scarlet runner bean truly a bean?

Yes, it is. It is closely related to the snap bean, and the beans are edible. It is an excellent, and somewhat unusual, choice as a quick-growing annual vine to cover a trellis.

How do I grow scarlet runner bean?

After all frost danger has passed, plant the seeds outdoors where the plants are to grow. Choose a site with full sun and rich, moist, well-drained soil. Fertilize at planting time and again each month with an all-purpose fertilizer.

I grew scarlet runner bean last year, but after midsummer it produced no more flowers. What did I do wrong?

If you provided it with the sun and soil conditions it needs, it might have been that you did not remove the beans. Keep the beans picked as soon as they form to encourage the plant to continue producing its red flowers.

Scarlet sage. See Salvia.

Scabiosa. See Pincushion flower.

Snapdragon *(Antirrhinum majus)*

When should I plant snapdragons?

Seeds should be started and grown under fluorescent tubes indoors six to eight weeks before planting outdoors. Do not cover the seeds as light is needed for germination. Set the young plants out in the spring when the ground has begun to warm up.

Why can't I grow snapdragons from seed outdoors? They never come up.

Choose a well-drained place where the soil is light and only moderately rich. In mid-spring, rake the soil until it is finely textured and free of stones and lumps. Sow the seed and cover it with sand not more than one-eighth inch deep; do not pack the sand hard. Cover the seedbed with burlap. As soon as the seed germinates, remove the protective burlap. Water regularly in dry weather.

What conditions do snapdragons require?

They should have full sun and a light, well-drained soil that is only moderately enriched. Early planting is advised for best bloom.

What is the best fertilizer and what is the preferred pH for snapdragons?

Incorporate peat moss or rotted or dehydrated manure when preparing the soil, which should be neutral or slightly alkaline. Add lime to correct the pH, if necessary. Feed the plants with liquid fertilizer when they come into flower, or apply a complete chemical fertilizer such as 5-10-5 around the plants.

Must snapdragons be supported by stakes at the time of planting? Mine were all in curlicues and staking them after they were eight or ten inches tall didn't help at all.

Put in stakes at the same time you set the young plants out, and then start tying them as soon as signs of flopping begin. You can also insert sturdy, branched twigs among the plants to provide support as they grow. In an open situation, in properly

Ann Reilly

Scarlet runner bean: This is an excellent, and somewhat unusual, quick-growing annual vine; its beans are edible.

Sturdy, branched twigs make excellent supports for snapdragons.

Snapdragon: Colorful and abundant, snapdragons will benefit from being pinched back when the seedlings are young.

Ann Reilly

prepared soil, they should not need much support. Some varieties are low-growing and base-branching and do not require staking.

Can you tell me how to grow snapdragons in Mississippi? I buy plants and they bloom for a little while, then die.

It may be too warm or shady or perhaps your soil is too rich, too heavy and claylike, or poorly drained. Snapdragons like an open situation, light soil, and not too much feeding. They dislike heat and bloom best in cool weather, although some of the newer hybrids are more heat-resistant. Do not overcrowd snapdragons as this encourages disease.

How can I encourage snapdragons to send up more stems so I will have more blooms?

When you plant snapdragons, pinch them to induce branching. After the flower spikes have faded on the first bloom, remove them immediately to encourage a second bloom.

What are the best snapdragons for the garden? I haven't had good luck with "snaps" recently.

By all means get rust-resistant kinds. Good dwarf varieties are Floral Carpet and Kilibri, both growing six to eight inches tall. Little Darling grows a bit taller, twelve to fifteen inches high. Bright Butterflies and Madame Butterfly grow twenty-four to thirty inches tall, and Rocket is the tallest at thirty to thirty-six inches; it is also the most heat-resistant. Coronet is a medium-sized plant that is rust-resistant and weather-tolerant.

I live in Texas. What causes snapdragons to wilt and die?

Southern blight, cotton root rot, verticillium wilt, stem rot, and some other diseases. Remove diseased plants. Try new plants in a different location.

Spider flower (*Cleome Hasslerana*)

I have seen lovely pink and white spider plants. Are they something special?

Rose Queen is a fine variety that won a silver medal for excellence. Helen Campbell and White Queen are both a pure white.

I don't like the purplish-red spider flowers that self-seed into my beds and borders. How can I avoid them?

Take care to pull up all unwanted colors before they go to seed.

Will spider flowers grow in the hot, dry climate of Arizona?

In fact, spider flowers like these growing conditions. Give them full sun and fertilize little, if any.

Do spider flowers need to be staked?

No. Although they grow quite tall — three to six feet — they have strong stems and do not need to be staked. They are quite attractive when allowed to sway in gentle breezes.

Spurge *(Euphorbia* species)

I thought euphorbias were houseplants, but I have heard there are some that are good garden plants. What are these?

There are several euphorbias that grow well in the annual garden. They do not flower, but are grown for their highly colored bracts, some of which actually resemble flowers. The annual poinsettia, *E. cyathophora*, has red bracts like the holiday plant. Snow-on-the-mountain, *E. marginata*, is another euphorbia, with bracts of white or green edged with white.

How do I grow euphorbia?

For best results, start seeds indoors six to eight weeks before the last spring frost, or buy bedding plants. They need only average soil, and, in fact, will grow well even in poor soils, but they need full sun. Water them very lightly, and do not fertilize. All varieties tolerate high heat and humidity.

I have heard that these plants are poisonous. Is this true?

The plants are not lethal, but their sap can be irritating to the skin.

Statice *(Limonium* species)

I thought statice was a perennial, yet I see it listed as an annual. Which is it?

There are both annual and perennial forms of statice. In areas too cold for the perennial types, those, too, can be grown as annuals if started indoors eight to ten weeks before planting outside. Give all statice full sun and light soil.

Can I grow statice at my beach house?

Yes, statice tolerates full sun, heat, dry soil, and even salt spray.

Stock *(Matthiola incana)*

What causes stock to mature without blooming?

It may have been common stock, a biennial that does not flower until the second year. Look for varieties that are classified as seven-week or ten-week stock, which is the amount of time after germination it takes for the plant to bloom. These include Trysomic Seven Week blend, Giant Imperial, Midget, Dwarf Ten Week, and Beauty of Nice, which are types that branch freely,

Ann Reilly

Spider flower: Although striking spider flowers grow quite tall, their stems are sturdy and usually do not need staking.

and Giant Excelsior, which grows in a columnar form. All of these should be started in early spring, for they require cool growing weather.

Of one hundred ten-week stock plants in our garden, only the twenty smallest and frailest bloomed. The other eighty grew beautiful foliage from early summer until a hard freeze came, but they bloomed. Why?

Ten-week stock usually fails to bloom if subjected to constantly high temperatures of 60° F. and over. Yours must have been grown under borderline conditions, enabling a few individuals to bloom. Next time, try the Trysomic seven-week stock, which is more heat-tolerant.

How can I make stocks bloom? I live in New Jersey.

Buy Trysomic seven-week stock seed and start it indoors in March in order to set plants outside late in April. This enables them to make their growth before hot weather comes.

How do I start stock seed indoors?

Start seeds indoors six to eight weeks before the outdoor planting date. Do not cover the seed; it needs light to germinate.

Can stock seed be started outdoors?

Yes, but success will be limited. If you live in a climate with mild winters, you can sow stock outdoors in the fall with generally good luck.

What growing conditions do stocks like?

Plant them in full sun and a light, rich, well-drained soil. Fertilize prior to planting and again every month during the growing period. Keep them well watered. To prolong the blooming period, keep flowers picked as they fade.

What is the best place in the garden to plant stocks?

Plant stock where its lovely fragrance will be enjoyed, such as along the patio or under windows. A close relative of stock is the evening-scented stock, *M. longipetala*, which does not have as pretty a flower, but has an overwhelmingly sweet fragrance.

Why can't I raise good-looking stocks in California? Mine are always spindly and buggy. Even when I spray them, they are small and sickly.

Stocks in California suffer from several diseases. Young seedlings get a bacterial wilt, which can be prevented by immersing seed in hot water held at 130° F. for ten minutes and planting in a different location from past plantings. A fungus crown rot appears on overwatered, poorly drained soil; mosaic stunts the

plants. Remove the infected plants and spray to control aphids with malathion or insecticidal soap.

What can be done to control stem rot on stock?

Stem and root rot are caused by a soil fungus that yellows the lower leaves, girdles the stem, causing wilting, and rots the roots. Since the fungus spreads for several feet through the soil away from the plant, it is not removed by taking up diseased plants and surrounding soil. Plant in a new location.

Strawflower *(Helichrysum bracteatum)*

I'd like to grow some strawflowers for drying. What advice can you give me?

If you grow them from seeds, do not cover the seeds: They need light to germinate. You will have the greatest success if you live where there are long, hot, sunny summers.

Summer forget-me-not. See Anchusa.

Summer poinsettia. See Amaranthus.

Sunflower *(Helianthus annuus)*

I would like to grow sunflowers in the garden, but do not have the room for the tall sunflowers I have seen in the Midwest.

The tall sunflower *H. giganteus*, reaching twelve feet in height, is a perennial that is often grown as an annual. For a lower-

Sunflower: Even in places where there is no room for the traditional tall annual, a cheery sunflower can be enjoyed in dwarf varieties such as this Pygmy Dwarf.

Ann Reilly

growing sunflower, choose *H. annuus*. Many of these grow four to six feet tall, but there are some varieties that are quite dwarf. The taller varieties include Italian White and Sunburst Mixed; lower-growing varieties are Sunbright and Teddy Bear.

Should I start sunflower seeds indoors?

Because sunflower germinates and grows quite quickly, it is not necessary to begin it indoors. Sow seeds outdoors where the plants are to grow after all danger of frost has passed.

My sunflowers did not bloom well last year. What was wrong?

You may have overfertilized, or the summer may have been too cool; they prefer high temperatures. Do not fertilize sunflowers, and do not give them too much water.

Swan River daisy *(Brachycome iberidifolia)*

I planted Swan River daisy last year, but the blooms lasted only a few weeks and the plant did not rebloom. Were the growing conditions unsuitable?

Maybe not. Swan River daisy is not a long-blooming plant. Add plants or seeds to the garden every three weeks to ensure continuous bloom all summer.

How do I grow Swan River daisy?

If you start your own seeds indoors, sow them four to six weeks before the last expected frost. Set plants into the garden or sow seeds after all danger of frost has passed.

Will Swan River daisy grow well in my garden in Georgia in summer?

No, your area is too hot, but it can be used in the spring where you live. Plant Swan River daisy in full sun in a warm soil, rich in organic matter. Keep it well watered and mulch to keep the soil moist and cool.

Sweet alyssum *(Lobularia maritima)*

Why does white sweet alyssum come up year after year, but purple varieties don't?

The white alyssum reseeds itself prolifically, but the seeds of the purple varieties are not as vigorous and are of more complex parentage.

What are the best varieties of sweet alyssum for the garden?

White Carpet of Snow is excellent, and Snow Cloth is similar but more compact and earlier to bloom. Rose-pink Rosie O'Day

Swan River daisy: For continuous bloom throughout the summer, make successive plantings of Swan River daisy at three week intervals.

is more heat-resistant than the others. Royal Carpet has deep violet flowers and grows taller than most.

How are sweet alyssum seeds germinated?

Start seeds indoors four to six weeks before the last spring frost, or where plants are to grow several weeks before the last spring frost. Do not cover the seeds; they need light toerminate. Sweet alyssum is very prone to damping-off disease, so be careful not to overwater or overcrowd the seedlings.

What is the best way to grow sweet alyssum?

Plant in full sun or partial shade in average soil, and do not overfertilize. It should be kept moist, although it will tolerate drought. It does best where nights are cool. Although it will grow successfully in hot areas, it may not flower as much.

By midsummer, my sweet alyssum always starts to get leggy. What can I do?

Cut it back: The plants will stay more compact and flower more freely.

Where should I plant sweet alyssum in the garden?

Sweet alyssum is very fragrant, so plant it along the patio or by the front door where you will enjoy its scent. Sweet alyssum is excellent as a border plant or cascading over the sides of a container.

Sweet pea *(Lathyrus odoratus)*

How should I go about planting sweet peas?

Cool temperatures, about 50° F., are needed for germination and good growth of sweet peas. Sow seeds in a cold greenhouse or cold frame a month or more ahead of the time when the frost can be expected to be out of the ground. For best results, use individual peat pots or Jiffy-7 pots, planting one seed per pot. Place them in a cool, sunny window or, after germination, under fluorescent tubes. You may also sow seeds where plants are to grow, as early as the ground can be worked in the spring.

Can I plant sweet peas in the fall?

If you have a frost-free cold frame, you can sow the seed in September or October in a flat or in small pots placed in the cold frame; in March, transplant the seedlings to their permanent location. Or, if you have a cool porch or window (temperature not above 45° to 50° F.), you can sow seeds in February and shift them into pots after they have germinated. Harden the plants (see page 36), and set them in the garden in late March. If neither

Sweet pea. The seeds of sweet peas need cool temperatures for germination.

of these techniques is possible, sow them where they are to flower as early in March as you can. You can get a head start by preparing the ground the preceding fall.

Can sweet peas be planted in very early spring if the ground softens to a depth of two inches?

No; the soil will be too muddy to work. Wait until all the frost is out of the ground.

What is the planting date for sweet peas in Oklahoma?

Sow in November and give protection during the coldest part of winter; or sow in late winter, as soon as it is possible to work the soil.

I have had trouble germinating sweet pea seeds. Do you have any suggestions?

Sweet pea seeds have a very hard seed coat. Soak seed in water for twenty-four hours before sowing, or nick the seed coats with a small file. Be sure the seeds are completely covered, as they need darkness to germinate.

How shall I prepare the ground for sweet peas for cut flowers?

Dig a trench one and one-half feet wide and equally deep. Mix with the soil a three- to four-inch layer of compost and rotted manure or peat moss; and bone meal or superphosphate at the rate of one pound for every ten to fifteen linear feet. If possible, do this in the fall so the seeds can be planted without delay early in the spring.

I want sweet peas in clumps in a flower border. How do I go about it?

Prepare the soil as described above except that instead of a long trench, you should make circular planting stations two to three feet in diameter. Support the peas on brushwood or a cylinder of chicken-wire netting held up by four or five stakes. Or use a dwarf variety such as Little Sweetheart.

How deep should sweet pea seeds be planted, and how far apart should the plants be left?

Sweet peas are usually sown about two inches deep. You may also sow them in a six-inch-deep trench and cover them at first with two inches of soil. As the plants increase in stature, gradually fill in the trench. This technique works well in sandy soils. Thin the plants to stand about four inches apart.

How early must I place the supports for sweet pea vines?

When they are about four inches high. If left until they topple over, they never seem to grow as well as they do when staked

early. Twiggy branches stuck in on both sides of the row, or in among the plants if they are grown in clumps, make good supports, but chicken-wire netting or strings supported by a frame will do.

Can you give me some general-care instructions for sweet peas?

Full, or nearly full, sun is best; some shade is tolerated. The soil should be deep, well-drained, rich, and well-supplied with humus. Be sure the soil is neutral or somewhat alkaline — never acid. Keep weeded and cultivated; water regularly; feed weekly with liquid fertilizer after the buds begin to show.

Should I use commercial fertilizer on sweet peas?

Apply commercial fertilizers, according to the manufacturer's directions, along the sides of the row after the plants are four inches high.

I have very healthy-looking sweet pea vines but no blossoms. Why?

The soil may be deficient in phosphorus, or the vines may have been planted too late for buds to open before the hot weather blasted them.

How can the blooming season of outdoor sweet peas be prolonged?

Pick the flowers as fast as they mature and shade plants from the hot sun with cheesecloth or similar material. Water them regularly and abundantly. Hot weather usually limits the season.

Sweet peas that are planted in November in Virginia often make some winter growth or early-spring growth. Is it advisable to cut this top growth and let the base of the plant start new and tender growth?

Yes, pinch the growth back to where the stem shows signs of sprouting at the base. This later growth produces better flowers.

Is there any way to keep birds from eating my sweet peas as they come up?

Because birds are afraid of snakes, lay a few pieces of snake-like garden hose or rope, or a rubber snake, alongside the rows to frighten them away. You can also try covering the plants with cheesecloth, or running strings hung with strips of white rags along the bed.

Which varieties of sweet peas are the best for our hot, dry Kansas climate? What is the best method of planting?

Sweet peas rarely succeed outdoors in a hot, dry climate unless sown very early. Your best chance is to plant in early

Provide support such as this chicken-wire cylinder for sweet peas.

spring, keep plants well watered, and shade them from direct sun with cheesecloth. There are, as far as is known, no varieties especially adapted to your conditions. The giant heat-resistant and spring-flowering types are effective, but need abundant moisture.

I have never been successful in Oklahoma with sweet peas, my favorite flower. I get about three bouquets and then the plants die. Can you help me? I have used a number of methods with no success.

Maybe the summer sun is too much for them; try shading the plants with cheesecloth as soon as really hot, dry weather sets in. Water thoroughly and regularly. Try preparing the soil and sowing in November or December (see page 129). Select heat-resistant strains from catalogs.

I understand there are two different types of sweet peas. What are they?

Sweet peas come in two forms: the annual vines can climb to six feet, whereas bush types grow twenty-four to thirty inches tall. Royal Family is a heat-resistant vining type; Bijou and Supersnoop are compact plants that grow about two feet high.

Will treating the soil prevent the blighting of sweet peas?

Soaking the soil with a benomyl solution before planting will help in the control of various root rot diseases that cause wilting or blighting of the plants.

What causes sweet peas to wilt just below the flower buds? The whole plant then turns greenish white and dies.

A fungus disease called anthracnose, common on outdoor sweet peas, has this effect. The fungus also causes a disease of apples. It lives during the winter in cankered limbs and mummied apples, as well as on sweet pea pods and seed and soil debris. Spray with benomyl biweekly during the growing season. Clean up all plant refuse in the fall. Plant only those seeds that appear sound and plump.

Why do my sweet peas develop a curled and puckered appearance? I plant on new ground each year, treat seeds with fungicide, and give plenty of moisture.

This is probably mosaic, carried from plant to plant by aphids. Virus diseases are common in the Northwest in particular, and there is nothing you can do except try to control aphids by sprays and remove infected plants promptly.

Tahoka daisy *(Machaeranthera tanacetifolia)*

My Tahoka daisy seeds did not germinate. What could the problem have been?

Tahoka daisy needs cold treatment to germinate, so sow seeds outdoors in early spring as soon as the soil can be worked, or chill seeds in the refrigerator for two weeks before sowing (see stratification, page 23). In mild areas, sow seeds in fall for spring germination and bloom.

Is it true that Tahoka daisy must have a cool climate?

Yes, and a dry one, too. Water and fertilize sparingly. Plant in full sun.

Toadflax. See Linaria.

Tree mallow. See Lavatera.

Tuberous begonia. See Begonia, tuberous.

Verbena *(Verbena x hybrida)*

How can I raise verbenas? I have not had much luck with them in Kansas.

Verbenas are not easy to raise unless you have adequate facilities, and the seed is variable in its germination. Because verbena requires a long season, sow seeds ten to twelve weeks before planting outside. Verbena seeds also benefit from being chilled in the refrigerator for seven days prior to sowing (see stratification, page 23). Verbena is very prone to damping-off disease, so be sure to use sterile sowing medium. Do not overcrowd seedlings and do not overwater. During germination and early growth, keep them at a temperature of 60° F. at night and 70 to 75° F. during the day. After the first true leaves appear (see page 21), transplant seedlings into flats containing a commercial soilless mix or equal parts of sterile loam, sand, leaf mold, and rotted or dehydrated manure or compost. When plants are established (about ten days), harden off the plants in a cold frame before planting them outside. Set them out in the ground when the danger of frost is past.

Which verbena varieties will do best in my garden?

Some verbenas grow upright whereas other varieties form a spreading ground cover. Ideal Florist, a vigorous older variety, is available in a good mixture of many colors. Romance has spreading plants that do not stretch, a breakthrough for verbenas. Showtime is also a spreading type, and one of the most heat-tolerant, with better germination than most verbenas. Sparkle is a mixture of bright colors, but has poor germination.

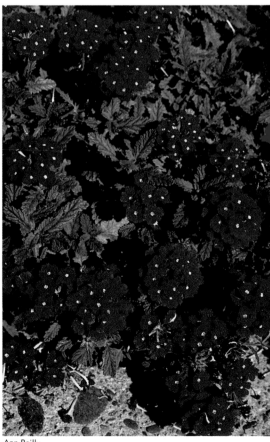

Verbena: These colorful annuals thrive in hot weather, even in infertile soil.

Ann Reilly

Springtime has a spreading habit, flowers early, and has a high germination rate. Trinidad, a dazzling pink, grows upright.

What type of growing conditions do verbenas like in the garden?

Grow in full sun in a light, rich, well-drained soil. Verbena is one of the best annuals to grow where it is hot and where the soil is infertile. Fertilize monthly with a soluble fertilizer.

Wax begonia. See Begonia, wax.

Wishbone flower *(Torenia Fournieri)*

What does wishbone flower look like?

It is an attractive little plant that is very bushy and has purple, lavender, and gold flowers similar to miniature snapdragons. Its foliage turns plum-colored in late autumn.

How do I grow wishbone flower from seed?

Seeds should be started indoors ten to twelve weeks before the last spring frost, when seedlings should be transferred to the garden.

Can I grow wishbone flower in the sun?

Only in cool climates, where night temperatures are below 65° F. Otherwise, grow it in partial or full shade, in a rich, moist, well-drained soil. Feed lightly.

Wishbone flower: The foliage of this bushy little plant turns plum color in late autumn.

Zinnia *(Zinnia elegans)*

How should zinnias be used in the flower garden?

Zinnias come in such diverse sizes and flower forms that they have many uses in the garden. Lower-growing varieties are excellent as borders or edgings. Taller types can be used at the back of the border, as tall hedges, or in the cutting garden. Zinnias also grow well in containers.

What are the best zinnia varieties to plant?

Border Beauty is a medium-sized plant with semi-double or double flowers. Cut & Come Again is a tall type, excellent as cut flowers. Dasher and Peter Pan are short, compact plants with large, double flowers. Pulcino, with semi-double flowers, is one of the most disease-resistant zinnias. Rose Pinwheel, with daisylike flowers, is very disease-resistant. Ruffles is a cutting type with ball-shaped flowers with ruffled petals. Small World has beehive-shaped flowers. State Fair has large flowers on tall plants; it is also disease-resistant. Thumbelina, with semi-double and double flowers, is one of the smallest zinnias.

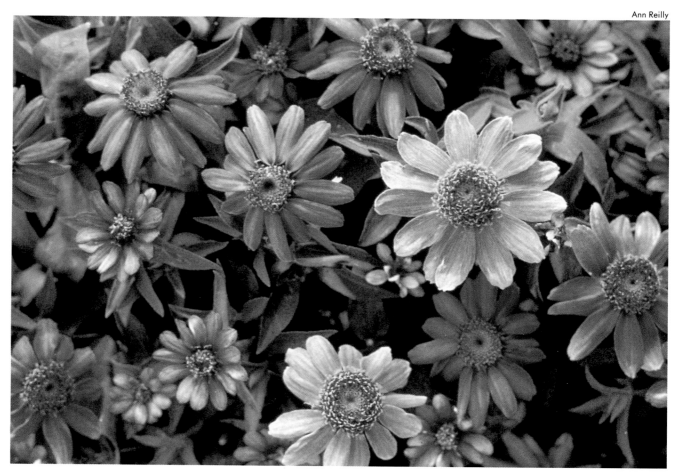

Zinnia: One of a wide variety of sizes, colors, and shapes of zinnias, this Rose Pinwheel, a daisylike zinnia, is quite disease-resistant.

I have seen zinnias that are predominantly red-, yellow-, and mahogany-flowered. They are unlike other garden zinnias. What are they?

This is the Mexican zinnia, *A. Haageana*. Good varieties are Old Mexico and Persian Carpet.

What soil is best for zinnias?

Zinnias appreciate a fairly heavy, rich loam. Additions of rotted or dried manure, compost, or peat moss, plus commercial fertilizer, will produce sturdy plants. They prefer a neutral soil (pH 6 or higher).

What type of growing conditions do zinnias like?

Plant zinnias in full sun. Although they like hot, dry climates, they should be watered when the soil starts to dry out. Prevent mildew by watering in the morning and not getting foliage wet.

Is the middle of April too early to plant zinnia and marigold seeds outdoors in central Pennsylvania?

Yes, it is a few weeks too early — after danger of frost has passed, May 1 to May 15, would be better.

Should zinnias be transplanted?

Zinnias are very easily transplanted, but they can be sown, if desired, where they are to grow, and then be thinned out.

How should I grow zinnias for the cutting garden?

When you first plant them, pinch them back in order to encourage more growing stems. Even if you don't cut them for indoor use, keep flowers cut as they fade; this will keep the plants producing more blooms.

At the end of the summer, my zinnia leaves have a white, powdery covering on them and they sometimes develop black markings. What is the problem?

Zinnias are prone to mildew and leaf spot diseases. To reduce this problem, choose disease-resistant varieties, keep water off the foliage, and increase air circulation by giving the plants adequate space.

This year my zinnias have been badly infested with stem borers, but there were no marks or sawdust visible on the outside. I cannot find material telling their life cycle or control. Can you supply me with information?

These probably are the common stalk borers, although they are listed as general only east of the Rockies. They winter as eggs on weeds and old stalks, so that the chief control measure is getting rid of these.

Annuals Selection Guide

NAME	PLANTING DISTANCE	MAINTENANCE LEVEL	HEIGHT	LIGHT	MOISTURE	TEMPERATURE	HARDINESS
African daisy	8-10″	medium	10-12″	S	d	c	H
Ageratum	5-7″	low	4-6″	S,PSh	a-m	a	HH
Alternanthera	8-10″	low	4-6″	S	a	a	T
Amaranthus	15-18″	medium	18-36″	S	d	a-h	HH
Anchusa	8-10″	medium	8-10″	S	d-a	a-h	HH
Aster, China	6-18″	high	6-30″	S,PSh	m	a	HH
Baby-blue-eyes	8-12″	low	6-8″	S,LSh	a	c	HH
Baby's-breath	16-18″	medium	15-18″	S	d-a	a	HH
Balsam	10-15″	low	12-36″	S,PSh	m	h	T
Basil	6-8″	low	12-15″	S	a	a	T
Begonia, fibrous	7-9″	low	6-8″	S,PSh,Sh	a	a	HH
Begonia, tuberous	8-10″	low	8-10″	PSh,Sh	m	c-a	T
Bells-of-Ireland	10-12″	medium	24-36″	S,LSh	a	a	HH
Black-eyed Susan vine	12-15″	medium	3-6′	S,PSh	m	a	HH
Blue daisy	15-18″	medium	30-36″	S	d	c	HH
Blue lace flower	8-10″	medium	24-30″	S	a	c	HH
Browallia	8-10″	low	10-15″	PSh,Sh	m	c	HH
Calendula	8-10″	high	10-12″	S,LSh	m	c-a	H
California poppy	6-8″	low	12-24″	S	d-a	any	VH
Calliopsis	4-12″	medium	8-36″	S	d	a	HH
Campanula	12-15″	medium	18-36″	S,LSh	a-m	a	VH
Candytuft	7-9″	low	8-10″	S	d-a	any	HH
Cape marigold	4-6″	low	4-16″	S	d	c-a	HH
Castor bean	4-5′	low	5-8′	S	m	h	T
Celosia	6-8″	low	6-15″	S	d	a-h	HH
Chrysanthemum	4-18″	medium	4-36″	S	a-m	c-a	T
Cineraria	10-12″	high	12-18″	PSh,S	m	c	HH
Clarkia	8-10″	high	18-24″	S,LSh	d-a	c	H
Coleus	8-10″	low	10-24″	PSh,Sh	a-m	a-h	T
Cornflower	6-12″	medium	12-36″	S	d-a	a	VH
Cosmos	9-18″	medium	18-30″	S	d-a	a	HH

Maintenance level: a rough indication of the amount of care that will be required
Light: S = Full sun
 LSh = Light shade
 PSh = Part Shade
 Sh = Full shade
Moisture: d = dry
 a = average
 m = moist
Temperature: c = cool (below 70° F.)
 a = average
 h = hot (above 85° F.)
Hardiness: VH = very hardy, will withstand heavy frost
 H = hardy, will withstand light frost
 HH = half hardy, will withstand cool weather, but not frost
 T = tender, will do poorly in cool weather, will not withstand frost

Annuals Selection Guide

NAME	PLANTING DISTANCE	MAINTENANCE LEVEL	HEIGHT	LIGHT	MOISTURE	TEMPERATURE	HARDINESS
Creeping zinnia	5-7″	medium	5-6″	S	d-a	a-h	HH
Dahlberg daisy	4-6″	low	4-8″	S	d-a	a-h	HH
Dahlia	8-10″	high	8-15″	S,LSh	a-m	a	T
Dianthus	7-9″	low	6-10″	S,PSh	a	c-a	HH
Dusty miller	6-8″	low	8-10″	S,PSh	d-a	a-h	HH
English daisy	6-8″	medium	4-6″	S,LSh	m	c	VH
Flowering cabbage/kale	15-18″	low	15-18″	S	m	c	VH
Forget-me-not	8-12″	low	6-12″	PSh	m	c	H
Four-o'clock	12-18″	low	18-36″	S	d-a	any	T
Fuchsia	8-10″	high	12-24″	PSh,Sh	m	a	T
Gaillardia	8-15″	medium	10-18″	S,LSh	d-a	a-h	HH
Gazania	8-10″	high	6-10″	S	d-a	a-h	HH
Geranium	10-12″	high	10-15″	S	a-m	a	T
Gerbera	12-15″	medium	12-18″	S	m	a	HH
Globe amaranth	10-15″	medium	24-30″	S	d	h	T
Gloriosa daisy	12-18″	low	18-36″	S,LSh	a	a-h	HH
Hibiscus	24-30″	medium	48-60″	S,LSh	m	a	H
Hollyhock	18-24″	medium	2-8′	S,LSh	m	a	H
Ice plant	8-12″	low	6-8″	S	d	a-h	T
Immortelle	9-12″	medium	18-24″	S	a	a-m	T
Impatiens	8-10″	low	6-18″	PSh,Sh	m	a	T
Iresine	12-15″	low	6-8″	S	a	a	T
Ivy geranium	10-12″	medium	24-36″	S	a	a	T
Kingfisher daisy	3-4″	medium	6-8″	S	d	c	HH
Kochia	18-24″	low	24-36″	S	d	a-h	HH
Lantana	8-10″	medium	10-12″	S	a	a	T
Larkspur	12-36″	high	12-60″	S	m	c	HH
Lavatera	12-15″	medium	18-30″	S	d-a	a	H
Linaria	6-8″	low	8-12″	S,LSh	m	c	VH
Lisianthus	12-14″	high	24-30″	S	a	a-h	HH
Lobelia	8-10″	low	3-5″	S,PSh	m	c-a	HH
Love-in-a-mist	8-10″	medium	12-24″	S	a-m	c	VH
Marigold, African	12-15″	high	18-30″	S	a	a	HH
Marigold, French	3-6″	high	5-10″	S	a	a	HH
Mexican sunflower	24-30″	medium	48-60″	S	d	a-h	T
Mignonette	10-12″	medium	12-18″	S,LSh	m	c	VH
Money plant	12-15″	medium	30-36″	S,LSh	a	a	VH
Monkey flower	5-7″	low	6-8″	PSh,Sh	m	c	HH
Morning-glory	12-18″	medium	3-30′	S	d	a	T
Nasturtium	8-12″	low	12-24″	S,LSh	d	c-a	T
Nemesia	5-6″	high	8-18″	S,LSh	m	c	HH
New Guinea impatiens	10-12″	low	10-12″	S,LSh	m	a	T

Annuals Selection Guide

NAME	PLANTING DISTANCE	MAINTENANCE LEVEL	HEIGHT	LIGHT	MOISTURE	TEMPERATURE	HARDINESS
Nicotiana	8-10"	low	12-15"	S,PSh	m	a-h	HH
Nierembergia	6-9"	low	4-6"	S,LSh	m	a	T
Nolana	12-15"	medium	5-6"	S,LSh	a	a	T
Ornamental pepper	5-7"	low	4-8"	S,PSh	m	a-h	HH
Pansy	6-8"	medium	4-8"	S,PSh	m	c	VH
Parsley	6-8"	low	12-18"	S,LSh	a	a	VH
Penstemon	12-18"	medium	24-30"	S	a	c	VH
Periwinkle	6-10"	low	4-12"	S,PSh	any	a-h	HH
Petunia	10-12"	medium	6-12"	S	d	a-h	HH
Phlox	7-9"	low	6-10"	S	m	c-a	H
Pincushion flower	10-15"	high	18-36"	S	a	a	T
Poor-man's orchid	10-12"	medium	12-24"	S,LSh	m	c	HH
Poppy	9-12"	high	12-36"	S	d	c-a	VH
Portulaca	6-8"	low	4-6"	S	d	h	T
Salpiglossis	10-12"	medium	18-24"	S	m	c	HH
Salvia	6-8"	low	12-24"	S,PSh	a-m	a-h	HH
Scarlet runner bean	2-4"	medium	8'	S	m	a	T
Snapdragon	6-8"	medium	6-15"	S	a	c-a	VH
Spider flower	12-15"	low	30-48"	S	d	a-h	HH
Spurge	10-12"	low	24-36"	S	d	a-h	T
Statice	12-24"	medium	12-36"	S	d	a-h	HH
Stock	10-12"	high	12-24"	S	m	c	H
Strawflower	7-9"	medium	15-24"	S	d	a-h	HH
Sunflower (dwarf)	12-24"	high	15-48"	S	d	h	T
Swan River daisy	5-6"	medium	12-18"	S	m	c	T
Sweet alyssum	10-12"	low	3-5"	S,PSh	a-m	a	H
Sweet pea	6-15"	medium	24-60"	S	m	c-a	H
Tahoka daisy	9-12"	medium	12-24"	S	d	c	VH
Verbena	5-7"	medium	6-8"	S	d-a	h	T
Wishbone flower	6-8"	low	8-12"	PSh,Sh	m	c	HH
Zinnia	4-18"	high	4-36"	S	d-a	a-h	T

Maintenance level: a rough indication of the amount of care that will be required
Light: S = Full sun
 LSh = Light shade
 PSh = Part Shade
 Sh = Full shade
Moisture: d = dry
 a = average
 m = moist
Temperature: c = cool (below 70° F.)
 a = average
 h = hot (above 85° F.)
Hardiness: VH = very hardy, will withstand heavy frost
 H = hardy, will withstand light frost
 HH = half hardy, will withstand cool weather, but not frost
 T = tender, will do poorly in cool weather, will not withstand frost

Annuals From Seed

ANNUAL	DAYS TO GERMINATE	BEGIN SEED INDOORS BEFORE PLANTING SEEDLINGS OUTDOORS (# OF WEEKS)	BEGIN SEED OUTDOORS BEFORE LAST FROST (# OF WEEKS)	MOVE SEEDLINGS OUTDOORS BEFORE LAST FROST (# OF WEEKS)
African daisy	21-35	6-8	4	4
Ageratum	5-10	6-8	last frost	last frost
Alternanthera	—	—	—	last frost
Amaranthus	10-15	3-4	last frost	last frost
Anchusa	14-21	6-8	last frost	last frost
Aster, China	10-14	6-8	last frost	last frost
Baby-blue-eyes	7-12	—	6-8	—
Baby's-breath	10-15	4-6	6	4
Balsam	8-14	6-8	last frost	last frost
Basil	7-10	6-8	last frost	last frost
Begonia, fibrous	15-20	10-12	—	last frost
Begonia, tuberous	15-20	12-16	—	last frost
Bells-of-Ireland	25-35	—	6-8	—
Black-eyed Susan vine	10-15	6-8	last frost	last frost
Blue daisy	25-35	10-12	6	4
Blue lace flower	15-20	6-8	last frost	last frost
Browallia	14-21	6-8	—	last frost
Calendula	10-14	4-6	6	4
California poppy	10-12	—	4-6	—
Calliopsis	5-10	6-8	last frost	last frost
Campanula	10-14	6-8	4	4
Candytuft	10-15	6-8	last frost	last frost
Cape marigold	10-15	4-5	last frost	last frost
Castor bean	15-20	6-8	last frost	last frost
Celosia	10-15	4-6	last frost	last frost
Chrysanthemum	10-18	8-10	last frost	last frost
Cineraria	10-15	24-26	—	4
Clarkia	5-10	—	last frost	—
Coleus	10-15	6-8	—	last frost
Cornflower	7-14	4-6	6	4
Cosmos	5-10	5-7	last frost	last frost
Creeping zinnia	10-15	—	last frost	—
Dahlberg daisy	10-15	6-8	—	last frost
Dahlia	5-10	4-6	last frost	last frost
Dianthus	5-10	8-10	last frost	last frost
Dusty miller	10-15	8-10	—	last frost
English daisy	10-15	6-8	6	4
Flowering cabbage and kale	10-18	6-8	—	last frost
Forget-me-not	8-14	6-8	6	4
Four-o'clock	7-10	4-6	last frost	last frost

Annuals From Seed

ANNUAL	DAYS TO GERMINATE	BEGIN SEED INDOORS BEFORE PLANTING SEEDLINGS OUTDOORS (# OF WEEKS)	BEGIN SEED OUTDOORS BEFORE LAST FROST (# OF WEEKS)	MOVE SEEDLINGS OUTDOORS BEFORE LAST FROST (# OF WEEKS)
Fuchsia	21-26	24-26	—	last frost
Gaillardia	15-20	4-6	last frost	last frost
Gazania	8-14	4-6	last frost	last frost
Geranium	5-15	12-15	—	last frost
Gerbera	15-25	8-10	—	last frost
Globe amaranth	15-20	6-8	last frost	last frost
Gloriosa daisy	5-10	6-8	2	2
Hibiscus	15-20	6-8	last frost	last frost
Hollyhock	10-14	6-8	—	last frost
Ice plant	15-20	10-12	—	last frost
Immortelle	10-15	6-8	last frost	last frost
Impatiens	15-20	10-12	—	last frost
Iresine	—	—	—	last frost
Ivy geranium	5-15	12-16	—	last frost
Kingfisher daisy	25-35	10-12	6	4
Kochia	10-15	4-6	last frost	last frost
Lantana	40-45	12-14	—	last frost
Larkspur	8-15	6-8	4-6	4-6
Lavatera	15-20	—	4-6	—
Linaria	10-15	4-6	6	6
Lisianthus	15-20	28-32	—	last frost
Lobelia	15-20	10-12	—	last frost
Love-in-a-mist	10-15	4-6	6	4
Marigold, African	5-7	4-6	—	last frost
Marigold, French	5-7	4-6	last frost	last frost
Mexican sunflower	5-10	6-8	last frost	last frost
Mignonette	5-10	—	4-6	—
Money plant	10-14	6-8	4	2
Monkey flower	8-12	10-12	—	2
Morning-glory	5-7	4-6	last frost	last frost
Nasturtium	7-12	—	last frost	—
Nemesia	7-14	4-6	last frost	last frost
New Guinea impatiens	14-28	10-12	—	last frost
Nicotiana	10-20	6-8	last frost	last frost
Nierembergia	15-20	10-12	—	last frost
Nolana	7-10	4-6	last frost	last frost
Ornamental pepper	21-25	6-8	—	last frost
Pansy	10-20	6-8	—	4-6
Parsley	14-21	6-8	2-4	last frost
Penstemon	10-15	6-8	6-8	4

Annuals From Seed

ANNUAL	DAYS TO GERMINATE	BEGIN SEED INDOORS BEFORE PLANTING SEEDLINGS OUTDOORS (# OF WEEKS)	BEGIN SEED OUTDOORS BEFORE LAST FROST (# OF WEEKS)	MOVE SEEDLINGS OUTDOORS BEFORE LAST FROST (# OF WEEKS)
Petunia	10-12	10-12	—	last frost
Phlox	10-15	—	6-8	—
Pincushion flower	10-15	4-5	last frost	last frost
Poor-man's orchid	20-25	10-12	—	last frost
Poppy	10-15	—	6-8	—
Portulaca	10-15	4-6	last frost	last frost
Salpiglossis	15-20	6-8	—	last frost
Salvia	12-15	6-8	—	last frost
Scarlet runner bean	6-10	—	last frost	—
Snapdragon	10-14	6-8	2	last frost
Spider flower	10-14	4-6	last frost	last frost
Spurge	10-15	6-8	last frost	last frost
Statice	15-20	8-10	last frost	last frost
Stock	7-10	6-8	last frost	last frost
Strawflower	7-10	4-6	last frost	last frost
Sunflower	10-14	—	last frost	—
Swan River daisy	10-18	4-6	—	last frost
Sweet alyssum	8-15	4-6	4	2
Sweet pea	20-30	—	6-8	—
Tahoka daisy	25-30	6-8	4-6	4-6
Verbena	20-25	12-14	—	last frost
Wishbone flower	15-20	10-12	—	last frost
Zinnia	5-7	4-6	last frost	last frost

Glossary

ANALOGOUS COLOR HARMONY. A planting made up of three colors that appear in a row on the color wheel.

ANNUAL. A plant that is sown, flowers, sets seeds, and dies all within one season.

BED. Flower beds are plantings, such as those in the middle of a yard, that are accessible from all sides and intended to be viewed from all sides.

BEDDING PLANTS. Plants raised indoors specifically for the purpose of planting in open-air beds.

BERM. A rounded mound of earth.

BORDER. Flower borders are plantings along the edge of an area such as a fence, driveway, or foundation, usually accessible and viewed from only one side.

BROADCAST. Scatter seeds freely over the entire seedbed.

COLOR HARMONY. Color scheme.

COMPLEMENTARY COLOR HARMONY. A planting made up of two colors that are directly opposite one another on the color wheel.

COTYLEDON. The seed, or first, leaves of a germinating plant.

CROWN. The area of a seed plant where the root and stem merge.

CULTIVAR. A cultivated variety, created by the successful cross-pollination of two different plants within a species.

DAMPING OFF. A fungus disease carried in unsterile soil that causes young seedlings to wither and die.

DEADHEADING. Picking or cutting off flowers as soon as they begin to fade in order to encourage continued bloom on the plant.

DISBUDDING. Removing most buds from a developing plant in order to leave one bud of increased size and strength.

DRILL. A shallow furrow into which seed is sown.

FLAT. A shallow, topless box with drainage slits or holes in the bottom, used for sowing seeds, inserting cuttings, and transplanting young seedlings.

GRANDIFLORA. A plant that contains both single blooms and clusters of blooms.

HALF-HARDY ANNUAL. A plant whose seeds can be planted fairly early in the spring because the plant is cold-resistant.

HARDENING OFF. A process of subjecting seedlings that were begun indoors to increasing amounts of light and outdoor temperatures prior to transplanting them into the garden.

HARDY ANNUAL. A plant whose seeds can be planted in the fall or in very early spring, because the plant is not injured by frosts.

HOT CAPS. Tentlike coverings of plastic or paper used to protect tender seedlings from too much sun, wind, or cold.

HYBRID. A new plant created by the successful cross-pollination of two plants of two different species, thus with different genetic traits.

LEACHING. The action of water percolating through the soil.

MASSED PLANTING. A planting entirely of one species.

MONOCHROMATIC COLOR HARMONY. A planting consisting of different shades of a single color.

MULTIFLORA. A plant containing a cluster of flowers.

PINCHING BACK. The technique of pinching out the growing point of developing plants in order to encourage bushiness.

SCARIFICATION. The technique of nicking or breaking the seed coat slightly with a small file or scissors in order to facilitate the entrance of water into the seed.

SERIES. Those annual varieties in which the same type of plant is available in a range of different flower colors.

SPLIT COMPLEMENTARY COLOR HARMONY. A planting made up of two colors, one of which appears next to the color opposite the other color on the color wheel.

STANDARD. A plant form whereby the strongest stem is selected and all other stems and lower foliage are pruned away, thus allowing the plant to fill out and bloom only at the top, like a small tree.

STRATIFICATION. A technique that involves chilling moistened seeds for a period of time prior to planting them.

TAMPER. A tool similar to a mason's float used for tamping soil firmly in flats.

TENDER ANNUAL. A plant whose seeds can be planted outdoors only after the ground has warmed up and all danger of frost is past because the plant is easily injured by frost.

TENDER PERENNIAL. Perennial plants that cannot survive cold winters and therefore must be treated like annuals in order to grow them in certain areas.

TRUE LEAVES. Those leaves that appear after the cotyledons, or seed leaves.

VARIETY. A plant that is different from the true species occurring in nature.

VOLUNTEER. Seedlings that spring up from seeds that were dropped and left in the ground from the year before.

Appendix

Abundant Life Seed Foundation
1029 Lawrence
P.O. Box 772
Port Townsend, WA 98368.

Applewood Seed Co.
5380 Vivian St.
Arvada, CO 80002

W. Atlee Burpee Co.
300 Park Avenue
Warminster, PA 18974

Comstock Ferre & Co.
263 Main St.
Wethersfield, CT 06109

Gurney Seed & Nursery Co.
110 Capitol St.
Yankton, SD 57079

Harris Seeds
961 Lyell
Rochester, NY 14624

Ed Hume Seeds, Inc.
1819 South Central
P.O. Box 1450
Kent, WA 98032

Jackson & Perkins Co.
2518 South Pacific Highway
Box 1028
Medford, OR 97501

Johnny's Selected Seed
Foss Hill Road
Albion, ME 04910

J.W. Jung Seed Co.
Randolph, WI 53957

Orol Ledden & Sons
Center Ave.
P.O. Box 7
Sewell, NJ 08080

Earl May Seed & Nursery Co
Shenandoah, IA 51603

George W. Park Seed Co.
Greenwood, SC 29647

Clyde Robin Seed Co
P.O. Box 2366
Castro Valley, CA 94546

Stokes Seeds Inc.
183 East Main
Fredonia, NY 14063

Thompson & Morgan
Box 1308
Jackson, NJ 08527

Vermont Bean Seed Company
Garden Lane
Fair Haven, VT 05743

MAIL-ORDER SOURCES OF ANNUAL SEEDS

GARDENS TO VIEW
ANNUALS
•

American Horticultural Society
River Farm
Mt. Vernon, VA 22121

Atlanta Botanical Garden
1345 Piedmont Ave.
P.O. Box 77246
Atlanta, GA 30357
404-876-5858

Biltmore Gardens
1 North Park Square
Asheville, NC 28802
704-274-1776

Blithewold Gardens
101 Ferry Rd.
Bristol, RI 02809

Boerner Botanical Gardens
5879 S. 92 St.
Hales Corners, WI 53130
414-425-1132

California Polytechnic University
San Luis Obispo, CA 93407

Cantigny Gardens
15151 Winfield Rd.
Wheaton, IL 60187

Chicago Botanic Garden
Lake Cook Road
Glencoe, IL
312-835-5440

Cypress Gardens
3030 Gypsy Garden Rd.
Moncks Corner
Charleston, SC 29461
803-553-0515

Denver Botanical Gardens
909 York St.
Denver, CO 80206
303-331-4000

Dow Gardens
1018 W. Main St.
Midland, MI 48640
517-631-2677

Duke Gardens
Duke University
Durham, NC 22706
919-684-3698

Filoli Center
Canada Rd.
Woodside, CA 94062
415-366-4660

Flower & Garden Magazine
4251 Pennsylvania Ave.
Kansas City, MO 64111

Fort Worth Botanic Gardens
3220 Botanic Garden Drive
Fort Worth, TX 76107
817-870-7686

Frelinghuysen Arboretum
53 E. Hanover Ave.
Morristown, NJ 07960
201-326-7600

Goldsmith Seeds
2280 Hecker Pass Highway
Gilroy, CA 95020

Harris Seed Co.
3670 Buffalo Rd.
Rochester, NY 14624

Hershey Gardens
612 Park Ave.
Hershey, PA 17033
717-534-3492

Hodges Garden
P.O. Box 900
Many, LA 71429
318-586-3523

International Peace Garden
Dunseith, ND 58329
701-263-4390

Kingwood Center
900 Park Ave. West
Mansfield, OH 44906
419-522-0211

Longwood Gardens
P.O. Box 501
Kennett Square, PA 19348
215-388-6741

Los Angeles State and County
Arboretum
301 N. Baldwin Ave.
Arcadia, CA 91006
818-446-8251

Michigan State University
East Lansing, MI 48824

Missouri Botanical Garden
4344 Shaw Blvd.
St. Louis, MO 63110
314-577-5100

Mohonk Mountain House
Mountain Rest Rd.
New Paltz, NY 12561
914-255-1000

Old Westbury Gardens
71 Old Westbury Rd.
P.O. Box 430
Old Westbury, NY 11568

Noelridge Park
4900 Council St. N.E.
Cedar Rapids, IA 52402

Norfolk Botanical Gardens
Norfolk, VA
804-441-5386

Park Seed Co.
Cokesbury Rd.
Greenwood, SC 29647
803-223-7333

Queens Botanical Garden
43-50 Main St.
Flushing, NY 11355
718-886-3800

Reynolda Gardens
Wake Forest University
Winston Salem, NC 27106
919-761-5593

San Antonio Botanical Center
555 Funston Pl.
San Antonio, TX 78209
512-821-5115

Sonnenberg Gardens
151 Charlotte St.
P.O. Box 663
Canandaigua, NY 14424
716-394-4922

Stan Hywet Hall
714 No. Portage Path
Akron, OH 44303
216-836-5533

State Botanical Garden of Georgia
2450 So. Milledge Ave.
Athens, GA 30605
404-542-6329

Strybing Arboretum and Botanical
Gardens
Golden Gate Park
Ninth Ave. at Lincoln Way
San Francisco, CA 94122

Sunset Magazine
80 Willow Rd.
Menlo Park, CA 94025

FURTHER READING

Annuals and Biennials, Kenneth Beckett, Ballantine Books, 1984
Annuals, Time-Life Books, 1988
Annuals: How to Select, Grow and Enjoy, Derek Fell, HP Books, 1983
Beds and Borders, Brooklyn Botanic Garden, 1986
Color with Annuals, Ortho Books, 1987
The Complete Book of Gardening Under Lights, Elvin McDonald, Doubleday & Co., 1973
Complete Guide to Pest Control with and without Chemicals, George Ware, Thomson Publications, 1988
Crockett's Flower Garden, James Underwood Crockett, Little, Brown and Company, 1981
Diseases and Pests of Ornamental Plants, Pascal P. Pirone, Wiley-Interscience, 1978
The Encyclopedia of Organic Gardening, Rodale Press, 1978

Garden Color: Annuals & Perennials, Sunset Books, 1981

Gardening Under Lights, Time Life Books, n.d.

Gardening Indoors Under Lights, Frederick and Jacqueline Kranz, The Viking Press, 1971

Gardening Under Artificial Light, Brooklyn Botanic Garden, n.d.

A Handbook on Annuals, Brooklyn Botanic Garden, 1974

The Indoor Light Gardening Book, George A. Elbert, Crown Publishers, Inc., 1973

Rodale's Color Handbook of Garden Insects, Anna Carr, Rodale Press, 1979

Taylor's Guide to Annuals, Houghton Mifflin Company, 1986

Index